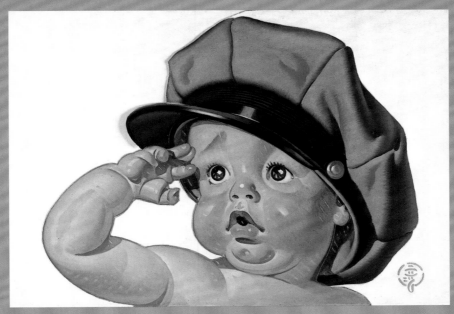

J.C. LEYENDECKER

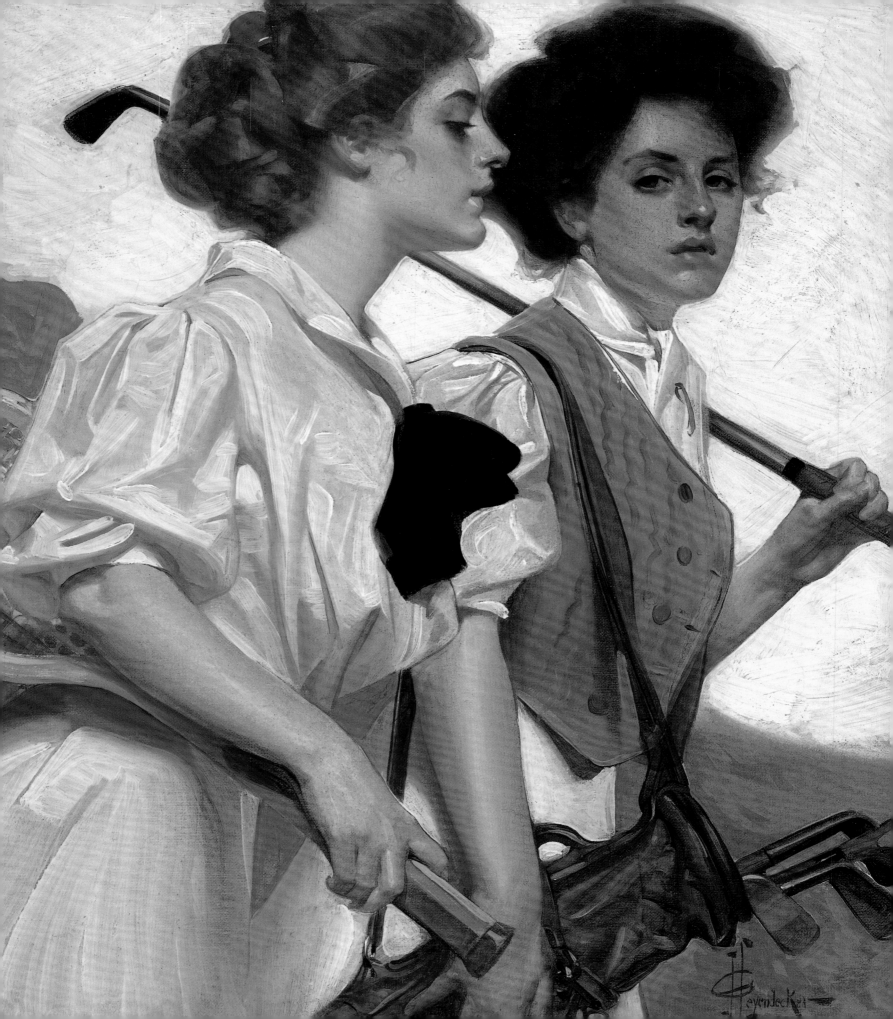

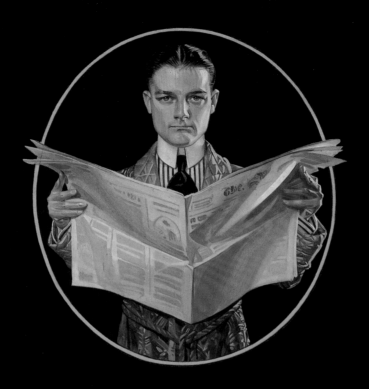

J.C. LEYENDECKER

AMERICAN IMAGIST

LAURENCE S. CUTLER

JUDY GOFFMAN CUTLER

& THE NATIONAL MUSEUM OF AMERICAN ILLUSTRATION

ABRAMS, NEW YORK

Dedicated to second children, especially boys, and these in particular:

Jeffrey Alpert, Martin Elliot Cutler, Zachary Wolf Cutler, Jacob Cutler,
Andrew Douglas Goffman, Jon Greenawalt, Jr., Julian Asher Banks Greenawalt,

and

Joseph Christian Leyendecker

EDITOR: Beverly Fazio Herter
DESIGNER: Laura Lindgren
PRODUCTION MANAGER: Jules Thomson

Library of Congress Cataloging-in-Publication Data:

Cutler, Laurence S.
 J.C. Leyendecker / by Laurence S. Cutler and Judy Goffman Cutler.
 p. cm.
 ISBN 978-0-8109-9521-5 (Abrams)
 1. Leyendecker, J. C. (Joseph Christian), 1874–1951—Catalogs. 2. Magazine illustration—United States—20th
century—Catalogs. I. Leyendecker, J. C. (Joseph Christian), 1874–1951. II. Cutler, Judy Goffman.
III. Title.
 NC975.5.L4A4 2008
 741.6'52092—dc22 2008014691

Printed and bound in China
10 9 8 7 6 5 4 3 2 1

Abrams books are available at special discounts when purchased in quantity for premiums and promotions as
well as fundraising or educational use. Special editions can also be created to specification. For details, contact
specialmarkets@hnabooks.com or the address below.

COVER: Adapted from *Quality by Kuppenheimer (Mermaid and Handsome Men)*. c. 1930. PAGE 1: *Baby Saluting*. 1940.
Oil on board, 17 x 24¹/₂". Amoco advertisement. PAGE 2: *Vacation* (detail). 1907. PAGE 3: *Man Reading the Paper*. 1916.
Oil on canvas, 29¹/₂ x 20". Arrow collar advertisement. PAGE 7: *Self–Portrait*. 1897. Pencil on paper, 8³/₄ x 6¹/₂".

HNA
harry n. abrams, inc.
a subsidiary of La Martinière Groupe
115 West 18th Street
New York, NY 10011
www.hnabooks.com

CONTENTS

I guess if I had to live it all over again,
I might have done it differently . . . ,
but maybe I couldn't have . . .

Joe Leyendecker
to Norman Rockwell, circa 1951

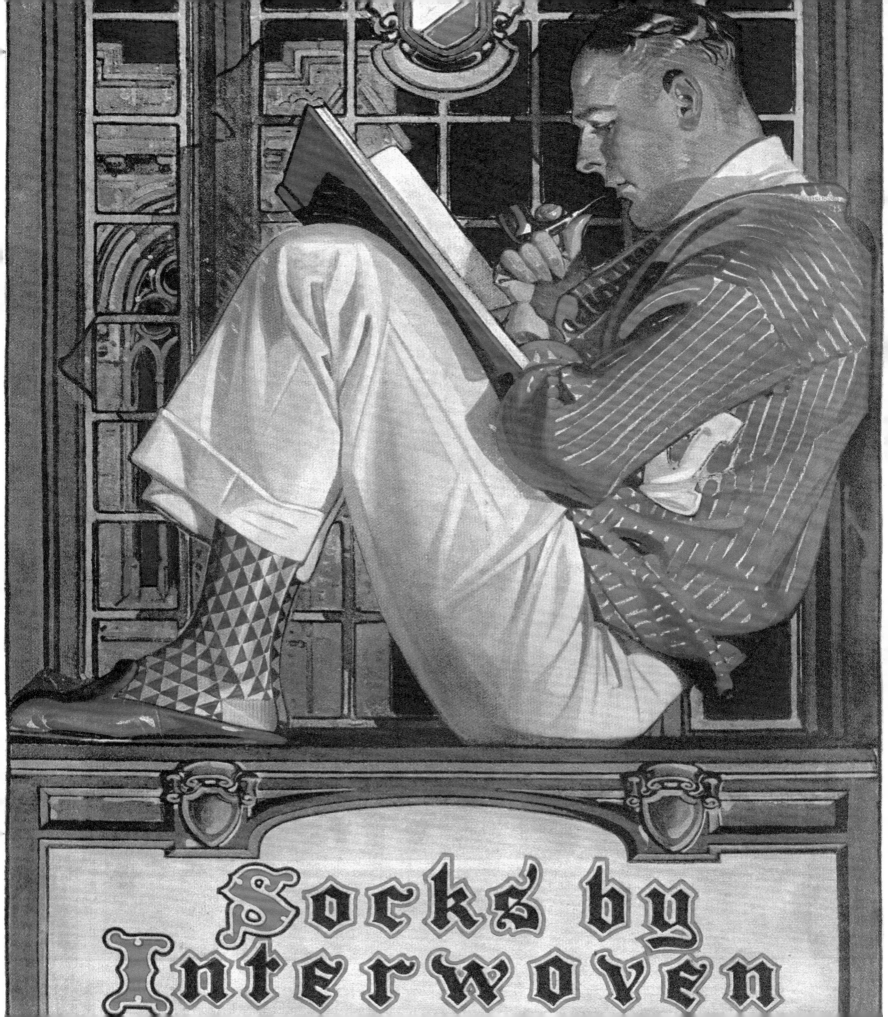

Socks by Interwoven

FOREWORD

The J.C. Leyendecker story is more than elusive, for very little information exists on either this great illustrator's life or his artworks. In fact, only one other book, Michael Schau's *J.C. Leyendecker*, published in 1974, a poster book, and a handful of articles were written in more than half a century since his death. For this reason, Leyendecker's paintings have proudly stood alone, speaking for themselves, until now.

Leyendecker's paintings on magazine covers and in advertisements were widely recognized by admirers nationwide. He was the most popular illustrator of his day and was published in the most popular magazines. Yet he moved among commuters on trains, mixed in markets and shops, on high streets, virtually unrecognized by an adoring public.

J.C. Leyendecker ("Joe" to family and friends) was a mysterious figure who shied away from the limelight and its consequent public scrutiny. Nevertheless, his fame and accomplishments as an illustrator were legion and lasting, and his time for acknowledgment has arrived.

Joe Leyendecker was a homosexual when it was nearly impossible to live such a life openly. While gay subcultures existed at the beginning of the twentieth century in New York and San Francisco, the homophobic disease was prevalent throughout the country. In Leyendecker's later years, Senator Joe McCarthy was on his anti-Communist tirades and anti-liberal witch-hunts, and it seemed that the whole world was intimidated by all-pervasive prejudice. Such an environment clearly accounts for the lack of information on this important icon-maker, perhaps the greatest American Imagist.

To conceal his gay lifestyle, Leyendecker meticulously cleansed his files and records of anything homosexually explicit or implicit. Only in his artwork can one find sex symbols and homoerotic images, which he caused to appear subtle or not so subtle. After his death, Joe's life-partner for nearly fifty years, Charles Beach, had been ordered to destroy all records, correspondence, even remaining original artworks.

While always sought after by the press, Leyendecker rarely gave interviews or permitted photographs. Consequently, there are very few photos of him or Charles Beach. Beach was his favorite model, and together they became the prototype for same-sex couples of their generation. Today, they are recognized by the gay community for their long-standing domestic partnership, alongside the likes of filmmakers Merchant & Ivory; J. Edgar Hoover and Special Agent Clyde Tolson; Michelangelo and his muse, Tomaso de' Cavalieri; and the notorious Oscar Wilde and his lover, poet Lord Alfred "Bosie"

Interwoven advertisement. Reproduced: *Saturday Evening Post*, April 27, 1929. The model is posed in the alcove of Leyendecker's New Rochelle studio.

Douglas of Hawick. (Coincidently, Joe treasured Wilde's writings—he read everything by Wilde, keeping his works on a shelf in his studio—and also the gossip whirling around his relationship with Bosie.)

In consequence of the above, it is not surprising that a Leyendecker archive does not exist. Nor are there stashes of letters, hidden troves, or any direct heirs to share family scrapbooks with an increasingly inquiring world. As a result, though Leyendecker was perhaps the primary image-maker in American civilization, when he died in 1951, his flame had already dimmed. He was all but forgotten save for by a few colleagues who coveted his incredible art. Only a very few, devoted Leyendecker collectors have any remnants, the detritus of his life, and it is spread so very thinly across the globe. Most of this we have been able to find and assemble, like cold case detectives.

Nearly forty years after his death, in 1989 the public had a major reawakening with An Age of Elegance, a milestone exhibition at American Illustrators Gallery NYC (AIG). Four years later, Joe was included in "The Great American Illustrators" exhibition, which toured Japan to record-breaking audiences, organized by AIG. In 1997, the "J.C. Leyendecker: A Retrospective Exhibition" was held at the Norman Rockwell Museum to adoring fans and "J.C. Leyendecker: The Retrospective" exhibition was simultaneously held at the American Illustrators Gallery to public acclaim. At that time, editor Eric Himmel and the late Paul Gottlieb, Editor in Chief of Harry N. Abrams, Inc., encouraged us to move forward with a book on Leyendecker. Almost simultaneously, we acquired Newport's fantastical Gilded Age mansion Vernon Court, and founded the National Museum of American Illustration (NMAI), devoted exclusively to illustration art. It includes the largest collection of original J.C. Leyendecker artworks.

This proposed book was shelved for practical reasons and is revived now that the museum is fully established. We dusted off the manuscript after ten years in storage, synthesized previously gathered materials, and restarted our search for Leyendecker in libraries, museums, archives, and on the internet. We visited Paris, finding the alley near Boulevard St. Germain des Prés where Joe and his illustrator brother F.X. Leyendecker lived in 1896. We visited the Académie Julian, where they studied under European masters in the Beaux Arts tradition, during La Belle Époque. The Salmagundi Club, where he was a member alongside other notable illustrators Howard Pyle, N.C. Wyeth, and Charles Dana Gibson, could only tell us that "he was a member." We rummaged through art research libraries, visited with his models, colleagues, aficionados, and collectors from Palm Beach to the Fiesole hills where Leyendecker visited Michelangelo's studio in 1897. We visited the Mount Tom Road estate to see what Norman Rockwell characterized as the "Leyendecker mansion." Today it houses a kindergarten and day-care program, which retains a vibrant interest in Joe Leyendecker and his work.

In the midst of this long quest, we fortuitously met one of his models, a wildly dynamic woman in her eighties, who had posed from 1922 to 1925. Phyllis Frederic met the Leyendecker couple through her actor father, Pops Frederic, a silent screen star. Phyllis openly accepted Charles and Joe as they were and they reacted quite kindly toward her from the moment they met—three extraordinary people. Her family, all actors, modeled

for both F.X. and J.C. Leyendecker, and for Norman Rockwell as well. She had photo albums to prove her remembrances, replete with hair cuttings (Joe's and Charles's too) and other memorabilia. Her anecdotal stories are included herein and were verified by her albums. With Phyllis's help, we visited a number of sites around Manhattan frequented by the artist and his coterie.

In actual fact, our archives at the American Illustrators Gallery proved to be our richest resource. Most of Leyendecker's original artworks have passed through AIG over the past thirty-five years, and we have compiled a collection of more than 1,300 images as a result of our research.

We know you will enjoy J.C. Leyendecker's artworks as presented in these pages, and we are hopeful that yet more information on his life and work will emerge with the ever-increasing interest in this great American Imagist.

<div align="right">

Judy and Laurence Cutler
National Museum of American Illustration
Vernon Court
Newport, Rhode Island
Spring 2008

</div>

OPPOSITE AND RIGHT: *Kuppenheimer Good Clothes (Sailor Farewell)* (details). 1917. Oil on canvas, 27 x 40½". House of Kuppenheimer advertisement

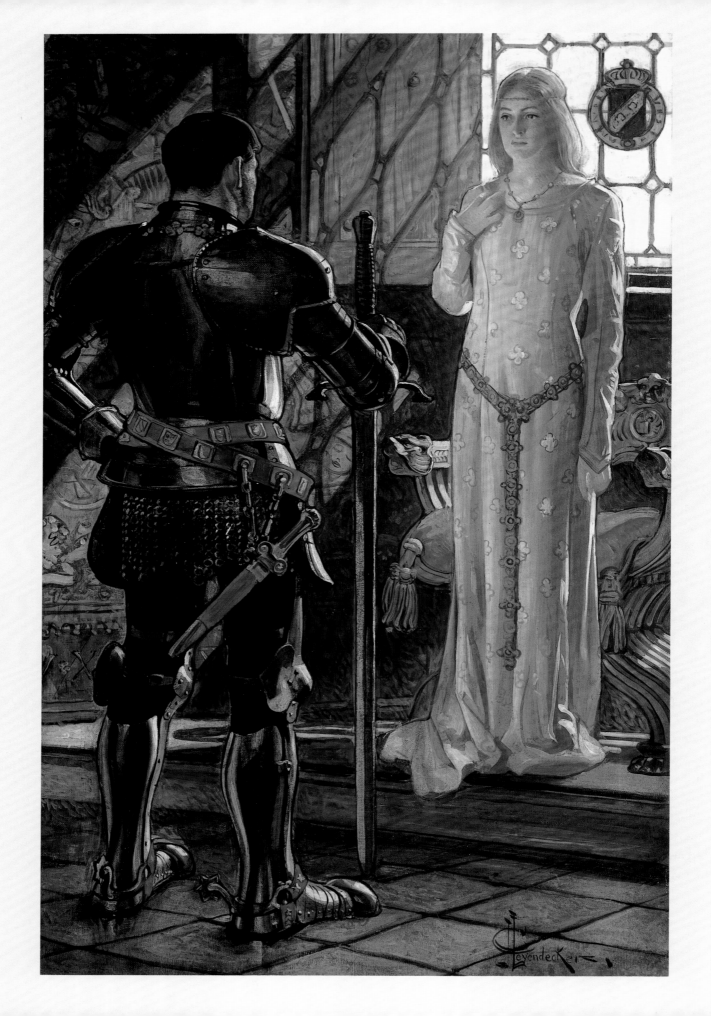

THE GOLDEN AGE OF AMERICAN ILLUSTRATION

The half-century period between 1895 and 1945 was an era of unparalleled excellence in book, magazine, and advertising design. During this Golden Age of American Illustration, masters of the art created a visual history that not only captured viewers of the time with its intensity, style, and vividness but impressed on the life of the nation a distinctive stamp that has endured to this day. And no Golden Age artist made more of an impact than J.C. Leyendecker. With his instantly recognizable style and his proclivity for self-promotion, he influenced the art of illustration immeasurably. He became a mentor to an entire generation of younger artists—most notably Norman Rockwell, who modeled his own career and technique on Leyendecker's. His powerful, iconic images, the blockbusters of those halcyon days, depicted a lifestyle that resonated with millions of viewers and came to symbolize American culture. He transformed society with the turn of a single page in a magazine.

To better understand the overall impact of J.C. Leyendecker, and of illustration art in general, one must recall the context of the age, when illustration was the only way for the public to receive images. *Harper's* and *Scribner's* magazines were the first to use wood engravings for their covers, as selling tools. Other periodicals soon jumped onto the bandwagon, and before long they began to print pictures inside as well. The inside image served a different function: it carried readers through the articles, complementing and clarifying the text. It was not long before nearly all magazines offered images. Their readership demanded it.

New periodicals were launched almost weekly, as muckrakers and yellow journalism proliferated attacks on the self-serving, corrupt elite. Illustrations, the most effective storytelling form for the public, became even more prevalent. As a consequence of the poignancy and popularity of their images, publishers became the most powerful political voices, thrusting William Randolph Hearst, Joseph Pulitzer, Charles Scribner, and other media moguls into the limelight as "movers and shakers."

Printing of illustrations in periodicals evolved from engraving on woodblocks and hand-etched metal plates to photomechanical line-methods to, in the late 1890s, halftones. Immediately older techniques were marginalized, print quality leapt ahead. With the advent of rotary presses and more efficient distribution systems, periodicals reached their rapacious audiences overnight. Seeing their illustrations so enthusiastically received by readers, publishers tried images on posters and in advertisements, to a

ABOVE: Howard Pyle. *Marooned.* 1887. Oil on canvas, 16 x 23"

OPPOSITE: *Ridolfo and Gismonda.* 1906. Oil on canvas, 29 x 18". Signed lower right. Reproduced in *Ridolfo: The Coming of the Dawn* by Edgarton R. Williams, Jr.

13

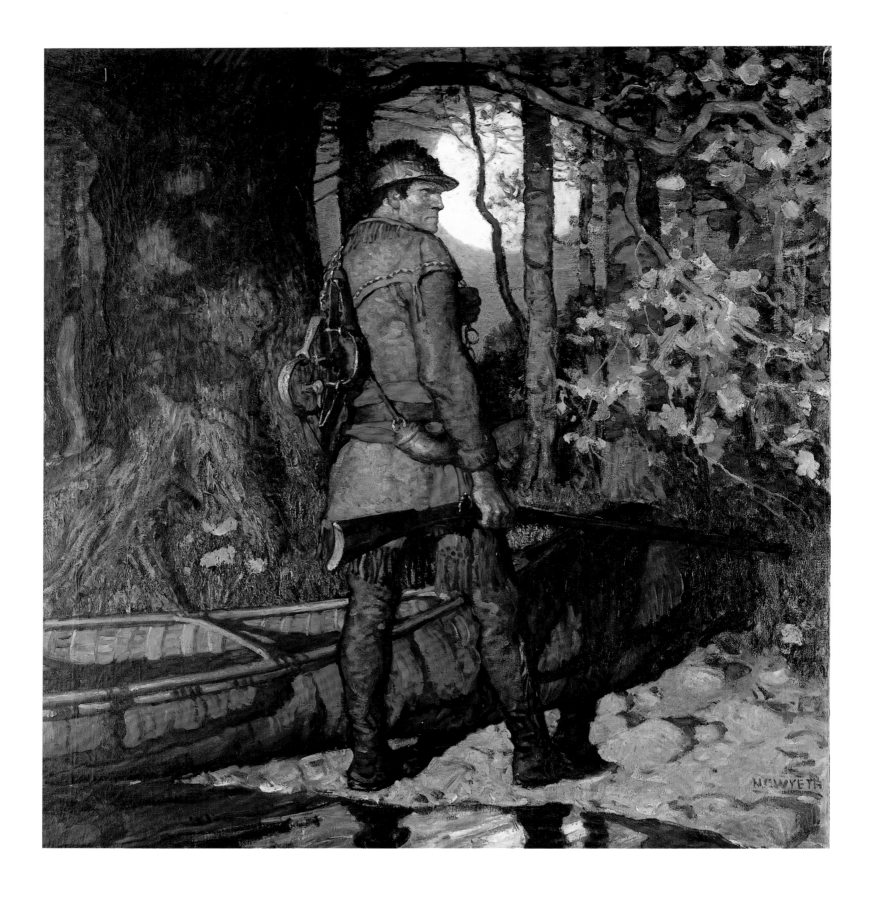

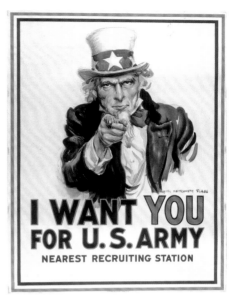

ABOVE: James Montgomery Flagg. *I Want You.* World War I U.S. Army recruiting poster

LEFT: Norman Rockwell. *Miss Liberty.* 1943. Oil on canvas, 41³/₄ x 31¹/₄"

delighted public. Artists experienced new freedoms of creative expression and welcomed a multitude of new corporate clients. When four-color printing was introduced, the art witnessed an even greater boom.

Like their modern counterparts Steven Spielberg and George Lucas, albeit through different mediums, illustrators became wealthy celebrities for giving the people contemporary images. J.C. Leyendecker, creator of icons; Norman Rockwell, America's most beloved and best-known illustrator; Maxfield Parrish, whose romantic and fantastical pictures have been reproduced more than any other artist, ever; Charles

OPPOSITE: N.C. Wyeth. *Frontier Trapper.* 1920. Oil on canvas, 34 x 32"

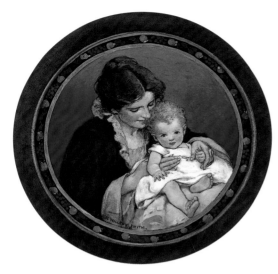

Jessie Willcox Smith. *Mother and Child.* 1921.
Mixed mediums on illustration board, 20" round

Charles Dana Gibson. *Gibson Girl.* 1908.
Charcoal on paper

RIGHT: Maxfield Parrish. *Daybreak.* 1922. Oil on
panel, 26½ x 43½"

OPPOSITE: Howard Chandler Christy. *The Dawn
of Victory (Stand by Your President).* 1933. Oil
on canvas, 60 x 40"

Dana Gibson, whose world-famous Gibson Girl created a standard of feminine beauty;
Jessie Willcox Smith, considered by many to be the greatest children's book illustrator;
N.C. Wyeth, whose swashbuckling, prototypical heroes swept the public consciousness;
Howard Pyle, "The Father of American Illustration"; James Montgomery Flagg, whose "I
Want You" portrait of Uncle Sam still points the way today; C. Coles Phillips and Howard
Chandler Christy, creators of the Fadeaway Girl and the Christy Girl, respectively; and
many other memorable graphic artists became household names in the Golden Age.

The leading illustrators were sought after by the highest echelons of society. They
rubbed elbows with popular stage and screen stars, influential statesmen, and scions of
business and industry. So great was their renown that it penetrated beyond the sphere
of the art world. When in 1921 the first Miss America Pageant was held in Atlantic City,
America's playland, Howard Chandler Christy was chairman of the panel of judges. The
public recognized that a famous illustrator would be the ultimate choice to select the
most beautiful woman in America, for illustrators set the standards for nearly everything
of aesthetic importance. In the second year of the contest, Christy selected other
illustrators—including Rockwell, Phillips, and Flagg—as judges.

By the end of World War I, the United States had grown into an emerging world power.
Brilliant ideas abounded. A modern age emerged from stifling, conservative Victorian
customs, leading the way into the exciting, liberal Roaring Twenties. Such universal
excitement gave birth to new styles in fashion, excessive drinking and smoking, debs and
vamps, dolls and swells, playboys—and a newfound commercialism.

Advertising grew into a serious profession, molding lifestyles at will. It was at once a
heyday and a turning point, as creative power was harnessed for millions to appreciate.
The public thirst for a new, idealized lifestyle combined with rapid communications
enabled the savvy young artist–illustrator J.C. Leyendecker to take the country by storm.

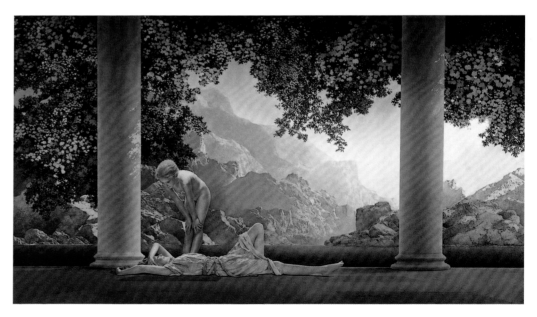

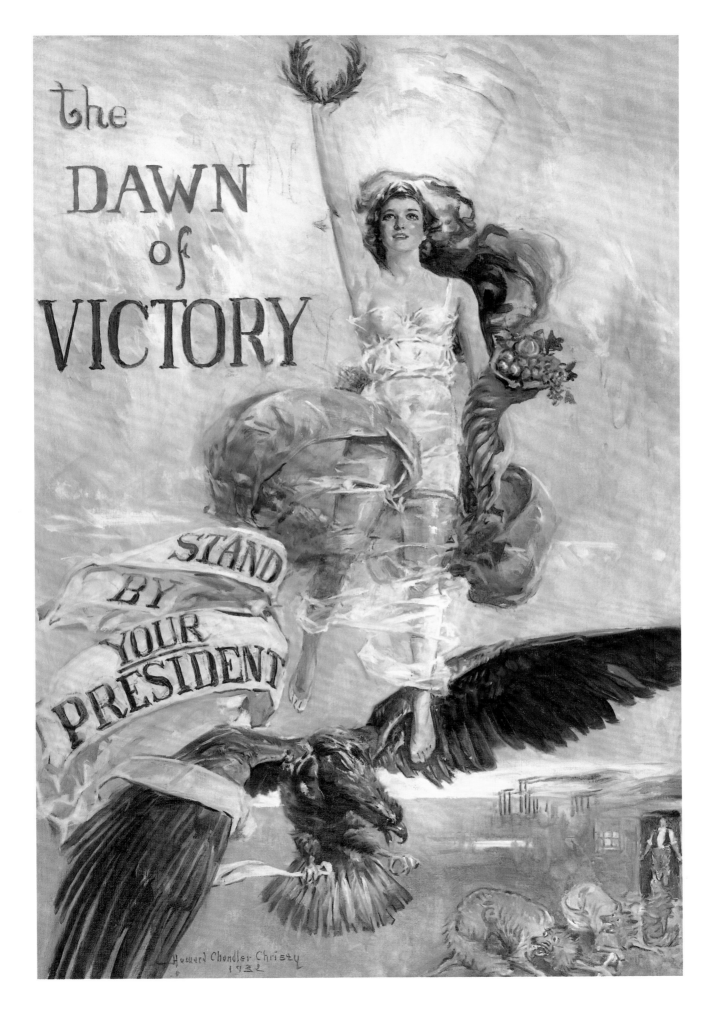

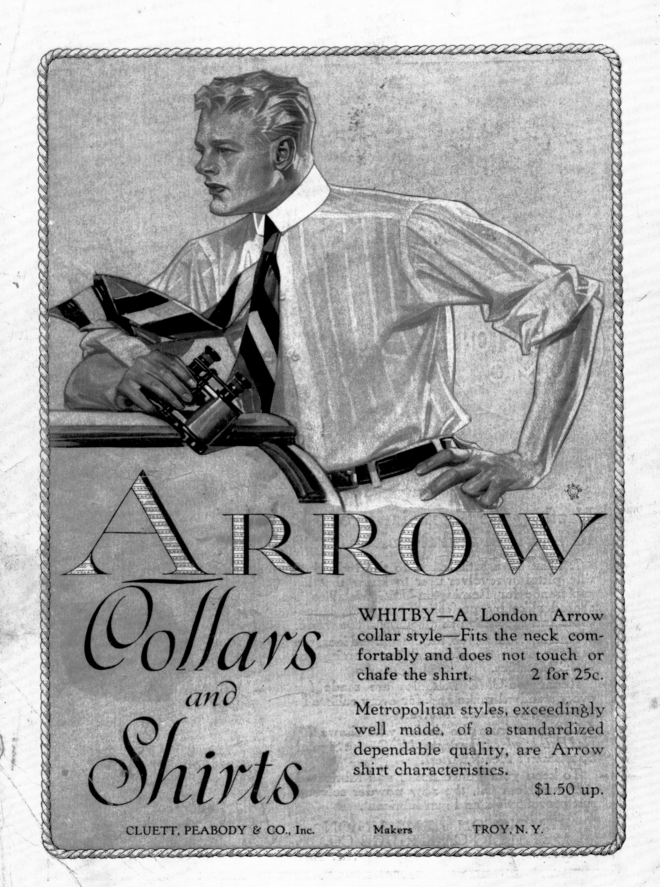

ARROW
Collars and Shirts

WHITBY—A London Arrow collar style—Fits the neck comfortably and does not touch or chafe the shirt. 2 for 25c.

Metropolitan styles, exceedingly well made, of a standardized dependable quality, are Arrow shirt characteristics.

$1.50 up.

CLUETT, PEABODY & CO., Inc. Makers TROY, N.Y.

THE LEYENDECKER LIFE

 The art world changed forever in 1874, for two reasons. One, an Impressionist art exhibition was held for the first time in Paris. That exhibition's impact was resounding, for Impressionists depicted reality in a totally new manner, using the secondary effects of light and color, and changing all two-dimensional perceptions thereafter.

The second seminal event of 1874 was the birth of Joseph Christian Leyendecker. Known as Joe to family and friends, J.C. to the public, Leyendecker spent his early years in Montabaur, a tenth-century town in the Rhineland-Palatinate situated in the heart of Westerwald, in southwestern Germany. Originally known as Humbach, Montabaur had its name changed by the Crusaders to "Mons Tabor" after the mountain in Lower Galilee, Israel. Crusaders settled in the area, adding a coat of arms suggested by Archbishop Dietrich II von Weid. Years later Joe Leyendecker, under their residual influence, collected armor, coats of arms, and medieval paraphernalia. He also had a passion for twelfth-century illuminated manuscripts (illustration by definition) and calligraphy.

One of Montabaur's most notable structures, a fifteenth-century Gothic church called St. Peter in Chains, was known for a mural, *The Last Judgment,* that graced its thick walls. Although it was acknowledged by a local priest as the only worthwhile painting within a hundred kilometers, the Leyendecker family managed to escape its aesthetic influence. At that time, there were no other cultural elements to inspire local youths.

Indeed, when Joe was born, there was nothing much to recommend Montabaur, either aesthetically or economically. With virtually no industry (today internet commerce thrives there), few prospects existed for more than menial labor, and locals—Peter Leyendecker (1838–1916), a brewer, and wife, Elizabeth (1845–1905), née Ortseifen, among them—emigrated in droves. With dreams of joining Elizabeth's uncle at his brewery in the United States, the Leyendeckers left Montabaur for Chicago in 1882 to seek a better life for their four *kinder*: Adolph A. Leyendecker (1869–1938), Augusta Mary Leyendecker (1872–1957), Joseph Christian Leyendecker (1874–1951), and Franz Xavier Leyendecker (1879–1924), known as Frank or F.X.

To a large degree their dreams were fulfilled. Elizabeth's uncle John McAvoy had built his McAvoy Brewing Company into an immensely popular beer business. As the ambitious Leyendecker family settled into a comfortable apartment in Hyde Park, their aspirations for their children were, for the first time, legitimately hopeful. Peter had a job, and his

Arrow Shirt Collar advertisement. 1914

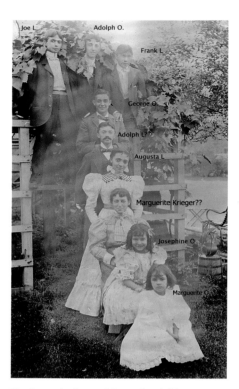

The Leyendecker and Ortseifen children, 1892

family was adjusting well to the new bustling environment in Chicago, a long way from Montabaur.

The Leyendecker family matched a prototypical new immigrant profile: white, Anglo-Saxon, Catholic, with a European heritage drawing from Spain, France, Alsace-Lorraine (Protestant from as early as 1523), Holland, and Germany. Regina Armstrong, a close family friend in later years, wrote that the brothers "drew from several strains to mould art; Holland ancestors were merchants contributing stability and resourcefulness; from the French and Spanish there had been artists and musicians and litterateurs, and so there culminated therein rhythm, poetry and a white fire of transfiguring absorption to a given calling that we call genius."[1] Yet Joe always claimed that the Leyendeckers were pure Dutch; perhaps he was not clear about the origins of a Dutch family from Germany's Rhineland, given two world wars promulgated by Germans against his new country. However, Leyendecker is a common German surname in the Montabaur region meaning "slater," someone who makes slate roofs.

Leyendecker ancestry traces back to a sect of Sephardic Jews who emigrated from Spain in the fifteenth century to escape the horrors of the Inquisition. They drifted into France (Peter's ancestry was traced partially to Alsace in 1648 after the Franco-Prussian War) and thence to Holland, known as a safe haven for its gracious acceptance of foreign immigrants. It was common practice in the Jewish Diaspora for Sephardic families to pragmatically convert to Catholicism en route to their destination.

Phyllis Frederic, one of J.C. Leyendecker's models, claimed that J.C.'s initials originally stood for "Jesus Christ." Joe told her that his father put the ultimate Christian emphasis on both his and Frank's names—Frank was named after Saint Francis Xavier, a Spaniard—to further protect the family from discovery of their origins. (Author Michael Schau's research substantiates a familial emphasis on the name "Christian" by pointing to Joe's maternal grandfather, Christian Ortseifen, and his godfather, Christian Joseph Leyendecker.) Joe legally changed his name to "Joseph Christian" in his teens and rarely talked about family. Nor did he, an agnostic, tolerate speculative stories about the religious origins of his surname. After all, in the melting pot that was America, everyone was encouraged to forget their past and to look together to their future. Joe Leyendecker loved his adopted country and chose to thrust aside his birthplace and religious origins.

At very young ages, the Leyendecker boys embodied characteristics similar to most American immigrants of the day. They studied hard and worked hard under the tutelage of encouraging parents. Although their sister, being a girl, had few prospects, the three brothers were urged on in their creative pursuits. Elizabeth enjoyed letting her sons draw on the kitchen table oilcloth, and she admiringly hung their sketches on hallway walls.

The children were close while growing up. Joe and Frank were inseparable as young men, but Adolph, the eldest, appears to have disappointed his parents from the beginning. As the first born, he would normally have engaged the lion's share of the family's attention; however, that does not seem to have been the case. A recently discovered family photograph (see above left) shows Adolph standing on the ground with the help of a cane, while his two brothers are near each other high on a trellis. In those times, many children

ADOLPH A. LEYENDECKER (1869–1938)

Glass Artist and Brother

Until recently, no one had even considered the possibility that there was a third Leyendecker brother, especially another artist. Adolph A. Leyendecker, a stained-glass artist, hitherto unknown, did, however, definitely exist. His middle name is listed in records as Aaych (possibly Aliyah), although it may have been Adam, and he spent most of his adult life in Kansas City, Missouri.

The first notice of a fourth sibling was gleaned from Frank Leyendecker's obituary, "He is survived by his brother Joseph, a brother Adolph of Kansas City, and a sister Augusta Mary, who made her home with him." The second came from Joe Leyendecker's funeral documents, which mentioned Joseph A. Leyendecker, a nephew from Kansas: Adolph's son. Further investigations showed that immigration records indicate that six persons with the Leyendecker name entered the United States together in 1882, a set of parents and four children.

Adolph's predilection for stained glass may have inspired his younger brothers to pursue art careers. As youths, Adolph and Frank briefly studied with Carl Brandt, a German-born artist interested in design and glass as a medium, while Joe apprenticed at Manz. When Joe and Frank left for Paris, Adolph apparently remained in Chicago; there are no further findings on his career as from that point. When his brothers returned, Adolph was not included in their plans, and by 1900, when Adolph was thirty-one years old, he was no longer living in the Leyendecker household at East End Avenue in Chicago.

Adolph died in 1938. On August 29 of that year, J.C. Leyendecker sent a telegram from New Rochelle to a funeral home in Kansas City agreeing to pay half of his brother's funeral expenses, with the other half to be borne by his nephew, Joseph A. Leyendecker. The Adolph Leyendecker family is buried in Calvary Cemetery in Kansas City, Missouri.

Adolph A. Leyendecker. *St. Patrick*. 1915. Stained glass

acquired polio, infantile paralysis, and other such afflictions from birth or afterwards. Funeral records indicate that Adolph suffered from paralysis, which was deemed to have contributed to his death. Joe too was described as walking with a limp, and it is likely that he had a related disease as a child.

Adolph had little to do with the family proper after about 1894. He went his own way, settling in Kansas City, Missouri, where his career as a stained-glass artist must have had

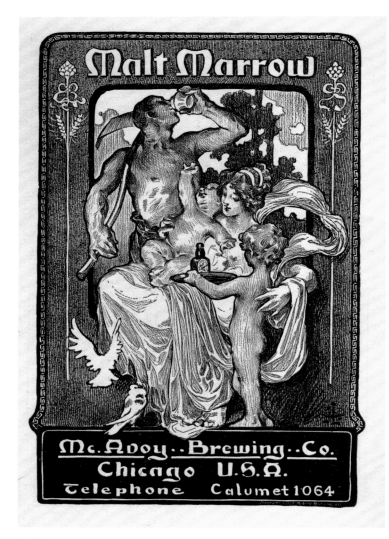

Malt Marrow advertisement. 1889

a degree of success. He founded the Kansas City Stained Glass Works Company in 1914 and worked there until 1925, when he sold the firm. After the sale, he stayed on as a business advisor to Paul H. Wolff, purchaser of the glass works. Adolph married a French girl, Francine DiGeronde, with whom he had two children, Genevieve Charlotte Leyendecker (1903–1929), who poisoned herself, and Joseph Adolph Leyendecker (1908–1977), also a suicide, this time by shotgun.

Ironically, despite all three brothers being professional artists there is no record of any contact between Adolph and the family whatsoever once he moved away. One can only speculate about the reasons for the split. Maybe Adolph reacted to being slighted by his parents during his youth, or perhaps he cut ties with his family over the fact that both of his brothers were homosexual. (Although there is no hard evidence of Frank's having had any long-term liaisons, his orientation was well known to his contemporaries.)

Frank Leyendecker, a well-known illustrator, lived a tragic life, wrestling with drug addictions and alcohol abuse and never achieving the unrivaled success of Joe. Mary adored her two baby brothers and ultimately devoted her life to their careers, dying a lonely spinster. Both of Adolph's children died without issue, the last direct heirs of J.C. Leyendecker.

The passion for artistic creation came to Joe at an early age, as he later recounted in an interview for the *Saturday Evening Post.*[2] "I was eight at the time and was already covering schoolbooks with rudely colored examples of my work. At home, I kept myself busy with more pretentious paintings, which, for want of canvas, were done on oilcloth of the common kitchen variety. Whatever their faults, these pictures lacked nothing in size. They were all dutifully presented to long-suffering friends and relatives."

At eleven years old, Joe designed a beer bottle label for the McAvoy Brewing Company, which at this point was run by another of his mother's uncles, Adam Ortseifen. Design ideas came instinctively to Joe. He noticed that while other beers had confusing, un-American-sounding names—Rheingold, Schlitz, Budweiser, Pabst—all but McAvoy had well-designed, recognizable labels. It occurred to Joe even at this tender age that a good brew was better remembered by illiterate immigrant consumers when it had a unique graphic component. Ortseifen, however, declined to consider a design prepared by a child, even a relative whose father worked in the business.

Some years later (1889), Ortseifen did hire his nephew to enhance the company image by designing advertisements and labels. This time he had compelling reasons: Joe had proven his facility with art and Ortseifen was trying to sell McAvoy Brewing Company

to an English-owned syndicate. Newly developed brewing technologies required major modernization of McAvoy's facilities, which stretched for blocks. Ortseifen was able to capitalize by selling out at just the right time, before revitalizing McAvoy's equipment. In the process, family members, including the Peter Leyendeckers, pocketed substantial amounts of money, permitting them to afford lifestyles they had never imagined in Montabaur. They were able to hire servants and lived quite comfortably thereafter.

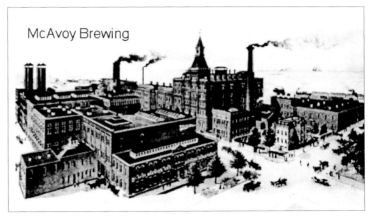

McAvoy Brewing Plant, Chicago, 1898

At fifteen, Leyendecker had realized his life's pursuit was to be an artist. "I felt I'd reached the saturation point in the oilcloth field, so I decided to find a job and gain some practical experience in the profession of being an artist. I still remember boarding an open cable car one windy day (we were living in Chicago) with three large canvases wrapped in newspaper and fighting my way through the crowded streets to an engraving house, where I showed my samples. The boss inspected a stag at bay, a chariot race and a Biblical subject, with amusement, but he did tell me to report for work."[3] Joe eagerly grasped at the opportunity to apprentice at J. Manz & Company, a Chicago engraving firm. At first, he was hired as an unpaid errand boy, but he soon rose in stature to a position earning two dollars a week. Manz prepared intricate drawings derived from Old Master paintings which they used to accompany biblical tracts. Such reinterpretations proved a constantly demanding regimen for a complacent, under-talented staff but a welcomed challenge for the gifted apprentice. Joe illustrated numerous religious pamphlets and Bible editions, gaining incredible experience in the process. In 1894, J.C. Leyendecker created sixty Bible illustrations published by the Powers Brothers Company. This marked the official start of his professional illustration career.

After that experience, Joe realized that a formal art education was necessary to further develop his talents to their fullest. He enrolled at the Art Institute of Chicago, taking three evening classes weekly. Meanwhile, he continued working at J. Manz & Company, where he rose to the position of Staff Illustrator.

Among Leyendecker's instructors at the Art Institute were Chicago artist Enella Benedict (1858–1942) and the famed John H. Vanderpoel (1857–1911). Professor Vanderpoel, a Dutch-born artist and master draftsman, anatomist, and muralist, took a special interest in guiding the *wunderkind* and recommended his aspiring young student to his alma mater, Académie Julian. (Years later, Vanderpoel collected Joe's works, which now rest in the John H. Vanderpoel Art Association Collection.) Now desperately hoping to become a full-fledged, working artist, Joe began to save his Manz earnings in the hopes of furthering his studies in Paris.

While still in Chicago, in the spring of 1896, J.C. Leyendecker created a major impact on the art world. He won first prize in a cover design contest for *The Century* magazine's August Midsummer Holiday Number. Another unknown, Maxfield Parrish, a twenty-six-year-old artist-illustrator from the Cornish Colony, won second prize, despite having

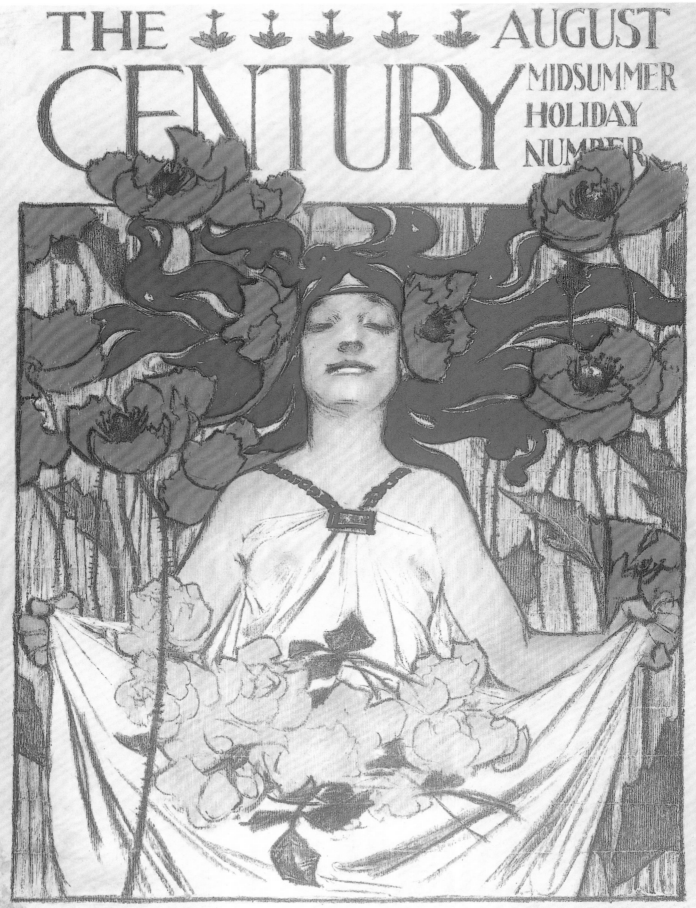

violated contest rules by using one extra color than was permitted. This was a milestone for both Leyendecker and Parrish, as *Century* was acknowledged as "the best American magazine." Leyendecker's winning piece was also reproduced in *Les Maître de l'Affiche* (*Masters of the Poster*), opposite graphic artist Henri de Toulouse-Lautrec's *Jane Avril at the Moulin Rouge*.

The prize was the publication of the winning image, and the noted Verlag von Gerhard Kuhtmann issued it as an art print. Joe was widely acclaimed, his work instantly recognized by cognoscenti in the United States and Europe. Large posters of his image were plastered all over Parisian walls as advertisements, where they created quite a stir. Art lovers known as "Drips" removed the crudely applied posters from masonry walls with sponges drenched with water and added them to incubator collections. Because the Drips were so active stealing Joe's *Century* poster, a French publisher realized its marketability and printed a special edition. For the first time, pristine posters were printed specifically to be sold. The Drips became referred to as "poster collectors." It was the beginning of graphic arts collecting.

Thus J.C. Leyendecker's contribution to illustration brought advertising into the realm of high art, a viable and respected pursuit. It also gave his finances the boost they needed to enable him to study at the Académie Julian.

For an often grueling and enervating five years, Joe had been working overtime to create advertising posters and book designs, saving his earnings so that not just he but also his brother Frank could study in Paris. Finally he had amassed enough money for the two Leyendecker brothers to achieve their dream. They arrived in France on September 17, 1896, with Joe's *Century* contest reputation having just preceded them.

Paris was an international magnet, attracting aspiring artists for technical training and a requisite Bohemian lifestyle on the Left Bank or in Montmartre. Somewhat of an oddity in a worldly Parisian environment, the well-washed American was immediately sought after by French art galleries. At twenty-two years of age, Joe was already considered by his peers to be an upcoming art figure alongside such luminaries as Jules Chéret (1836–1933), Alphonse Maria Mucha (1860–1939), and Henri de Toulouse-Lautrec (1864–1901).

Frank, in his brother's shadow, was more interested in the French urbane lifestyle of bistros, cafes, and dens of iniquity. He reached out to a shifty, absinthe-drinking group of rebellious artistic brigands. They caroused while chain-smoking Gauloises and used seriously addictive drugs freely acquired in France and the United States at that time. Joe, absorbed with his work, noticed little else.

Académie Julian had been established in 1868 as an alternative to the government sanctioned Ecole des Beaux Arts. A new school, it attracted the most promising young artists with superb faculties and the gift of freedom to explore. Joe openly welcomed the genteel traditions of French academicians, and the brothers enjoyed the twists that could be discovered from their studies of the Old Masters. At the Académie Julian the Leyendeckers joined classes with faculty members Benjamin Constant (1845–1902), known for portraiture of English high society; Jules-Joseph LeFebvre (1836–1911), a

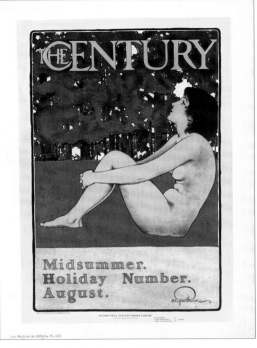

Maxfield Parrish. *The Century* "Midsummer Issue." August 1896. Printed magazine cover

OPPOSITE: *The Century* "Midsummer Issue." August 1896. Printed magazine cover

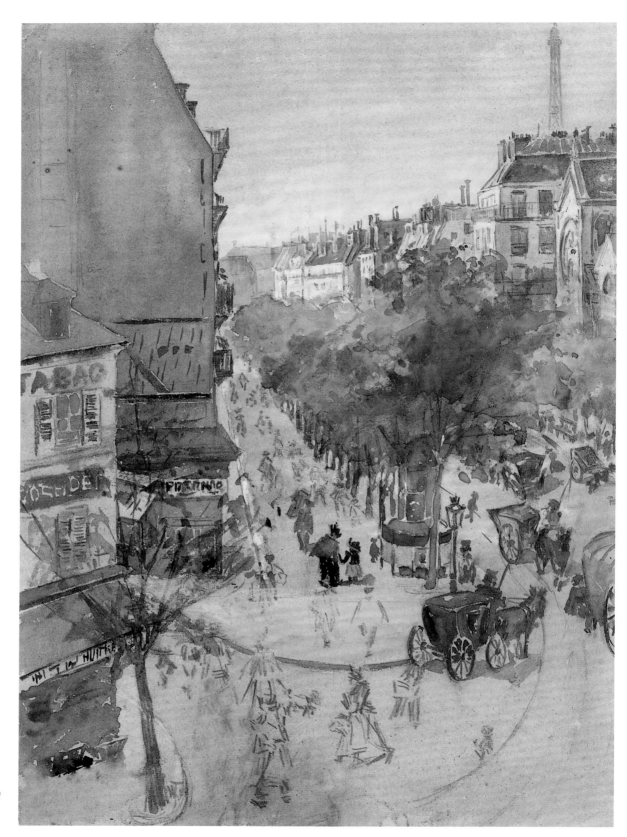

RIGHT: *Paris Street Scene*
(study). 1898. Watercolor,
18½ x 13". Unsigned

OPPOSITE: *Woman with Parasol*
(study). 1900. Watercolor and
ink on paper, 10 x 7". Unsigned

the most coveted commission, a cover for the nation's most popular magazine. "My first *Post* cover appeared May 20, 1899," he later recalled. "There was nothing distinctive in the appearance of the first few numbers; it was not until George Horace Lorimer became the editor that color was introduced and the cover became a design complete in itself."[4] This single project assured his position as the rising star of illustration.

Joe and Frank settled into a rented apartment in Hyde Park and a studio in the Fine Arts Building, 410 South Michigan Avenue. Touted as the "Chicago Center for Creativity," it was an important address for the arts. Isadora Duncan was dancing in a theater on the ground floor, L. Frank Baum was writing *The Wizard of Oz* upstairs, Frank Lloyd Wright settled his burgeoning architectural practice in a studio suite, and *The Dial*, a noted intellectual magazine, was being published from the building as well. The Leyendeckers' tenth-floor studio was a social magnet for emerging artists, some seeking Joe's early fame to rub off on them.

The American art world, not surprisingly, had changed dramatically in the Leyendeckers' absence. Toulouse-Lautrec's lithographs and posters were being distributed internationally and acclaimed as the "basis for modern graphic arts and commercial art." After the poster fad hit America, Chap Books advertised posters by J.C. Leyendecker, Will Bradley, and Edward Penfield. Simultaneously, the influence of Japanese printmaking captivated Northeastern art colonies at Cornish, Old Lyme, and Ogunquit. Newly developed woodcut techniques permitted more artists to make forays into graphic arts. Joseph Bowles's journal, *Modern Art*, promoted posters and proved effective at garnering mail orders for books and art prints as well, impressing the art world. Illustration art was now everywhere. Joe Leyendecker took especial note.

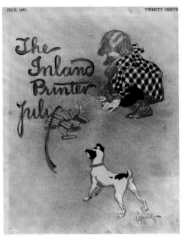

While in Paris, J.C. Leyendecker had been awarded a multiple commission to prepare twelve covers for *The Inland Printer*, an imaginative and influential American magazine for the printing trade. He was hired after having brazenly sent his portfolio—garnished with awards from French art academies coupled with a catalogue from his Salon du Champs de Mar exhibition, potent imprimaturs from the art capital of the world—to the great artist-illustrator Will Bradley, a frequent and celebrated *Inland Printer* contributor. That Bradley himself had selected him was a great honor in itself.

The success of J.C. Leyendecker's *Inland Printer* magazine covers engendered an exhibition at Chicago's New York Life Building. Again Leyendecker hung original paintings next to the printed magazine covers, creating perhaps the first American exhibition to juxtapose studies and replication examples to the original art—exactly what Gauguin despised. The Leyendecker exhibition for the *Inland Printer* covers was yet another powerful endorsement and affirmation of illustration art. Young artists had an epiphany of sorts when they saw that it was possible to create an image one day that the next day, thousands could appreciate.

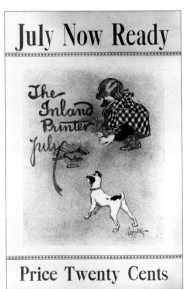

It was not difficult to conclude from the exhibition that paintings could be used identically as a format for posters, magazine covers, full-page advertisements, and billboards. In fact, J.C. Leyendecker had already realized that a single illustration could be applied to many commercial uses, enhancing its value in the marketplace. He was further

AUGUSTA MARY LEYENDECKER (1872–1957)

Sister

Mary Leyendecker sacrificed her life to her two beloved and talented brothers; as far as is known, she had no other personal relationships. She never married and lived an austere, convent-like existence after her family passed on, until her death in 1957.

In the early days in Chicago, after Adolph left the nest, Mary resided with Frank, Joe, their parents, and a servant girl. In New York, she lived with Joe and Frank, caring for them when they returned from Paris, and then later, in 1905 after Elizabeth died, with Peter Leyendecker as well. Originally, Mary assumed the role of foil and peacemaker between the tormented brothers as Joe rose to higher, loftier planes. In addition, she acted as the business manager for both Frank and Joe. This arrangement seems to have suited Mary until 1916, when Charles Beach moved in.

An avid promoter of both her brothers' work, Mary actually made excuses for Frank's delinquencies, often gaining more time for him to perform; in the process she relinquished Joe totally to Beach's hands while she cared for Frank's far greater needs. In 1923, after years of trying to make an uncomfortable situation work, there was a blowup between Frank and Charles Beach. Mary left the next day and moved into the Martha Washington Hotel for Women in New York, where she lived modestly for the next thirty-four years.

Mary Leyendecker, far left, at the presentation of Leyendecker's *City of Huguenots* painting to the Historical Association of New Rochelle, April 1953. Artist Molly Guion is at far right.

After Joe passed away in 1951, Mary inherited a tidy sum of money, equivalent to approximately $450,000 in 2007 dollars. With previous debt and no prospect for future income, however, she felt financially insecure and apprehensive regarding the future. Consequently, she did not order a footstone for Joe's grave until three years after his death. It was only after Earl Rowland, a fan of J.C. Leyendecker's artworks, wrote on November 30, 1953, informing her of his intention to raise money for a grave marker—offering to replicate Frank's but add Joe's monogram-like signature—that she turned her attention to the matter. A letter was sent to Rowland stating, "arrangements have already been made for the placing of a marker at the grave of Joseph C. Leyendecker…by Miss Mary A. Leyendecker." A footstone was made to match the other family markers and placed on J.C. Leyendecker's grave in 1954.

Rowland, a "commercial art buff," wrote again to Mary Leyendecker, this time requesting that she donate J.C. Leyendecker paintings to his museum, the San Joaquin Pioneer and Historical Museum, now called the Haggin Museum, in California. Mary was eighty years old at the time, and still residing at the Martha Washington Hotel, on a limited budget. Rowland began a correspondence regarding her brother's artworks, and according

to Museum Director Tod Ruhstaller, in his attempt to get at least one painting, "arranged for his son in New York, to take Mary out for dinners and to host her for holiday meals." Rowland also promised to arrange for the publication of a book on her brother and his art. His attempts to win Mary over seem to have worked as planned, as she donated all of the approximately sixty remaining paintings, memorabilia, and studies in her possession. In fact, she also changed her will, dated May 5, 1958, to leave half her estate to Rowland's museum, "this bequest in memory of my deceased brother, Joseph C. Leyendecker…to be used either toward the expense of publication of a manuscript on the life and work of my said brother, currently called "Leyendecker—Painter to a People," or that it be used otherwise for the perpetuation of my brother's art work as shall be determined by Earl Rowland." (The balance was left to the "care and maintenance of the lot in The Woodlawn Cemetery.") While still bitter that Joe had forsaken her and Frank for Charles Beach, Mary remained loyal to Joe's artistic legacy.

Fifty years later, still no book. It is presumed that "perpetuation" of the work was completed. An exhibition of Augusta Mary Leyendecker's gift of paintings toured several museums across the United States beginning in 2006 under the title "J.C. Leyendecker, America's 'Other' Illustrator."

aware that he could gain fame and fortune while satisfying a client's needs in this manner. Having already been lavished with awards, solo exhibitions, and international recognition, Joe began actively to pursue commissions in advertising. Assignments flowed into his studio like a river. He quickly determined that the technological advances in printing, emerging industries, and the public's new admiration for illustration art would allow him to expand his market throughout the country. Unfortunately, projects of national significance were not to be found in Chicago.

In 1900, the Leyendecker brothers, along with their sister, Mary, moved to New York City—Mecca of the art world, center of international commerce, and hub of the up-and-coming advertising industry. The Leyendeckers took full advantage of all the city had to offer. Through Parisian contacts, the brothers were directed to a rather large rental studio with a modest rent at 7 East 32nd Street. They also rented a four-story, Federalist-period brick townhouse in nearby Washington Square. Augusta Mary Leyendecker was pleased that the whole townhouse was for them alone.

Uptown, their neighbors were foreign artists and their studio was reminiscent of European lofts, while the Square was a potpourri of native eccentrics. Joe recalled Henry James's novel *Washington Square* (1881), lent to him by a Parisian classmate, and felt privileged to have found their townhouse abode and a suitable studio. Both Joe and Frank enjoyed the pace and diversity of New York, while Mary cooked, cleaned, and organized her brothers' lives in lieu of pursuing a career of her own.

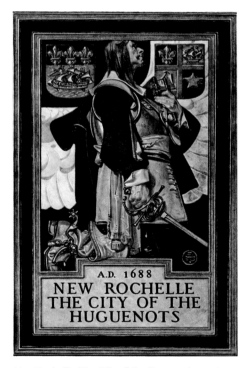

New Rochelle: The City of the Huguenots. 1938. Printed brochure cover

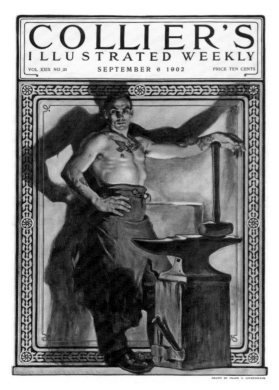

ABOVE: F.X. Leyendecker. *Collier's* cover. September 6, 1902. Printed magazine cover

RIGHT: F.X. Leyendecker. *The Blacksmith.* 1902. Gouache on illustration board, 18½ x 15". Signed lower left

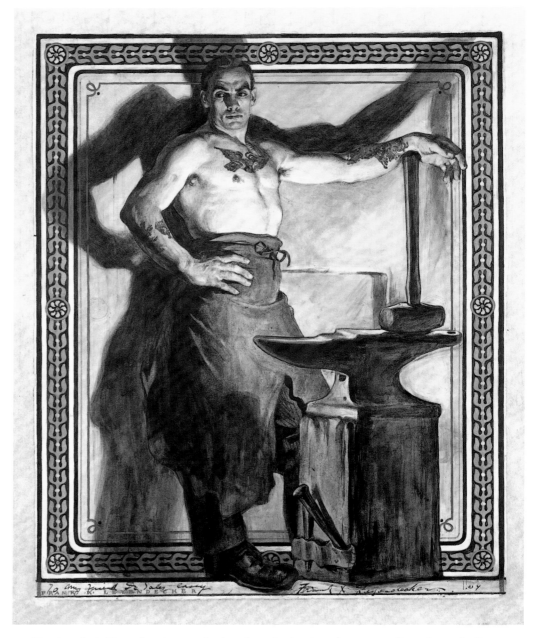

During their French sojourn, the brothers had enjoyed promenading along the River Seine, exploring and finding interesting cafes and antique shops. In New York, they walked around Washington Square, ogling locals who gathered by the central fountain, smelling foods on push carts, and watching jugglers and magicians touting their talents. Greenwich Village surrounded them, a complete joy for Joe though a danger for Frank, with his acquired weaknesses. The two brothers and sister were idyllically happy, for a time. They had more than adequate accommodations, a studio with northern light in a neighborhood with other artists, commissions from top-notch commercial clients, and, soon, covers for the most popular magazines.

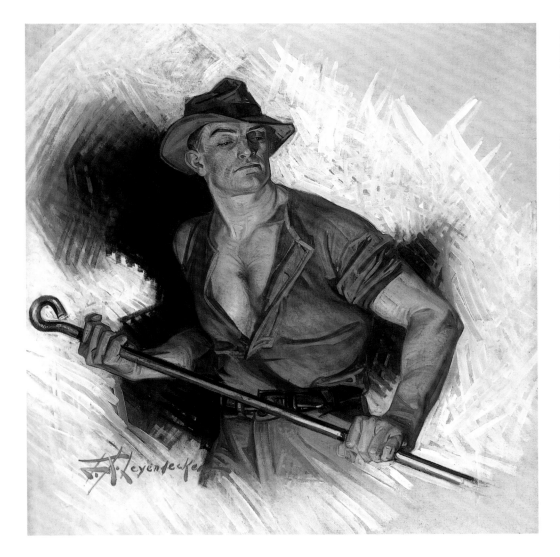

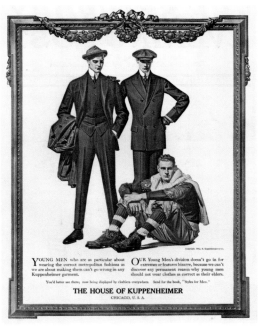

ABOVE: House of Kuppenheimer advertisement. Reproduced: *Saturday Evening Post*, September 14, 1912

LEFT: F.X. Leyendecker. *Man Stoking Furnace*. 1920. Oil on canvas, 32 x 28". Signed lower left. Reproduced: *Collier's*, March 20, 1920, cover

F.X. Leyendecker quickly received the first of his *Collier's* cover assignments, a commission that would continue on a regular basis for the next fifteen years and sporadically thereafter, providing him with a steady income. As always Joe found even more success: having already worked for *The Saturday Evening Post* while back in Chicago, he now negotiated assignments for the publication on a long-term basis. He would paint *Post* covers for decades, eventually completing more than three hundred compelling and admired images and becoming the most popular artist for the most popular magazine.

Joe, and to a lesser degree Frank as well, found much in the way of corporate work in New York. One of the long-term clients shared by the brothers was B. Kuppenheimer & Co., a prominent men's clothier. Joe and Frank sometimes worked as a team on the Kuppenheimer advertisements, in which case J.C. was always the leader. He would come up with the concept, and then both brothers would go from canvas to canvas and one assignment to another, each participating to a lesser or a greater degree. While Joe worked quickly and competently, Frank, apparently weakened by his addiction problems, could

not always be counted upon to bring a commission to fruition. He dallied and sometimes lost interest halfway through, more compelled to use heroin or alcohol than to finish his work. In order to avoid missing deadlines and the subsequent very real possibility of their joint termination, Joe was forced to complete many of Frank's works.

For the Leyendecker brothers, painting young males was a priority interest, so they focused on male characters in their advertising work. Neighboring artists shared models with the brothers, which meant a seemingly endless train of attractive Greenwich Village lads parading through their chilly studio in the buff. One momentous day in 1903, a particularly striking young man appeared at their door, having just arrived in the United States from Europe, where he had lived for the past year. His name was Charles A. Beach, and Frank immediately hired him in Joe's absence. When Joe returned, he could not believe his eyes: his dreams had been realized. Frank graciously allowed his brother the use of his model, and Joe and Charles Beach were inseparable thereafter, both personally and professionally, for forty-eight years. Joe was twenty-nine and Charles seventeen years old when they first met.

Joe Leyendecker was physically unimpressive—skinny, about five feet, six inches tall, with deep-set eyes, a swarthy complexion, pursed lips, wispy hair, and no sideburns. He was also, however, quite sophisticated, with a *soigné* no doubt acquired in Parisian art galleries, and well dressed, even meticulous in his attire. Charles Beach was his direct opposite. He stood about six feet, two inches tall and had an Adonis-like figure with massive biceps, narrow waist, and flat stomach. Charles put on affectations peculiar for someone from Ontario, Canada, and in later years dressed outrageously, frequently carrying a walking stick and wearing an overcoat laden with Persian lamb collars, cuffs, and hem trim. Clever but uneducated, he offered no challenges intellectually and was usually silent while modeling for Leyendecker, though always looking quite beautiful. Charles moved into a studio apartment on West 31st Street, one block from the Leyendeckers' studio.

After their mother's death in 1905, Joe, Frank, and Mary moved from Washington Square to a rental house on Pelham Road in New Rochelle, some sixteen miles from midtown Manhattan. Soon thereafter, their father, Peter, moved in as well. In a bold move, in 1910 Joe and Frank also moved to a larger, luxuriant new studio in Ashforth & Duryee's newly built Bryant Park Studio Building, later known as the Beaux Arts Building. Its 40th Street and Sixth Avenue location made it especially convenient, as many publishers and advertising agencies had offices at nearby Madison Square Park.

The main studio room had twenty-two-foot-high ceilings, a large balcony overlooking Bryant Park, several smaller rooms, and storage areas. Studio decor in the opulent workspace included Renaissance sideboards, Louis XV chairs, tapestries, oriental rugs, and oversized foreboding Italian Baroque side tables, all acquired during their stay in Paris. On virtually all horizontal surfaces there were silver trays loaded with squeezed, empty paint tubes. Recalling his childhood in Montabaur, Joe hung suits of armor on the door, one on the hallway side and the other inside. The studio was staffed by Charles Beach, who had moved from his small efficiency unit into a side bedroom, and a Filipino

CHARLES A. BEACH (1886–1952)

Model and Life Partner

Norman Rockwell described Charles Beach as: "tall, powerfully built, and extraordinarily handsome—looked like an athlete from one of the Ivy League colleges. He spoke with a clipped British accent and was always beautifully dressed. His manners were polished and impeccable…"* He was Joseph Leyendecker's ideal man.

Charles was also compliant and understanding of Joe's worldly desires and emotional needs. And for his part, Joe enjoyed the irony of painting Charles as a prototype, the classic all-American male.

After deferentially living with Frank and Mary for two decades, Beach recognized newfound strengths. Again, according to Rockwell, "Little by little, day by day, he insinuated himself into Joe's life…Beach hired the models, bought the art supplies, rented the costumes, paid the gardeners and servants." By 1923, he had completely taken over Joe's business affairs. Next, he wrestled household control from Mary, and startled Frank by

Beach as portrayed in *Man with Hands in Pockets*, Arrow Collar advertisement. Date unknown

refusing his requests for menial help, openly insulting him in front of guests. Frank, unable to defend himself, was soon diminished by the constantly aggressive posture. Thereafter, every aspect of Joe's life, including painting, was under Beach's control. Joe had been teaching Charles to assist him by preparing canvas stretchers, and other basic art tasks. Over time, this encouraged Beach to feel he was an equal partner in the creativity as well as with the household. Joe was amused by the concept, although it increasingly upset his siblings, friends, and clients.

Charles Beach was not only Joe's idea of the perfect man. Leyendecker's advertisements for Arrow Collars and Arrow Shirts made him the paradigm for a nation. He was, in fact, the first American "culture hero." Few, if any fans ever realized that their lofty ideal man was not only a homosexual but a kept man, the live-in lover of the famed artist who thrust himself into such an exalted status.

Charles Beach followed J.C. Leyendecker in death as he did in life. He passed away a year after Joe, in 1952.

* Norman Rockwell, *My Adventures as an Illustrator* (Garden City, NY: Doubleday and Co., 1960), pp. 197–98.

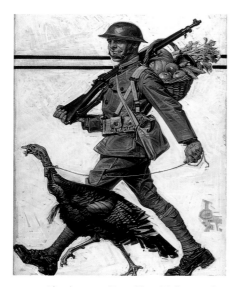

ABOVE: *Thanksgiving (Doughboy Walking with Turkey)*. 1918. Oil on canvas, 28 x 21". Monogrammed lower right. Reproduced: *Saturday Evening Post*, November 30, 1918

BELOW: Neil Hamilton with Leyendecker oil painting, 1920s

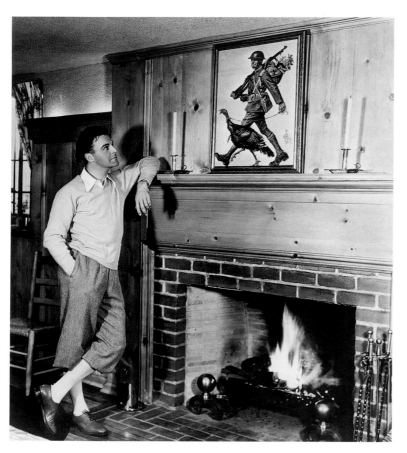

houseboy who presented himself in full livery, as per Beach's orders. Visitors' arrivals were enhanced by major domo announcements.

The Beaux Arts Building, aside from having artist studios, also housed apartments for actors and other creative types. All in all, it was a grand place for an artist—in fact two artists—in which to work. Certainly, the Leyendecker brothers were exceedingly comfortable in this new studio, though Frank was increasingly horrified at the more than obvious shows of affection between Joe and Charles Beach.

Although both brothers ostensibly commuted from their New Rochelle home, Joe was happier spending nights in the city with Beach and frequenting the local bars and lounges with him and the many friends they shared. Joe and Charles dined frequently at Longley's, a popular Sardi's-like steak joint that was open all night for the theater crowd, and made fast friends with five or six waiters. One of them was Brian Donlevy (1901–1972), destined for stardom on the silver screen. Donlevy had the image Leyendecker sought as a counterpart to Beach and his affected mannerisms: a rigid military-like demeanor combined with raw toughness. Joe soon hired him as a model. Donlevy appeared in a number of Arrow Collar advertisements, sometimes alongside Beach but never supplanting him in any way.

Another famous movie star, Neil Hamilton (1899–1984), also modeled for Joe early in his career. Hamilton would eventually work with D.W. Griffith in *The White Rose* (1923), appear as *Tarzan the Ape Man* (1934) and as Police Commissioner Gordon in the *Batman* television series of the 1960s, and ultimately act for virtually every studio in Hollywood, but in 1917 he was an unemployed actor hanging around movie studio lots in Fort Lee, New Jersey, when a particularly handsome man walked by. A fellow standing next to him muttered, "Did you notice that guy who that just went out, do you know who he is?" It was the Arrow Collar Man. Nearly speechless, Hamilton drew up the strength to say, "I'd actually SEEN him in person."[5]

Never having modeled previously but yet to receive any movie roles, Hamilton garnered from this chance encounter inspiration regarding the means to get some badly needed cash. He made his way to Joe's Beaux Arts Building studio and offered himself as a model. Hamilton described the encounter: "My knock was answered by a butler in full uniform. . . . I was ushered into the great man's presence. His studio looked like a somewhat smaller Grand Central Station. He himself was a fairly small person, but intensely attractive, as he gave his FULL attention to every word I uttered."

Leyendecker hired Hamilton for six dollars per day and threw in lunch as well. He used him in several Arrow Collar advertisements and *Saturday Evening Post* covers. Later Joe

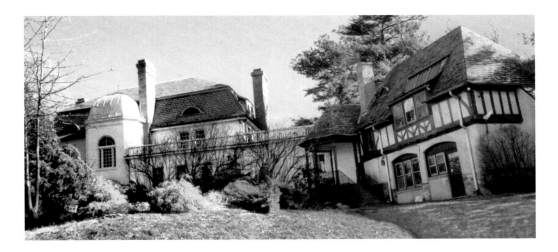

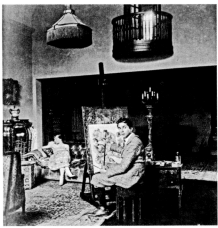

introduced him to other artists to help him find additional modeling work; Hamilton posed for Norman Rockwell, Howard Chandler Christy, James Montgomery Flagg, and for Frank Leyendecker, too. As Hamilton himself said, "Man alive—I had made it made it in capital letters—MADE!!!"

Some years later, in the mid-1920s, Neil Hamilton and his wife dined with Joe Leyendecker. After dinner, Joe invited the couple back to his studio. Charles Beach was asked to fetch an original painting of a *Post* cover (November 30, 1918) for which Neil modeled. Hamilton and his wife were thrilled at its sight. He offered to purchase it from Joe, who refused, explaining that he never sold his paintings. Realizing their residual future uses, Joe insisted upon retaining physical control of all his images; and he sold only a one-time use of each to the *Post*, insisting the painting be returned to him after the picture's publication. After dinner, however, Joe sent the painting to the Hamiltons

CLOCKWISE FROM ABOVE LEFT: The Mt. Tom estate, c. 1995. Mary and Frank pose in Joe's Mt. Tom studio, 1915. Charles Beach and dogs in the living room at Mt. Tom, 1919; the original painting for *Ridolfo* (left) and a portrait of Frank and Joe (right) grace the walls. The staircase at Mt. Tom, 1919. When the photograph of Beach was originally reproduced in *Country Life* magazine, Charles was not identified, but the caption read, in part, "It is evident that in this home man's best friend is appreciated at his true worth"—perhaps a subtle nod to his and Joe's relationship.

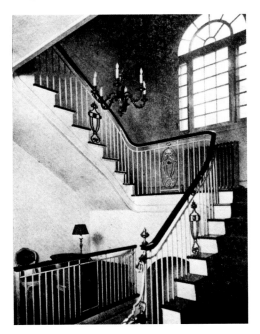

FRANK XAVIER LEYENDECKER (1879–1924)

Illustrator and Brotherr

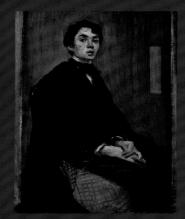

Portrait Of F. X. Leyendecker
(study). 1897. Oil on canvas, 15½ x
12⅝". Unsigned

Sometimes confused by collectors, F.X., or Frank, and J.C. Leyendecker had practically identical training, similar styles to the untrained eye, and were both celebrated talents. They even looked alike. Like Joe, Frank Leyendecker was short and slight of build, with an unnaturally sallow complexion, and a weak jaw. Both shared nearly exact profiles, though Frank had cruder, more rounded features and fuller lips than his brother. The fourth child in a German household, where primogeniture reigned still—an Old World legacy—Frank was doomed not to lead the pack. With oldest brother Adolph out of the picture, Joe was considered the favorite child. Frank viewed Joe's early academic and commercial successes as signs of his own unworthiness. Sympathetic, Joe tried to ameliorate his baby brother's situation but succeeded only in further damaging his self-confidence. Ultimately, this affected Frank's social relationships, even his drive and stamina.

Frank got off to a flying start upon the brothers' arrival in New York. For six years beginning in 1900, *Collier's* commissioned Frank for twenty-six covers, while Joe painted fewer than half that many. Other clients did not always like Frank's work as much, perhaps because he often chose to satisfy his own artistic desires at the expense of a client's specific needs. One of his models, Neil Hamilton, provided a glimpse of Frank's attitude toward clients. After posing for three days for an Interwoven Socks ad, Hamilton was asked by Frank for his opinion of the finished picture. At first he was afraid to criticize, but finally said he thought the feet were huge. "You see it—you really see it?" Frank asked. "I get a fat sum of money from the manufacturer of these stockings, but I despise myself for doing them, although I HAVE to do them, so I take out my spite on the art critics and those who won't let me paint anything I'd like to paint, such as illustrations for a story." One can see other examples of inexplicable "errors" in Frank's advertisements, such as putting extremely short trousers on a figure, inserted to show the world the indignities he suffered from having to accept commercial commissions.

After his early *Collier's* cover triumphs, Frank fell under the overwhelming shadow of his prolific, more able older brother. He became known as "The Lesser Leyendecker"; the title stuck, tainting him professionally. Yet *Collier's* covers painted by Frank Leyendecker are considered as being among the most important magazine illustrations.

As his brother's star continued to rise, Frank grew more depressed and less able to perform. He lost commissions and clients to younger illustrators with

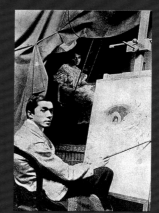

F.X. Leyendecker, 1914

new ideas and techniques. Sparse commissions during his last few years did not generate enough income to provide for himself, and he came to rely more and more on his brother's largesse. Between 1912 and 1919, he did only six magazine covers and no other work, a sad comment on this creative genius's disintegrating reputation. As their careers careened on divergent paths, Frank increasingly resented Joe's help. Joe sometimes hired Frank to finish his own paintings, a well-meaning but ultimately hurtful gesture. F.X. Leyendecker's last magazine cover, for *Life*, was published October 4, 1923.

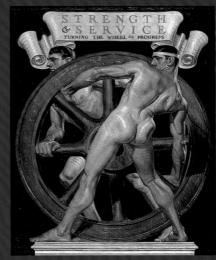

F.X. Leyendecker. *Chevrolet Review: Strength & Service*. Oil on canvas, 35 x 28". Signed lower right

After the blowup with Charles Beach in 1923, Frank moved into an efficiency unit next to Norman Rockwell's New Rochelle studio on Lord Kitchener Road, bringing with him an oversized Italian Baroque bed, his last prized possession from Europe.* With nothing else left, no place in the fraternal relationship, a broken spirit, and overshadowed by Joe's successes, Frank lapsed further into his sad indulgences. He took even greater amounts of drugs, smoked and drank more heavily, and near the end, sought psychiatric help. Rockwell claims to have on several occasions accompanied F.X. to his analyst in the attempt to thwart his further decline.

A year after he moved out, Frank Xavier Leyendecker was dead. He passed away near midnight on Good Friday, April 18, 1924, at the age of forty-five. According to the order for internment, the cause of death was a cerebral hemorrhage. Some have claimed it was really due to a broken heart after slowly losing his brother; others blamed the drugs that dissipated his health; still others implied suicide.

A mysterious figure in life, Frank remained so after death. His page-one, April 19, 1924, obituary claims, "One of the foremost artists and illustrators of this country died in this city last night at midnight, when Frank X. Leyendecker passed away at his home on Mt. Tom Road."† In reality, of course, Frank had moved from that house a year earlier. Joe, however, still living there with Charles Beach, did not want the world to know that.

On December 20, 1924, the Art Association of New Rochelle held a Memorial Exhibition of Frank X. Leyendecker's artworks at the Public Library. Mary Leyendecker, Coles Phillips, Norman Rockwell, Mrs. Robert Collier, and the publishers of *Collier's*, *Life*, *McClure's*, *Vogue*, and *Vanity Fair* made loans of originals and prints. He was eulogized as having given "fidelity to tradition and no less to suavity and grace and authority of method that he raised the standard of commercial art to a place never before occupied, as a legitimate adjunct to what we know as true art, that is, enduring art." The exhibition drew unabated crowds.

If he had not worked in the shadow of his brother, F.X. Leyendecker might have been recognized as one of the most successful artists of the Golden Age—a superstar. Few other illustrators had such notable commissions from the most important publications.

* Norman Rockwell, *My Adventures as an Illustrator* (Garden City, NY: Doubleday and Co., 1960), p. 203.
† "Noted Illustrator Dies," *The Standard-Star* (New Rochelle), p. 1.

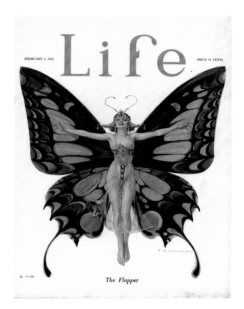

ABOVE: F.X. Leyendecker. *Life* cover. February 22, 1922. Printed magazine cover

OPPOSITE: F.X. Leyendecker. *The Flapper.* 1922. Oil on canvas, 29 x 27". Signed lower right

at their hotel. They could hardly believe the wonderful gift and hung it over their home fireplace mantel. Neil reported that his artist friends were always "transfixed" when they saw it. Beach commented later that this was one of only two *Post* cover paintings that Leyendecker had ever given away.

In 1914 J.C. Leyendecker and family moved from the rental house on Pelham Road into a fourteen-room house that Joe had designed and built on a nine-acre estate in New Rochelle. Joe named the street Mount Tom Road, an Americanized version of his birthplace, Montabaur. Architect Louis Rochet Metcalfe (1873–1946), a New Yorker whom Joe had met in Paris at the Ecole des Beaux Arts, used his entire range of European training to satisfy the array of styles demanded by Charles Beach for "their" house. (Beach took credit for getting the house built, having acted as Clerk of the Works for Metcalfe.) Deemed a "mansion" by Norman Rockwell, the house was an agglomeration of Elizabethan exteriors, a French mansard roof, Georgian details, and quasi–French Provincial elements. A winding footpath graced by low piers led up a sharp slope to the Leyendecker residence. Belgian cobblestones defined a driveway and parking area used exclusively for Joe's Pierce Arrow roadster and a chauffer-driven Lincoln limousine. A small archway into the gardens was hidden behind the long, low building facade. Inside, Arts and Crafts windows, Gothic Revival fireplaces, chandeliers of dubious styles, and a local hardware store stair railing with skinny balusters completed this Americana delight. An eccentric interpretation of incompatible styles and scale, the Mount Tom house is nevertheless charming for its eclecticism.

Joe's large private suite overlooked the splendid gardens. He loved their formality, with their classical order echoing the Renaissance, and enjoyed working in them in his spare time. Gaggles of geese, ducks, chickens, and turkeys provided an informal counterpoint to the gardens. There was also a koi fishpond and small gazebo reached by a footbridge over a miniature waterfall.

The house included, at the extreme right-hand end, a studio for Frank. After many years of torturous studio sharing, rife with uncomfortable compromise, Joe hoped separate workplaces would ameliorate their relationship and alleviate Frank's personal addictions. Joe envisaged that some day he might work at home as well, and so space was created for another studio at the left-hand end for potential future use. For the time-being, however, he continued to commute to the 40th Street studio—and to Charles. Beach was satisfied, and so apparently was Frank. He enjoyed working at his lavish studio with northern light, alcove dressing rooms for models, private bathroom, and balcony for flexible poses and views of models from a distance or from below.

In 1916, Peter Leyendecker died, and Charles Beach moved into the house on Mount Tom Road. Finally Joe and Charles were able to share quarters without pretense. Now Joe and Beach, Frank and Mary, a new housekeeper, and two Filipino houseboys all lived together, on Mount Tom Road. Joe and Charles still commuted daily to the New York City studio.

Charles's move to Mount Tom Road directly pitted him against Frank and Mary, putting them on a collision course. Beach felt the house *and* Joe belonged to him, while

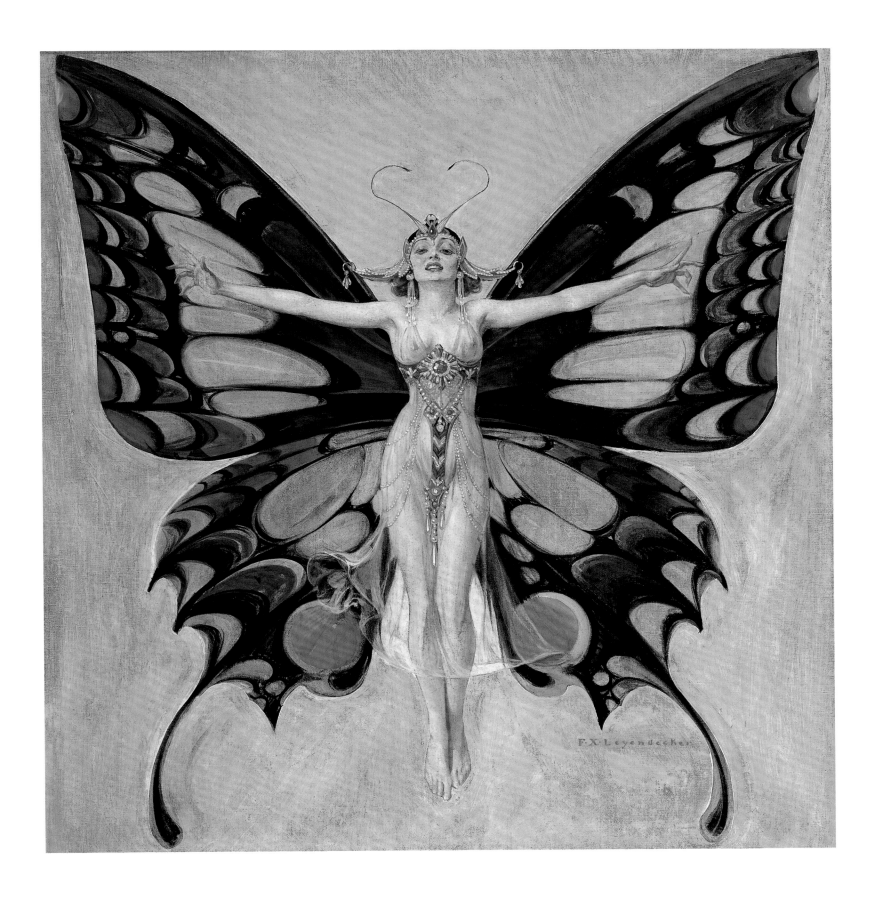

Frank found it difficult to satisfy his own needs while wrangling with Charles over everything and nothing. According to Norman Rockwell, Beach had "corrupted Joe's relationship with his brother and sister . . . fouling it so slowly that Joe didn't realize what was happening, though if he had I doubt he could have stopped it, his dependency on Beach ran so deep."[6] Frank and Beach grew increasingly antagonistic toward each other, while Mary grew angrier with Joe. The living situation was becoming intolerable. The ongoing dispute between Charles Beach and Frank Leyendecker culminated in 1923 with Mary spitting in Beach's face. Mary and brother Frank moved out to residences of their own.

In the aftermath of World War I, the 1920s roared into North America and especially to New York. The nation needed revelry. Societal and cultural upheavals became the norm, the economy boomed, and increased advertising spread new technology to the masses. Flappers came into vogue with Frank's cover for *Life* entitled *The Flapper* (February 2, 1922). Meanwhile, Joe's characterizations of his profligate peer group became the personification of a decade of decadence.

With the end of the war, the Beaux Arts Building started to attract more ordinary folk, as compared with the previous rarified residents. It was considered déclassé for a famous artist to continue working in what had become a middle-class apartment building. In 1919, Joe moved his studio again, fourteen blocks north to 151 West 54th Street, an up-and-coming "artists zone."

The new studio was in a neighborhood with magnetic ambience. The location drew a crazy mix of artists, writers, thespians, gangsters, socialites, gays, and lesbians. Leyendecker chose the building at the suggestion of Texas Guinan (1884–1933), one of the tenants. Leyendecker had met Guinan back in 1907, while he was sitting on a bench with Charles Beach in Washington Square taking in the harvest moon and exotic Village sights. By this time, J.C. Leyendecker was already known throughout the country. Texas introduced herself, mentioning that she had recently moved onto the Square from Waco, Texas, and just landed a job as a chorus girl. Texas and Joe's similar backgrounds and mutual goals made for a lasting friendship. Like the Leyendeckers, her people were immigrants, and she had moved from the Midwest to seek fame and fortune in the big city. While not a lesbian, Texas's reasons for choosing to live in an urban incubator for the arts and sexually tolerant cultures paralleled Joe's own.

Years later, Texas Guinan gained fame as a saloonkeeper, entrepreneur, and actress, even engendering several movies about her life.[7] She opened a speakeasy called the Club Intime in the basement of the West 54th Street building to satisfy a public need during Prohibition. The Club Intime was an immediate hit, and Texas Guinan became the undisputed queen of the nightclub scene. Texas greeted guests with the words, "Hello, Sucker"—one of several phrases she coined and popularized—and politely proceeded to relieve them of their cash.

To hide it from raids, Texas kept the bar on the building's top floor, a situation of which Leyendecker took full advantage, as Norman Rockwell related: "Texas had her speakeasy

Man and Woman Dancing. 1923. Oil on canvas, 39³/₄ x 26¹/₈". Unsigned. Arrow Collar advertisement featuring models Phyllis Frederic and Brian Donlevy

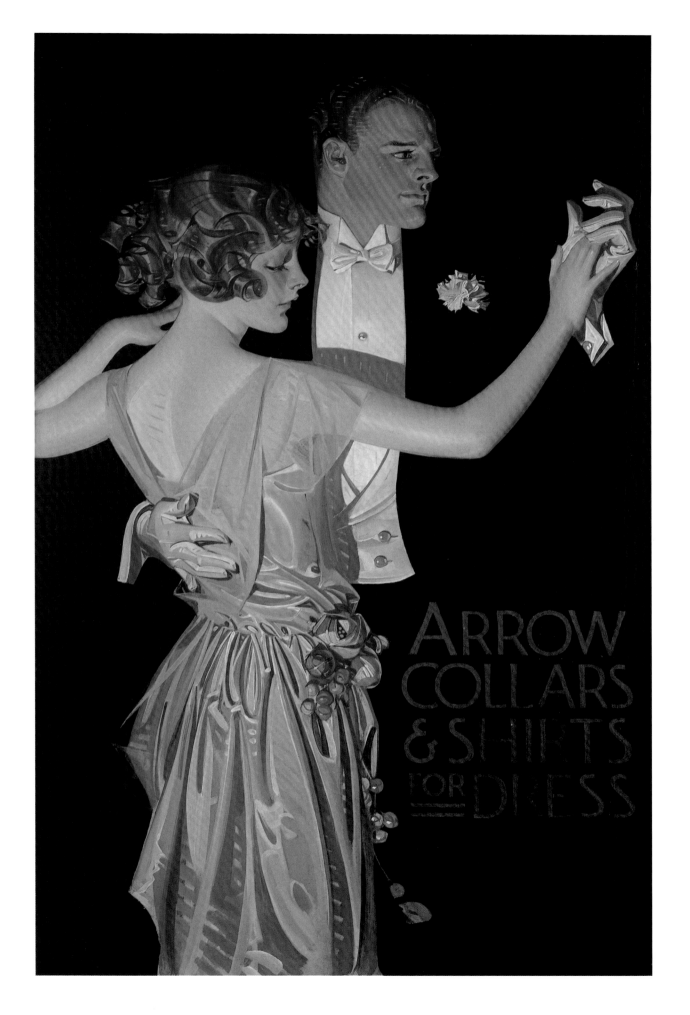

in the basement, but the bar was hidden from view on an upper floor. Leyendecker's studio was in-between. On occasions when Rockwell visited with Joe and Beach, Joe always offered Norman a drink. Rockwell noted that there was an open dumbwaiter, which passed from the bar, through Joe's studio to the speakeasy in the basement. Pulling ropes to move it from the bar on an upper floor to the speakeasy operated the dumbwaiter. It passed through many studios, but in Joe's alone, it was open exposing it to the studio space. Joe would take drink orders and then await until the correct order was passing through the studio on its way to a disappointed customer, while Joe gingerly helped himself for himself, Charles, and for his guest—Norman Rockwell."[8]

Texas's saloon soon became the favorite haunt of the wealthy and the accomplished—New York's earliest "beautiful people." The custom included Walter Chrysler, Reggie Vanderbilt, John Jacob Astor, Gloria Swanson, Al Jolson, John Gilbert, Clara Bow, John and Ethel Barrymore, Ruby Keeler, Rudolph Valentino, F. Scott Fitzgerald, Dorothy Parker, Texas's good friend Mae West—and Joe Leyendecker and Charles Beach, the "it" couple. Joe met everyone of consequence in society—brash girls with bobbed hair, short skirts, and heavy makeup; dapper gadabouts in flashy cars—studied their demeanor, profiles, haughtiness and accoutrement, spats, monocles, and recorded it all, passing it along in his illustrations for everyone to see and emulate.

Texas Guinan's influence on Leyendecker's view of the world is not to be dismissed. Her notions of style and bravado became the filter through which he saw the world, and the lifestyle she promoted transformed his own way of life. Charles Beach began to organize risqué parties in New Rochelle, usually with holiday themes. J.C. Leyendecker and Charles Beach offered a certain mystique and panache to each occasion. The Arrow Collar Man was a perennial draw, and Joe, America's foremost illustrator and a celebrity, attracted people of consequence like moths to a flame: everyone coveted a platonic relationship with Leyendecker, sexual preferences notwithstanding. The parties at Mount Tom Road became important social and celebrity-making events. The popular gossip maven Walter Winchell (1897–1972) in particular frequented the Mount Tom Road parties as well as the Club Intime (Texas was his gossip mentor) and wrote about them often. The coverage set fashion fads, established drinking and smoking trends, even dictated which automobiles were acceptable, and forever changed the shape of journalism by exposing private lives with salacious stories. The accounts never touched upon the relationship between Joe and Charles, however, due to Joe's cultural influence on the nation—and perhaps because the columnists would not be invited back.

Leyendecker's depictions of this opulent existence, and perhaps his own lifestyle as well, helped to shape an entire generation. While in Paris, Joe had learned that manners, style, and fashion were tantamount to accomplishment in society. The "common folk" attempted to gain acceptance by parroting styles they witnessed in magazines. (Of course, foreign-born, Catholic, and gay, without high school or college education, J.C. Leyendecker knew only too well how difficult such acceptance could be to attain.) Leyendecker became the purveyor, and his Arrow Collar Man the epitome, of everything the public sought. In the process of developing that image, together J.C. Leyendecker and

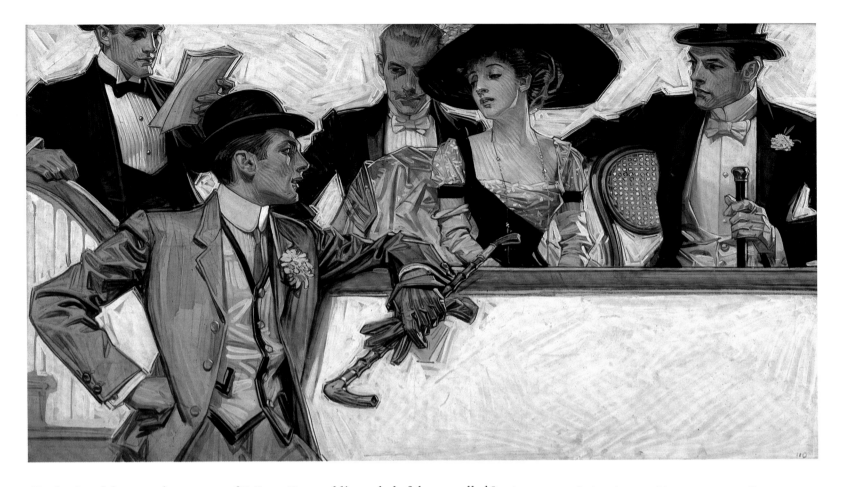

In the Stands 1. 1913. Oil on canvas, 20 x 24".
Unsigned. Arrow Collar advertisement

Charles Beach became the persona of F. Scott Fitzgerald's symbol of the so-called Lost Generation, Jay Gatsby.

Francis Scott Key Fitzgerald (1896–1940), novelist and screenwriter, was an internationally influential writer and national celebrity living an opulent life of gaiety and alcoholic abandon when he first met Joe Leyendecker and Charles Beach. Scotty and his wife, Zelda, traveled in Europe and socialized on Long Island, and at Texas Guinan's speakeasy. It was there that he met Joe and Charles.

The parallels between the Leyendeckers and Gatsby are uncanny. Michael Schau put it most succinctly when he said, "The characters of F. Scott Fitzgerald's *The Great Gatsby* come to mind in many Leyendecker pictures of the twenties: well-to-do, civilized people with self-confidence reinforced by breeding, education, position, and taste. They were sophisticated, but not above gaiety."

Both Joe Leyendecker and Jay Gatsby rose from impoverished Midwest beginnings to live lives of great wealth, sophistication, and lavish spending. Charles and Joe enjoyed entertaining and had what were considered to be "the best" parties. Fitzgerald's written descriptions of Gatsby's parties echo Leyendecker's visual interpretations of his guests: they included "businessmen, wealthy East Eggers, theatre people, even a prince." In *The Great Gatsby* (1925), Jay Gatsby was described as throwing wild weekend parties

throughout the summer, remaining aloof from the guests, people whom he hardly knew. Like a surgeon selecting a scalpel, Joe too surveyed his guests from the fringes, studying them for future depiction. Gatsby's soirees ended after Daisy expressed her distaste for them. Likewise, Mary Leyendecker openly expressed her disgust with Beach, his friends, and the endless parties.

In *The Great Gatsby*, shirts represented Gatsby's wealth—a colossal illusion invented by the upper classes to proclaim their status at the expense of those who could not care less—and so too did Leyendecker invent the Arrow Collar Man to become a virtual symbol of the Roaring Twenties. This was Joe's goal on behalf of Arrow Collars, later Arrow Shirts: to make "his" customers crave the world as their toy, their oyster. By simply purchasing an Arrow Shirt for $1.50, or so Leyendecker made one believe, a man could buy into the world of civility and prominence.

Soon, the Leyendeckers' legendary galas and glamorous lifestyle helped turn the sleepy suburb of New Rochelle into a magnet for celebrities of all sorts. In time it became the third wealthiest city per capita in the country. Of course, an elegant and dissolute place to gather was not all that New Rochelle had to offer. The historic community's rural setting, with rolling fields and wildflowers, the nearby ocean, and a short, forty-minute train ride into New York City made it the best of all worlds. Realizing the positive lifestyle it could afford them, other artist–illustrators gravitated to New Rochelle, making it a virtual artist's colony, albeit an unlikely one in such a suburban setting. Among the luminaries who followed the Leyendeckers' lead were C. Coles Phillips, Orson Byron Lowell, Lucius Walcott Hitchcock, Ernest Albert, Rudolph Belarski, Edward Penfield, Franklin Booth, Clare Briggs, Victor Clyde Forsythe, Walter Beach Humphrey, Fred Dana Marsh, L. A. Shafer, George Tobin, and Revere F. Wistehuff.

For Norman Rockwell, it was neither New Rochelle's scenic landscape nor its proximity to New York City that attracted him. Rockwell moved to 24 Lord Kitchener Road the year after the completion of the Mount Tom Road house to be near J.C. Leyendecker. Rockwell vividly described his admiration for Leyendecker in his biography, published nine years after Joe's death, citing him as an early idol and recalling that he had a Leyendecker picture hanging in his studio. He came to fault Leyendecker in later life, however, for withdrawing from society and for not experimenting more beyond what Rockwell considered Leyendecker's "true and tried style."

Rockwell got the chance to have his work reproduced along with Leyendecker's in 1938 when, in a burst of uncharacteristic insight, the New Rochelle Chamber of Commerce hired the best of the local illustrators to prepare a booklet entitled "AD 1688: New Rochelle—The City of the Huguenots." At the time of publication there were ninety-six members in the local Art Association, many with national reputations. J.C. Leyendecker was selected to provide the bold cover painting (see page 33); Norman Rockwell, along with Coles Phillips and Orson Lowell, was asked for an inside illustration. Rockwell later griped, "New Rochelle published a brochure illustrated with reproductions by all the famous artists who lived in town. Joe worked on his painting for

C. COLES PHILLIPS (1880–1927)

Illustrator and Friend

Coles ("Cy") Phillips, an illustrator whose paintings and reputation rivaled those of Gibson, Christy, and even Leyendecker, became Joe's closest friend. Cy focused on the depiction of the ideal American woman. His "Fadeaway Girls," which featured a technique he pioneered whereby the background matches the color of a model's dress, were distinctive for his technique and graphic strength, although his images are not well known today. With his Fadeaway Girl, Coles Phillips provided a counterpart to Leyendecker's ideal American male.

Norman Rockwell. *Portrait of Coles Phillips.* 1927. Oil on canvas, 24 x 20". Signed lower right

Unlike J.C. Leyendecker, who was well educated in his craft and began painting at eight years old, Cy Phillips was an untrained painter who started late in life. Consequently, Phillips relied more on graphic design talents than on technical painting abilities. He simply could not mold the shape of an elegant hand, for example, with shading and light.

Coles Phillips arrived in New York from Ohio and was later introduced to Leyendecker at The Players Club in Gramercy Park, a meeting ground for publishers, writers, and illustrators, where many important art commissions were awarded over lunch or in the lounge while dousing one's throat with ruby red port by the fireplace. Leyendecker suggested that Cy take a studio at the Beaux Arts Building, where their friendship flourished. Cy took professional advice from Joe, and they became close friends. When the Leyendeckers espoused the virtues of life at New Rochelle, Cy decided to move wife Teresa and his family to Sutton Manor in New Rochelle as well, to have a better environment to bring up his children.

At a young age, Cy became racked with kidney disease, tuberculosis, and rapid sight deterioration. Joe helped Cy's family as much as he could. Childless himself, Joe particularly centered loving attention on the four Phillips children. It was likely the most purely altruistic thing Joe ever did and perhaps stemmed from the loss of his own family relationships.

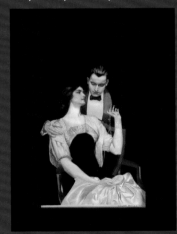

J.C. Leyendecker was entertaining the Phillips children at a parade on Fifth Avenue honoring Charles Lindbergh upon his return from France on the day their father died. Joe gave the eulogy for his friend. He mentioned Phillips's depictions of "young womanhood" and his "sense of decoration and color" and spoke of Cy's long enduring battle and how "art had contributed beauty rather than pain into his life and consequently into the lives of others through his illustrations."*

C. Coles Phillips. *Diary of a Mere Man.* 1913. Gouache on paper, 32 x 22"

*Michael Schau, *All American Girl: The Art of Coles Phillips* (New York: Watson-Guptil, 1975), p. 40.

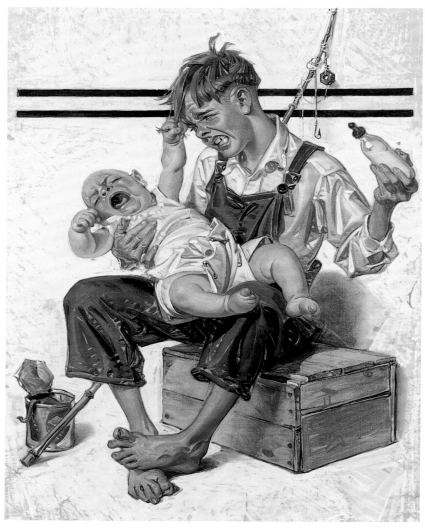

The Babysitter. 1923. Oil on canvas, 26 x 20".
Monogrammed lower right. Reproduced:
Saturday Evening Post, August 25, 1923, cover

months and months, starting it over five or six times. I thought he would never finish." It's possible he meant to suggest that his mentor had problems with inconsequential commissions, focusing better on work for publications such as *The Saturday Evening Post*, with millions of readers. Or else he simply took the opportunity to disparage a competitor.

While Rockwell, who came to know Joe quite personally from about 1925 onward, admired, even revered Leyendecker as an artist, he had nothing but disdain for his relationship with Charles Beach, whom he characterized as "a real parasite—like some huge, white, cold insect clinging to Joe's back. And stupid. I don't think I ever heard him say anything even vaguely intelligent." In later years Rockwell also came to be disturbed by his former idol's lifestyle and personal problems. He attributed what he considered to be Leyendecker's downfall—a descent into decadence, alcohol, and unproductiveness—to his relationship with and increasing reliance on Charles, who had insinuated himself into every aspect of Joe's life. Joe, who had always been anxious and timid, began to take on an aggressive behavior with others, perhaps to hide his insecurities. Other than Beach, his sister, and some remote cousins and houseboys, he was said to rarely speak to anyone after 1930—quite different from the convivial host from so many Gatsbyesque parties he had been in the past.

Joseph Leyendecker and Charles Beach led lives of art and companionship for nearly half a century. In their winter years, public tastes changed, the incursions of film and television slowly but dramatically altered the publishing industry forever, and the demand for Leyendecker's work dwindled. By the end of the 1930s, commissions began to wane. The couple's income fell, and after years of spending lavishly, their finances had depleted significantly. Joe let his entire household staff go, and from then on he and Beach maintained the extensive estate themselves.

With Ben Hibbs replacing George Lorimer as the editor of the *Saturday Evening Post* in 1941, Leyendecker's most lucrative and celebrated string of commissions came to an end; his last cover for the magazine, fittingly a New Year's Baby, was published in January 1943. New commissions continued to filter in, but slowly. Some of the most prominent were for posters for the United States War Department, in which Joe depicted commanding officers of the armed forces encouraging the purchase of bonds to support the nation's efforts in World War II. In 1945, Joe began painting covers for *The American Weekly* magazine, a Sunday newspaper supplement printed on newsprint, a far cry from the high-quality production values of the *Post*. Joe and Charles retreated, hermit-like, into their Mount Tom refuge for fear of becoming destitute and without recourse.

NORMAN ROCKWELL (1894–1978)

Illustrator

In many ways, the man whose name is considered to be synonymous with American illustration—Norman Rockwell—modeled himself on a now lesser-known artist, one of his self-proclaimed idols, J.C. Leyendecker. In 1960, Rockwell included a chapter on J.C. Leyendecker in his biography, *My Adventures as an Illustrator.* Rockwell claimed to have followed Joe about town emulating the stance, swagger (limp), and "attitude" of the man he and America considered the best illustrator. As a budding young artist and with high hopes of rising to the same exalted plateau—the preeminent *Saturday Evening Post* cover artist—Rockwell was consumed by the man and his art. When the opportunity arose, Rockwell, an aggressive up-and-coming competitor, picked Joe's brain for ideas, for contacts, and ultimately for clients. The shy Leyendecker, unaware of Rockwell's competitive nature, naively revealed his contacts. Less than a year later, in 1916, the *Post*, Leyendecker's single most important client, commissioned Norman Rockwell to paint his first cover. For some time, they both produced *Post* covers, but Norman Rockwell ultimately supplanted his idol as the best-known cover artist for the *Saturday Evening Post.*

While Joe received little adulation or credit for his iconic images, Rockwell *de facto* took that credit. Today it is generally accepted that Norman Rockwell established the best-known visual images of Americana. In reality, in many cases they were in large part picked from Leyendecker's repertoire by the younger artist. Rockwell's holiday cover interpretations, for example, were not creatively developed like Joe's, but rather were reinterpretations of themes established by J.C. Leyendecker.

Rockwell virtually did everything possible to imitate J.C. Leyendecker. He moved to New Rochelle to be near Leyendecker. He analyzed how J.C. developed his cover ideas. He studied his style and technique, using in his own work the same broad, white background strokes, projecting figures outside the cover frame overlaying the logo masthead, and painting caricatures. He imitated Joe so completely the public became confused as to the source. Leyendecker's career slumped thereafter.

Whereas Leyendecker shrunk from the public eye, especially in his later years, Rockwell sought the spotlight. He longed for public recognition, not only for his images but for himself. Unlike Leyendecker, he had no personal style and little sense of flash. Gawky and awkward, he had trouble looking at himself in the mirror, for what stared back did not please him. In later years, he often placed his own image into his illustrations in order to gain attention, and portrayed himself accurately but with more Adam's apple than neck. Eventually, Rockwell replaced Leyendecker in America's collective consciousness.

Norman Rockwell. *The Babysitter* (study for *Saturday Evening Post*, November 8, 1947). 1947. Oil on canvas, 30 x 28". Signed and inscribed upper right

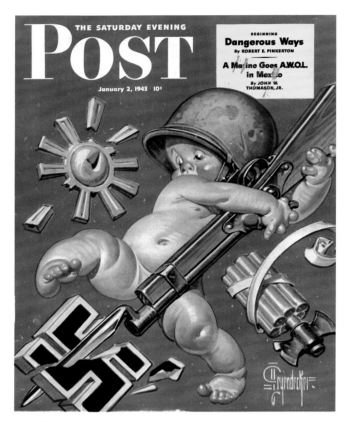

Saturday Evening Post. January 2, 1943. Printed magazine cover

Joe Leyendecker's last debilitating years were spent fighting heart disease *sans* friends, most of whom who had long forgotten the disconsolate living legend. His last visitors were fellow illustrators and lackluster acquaintances from bygone days. Others seeking audiences with the master were rebuffed by Charles, perennial guardian of their nest. For the last weeks of Joe's life, Charles forbade company altogether, arousing rancor among those colleagues who had hoped to pay final homage to their falling idol.

On July 25, 1951, Joe Leyendecker lay on a beaten-up aluminum chaise in his overgrown garden, once the delight of horticulturalists. Wearing a collarless, unironed Arrow shirt with rolled-up sleeves and wide-pleated, pinstripe trousers, he looked a bit frowsy but not out of place. With the *London Times* in one hand, he was sipping a Chapman's (black rum, orange juice, and a splash of bitters—a Gatsby-worthy libation) with the other. Undoubtedly dreaming of halcyon days, he felt a dull, throbbing pain in his forehead. He called out to Charles, drawing him from inept hedge pruning. When the newspaper fell and the cocktail glass shattered on the slate terrace, Joe began mumbling inaudibly and slumped. Kneeling by his partner's side, Charles took his pulse, ran to summon the doctor, and prepared another Chapman's. Joe never got the chance to take another sip: he died in Charles's still-strong arms, just minutes after the doctor arrived. Death was reported as an acute coronary occlusion.

Norman Rockwell was among the seven people who attended the wake in Joe's studio, where he found Joe's painting smock neatly laid out, his wide brushes all arranged nearby, and Charles "hovering about the corners of the studio, straightening out pillows on the couch or dusting a table." The day was bleak, with dark gray skies; a downpour had caused the rear terrace to puddle like a small pond. Besides Beach and Rockwell, the only other people in attendance were his sister, Mary; two cousins on his mother's side; a priest; and the funeral director.

After Joe's death, Charles carried out his instructions to "destroy everything," at least as far as personal mementos, records, and correspondence went. But despite Joe's wishes, he could not bring himself to destroy all the paintings and sketches; he later sold remainders in a yard sale. With a rather large inheritance (having lived his last years frugally, Joe left a sizable estate, which Beach and Mary shared equally), he did not need the money from the sale but wanted artists and fans to be able to get something. Buyers, however, were scant; among them were a few illustrators and neighbors who were curious about the artsy homosexual couple down the street. J.C. Leyendecker's work fetched pitifully low prices. Nothing went for more than seven dollars, and some sold for as little as fifty cents—a sad legacy for the man whose ethereal visions had made him the most famous and celebrated illustrator in America.

OPPOSITE: *The American Weekly.* July 4, 1948. Printed magazine cover

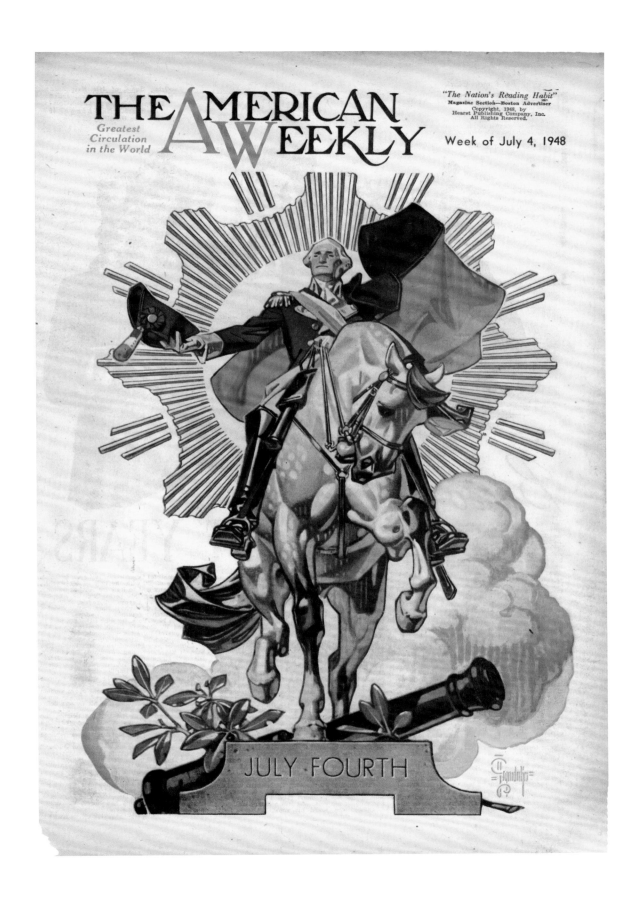

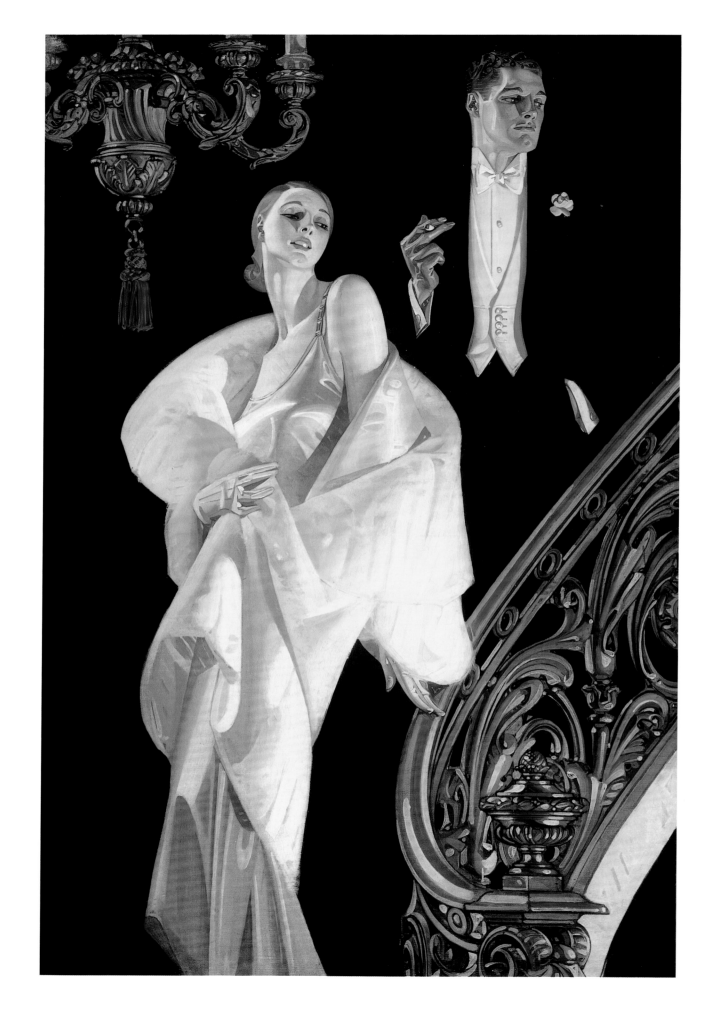

THE LEYENDECKER LOOK

 In evaluating how to best promote himself and his work, J.C. Leyendecker believed that his greatest impact as an artist was creating images easily reproduced, immediately recognized, and broadly distributed for audiences by the millions to appreciate. It was not an accident that his advertising and cover paintings morphed into iconic visions and prototypes. He knew intuitively that representational, symbolic images could become icons of our civilization and his own legacy.

Leyendecker developed a particular ambience for the product of each corporate client or magazine cover. Yet, after his move to New York, J.C. Leyendecker's style of painting never changed; it was always identifiable by the public. The words echo still in front of each of his advertisements or magazine covers, "That's a Leyendecker!" And the viewer uttering those words would never be wrong, for no one else painted like J.C. Leyendecker.

One of the most striking characteristics of his works is their underlying homoerotic nature. In his glory days, friend and foe brushed Leyendecker's sexual orientation aside. Largely ignored, if the subject did come up it was characterized as a "notorious affliction, not to be discussed"; rather, it was Joe's fame as an artist that was touted. Knowing that revealing his secret would threaten his popularity and success, Joe never came out of the closet (in fact, almost no one did in those days). He also attempted to conceal his sexual orientation in his work, which was often characterized by heterosexual female adoration for handsome males depicted in overtly erotic poses. Yet, ironically, he was the most manifest homosexual artist of the early twentieth century—a virtual hero—as his work clearly demonstrates to today's enlightened audience.

To create such delicious illustrations, he smoothed oils on models' muscles, enhancing the light reflecting on male surfaces he admired most: one model said that Joe always painted him in a darkened studio, with only candlelight highlighting the erotic qualities of his gleaming form. The gay subculture saw the irony in his work and appreciated the erotic images he lavished upon the world.

These homoerotic images appealed to heterosexual viewers as well, however. In a subtle subversion of heterosexual mores, unattractive men turned to them in their quest to be more appealing through the products being advertised. Sportsmen never saw the football players' images as anything but manly, for they reveled in the enthusiasm created among the fans. College men, particularly Ivy Leaguers and prep school chums, were

Couple Descending Staircase. 1932. Oil on canvas, 49¼ x 32". Unsigned. Arrow Collar advertisement featuring models Phyllis Frederic and Brian Donlevy

proud that their alma maters were highlighted. And most of all, women were drawn to Joe's images, dreaming of intimacies with men who possessed "The Leyendecker Look."

It was in his 32nd Street studio that Joe more fully developed his painting technique and The Leyendecker Look. The totality of previous experiences had simmered like a stew, and when done, it was presented to the public. The Leyendecker Look captured the ambience of an entire *époque*, offering the audience glamorous escapism. Combining convincing depictions of attractive people with Impressionistic effects of light and color and discernable brushstrokes, Leyendecker refined complex, abstract thoughts to a single image. The men were always handsome, muscled, and dapper; the women beautiful and svelte (belying Joe's claim that he had serious technical difficulties in painting women; his *Couple Descending Staircase* for Arrow Collars, for example, shows as seductive and vibrant a depiction of the feminine form as can be found in advertisements of the period). All were positioned in heroic poses, portrayed in perfect anatomical replications learned from Royal Academicians. In addition, Leyendecker often embellished images with props from bygone eras, such as medieval swords and shields, recalling his dormant nostalgia for the chivalrous past. He incorporated it all into diagrammatic layouts with graphic clarity and capped it all off by his use of elaborate fonts and his instantly identifiable signature. A red or orange monogram-like composite of his initials, sometimes encircled, other times with his surname completely spelled out, it looked like an Asian chop mark derived from Japanese *Ukiyo-e* prints so popular among the Impressionists.

Some artists are copyists when they start their careers and copycats when they end, but most try to develop their own style. Those whose art takes a unique direction are considered masters. J.C. Leyendecker was just such a master.

Unquestionable draftsmanship coupled with a liquid, loose brushstroke was his means to accomplishing the fresh, vibrant Leyendecker Look. Always the consummate professional, he made studies in multiple sizes to produce a realistic depiction of a single aspect. Some of his most interesting work can be found in these wonderfully detailed sketches, where articulated studies of hands, aquiline noses, costumed buttocks, and muscular thighs float together as ethereal visions on the same canvas.

Leyendecker's favorite mediums were oil, watercolor, gouache, pencil and ink, usually on a white background. He invented and popularized the exaggerated, quick brushstroke effect known as *pochet*, or crosshatched strokes with oil paint, just as Beaux Arts architects rendered elevation drawings. The noted graphic artist Franklin Booth (1874–1948) had used a similar technique in ink renderings, but Joe used it in color and at a larger scale, and not just for shadows and shading, but also for depicting light on nearly all surfaces. He also used Pointillist-style dots in colors and patterns to accomplish the *pochet* effect. In order to do so, oil paints must dry quicker than normal, particularly to get a casual, fleeting "snap-of-the-wrist-look." Joe created a special mix of linseed oil and turpentine that dried almost instantly, keeping it a secret from all but Frank for years. He also coupled accuracy with exaggeration to assure that an average audience could understand the message. The result forced the viewer's eye to the focus of the painting, the subject. Every

artwork he created was thus in a sense an advertisement, for one cannot avoid the object selected to be viewed.

Unlike many other artists—Maxfield Parrish and Norman Rockwell among them—Joe abhorred the idea of painting from photographs and used only live models. His models included some of the most attractive men of the day: John Barrymore, Brian Donlevy, Neil Hamilton, Fredric March, Pops Frederic, and Jack Mulhall all became noted movie stars. Before he brought in a model J.C. Leyendecker first made prolific stick figure sketches. Next, rough sketches in pencil or charcoal were made of a model's anatomy, bone structure, hands, cheeks, arms, and legs. Sometimes the initial vitality of these sketches caused Leyendecker to snatch them from a pad and elaborately redo them in oil paint on canvas immediately, before the "creative moment" disappeared. A slight quirk in the position of a hand would cause the artist to try several different alternative positions. Each subtle gesture of body language, even the slight tilt of a finger, was of paramount import in sending a message to his audience. After all, the goal was to seduce the viewers through an image and its subtle implications.

J.C. Leyendecker described his technique in a letter written to Mr. Ial Radom, an illustrator-fan, on Christmas Day, 1950, and quoted in Michael Schau's book *J.C. Leyendecker*[9]:

"One can often work directly from the model, whereas a cover requires more careful planning and should be designed to fill a given space on the order of a decoration. My first step is to fill a sketchpad with a number of small rough sketches about two by three inches, keeping them on one sheet so you can compare them at a glance. Select the one that seems to tell the story most clearly and has an interesting design. Enlarge this by squares to the size of the magazine cover adding more detail and color as needed." Only then would Leyendecker bring his model in for a "number of pencil or charcoal studies. Select the most promising and on a sketch canvas [his name for small, about 10 x 15" canvases] do these in full color, oil or watercolor with plenty of detail. Keep an open mind and be alert to capture any movement or pose that may improve your original idea . . . the final canvas will resemble a picture puzzle, and it is up to you to assemble it and fit it unto your design, at that same time simplify wherever possible by eliminating inessentials. All this is done on tracing paper and then retraced onto the final canvas. Your finished painting may be any size to suit you, but it is usually about twice the size of the reproduction [study]."

Football Hero. 1916. Oil on canvas, 30 x 21". Signed lower left. Reproduced: *Collier's,* November 18, 1916, cover

OVERLEAF: *Men with Golf Clubs.* 1914. Oil on canvas, 20½ x 42½". Unsigned. Arrow Collar advertisement. Reproduced: *Collier's,* April 3, 1909; March 14, 1914

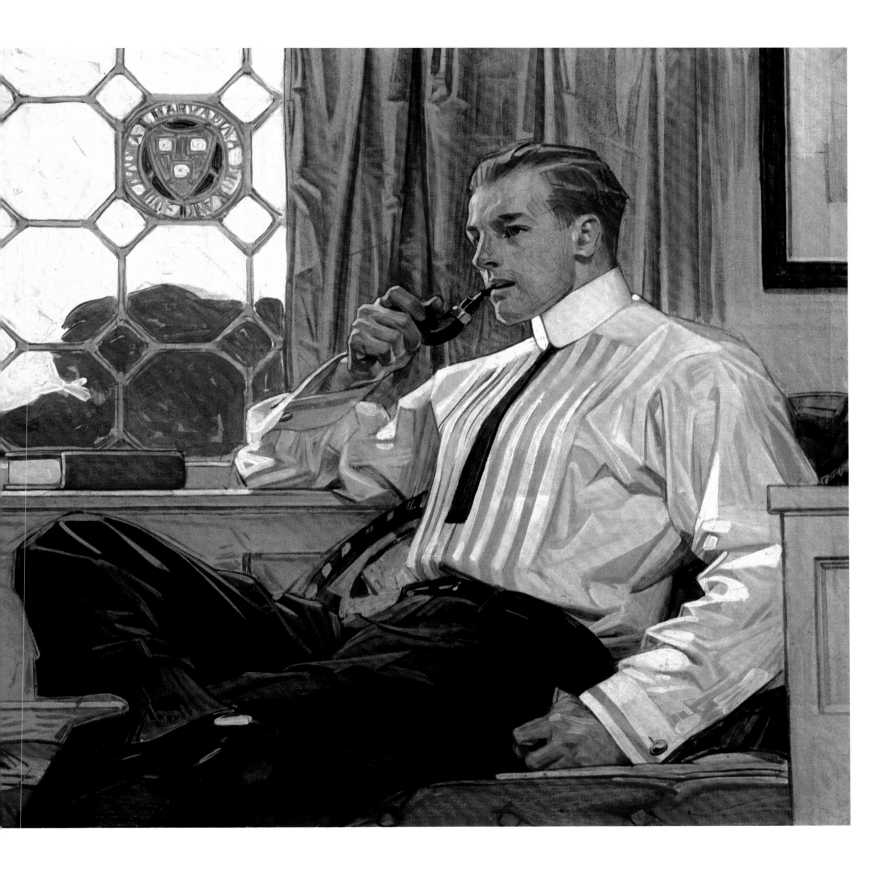

RIGHT: *Interwoven Socks—Famous for Their Colors* (study). 1927. Oil on canvas, 21¹/₂ x 14¹/₂". Unsigned. Study for Interwoven Socks advertisement reproduced: *Saturday Evening Post*, December 27, 1930 (see page 241)

OPPOSITE: *Butterfly Couple* (study). 1923. Oil on canvas, 17 x 13". Unsigned. Study for House of Kuppenheimer advertisement

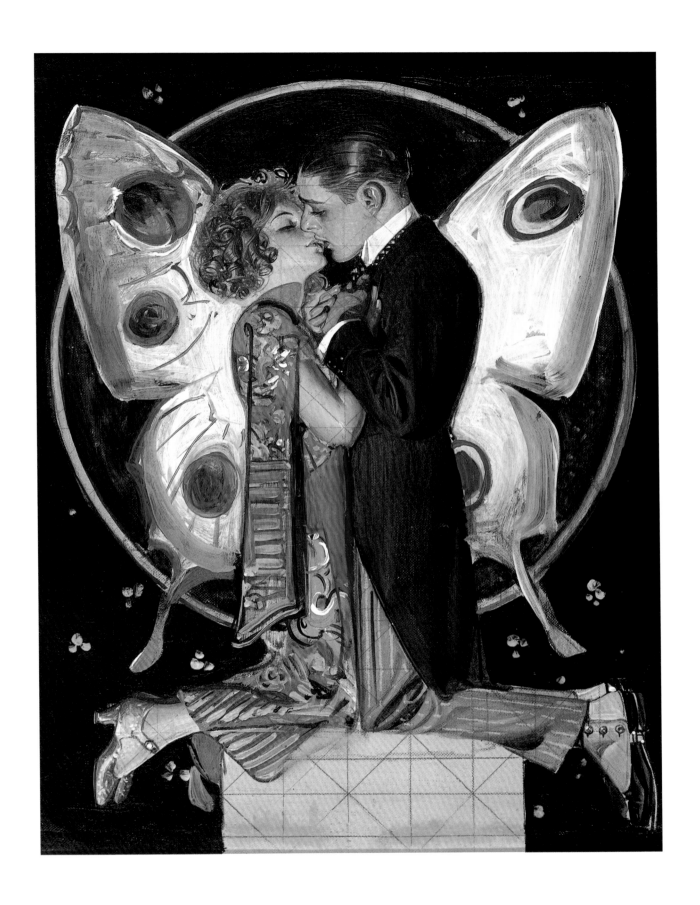

PHYLLIS FREDERIC (1906–CIRCA 1991)

Model

In 1989, a woman called, asking to visit the American Illustrators Gallery to see original J.C. Leyendecker paintings from the Golden Age of American Illustration. Once there, the first thing she did was turn her profile to the side and stand next to the original Leyendecker painting for the 1923 *Post* cover of *Cleopatra*. It was indeed Phyllis Frederic, sixty-four years later.

Phyllis still lived in the tumultuous apartment building on West 54th Street that once housed Joe's studio and Texas Guinan's Club Intime. Her father, William Frederic (1861–1931), had been a famous theatrical and silent screen star; her mother, Helene, as well as various aunts, siblings, and other relatives were all on the silent screen. In short, they were a lesser-known Barrymore-like family. William Frederic, also known as "Pops," had a command presence, which made him a great model in his later years. He appeared in dozens of Norman Rockwell paintings, the most memorable of which was his image as Santa. Phyllis also sat for Rockwell, and her dog Spot was a favorite model for both Rockwell and Leyendecker as well.

Phyllis passed Joe's studio almost daily on her way

Cleopatra. 1923. Oil on canvas, 24³/₄ x 18³/₈". Signed lower right. Reproduced: *Saturday Evening Post*, October 6, 1923, cover

to meet her father at Rockwell's studio. A true beauty, she soon caught Joe's eye. Seeking more modeling work, Pops and his daughter dropped in on J.C. Leyendecker one day in 1922. After talking at some length both were hired on the spot. Spot was thrown in with the package and became popular fodder for comedic spice in Joe's works thereafter, often appearing without Pops or Phyllis.

Phyllis worked for Leyendecker until 1932. She recalled being portrayed as the redhead in *Couple Descending Staircase* (see page 54), along with the actor Brian Donlevy. Because Donlevy was too short for the pose, Beach added orange crates to raise him to the right height on the "staircase."

Phyllis Frederic, c. 1914

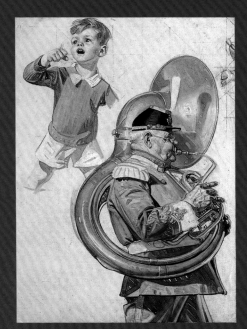

Marching Brass Band (study). 1933. Oil on canvas, 17³/₄ x 12". Unsigned. "Pops" Frederic posed as the tuba player

During this period, Joe was undergoing personal upheavals. Being in the public eye—successful, a star—he worried that rumors of his sexual orientation would damage his reputation and came to think it would be prudent to hide behind a "beard." The striking sixteen year-old Phyllis could be that beard. There is also some speculation that Joe may have been trying to lend more support to Frank, now ailing and increasingly distraught, by leaving Beach and changing his own life's direction with an arranged marriage.

To that end, a few months after they began working together, Joe unabashedly asked Pops for Phyllis's hand in marriage, attaching a business plan to the proposal. Pops, recognizing the "problems," brusquely rejected the idea, saying that the age difference was too great and that if Joe really thought about it, he would recognize what a "grave error" he would be making. Phyllis herself only learned of Joe's proposal at the age of sixty-five.

Phyllis contrasted the different working styles of America's two most famous illustrators: "Rockwell took photographs of me and my father. Rockwell would paint a picture later and you would not even know that he used you for the painting. After my father died, Rockwell used pictures of him for years beyond.... It

sometimes hurt my mother to recognize father, seeing him appear after he had passed." As for Leyendecker, "I never saw any paintings by Leyendecker from photographs.... We just kept posing, like it or not. J.C. Leyendecker had Beach go to the library to research photographs of items he would use as props in his paintings. He never used photos of me, but did lots of sketches of what he called my brain. Mr. Leyendecker often asked me questions while I modeled. I once told him a story my mother told me, that when I was nine, I talked in my sleep in languages, Romance languages, and he joked with me about that all the time."

The last time we interviewed Phyllis was in March 1990.

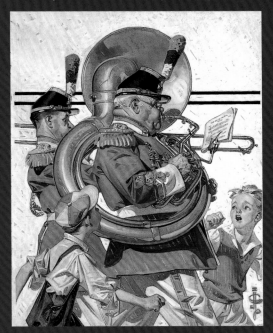

Marching Brass Band. 1933. Oil on canvas, 31 x 24". Monogrammed lower right. Reproduced: *Saturday Evening Post*, July 1, 1933, cover

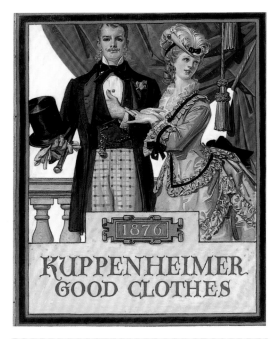

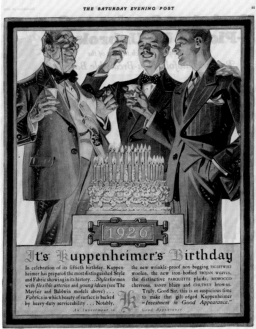

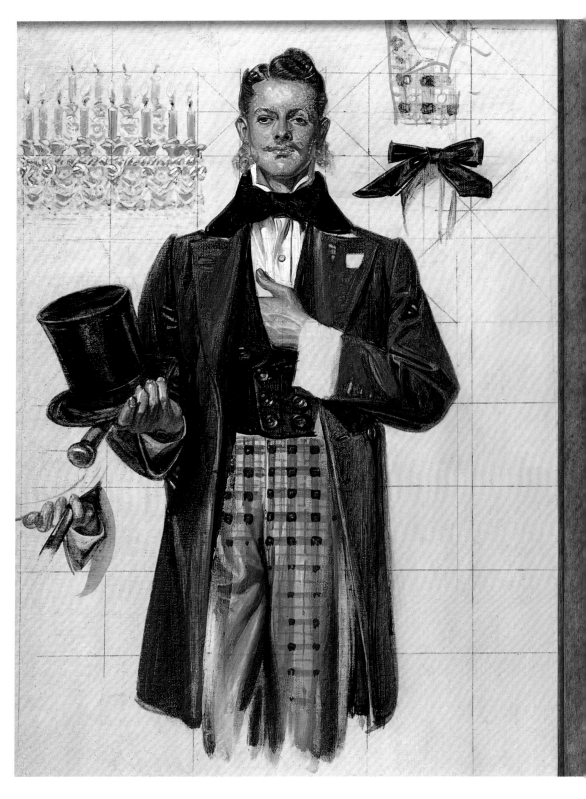

TOP: *Kuppenheimer Good Clothes 1876*. 1926. Oil on canvas, 26 x 20". House of Kuppenheimer advertisement. Reproduced: *Saturday Evening Post*, September 18, 1926

ABOVE: *Kuppenheimer Good Clothes 1926*. 1926. Kuppenheimer advertisement. Reproduced: *Saturday Evening Post*, September 18, 1926

Kuppenheimer's Good Clothes (Cut Yourself a Piece of Cake. It's Kuppenheimer's Birthday) (study). 1926. Oil on canvas, diptych, a: 18 x 12½"; b: 18 x 20". Unsigned. Study for House of Kuppenheimer advertisement

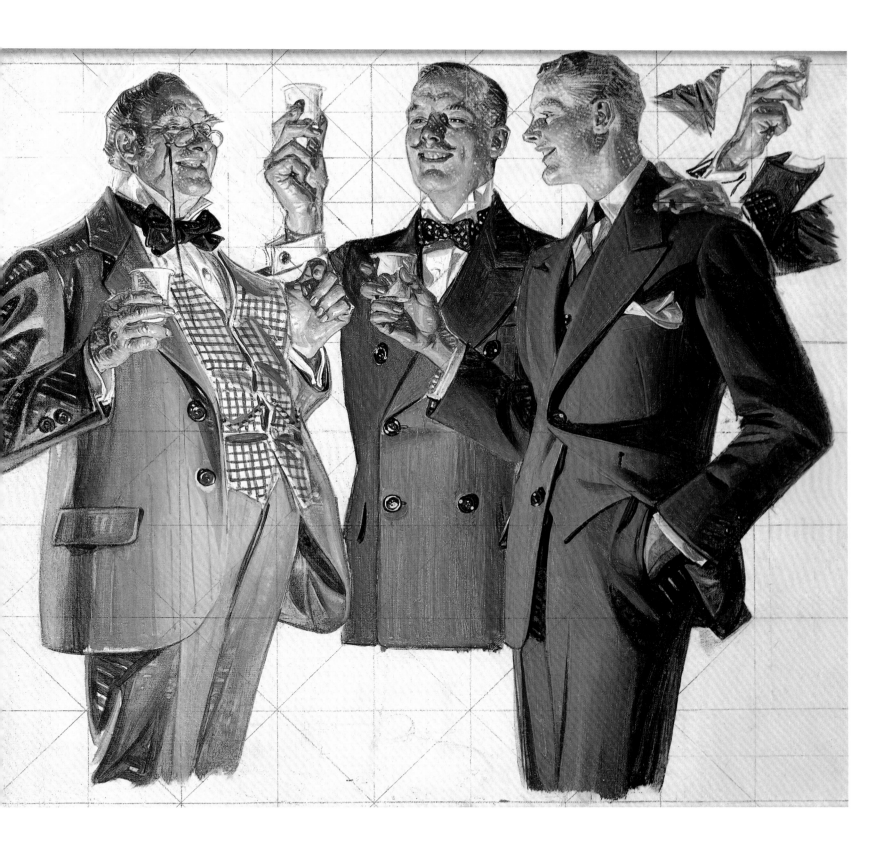

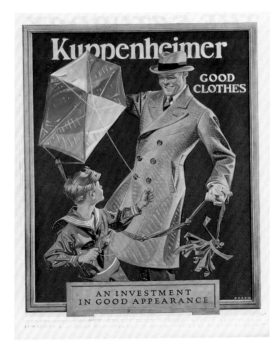

ABOVE: Kuppenheimer Advertisement. Reproduced: *Saturday Evening Post*, March 25, 1922

RIGHT: *Kuppenheimer Good Clothes—Kite Flying* (study). 1922. Oil on canvas, 21 x 13". Study for House of Kuppenheimer advertisement

OPPOSITE AND OVERLEAF: *Saturday Evening Post* cover art

OPPOSITE, clockwise from above left: *Children under the Mistletoe.* 1908. Oil on canvas, 23 x 19". Signed lower right. Reproduced: December 26, 1908. *Yuletide—The Kiss under the Mistletoe.* 1933. Oil on canvas, 30¼ x 25". Signed lower right. Reproduced: December 23, 1933. *Christmas Prayers.* 1921. Oil on canvas, 27½ x 19½". Monogrammed lower right. Reproduced: December 24, 1921. *Twas the Night Before Christmas, 1936.* 1936. Oil on canvas, 31¼ x 24". Signed lower right. Reproduced: December 26, 1936. *Santa Loves You.* 1925. Oil on canvas, 28 x 21". Monogrammed lower right. Reproduced: December 26, 1925

PAGE 68, clockwise from above left: *God Rest Ye Merrie Gentlemen.* 1932. Oil on canvas, 32½ x 24¼". Signed lower right. Reproduced: December 24, 1932. *Holy Night.* December 29, 1934. Oil on canvas, 32 x 24". Monogrammed lower right. Reproduced: December 29, 1934. *Good Boy.* 1915. Oil on canvas, 26 x 22". Signed lower right. Reproduced: December 11, 1915. *Yule.* 1931. Oil on canvas, 30¼ x 22¼". Monogrammed lower right. Reproduced: December 26, 1931

PAGE 69, *Easter (18th Century Frenchman with Poodle).* Monogrammed lower right. April 19, 1930. Printed magazine cover

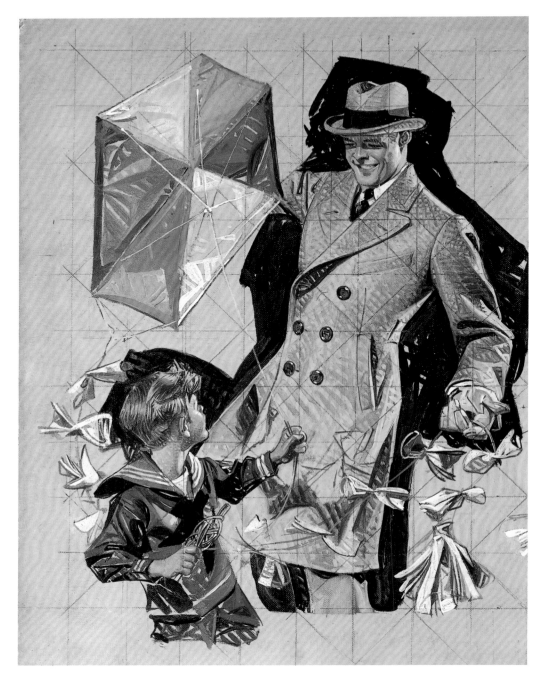

When a sketch particularly suited him, Leyendecker drew a pencil grid on the final canvas and then enlarged it to the final size so that the change of scale did not alter the concept or the strength of the image. Leyendecker referred to this process as a "picture puzzle" due to the fact that he would assemble the sketches with alternative poses and compile them as an aggregated composite, the diametric opposite of artist Chuck Close today. Such a compilation enabled Joe to eliminate unessential elements, clarify the graphic layout, and fulfill his notion of what was required by his commission.

 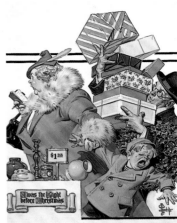

As for brushes, "As a rule I start work with a round or flat sable using a thin wash with turps as a medium. Keep shadows very transparent and as the work progresses apply the paint more thickly on lighted areas adding some poppy or linseed oil if necessary, and using a larger flatter brush for the heavier paint. . . . When the work is dry, apply a quick-drying retouching varnish either with a brush or an atomizer . . . try and avoid photography, if possible."[10]

J.C. Leyendecker created some of our most beloved and endearing symbols, iconic images that set the style and tone for entire generations of Americans. From the Age of Opulence, through Art Deco and the Age of Style, Joe Leyendecker remained steadfastly true to his view of the world. The power of his images is such that many of them reign today, part of our everyday life. They pique the imagination for all ages and have spread the world over.

In a widely supported editorial in 1903, *The Saturday Evening Post* called for a revamping of the national holidays, lamenting that although there were thirty holidays on the calendar, only five received any general observance. "We have on Christmas the opportunity for love and charity, at Thanksgiving the occasion for gratitude, on Election Day the right of self-government, on the Fourth of July the display of patriotism." Joe took these words to heart. Not only did he create for those special days images that came to symbolize the holiday itself, his depictions actually changed the way America celebrated. Thus began a tradition at the magazine. At first Joe asked for the holiday issues, but later the art editor automatically came to him with those assignments. The public came to expect the Leyendecker images, and the magazine thrived. So popular were Joe's holiday covers that *Post* subscriptions increased with each one; by 1913, circulation had risen to two million copies a week, making it the most popular magazine in the world. It did not elude Joe that the huge response his

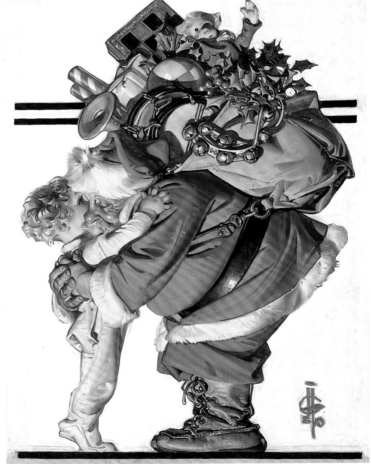

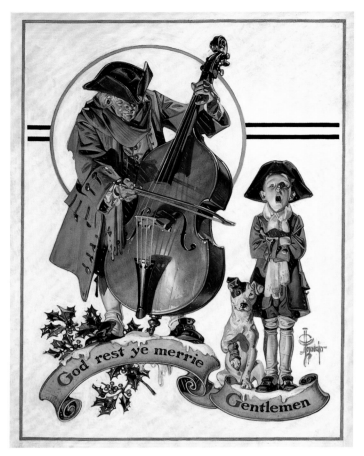

God rest ye merrie Gentlemen

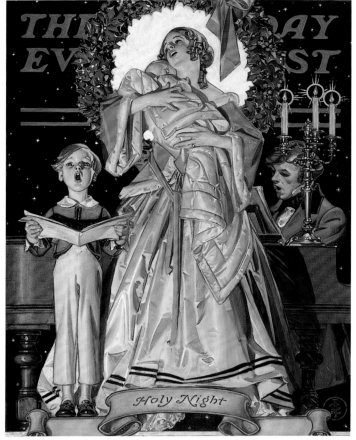

Holy Night

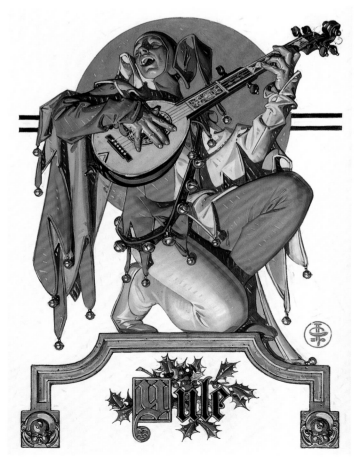

Yule

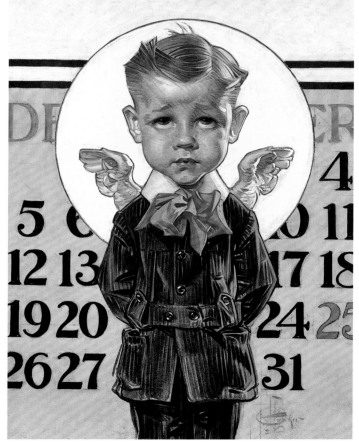

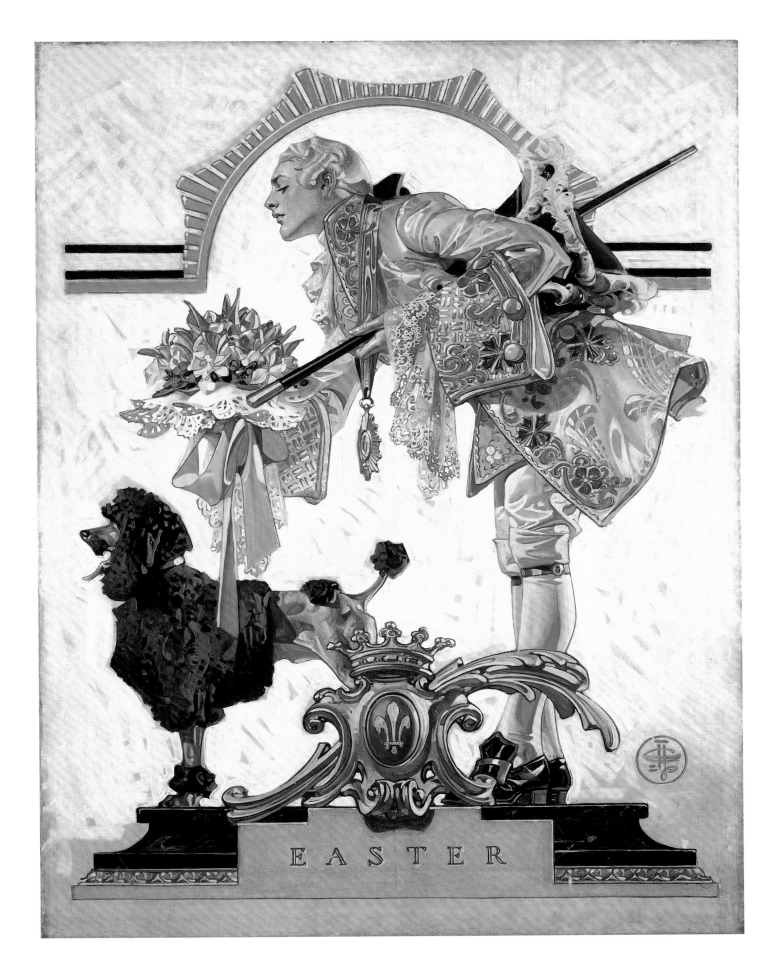

EASTER

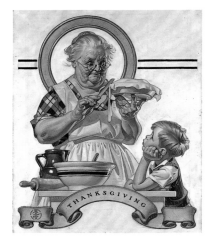
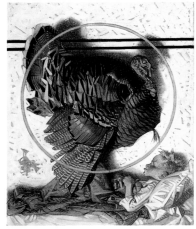
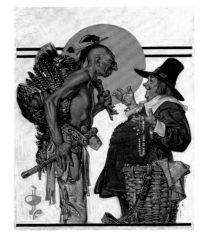
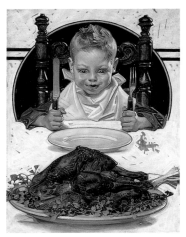
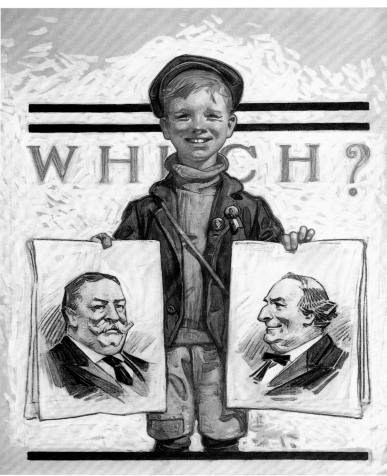
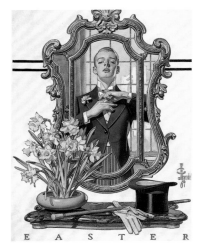
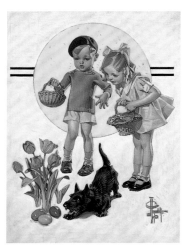

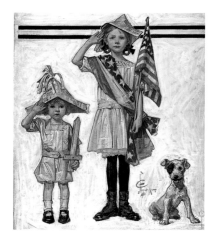
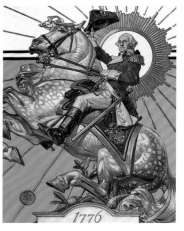

An assortment of *Saturday Evening Post* holiday cover art. Left to right, from top: *Thanksgiving 1935*. 1935. Oil on canvas, 32 x 24". Monogrammed lower left. Reproduced: November 23, 1935. *Thanksgiving—Boy Dreaming of Turkey*. 1917. Oil on canvas, 24¼ x 19". Signed lower left. Reproduced: November 24, 1917. *Thanksgiving—Indian Bartering with Pilgrim*. 1923. Oil on canvas, 26 x 20". Monogrammed lower left. Reproduced: December 1, 1923. *Ready for Thanksgiving Feast*. 1919. Oil on canvas, 24 x 18". Signed center right. Reproduced: November 29, 1919. *Which?* 1908. Oil on canvas, 24 x 20". Signed lower right. Reproduced: October 31, 1908. *Easter (Man in Mirror)*. Oil on canvas, 30 x 24". Signed lower right. Reproduced: April 11, 1936. *Easter Egg Hunt*. 1933. Oil on canvas, 32 x 24". Signed lower right. Reproduced: April 15, 1933. *Easter Bonnet*. 1921. Oil on canvas, 25½ x 18½". Monogrammed lower right. Reproduced: March 26, 1921. *Easter—Girl with Bonnet*. 1910. Oil on canvas, 22 x 18". Signed lower right. Reproduced: March 26, 1910. *4th of July*. 1913. Oil on canvas, 30 x 22". Signed lower right. Reproduced: July 5, 1913. *George Washington*. 1927. Oil on canvas, 28½ x 21½". Monogrammed lower left. Reproduced: July 2, 1927

images received was at least in part due to his having chosen a specific symbol for each holiday, enabling his public to focus on a single comprehensible theme.

Many of J.C. Leyendecker's concepts (a baby for the New Year, flowers for Mother's Day) have lasted well beyond the demise of the *Post* and remain iconic images today. His most famous figure, the Arrow Collar Man, virtually created the concept of "branding." He took branding further when his images created a demand for an entire industry: advertising.

THE ART OF ADVERTISING IN A PRODUCT-ORIENTED SOCIETY

The era between 1920 and 1930 became the epitome for advertising illustration and for illustration as art, advertising as art. Almost all companies engaged in advertising, though early on the norm was to emphasize the consumer more than the product. New professions had emerged and were maturing; advertising agencies blossomed into quasi-professional business corporations. Their executives, creative directors, and marketing managers were all-pervasive. The best-known gathering of such talent was in New York on Madison Avenue; the address itself became synonymous with "advertising." Money flowed, ideas blossomed, until Madison Avenue felt that it was in control of the nation's conscience and the very direction of our country. Advertising executives assumed that they could provoke whole new "crazes" and fashions—and they did. Advertisers, their consultants, and their illustrators were missionaries carrying forth messages of faith to our people. The most influential amongst them all was J.C. Leyendecker.

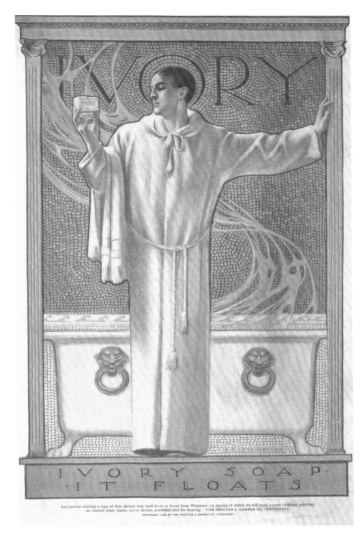

Ivory Soap. 1900. Printed advertisement

One of the greatest strengths of Leyendecker's style was his uncanny ability to focus on a single part of a subject, for example a part of the anatomy, highlight it, and make it reflect like a facet of a jewel. This was what advertisers and marketing directors sought from illustration; a sole focus. An illustrator wants to gently guide his audience's eyes directly to the subject at hand, be it a supple satin shirt draped over a gentleman's muscular chest, an elegant uniform fitted onto the chiseled frame of a handsome, argyle-sock-clad bagpiper—or a gentle soul in a silk robe, standing in a bathroom with a semi-obvious erection, holding up a bar of soap. The viewer's eye skipped all over but landed on the small bar of soap—the advertisement worked (although perhaps the gay community had a good laugh en route to purchasing a dozen Ivory Soap bars, for their eyes went elsewhere). A product-oriented society was born.

As early as just after the turn of the century, Leyendecker was already changing the course of advertising. Leyendecker was able to discern trends and advertisers' needs for satiating customers' demands. The times were evolving quickly from Victorian into

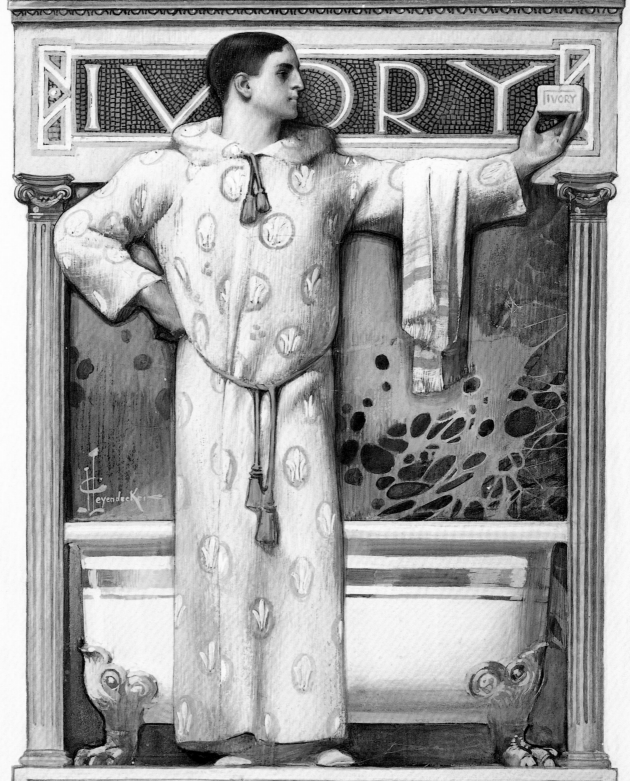

modern. The Luna Park opened at Coney Island, cattle shows
and county fairs were taking place countrywide, Palm Beach
boomed, as did the rest of Florida, fashion changes made
dress easier, and new products abounded. Joe exploded his
professional reputation in 1908 with advertisements for
B. Kuppenheimer & Co., and soon thereafter Interwoven
Socks commissioned the now renowned commercial artist
to undertake their advertising thenceforth. His ads for
Kuppenheimer were so successful that within two years later,
the company employed two thousand men and women, hustling
to make suits to meet demand.

Arrow Collar Man · Sex Symbol

In the latter part of the nineteenth century, Victorian styles
dictated a starched, stiff collar be worn by gentlemen. Easier
than cleaning the whole shirt, simply replacing only the
collar was a sensible answer to the all pervasive problem. Cluett, Peabody & Company
manufactured Arrow shirts and collars. In 1905, J.C. Leyendecker lobbied their new
advertising director Charles M. Connolly with an original and innovative concept for
marketing. He proposed creating a unique male symbol for their products: "Not simply
a man, but a manly man, a handsome man . . . an ideal American man." Connolly, already
familiar with Joe's previous Arrow work as well as his famous magazine covers, believed
in Joe's concept to create a "brand." (The word came from cowboys "branding" cattle,

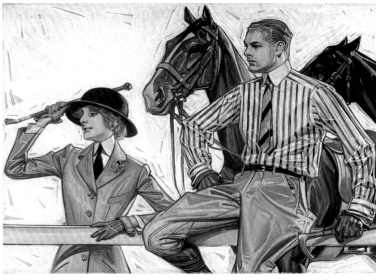

Man and Woman with Horses. 1914. Oil on
canvas, 17½ x 24". Unsigned. Arrow Collar
advertisement. Reproduced: *Literary Digest*,
June 6, 1914

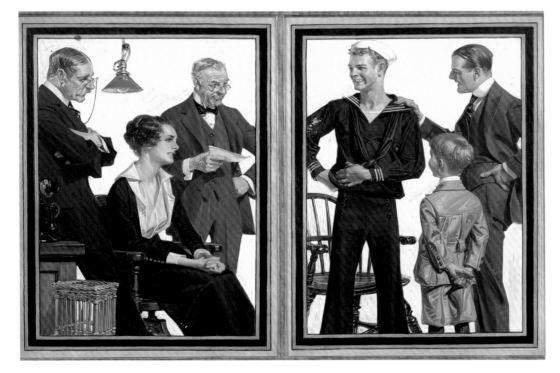

LEFT: *Kuppenheimer Good Clothes (Sailor Fare-
well)*. 1917. Oil on canvas, 27 x 40½". Unsigned.
House of Kuppenheimer advertisement

OPPOSITE: *Ivory Soap It Floats*. 1900. Gouache
on board, 17½ x 12¼". Signed center left.
Ivory Soap advertisement. A more obviously
homoerotic version of the advertisement seen
on page 71

identifying them with a logo, of sorts.) The Arrow advertisements were not only the first major branding effort, they were the first real advertising campaign ever launched.

Cluett, Peabody was already successful; they had thirty competing companies producing over twelve thousand different collar designs to contend with. Leyendecker's illustrations catapulted Arrow to the apex of the industry: the company grew to a 96 percent market share, putting much of their competition out of business. This phenomenal growth gained widespread attention and affected the way everyone thought about marketing. From a logical suggestion by an artist–illustrator, a fledgling advertising industry blossomed into a mighty force, building consumerism into a near religion. In the 1920s, J.C. Leyendecker advertisements for Arrow appeared everywhere, often with decorative frames enclosing his images, depicting various collar styles. The frames were prepared by the celebrated industrial designer Walter D. Teague, using a variety of different elements, something like the current practice of clipart.

Joe wanted to create a matinee idol for Arrow to stir the imagination of a generation, and he did. The future of the American male stepped onto the fashion scene with the birth of the Arrow Collar Man.

Charles Beach, the Arrow Collar Man, was the first male sex symbol and the first sex symbol of either gender in advertising, an idol for the public to fawn over. Women swooned when they saw Beach pictured in advertisements, and men longed to emulate him. He set the standard for elegance, for what a sophisticated gentleman should not only look like, but be. The Arrow Collar Man was the American Spirit personified. A virtual Beau Brummell, he led all the trends for menswear for decades. Few, if any, of Leyendecker's clients or viewing public knew that the Arrow Collar Man was, in fact, the artist's long–time partner.

Although Leyendecker recognized the sensitivities and physical danger of homoerotic depictions in his work, he felt confident enough to carefully and secretly portray them. A certain test was his client's reception to such illustrations. After an immediately positive

TOP: *The Aristocrat of Collars*. 1925. Oil on canvas, 14½ x 78½". Unsigned. Arrow Collar advertisement

ABOVE: *Man with Tie in Circle*. 1919. Oil on canvas, 29½ x 20½". Unsigned. Arrow Collar advertisement. Reproduced: *Literary Digest*, March 1, 1919; *American Magazine*, March 1919; *Saturday Evening Post*, June 7, 1924

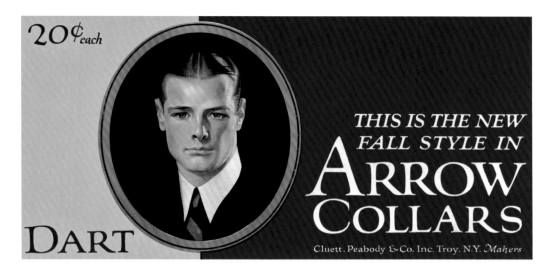

20¢ each

DART

THIS IS THE NEW FALL STYLE IN
ARROW COLLARS

Cluett, Peabody & Co. Inc. Troy, N.Y. *Makers*

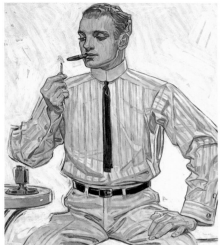

response, Joe was encouraged to insert more such homoerotic imagery, all without the public understanding. The result was subliminal and successful. His clients considered the advertisements "humdingers": they appealed to the real swells, and they worked.

Leyendecker's artworks unfettered the advertising industry from its earliest, conservative, and unimaginative inception to spawn bold marketing campaigns like the Marlboro Man. Paul Stuart, a high-end men's clothing store, still uses a Leyendecker figure as their logo. Advertising continues to play on the use of sex symbols and exploitation of sexual situations and poses, with ambiguous allusions appealing to both mainstream society and to the gay audience. One only has to look at a Ralph Lauren advertisement inside the cover of the *New York Times Sunday Magazine* or in a department store window to see Leyendecker-like images of handsomely attired men staring back in a ghostly echo from an age Joe defined and which prevails yet. Even some of today's styles are emulated and expropriated from Leyendecker advertisements of old.

Arrow, Kuppenheimer, Ivory Soap, and Kellogg's—his paintings of children for Corn Flakes ads were among his sister's favorites—were some of Leyendecker's most loyal clients, but over the years he did advertisements for dozens of other firms as well. Some other national Leyendecker advertising clients included: A. B. Kirschbaum, Amoco, Boy Scouts of America, Carson Pirie & Scott Department Stores, The Chap Book, Chesterfield Cigarettes, Cooper Underwear, Fisk Rubber Company, Cream of Wheat, Franklin Automobile, Hart Schaffner & Marx, Interwoven Socks, Inc., Karo Syrup, Kaynee Company, Overland Automobile, McAvoy Brewing Company, Palmolive Soap, Pan American Coffee, Pierce Arrow Automobile, Procter & Gamble, Right Posture Clothes, Rogers & Company Printers, The Timken Company, U.S.A. Bond Drives, U.S. Fuel Administration, Value First, Willys-Overland Company, U.S. Army, Navy, and Marines.

ABOVE LEFT: *Arrow Collar 20¢ Ticket*. 1924. Printed Arrow Collar advertisement

TOP: *Man with Narrow Tie*. 1910. Oil on canvas, 19 x 16½". Unsigned. Arrow Collar advertisement

ABOVE: *A Portrait of a Man* (study). 1921. Pencil and oil on canvas, 6¼ x 5½". Study for Interwoven Socks advertisement, now used by Paul Stuart

OVERLEAF: *Men Reading*. 1914. Oil on canvas, 19 x 39". Unsigned. Arrow Collar advertisement

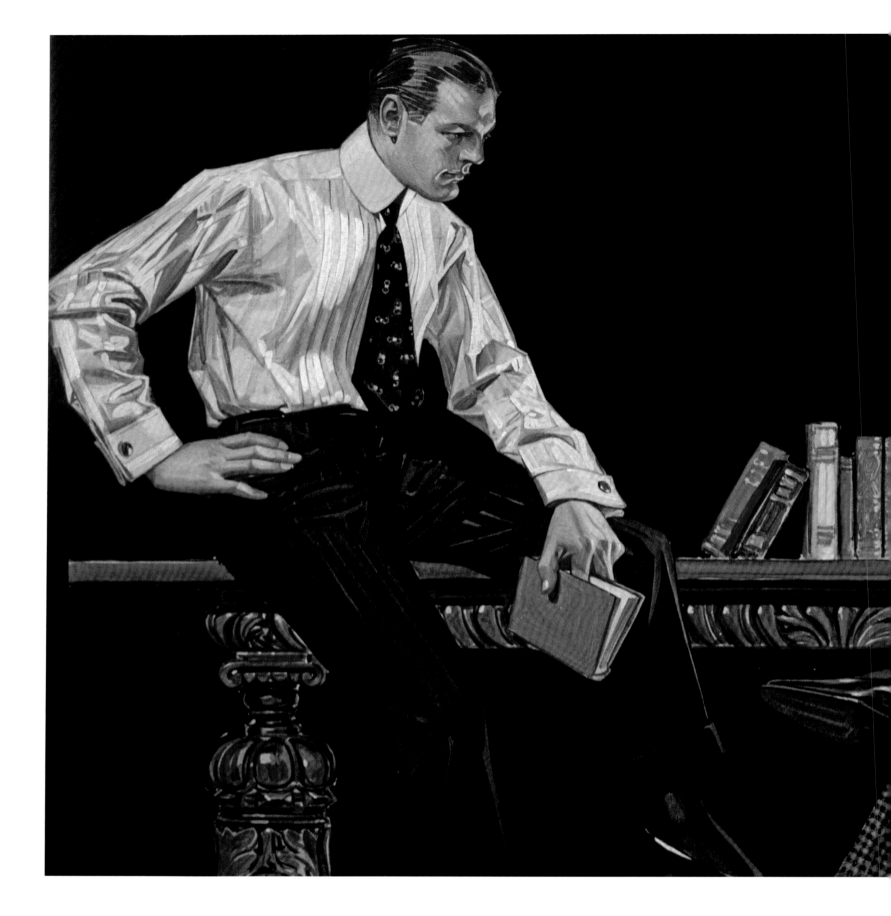

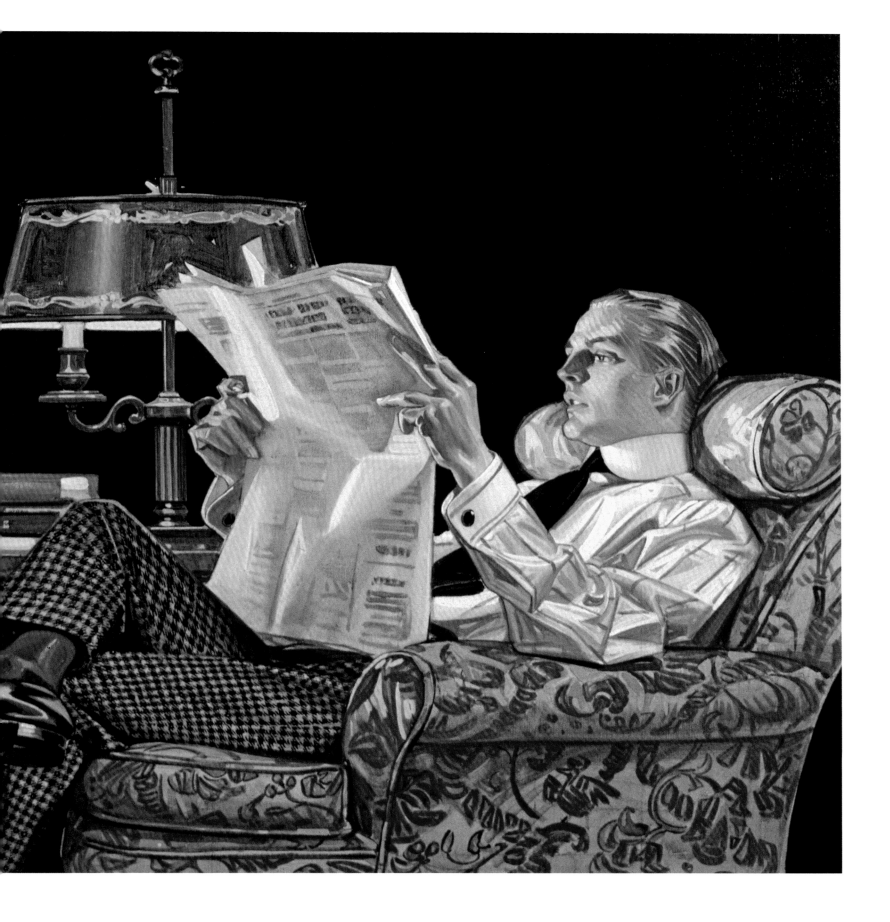

Couple in Boat. 1922. Oil on canvas, 20½ x 29½".
Unsigned. Arrow Collar advertisement featuring
models Charles Beach and Phyllis Frederic

RIGHT: *Golf*. 1922. Oil on canvas, 29 x 20¹/₂". Unsigned. Arrow Collar advertisement

OPPOSITE: *Alden*. 1922. Oil on canvas, 20¹/₂ x 20" oval. Unsigned. Arrow Collar advertisement

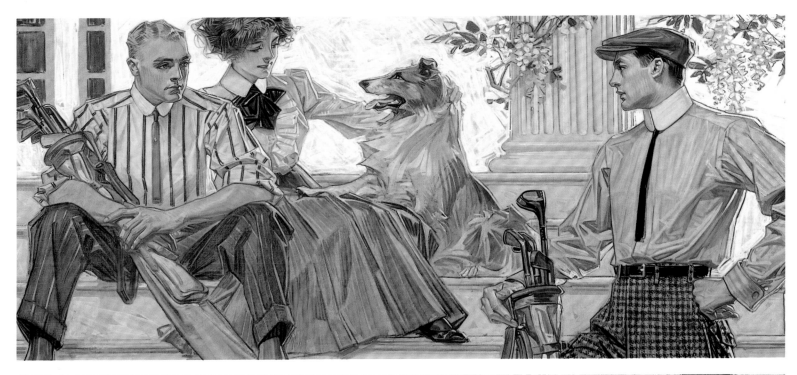

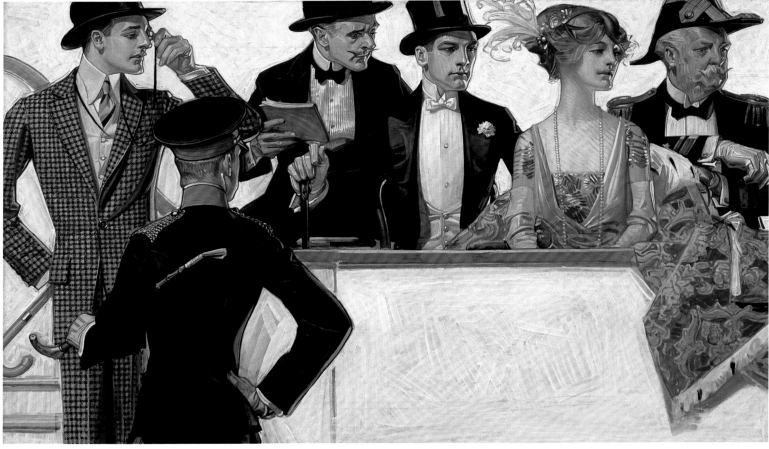

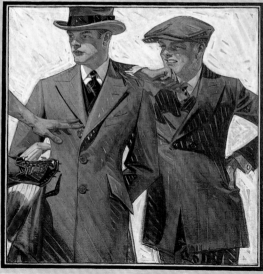

THE PART UNSEEN in clothes is important—linings, canvas, how the clothes are modeled and tailored—don't worry about the part unseen in Kuppenheimer good clothes.

They are the cheapest clothes to buy—not only because they wear longer but they look better through their period of service.

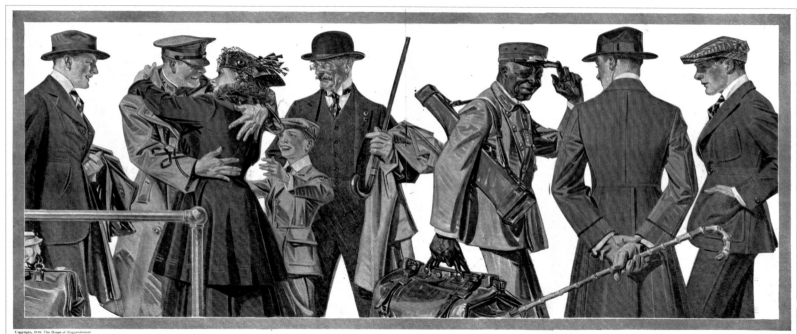

Copyright, 1919. The House of Kuppenheimer

THE MEN who are coming home breathe the spirit of a new order. They represent a new type of young America, new mentally and physically.

The House of Kuppenheimer, alert and responsive to every tendency, has caught this new spirit in a remarkable way.

The styles are for the new American figure, upright posture, slender waist and full chest. Fabrics, patterns and tailoring are such as to again justify the reputation of the best tailored young men's clothes in America.

Our spring Style Book illustrates the point. Write for it.

"A National Clothes Service" The HOUSE OF KUPPENHEIMER *Chicago, U. S. A.*

OPPOSITE, ABOVE: *Arrow Collar Advertisement with Collie.* 1910. Oil on board, 19 x 40". Unsigned

OPPOSITE, BELOW: *In the Stands 2.* 1913. Oil on canvas, 21 x 37½". Unsigned. Arrow Collar advertisement

TOP LEFT: *Kuppenheimer Good Clothes (The Hurdler).* 1920. Oil on canvas, 2 paintings, 23 x 22" each. Unsigned. House of Kuppenheimer advertisement

TOP RIGHT: House of Kuppenheimer advertisement. 1920. Printed page from Kuppenheimer catalogue

ABOVE: House of Kuppenheimer advertisement. Reproduced: *Collier's,* March 8, 1919

OVERLEAF: *S.S. Leviathan.* 1918. Oil on canvas, 28 x 42". Unsigned

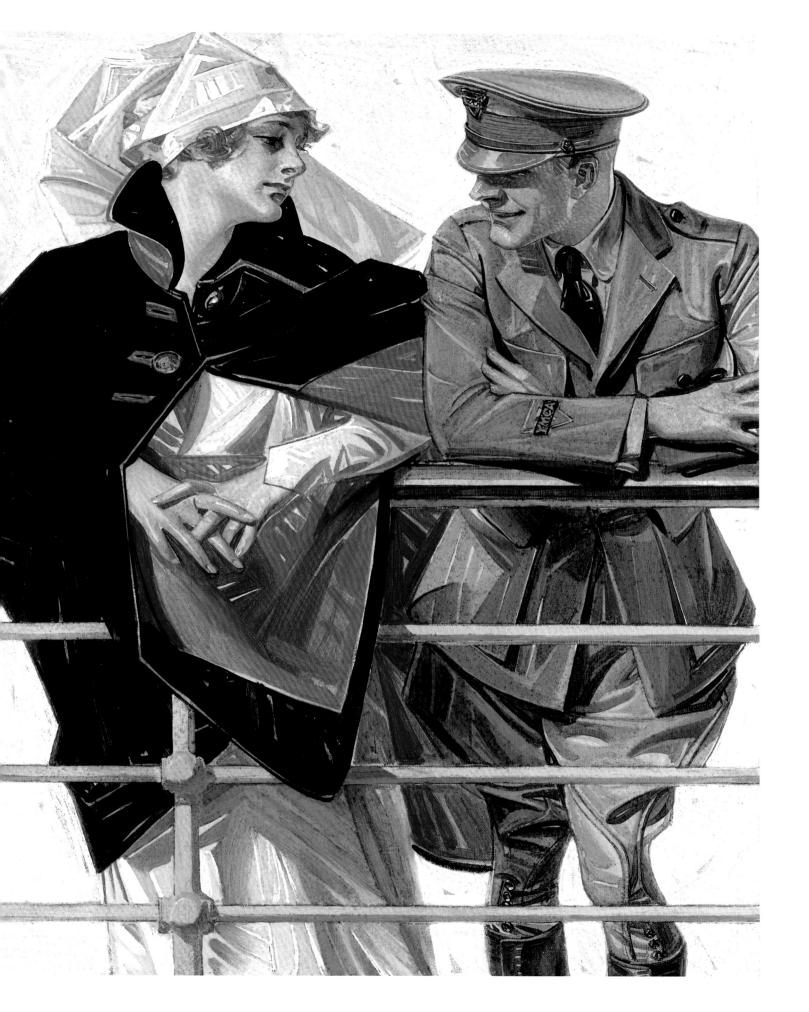

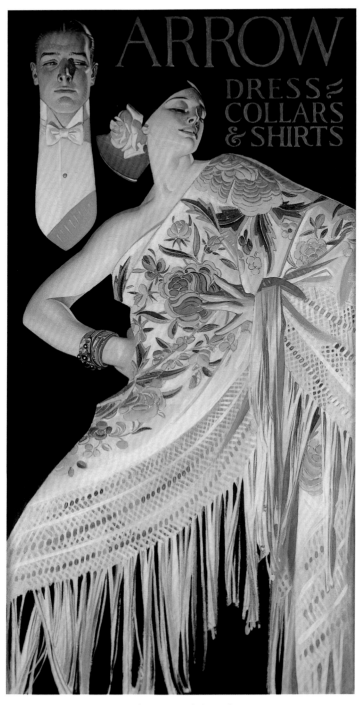

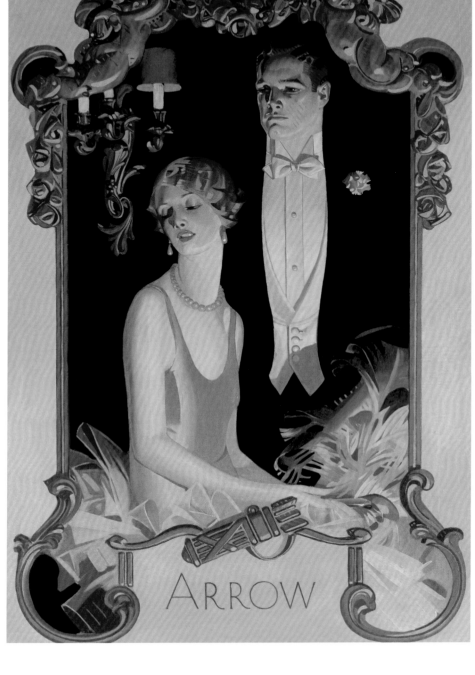

ABOVE LEFT: *Man and Woman with Spanish Shawl.* 1926. Oil on canvas, 51 x 25". Unsigned. Arrow Collar advertisement

ABOVE RIGHT: *Man with Seated Lady.* 1929. Oil on canvas, 51 x 33". Unsigned. Arrow Collar advertisement

OPPOSITE: *Dancing Couple.* 1930. Oil on canvas, 38 x 24". Unsigned. Arrow Collar advertisement Reproduced: *Saturday Evening Post,* November 8, 1930

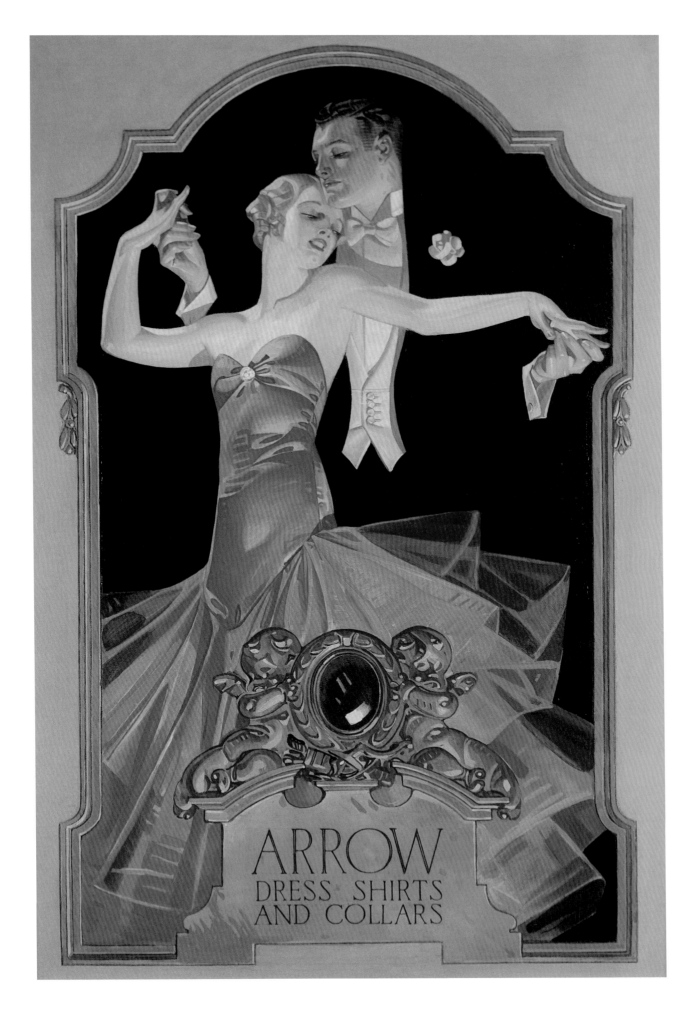

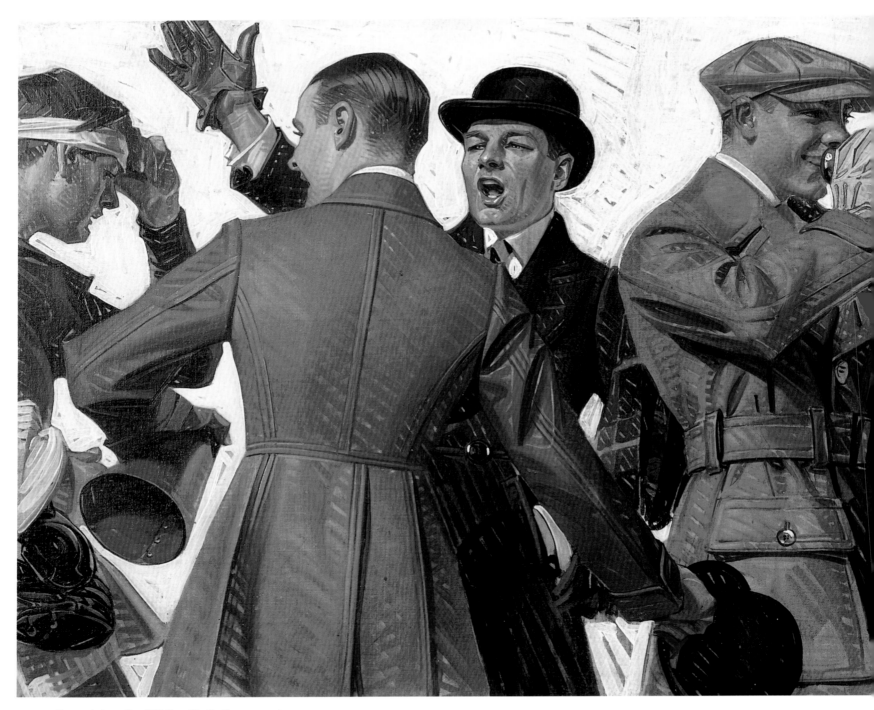

Kuppenheimer Good Clothes (Football Players and Fans). c. 1917. Oil on canvas, 26 x 60". Unsigned. House of Kuppenheimer advertisement

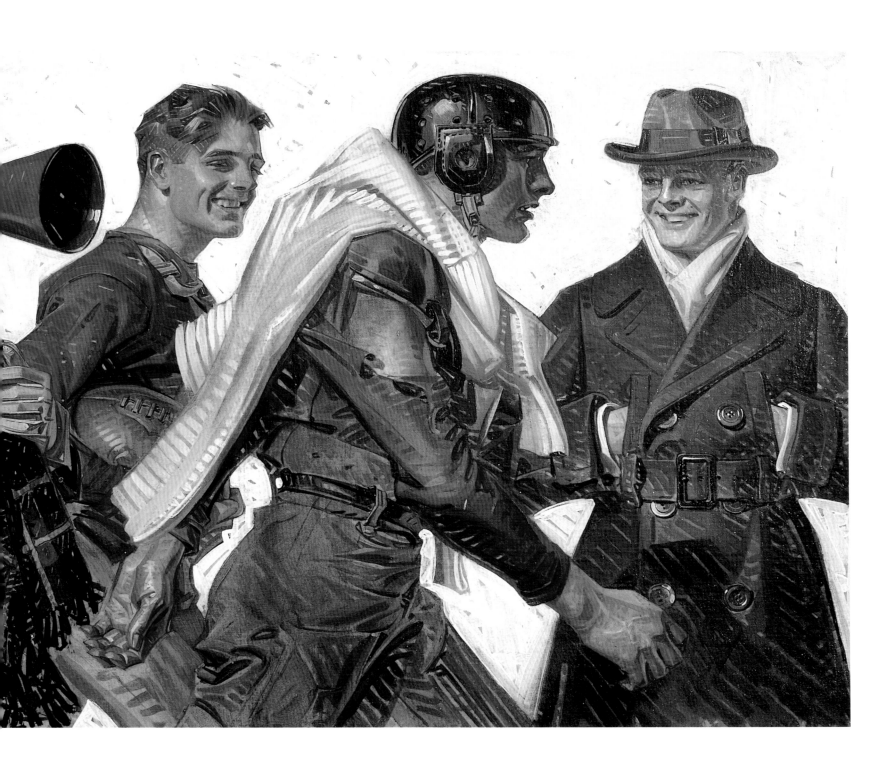

ABOVE: *Matador (Unfold Your True Colors.)*
1940s. Oil on canvas, 21 x 53½". Mallory Hats (?)
advertisement

OPPOSITE: *Matador* (study). 1940s. Oil on canvas,
29¾ x 16". Unsigned. Study for Mallory Hats (?)
advertisement

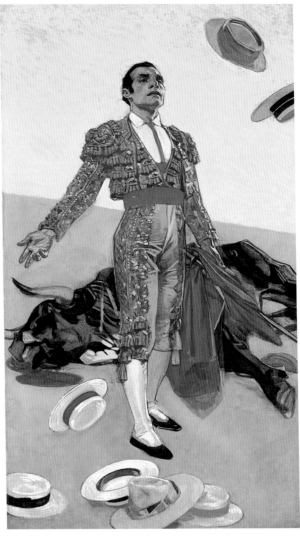

PAGE 92:

ABOVE LEFT: *Kuppenheimer Good Clothes (Man and Jockey)*. 1923. Oil on canvas, 28 x 21". Unsigned. House of Kuppenheimer advertisement. Reproduced: *Saturday Evening Post*, June 14, 1923

ABOVE RIGHT: *Kuppenheimer—The Homecoming*. 1918. Oil on canvas, 28¼ x 42⅜". Unsigned

BELOW: *New Styles for the New Figure*. 1918. Oil on canvas, 22 x 30". Unsigned. House of Kuppenheimer advertisement

PAGE 93: *Kuppenheimer Good Clothes (Wolfhound)*. c. 1925. Oil on board, 26¾ x 20¾". Unsigned. House of Kuppenheimer advertisement

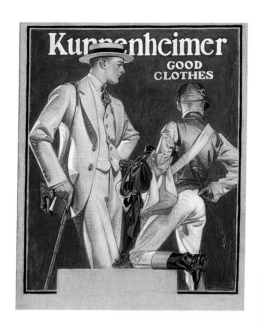

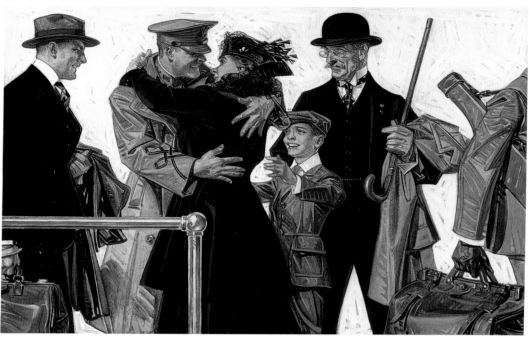

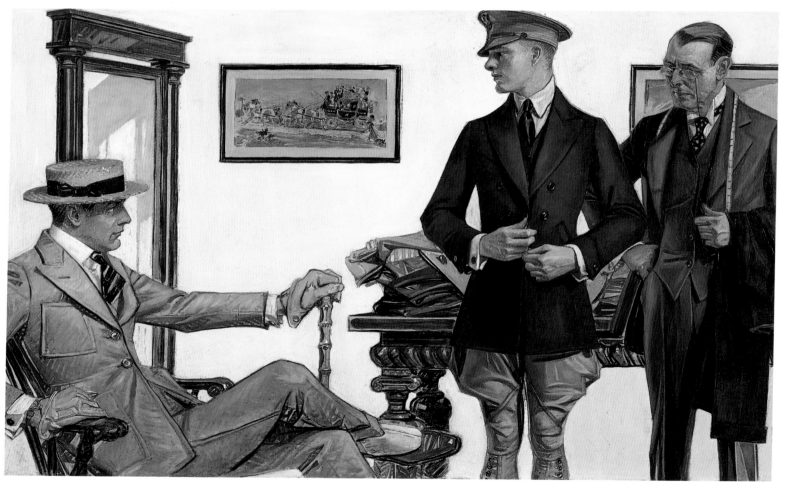

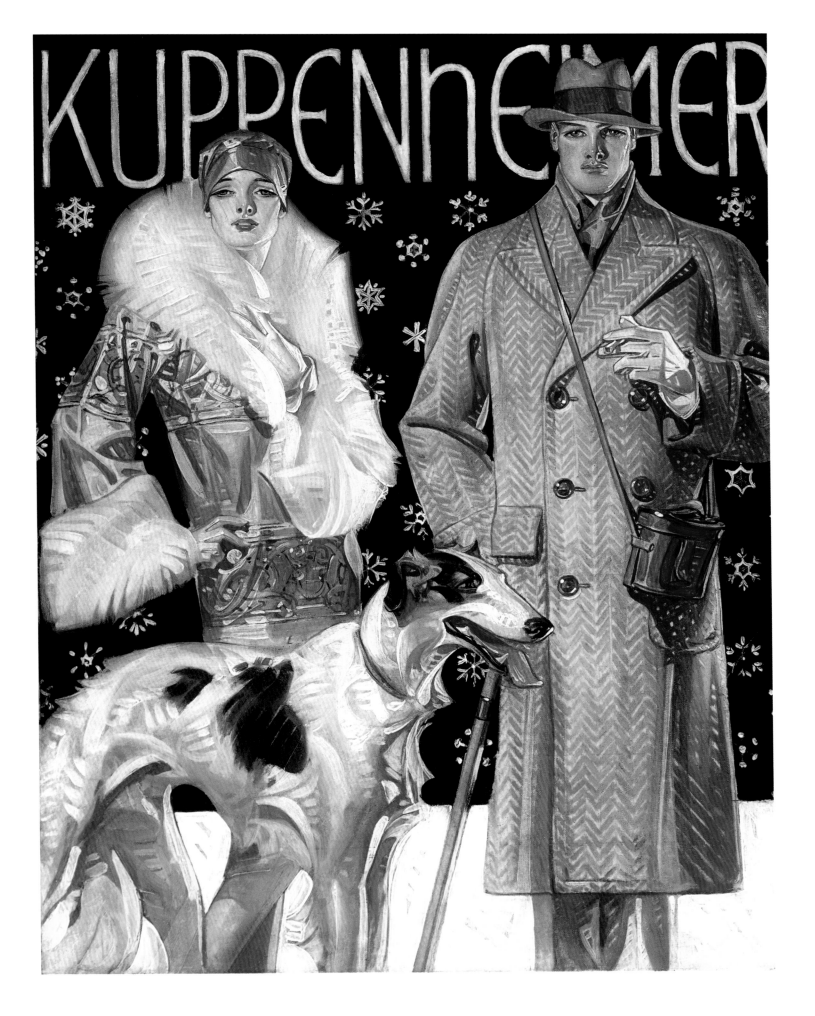

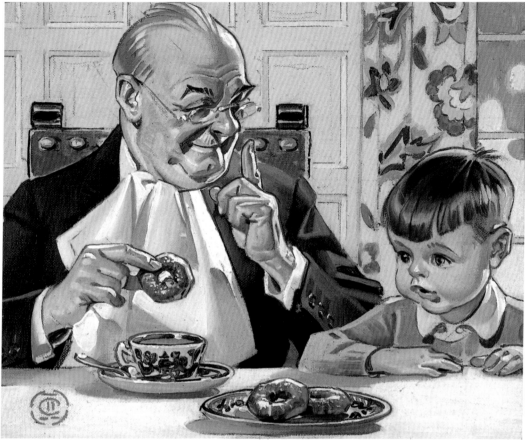

TOP: Printed Pan American Coffee Producers advertisement. Reproduced: *Saturday Evening Post*, October 7, 1940

ABOVE: Printed Pan American Coffee Producers advertisement. Reproduced: *Collier's*, February 22, 1941

RIGHT: *Some Folks Frown on It…But It's a Lot of Fun*. 1940. Oil on canvasboard, 9½ x 11". Monogrammed lower left

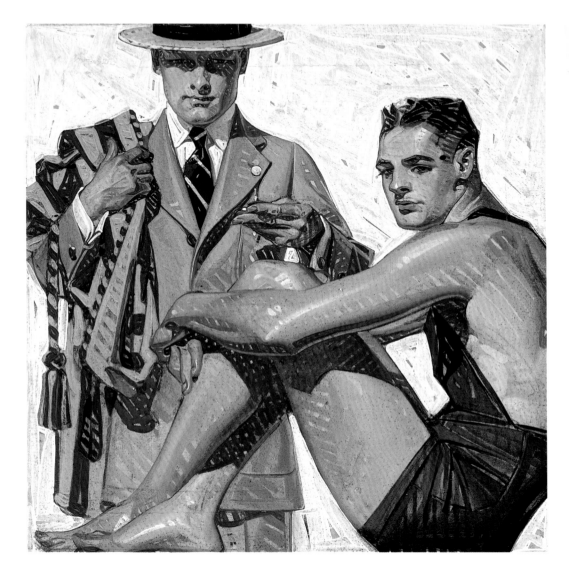

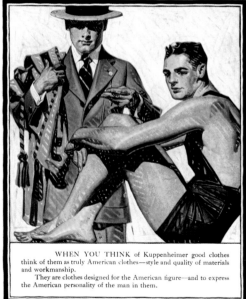

WHEN YOU THINK of Kuppenheimer good clothes think of them as truly American clothes—style and quality of materials and workmanship.

They are clothes designed for the American figure—and to express the American personality of the man in them.

ABOVE: Kuppenheimer advertisement. 1920. Printed page from Kuppenheimer catalogue

LEFT: *Kuppenheimer's Good Clothes (Record Time)*. c. 1920. Oil on canvas, 21½ x 20½". House of Kuppenheimer advertisement

OVERLEAF: *Quality by Kuppenheimer (Mermaid and Handsome Men)*. c. 1930. Oil on canvas, 2 panels, 25 x 19" each. Unsigned. House of Kuppenheimer advertisement

PAGES 98–99: *Two Men on Sofa*. 1912. Oil on canvas, 23 x 38". Unsigned. Arrow Collar advertisement

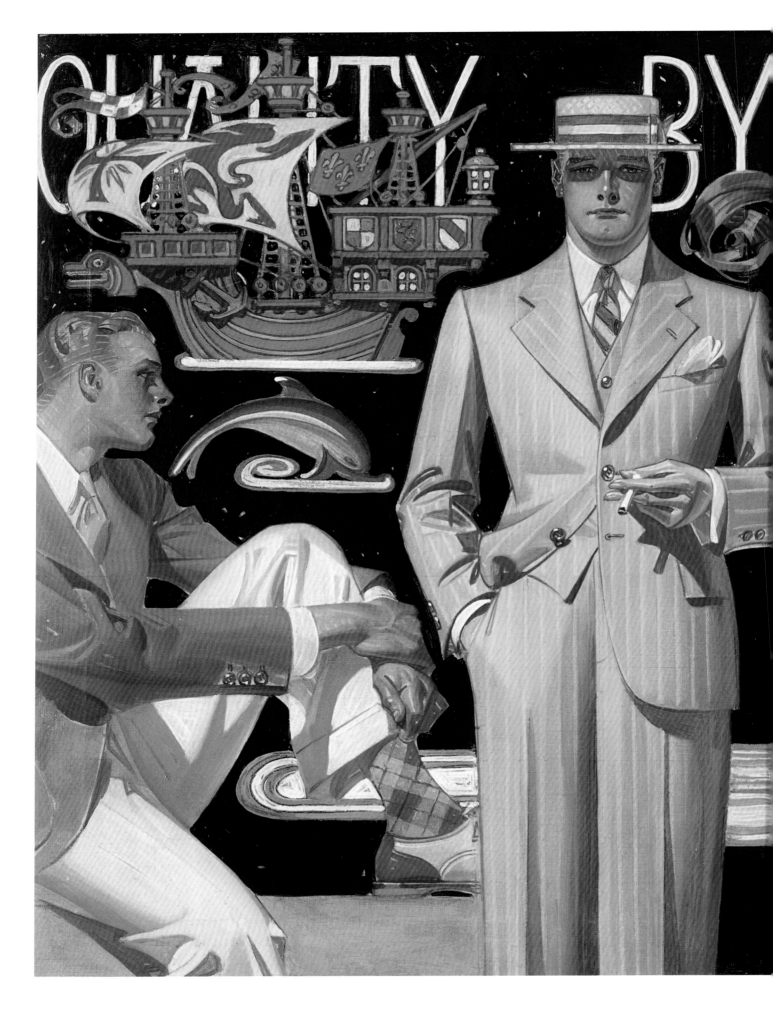

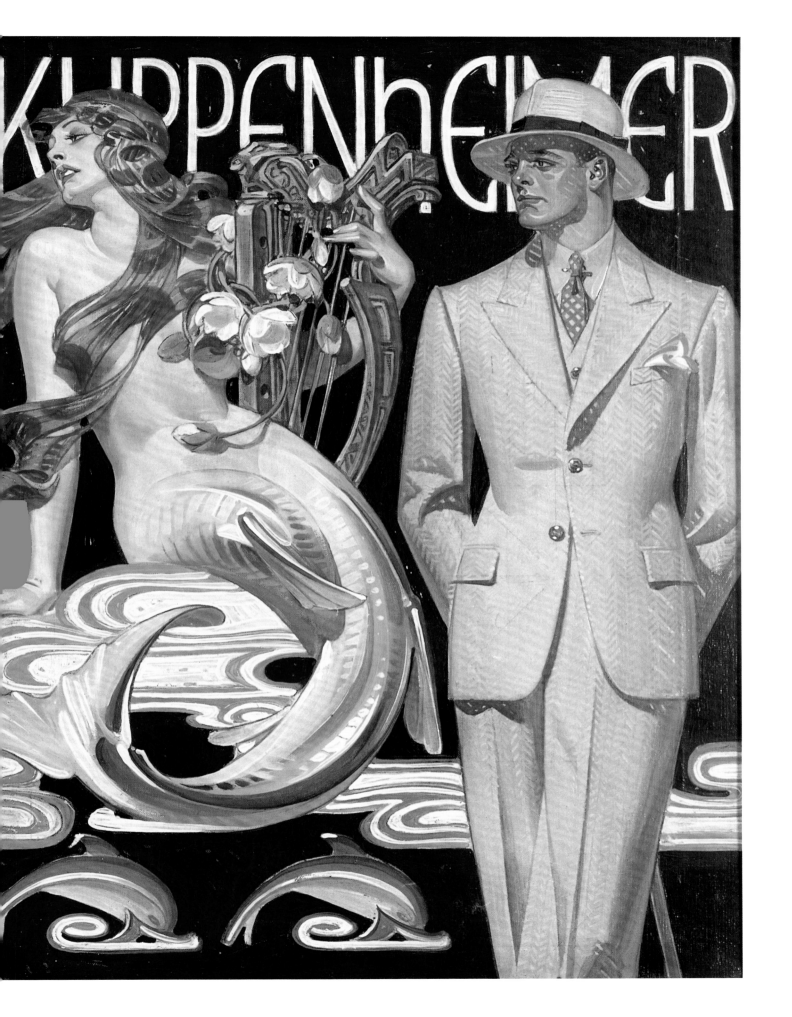

MASTER OF THE MAGAZINE COVER

Between 1900 and 1945, Joe Leyendecker painted like a machine gun. His illustrations graced the covers of the most important national magazines, including *Century Magazine*, *The Chap Book*, *Circle*, *Club-Fellow & Washington Mirror*, *Collier's*, *Delineator Magazine*, *The Inland Printer*, *Interior*, *Judge*, *Ladies Home Journal*, *Leslies*, *Literary Digest*, *McClure's*, *Popular*, *The Saturday Evening Post*, *Scribner's Magazine*, *Success*, *Survey*, *Up to Date*, *Vanity Fair*, *Woman's Home Companion*, *The Woman's Magazine of St. Louis*, and *World's Work*, and from 1945 on, *The American Weekly*.

Of all periodicals, J.C. Leyendecker's most prestigious and significant client was for four decades *The Saturday Evening Post*. Founded in 1821, it claimed descent from the *Pennsylvania Gazette*, first published by Benjamin Franklin in 1728, through Curtis Publishing Company ownership. Cyrus Curtis bought the *Post* for $1,000 in 1897, when it had a circulation of 2,300 subscribers. He later acquired the *Ladies' Home Journal* and eventually built a mighty empire made up of an array of the most successful magazines in several distinct categories. Under the leadership of George Horace Lorimer, its editor from 1899 through 1937, the *Post* hired the best writers available, including Stephen Vincent Benet, James Branch Cabell, Willa Cather, Joseph Conrad, Stephen Crane, Theodore Dreiser, F. Scott Fitzgerald, Bret Harte, O. Henry, Rudyard Kipling, and Jack London.

Circus Corner. 1908. Oil on canvas, 25 x 21½". Unsigned. Reproduced: *Saturday Evening Post,* May 23, 1908, cover

Two years after Curtis bought the *Post*, the magazine also hired the best illustrator, J.C. Leyendecker. He was first commissioned to paint a *Post* cover for the May 1899 issue. Ultimately Leyendecker produced more *Saturday Evening Post* covers (322) than anyone else, even Norman Rockwell (who painted 321 different images for the magazine). Leyendecker worked for the *Post* for forty-four years, ending in 1943, producing one cover per month in some years. He was without a doubt their most coveted property.

To a large extent, Leyendecker covers were the reason for the early success of the *Post*. Most periodicals were sold at newsstands, and the cover images attracted customers, stimulating sales. After Leyendecker's precedent-setting career, Charles Livingston Bull, John Clymer, Steven Dohanos, John Falter, Anton Otto Fisher, Harrison Fisher, James Montgomery Flagg, Charles Dana Gibson, J.F. Kernan, Frederic Remington, Robert Riggs, N.C. Wyeth, and other famous artists went on to make their names with the *Post*. But the best-known of all remained J.C. Leyendecker and Norman Rockwell.

The following pages comprise a range of periodical images, which confirm all said herein regarding this artist's abilities and strengths. All 322 of Leyendecker's *Saturday Evening Post* covers are reproduced, some twice due to their specific importance. Images are arranged chronologically by publication. Some of Leyendecker's iconic images were so groundbreaking they deserve particular attention.

OPPOSITE: J.C. Leyendecker's first *Saturday Evening Post* cover, May 20, 1899

THE SATURDAY EVENING POST

Founded A° D¹ 1728 by Benj. Franklin

Volume 171, No. 47 Philadelphia, May 20, 1899 5 Cents the Copy; $2.50 the Year

THE DREAM WOMAN*

By JOHN LUTHER LONG

With *Pictures* by J. C. Leyendecker

THEY were nursing a handful of coals between them in a hole behind the intrenchments. Kelly looked off toward the sea where the sun would presently rise.

"We'll have some hot work, I expect, as soon as they can make us out," he mused sleepily.

"Yes," answered Gordon absently. He was staring into the little fire.

"Still dreaming?" smiled the older soldier.

Gordon have frankly confessed it.

"The young soldier dreams of before going into battle of a woman."

Kelly spoke so softly that Gordon looked up. But he said nothing.

"Sometimes it is his mother——"

"My mother is dead," said Gordon.

"You should have been a poet—not a soldier."

"All poets are soldiers. They have made war glorious."

"That is why they call you 'Sweet Devil,' I suppose—because of the poetry in your soul and the glory of your sword," gibed Kelly, quite awake now.

But he saw that he had made Gordon uncomfortable.

"Who is the woman?"

Gordon tried to be frigid.

"Oh, don't! Can't you see I want an excuse for talking about—mine? We all have those moments before a battle. And you are the only man I can talk to in that way. I knew from the first that you were an ass like me. That's why I put you on my staff."

Gordon showed his amazement.

"Yes, grizzled, fighting old Kelly!" He, too, looked into the fire a silent moment. "I was to go with Custer to the Little Big Horn. She asked me not to go. I feigned illness. I wish I hadn't. She's dead." He shook himself. "I wouldn't give a hang for a man who doesn't adore some woman. He can fight better—he can do anything better."

"Mine," said Gordon, as if continuing Kelly's mood, "is only a dream. I have never seen her. But she lives, I know, and I shall some day meet her. I have dreamed her just as I would have her. I shall wait for her." Gordon smiled.

·

Kelly reached his hand across the little fire. Another attack of amazement held Gordon an instant. Then he took it.

"This is before the battle. When that comes it will be different with both of us. Now we are men. Then we will both be devils—and not sweet ones, either."

"I don't know," said Gordon. "It is my first——"

"I know," said Kelly. "It may be my last."

The sun shot above the sea with theatrical suddenness. Kelly put the tincups on the fire.

"We'll have some coffee to make courage for us till we are in it. Then we won't need coffee."

The light showed them both covered with the mud and grime of hasty campaigning. Kelly stood up and looked off toward the painted-seeming jungle.

"I think we cleaned that last night."

"I think so," said Gordon.

He, too, stood up—thinking of something else.

From somewhere came the wiry "whew" of a Mauser bullet. Gordon dropped and spilled the coffee.

"Little things like that are useful. They tend to make one think of the very present. Oh!—not hit, are you?"

Gordon's face was white, and he was pressing his chest.

Kelly ripped open his coat, then his shirt. He

*Copyright, 1899, by John Luther Long

smiled a little. But he straightened his face instantly. Gordon reddened furiously. He had caught the smile.

"I've fancied myself hit when I wasn't within a mile of danger," comforted the Colonel.

Guantanamo was Gordon's first experience. He himself was quite uncertain how it would result. He understood his temperament as much and as little as any one else did. He liked his dreams and he hated slaughter. But always the thundering guns, the crackling rifles, the bugling and drumming expanded something within. Perhaps it was then that Gordon was the Sweet Devil. For then he would close his teeth under his little yellow mustache and do whatever the thing within wished. But, after it was over, the devil would go and the sweetness return—and then Gordon was likely to turn priest and nurse to the men he had killed and wounded.

"I hope the Marblehead will stand by to there's to be more of

this. It is not necessary to risk the men against an ambushed foe," mused Kelly. He went a few steps up the hill. Gordon followed. Each had a tincup. The "whew-pap" of a bullet striking made him dodge.

"Too late! After you hear the 'pap' it's all over. Not your call this time," comforted Kelly.

Gordon struck at some of the hardening mud on his trousers. But Kelly saw his blush.

"I dodged myself, you know."

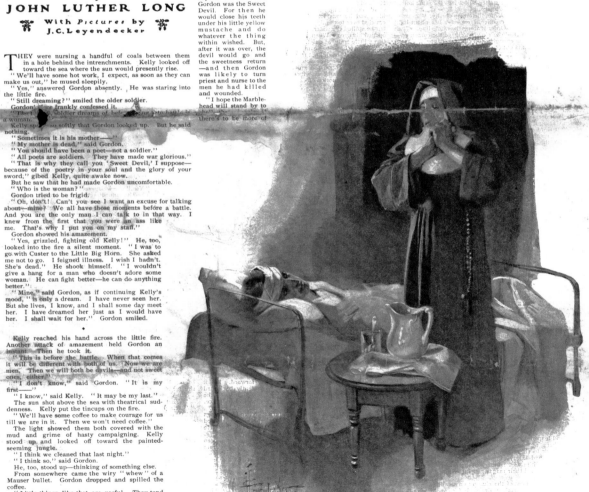

"I KNOW THAT YOU ARE ONLY A DREAM—THAT I AM DREAMING NOW," SAID GORDON

February 7, 1903

May 16, 1903

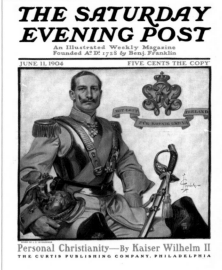

June 11, 1904

July 9, 1904

October 22, 1904

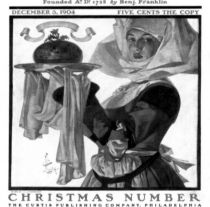

December 3, 1904

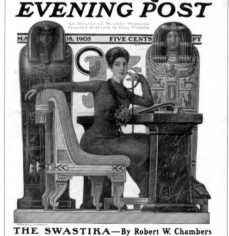

March 18, 1905

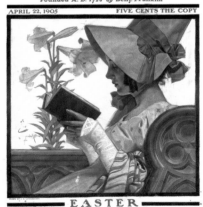

April 22, 1905

June 3, 1905

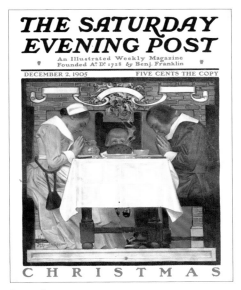

December 2, 1905

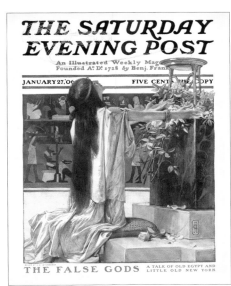

January 27, 1906

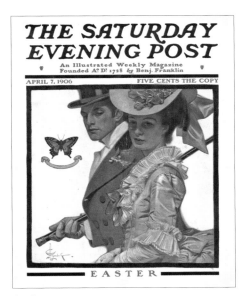

April 7, 1906

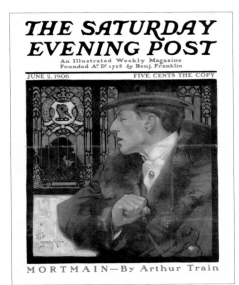

June 2, 1906

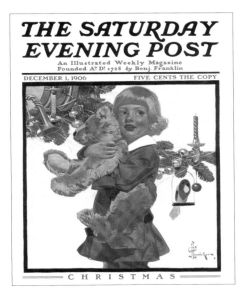

December 1, 1906

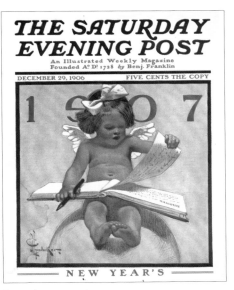

December 29, 1906

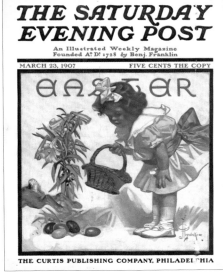

March 23, 1907

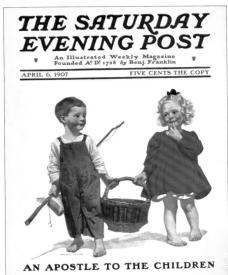

April 6, 1907

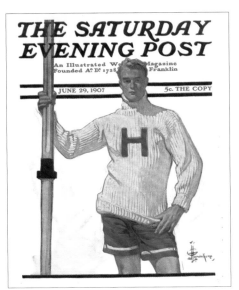

June 29, 1907

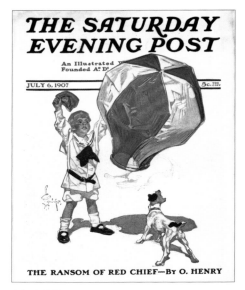

July 6, 1907

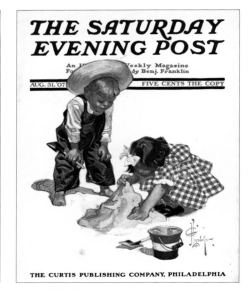

July 20, 1907

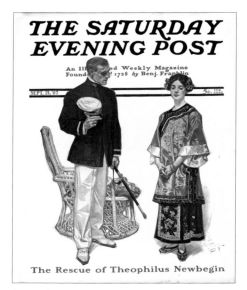

August 31, 1907

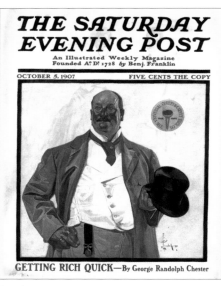

September 21, 1907

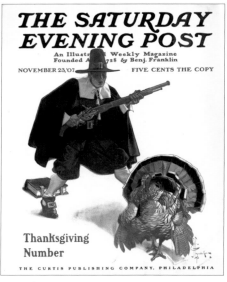

October 5, 1907

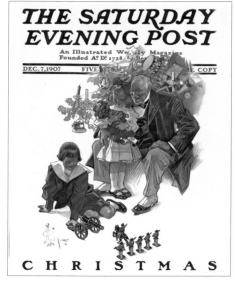

November 23, 1907

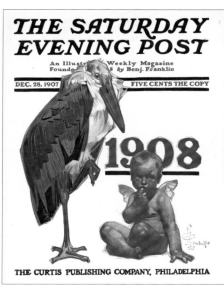

December 7, 1907

December 28, 1907

February 29, 1908

OPPOSITE: *Young Boy, His Dog and a Balloon.* 1907. Oil on canvas, 29³⁄₄ x 21". Signed lower left

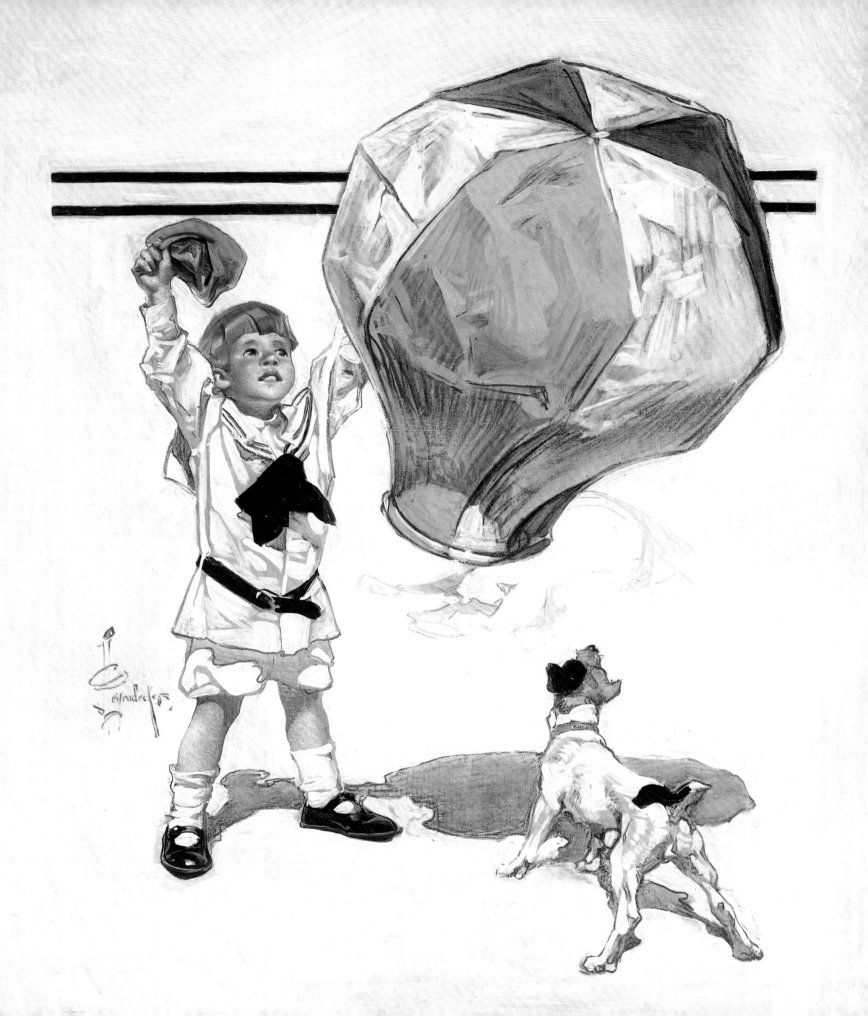

April 4, 1908

April 11, 1908

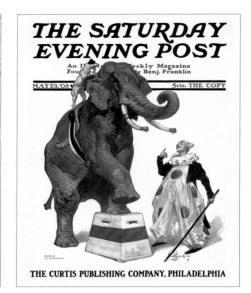

May 23, 1908

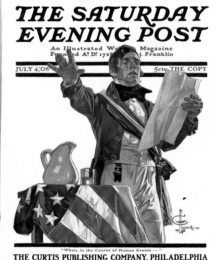

July 4, 1908

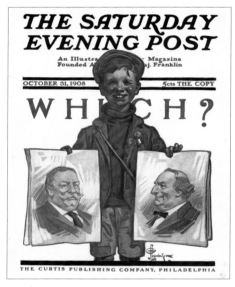

September 12, 1908

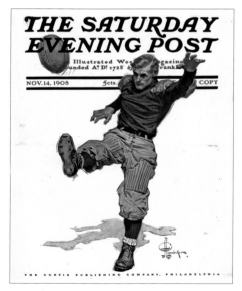

October 31, 1908

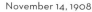

November 14, 1908

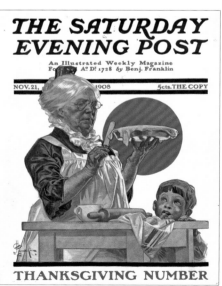

November 21, 1908

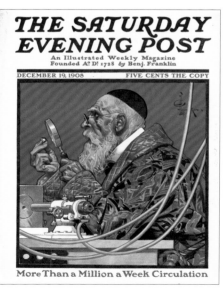

December 19, 1908

OPPOSITE: *The Punter.* 1908. Oil on canvas, 25 x 20". Signed lower right

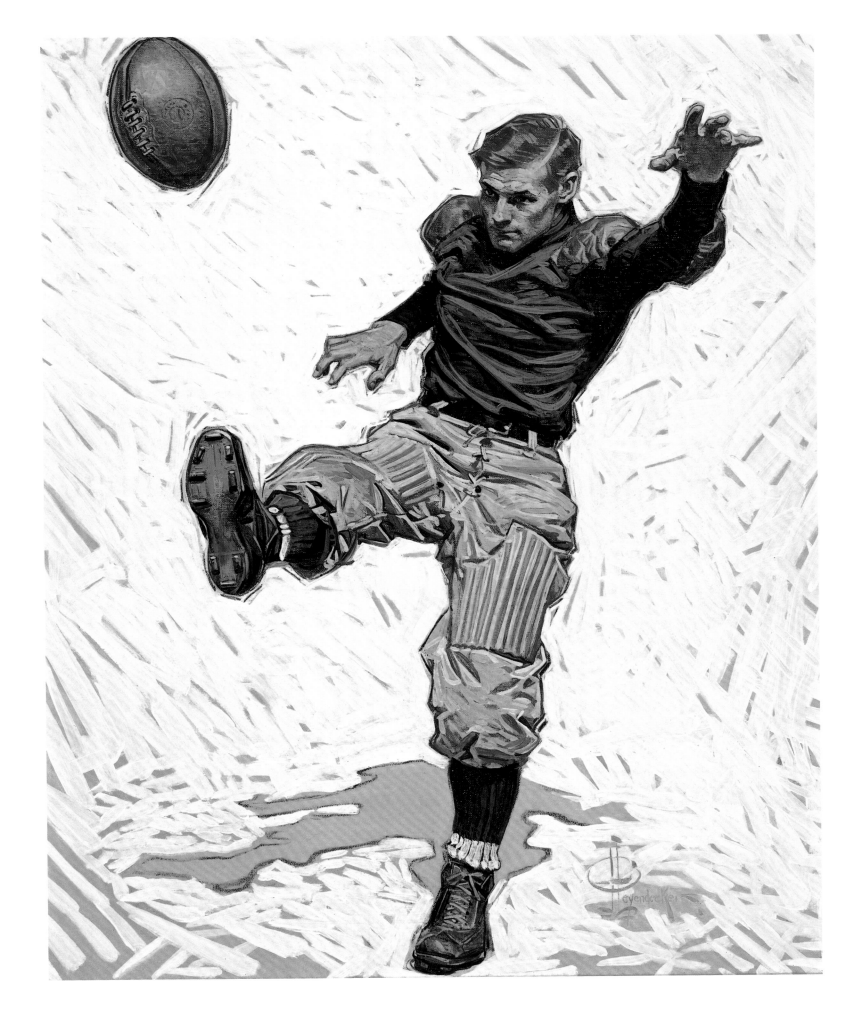

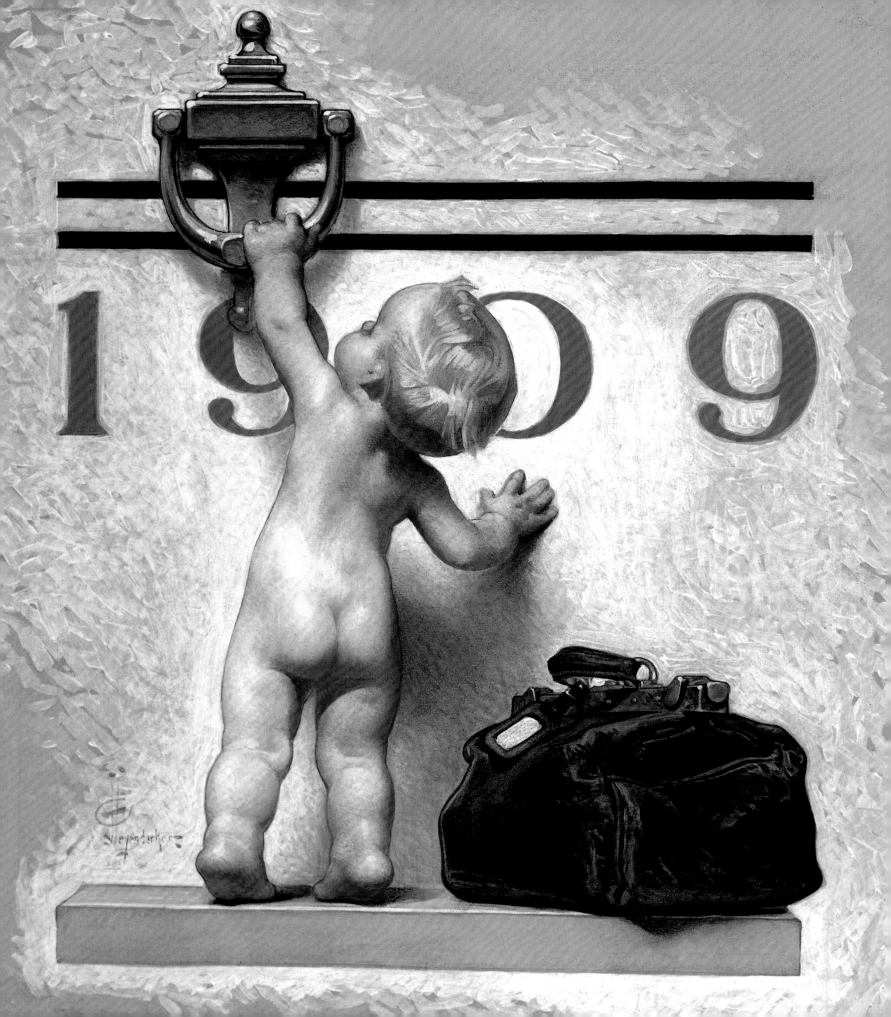

December 26, 1908

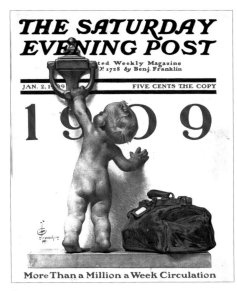

January 2, 1909

January 16, 1909

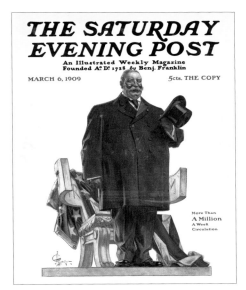

March 6, 1909

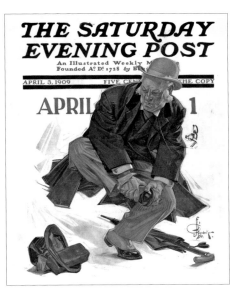

April 3, 1909

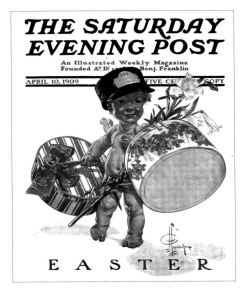

April 10, 1909

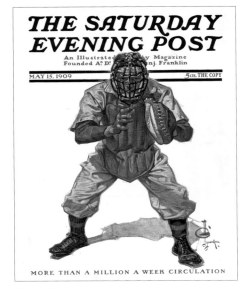

May 15, 1909

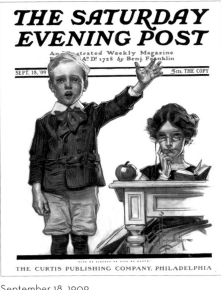

September 18, 1909

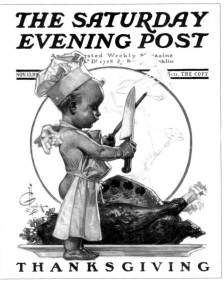

November 13, 1909

OPPOSITE: *New Year's Baby 1909*. 1909. Oil on canvas, 28 x 26". Signed lower left

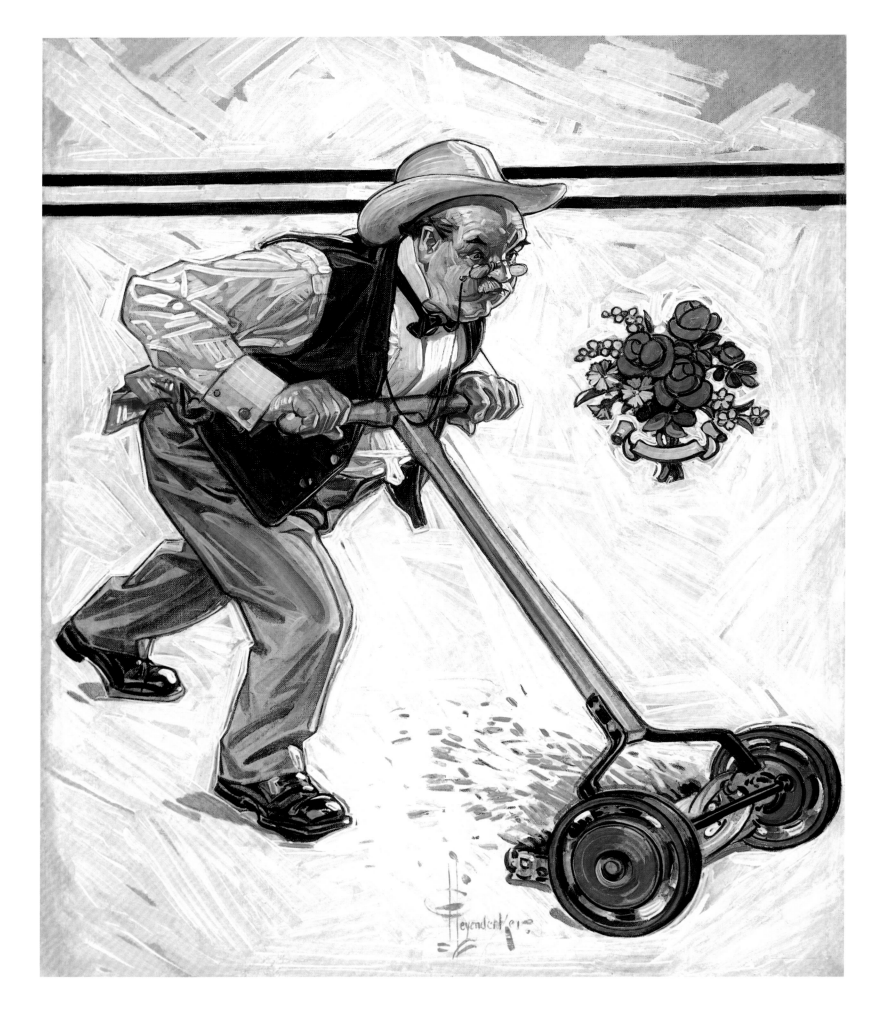

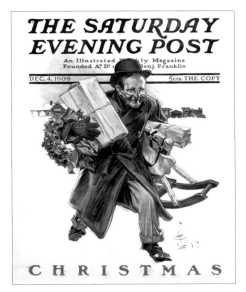

December 4, 1909

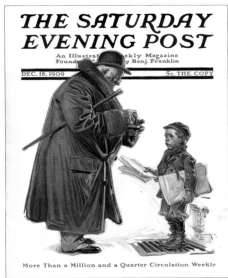

December 18, 1909

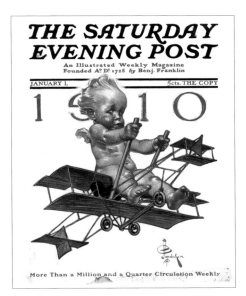

January 1, 1910

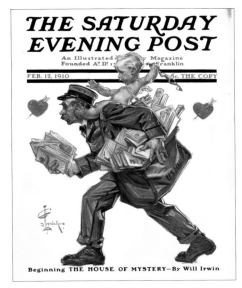

February 12, 1910

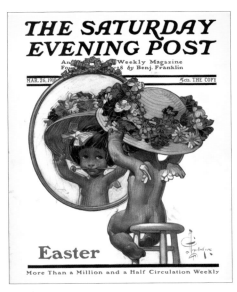

March 26, 1910

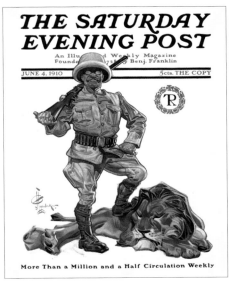

June 4, 1910

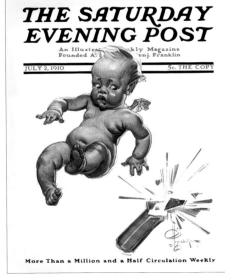

July 2, 1910

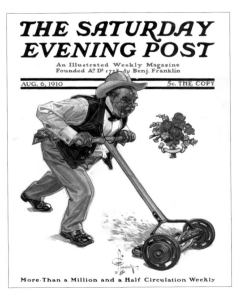

August 6, 1910

September 10, 1910

OPPOSITE: *Mowing the Lawn.* 1910. Oil on canvas, 26 x 21½". Signed lower center

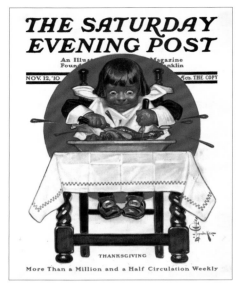

November 12, 1910

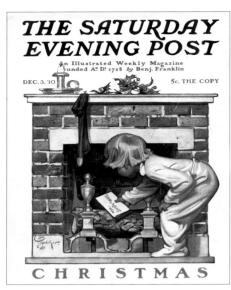

December 3, 1910

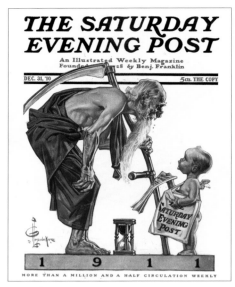

December 31, 1910

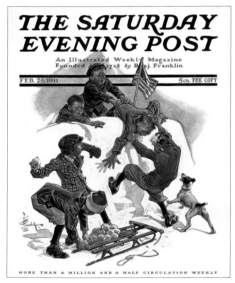

February 25, 1911

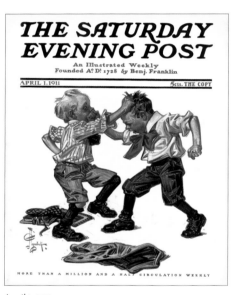

April 1, 1911

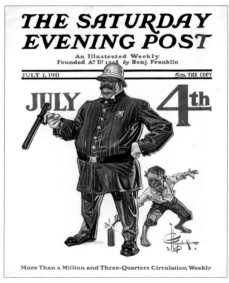

July 1, 1911

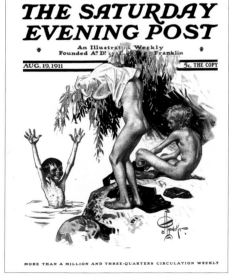

August 19, 1911

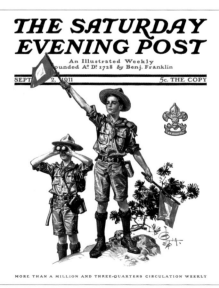

September 2, 1911

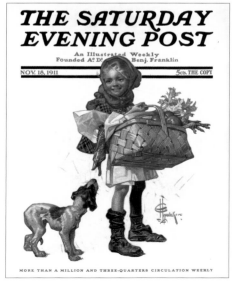

November 18, 1911

OPPOSITE: *Snowball Fight.* 1911. Oil on canvas, 30 x 21". Signed lower left

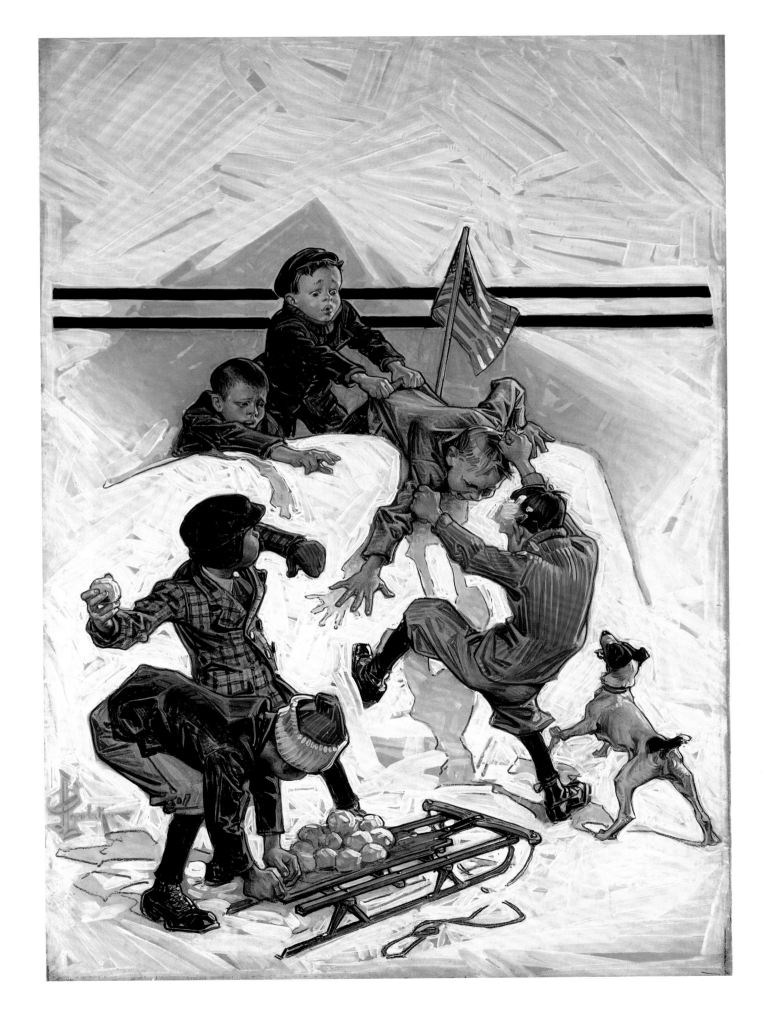

December 2, 1911

December 30, 1911

April 6, 1912

May 25, 1912

July 6, 1912

October 26, 1912

November 16, 1912

November 30, 1912

December 7, 1912

OPPOSITE: *Football Player: Drop Kicker.* 1912. Oil on canvas, 30 x 20". Signed lower left

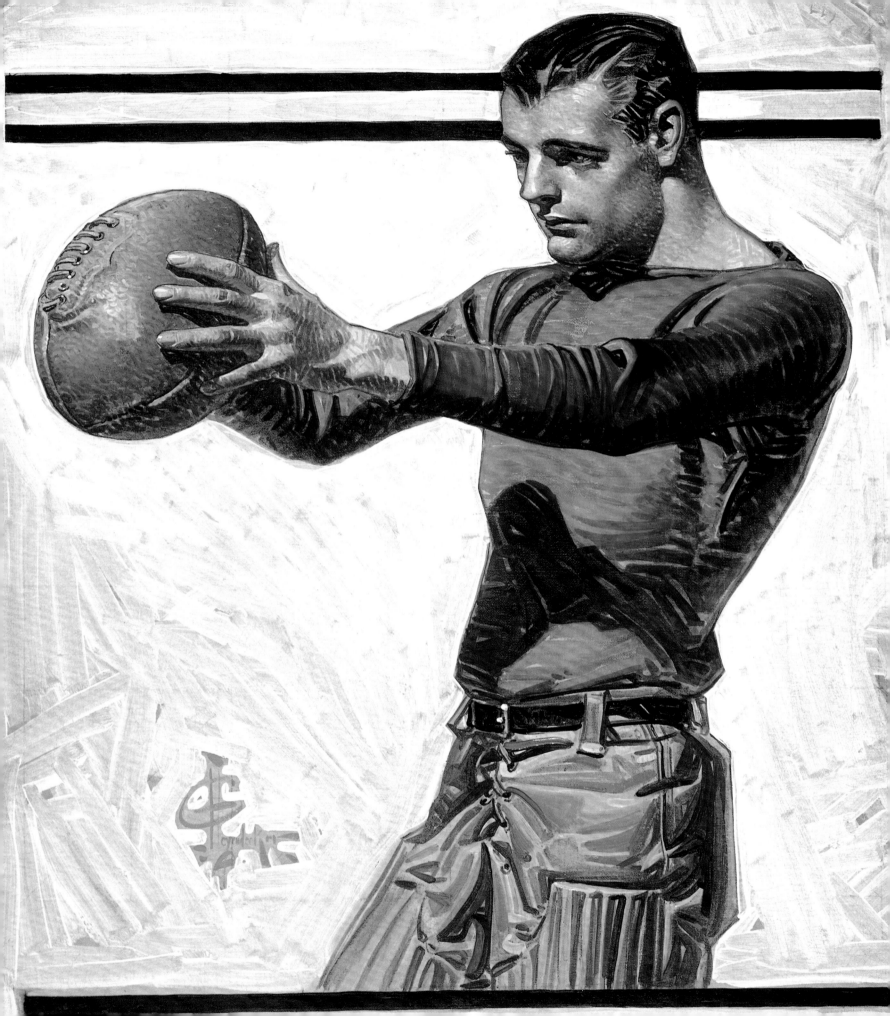

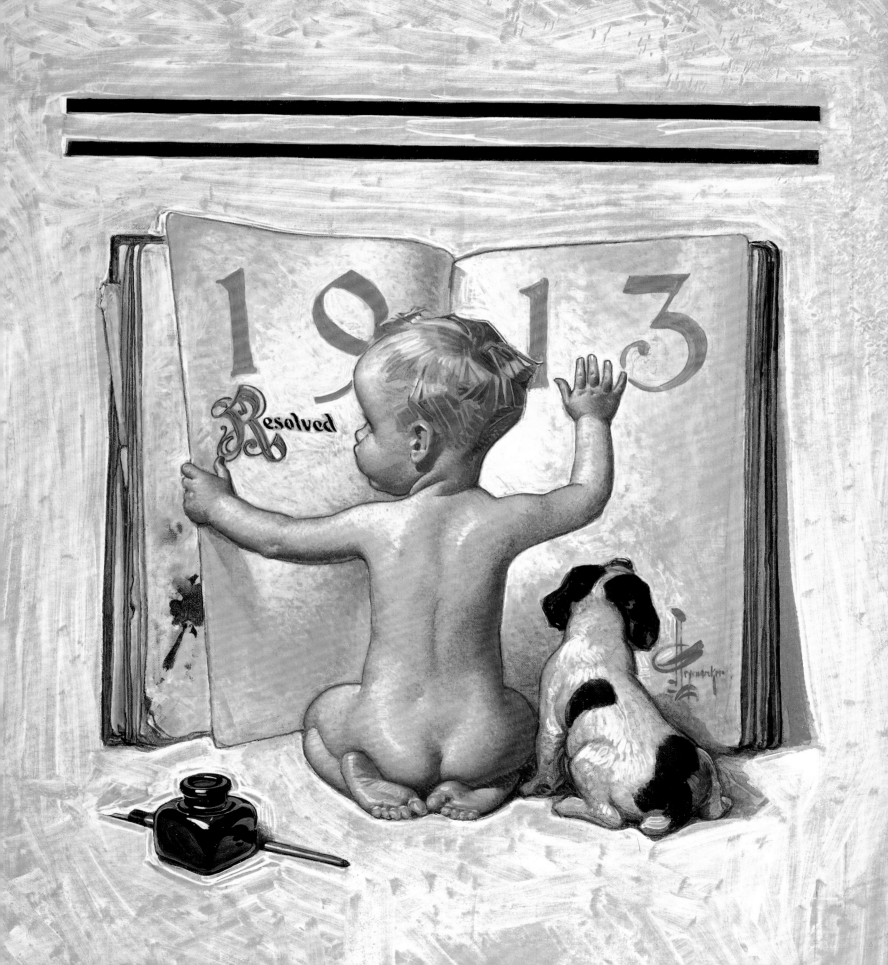

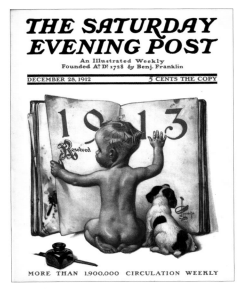

December 28, 1912

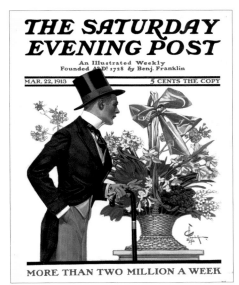

March 22, 1913

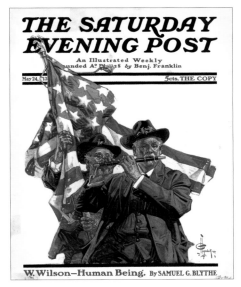

May 24, 1913

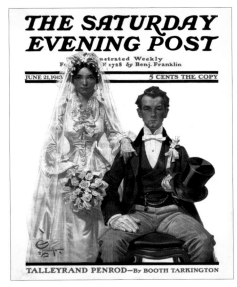

June 21, 1913

July 5, 1913

July 19, 1913

September 20, 1913

November 1, 1913

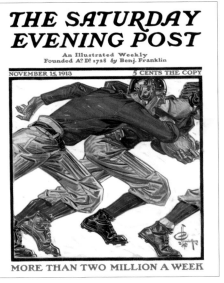

November 15, 1913

OPPOSITE: *New Year's Baby 1913*. 1912. Oil on canvas, 28½ x 21¼". Signed center right

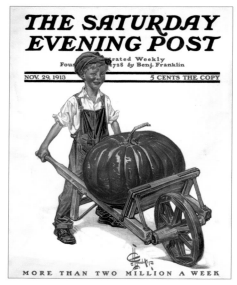

November 29, 1913

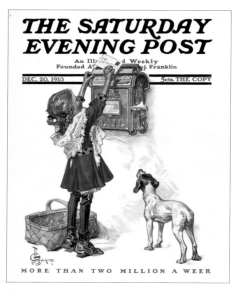

December 20, 1913

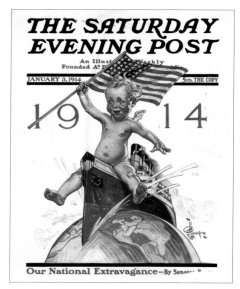

January 3, 1914

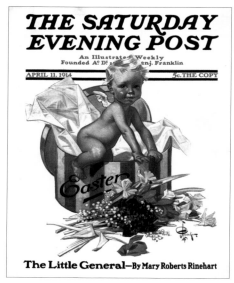

April 11, 1914

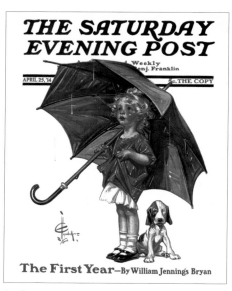

April 25, 1914

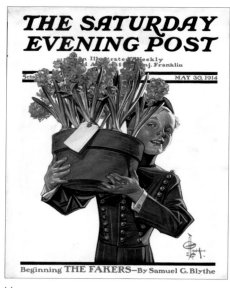

May 30, 1914

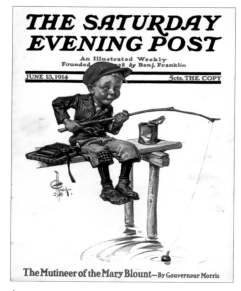

June 13, 1914

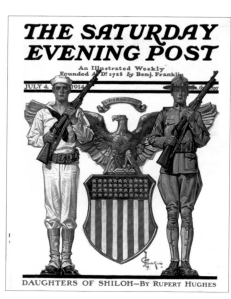

July 4, 1914

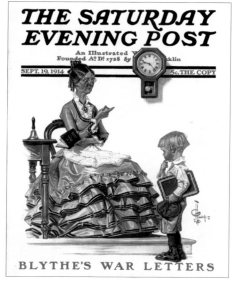

September 19, 1914

OPPOSITE: *New Year's Baby 1914 (Baby on a Boat)*. 1914. Oil on canvas, 20 x 14". Signed lower right

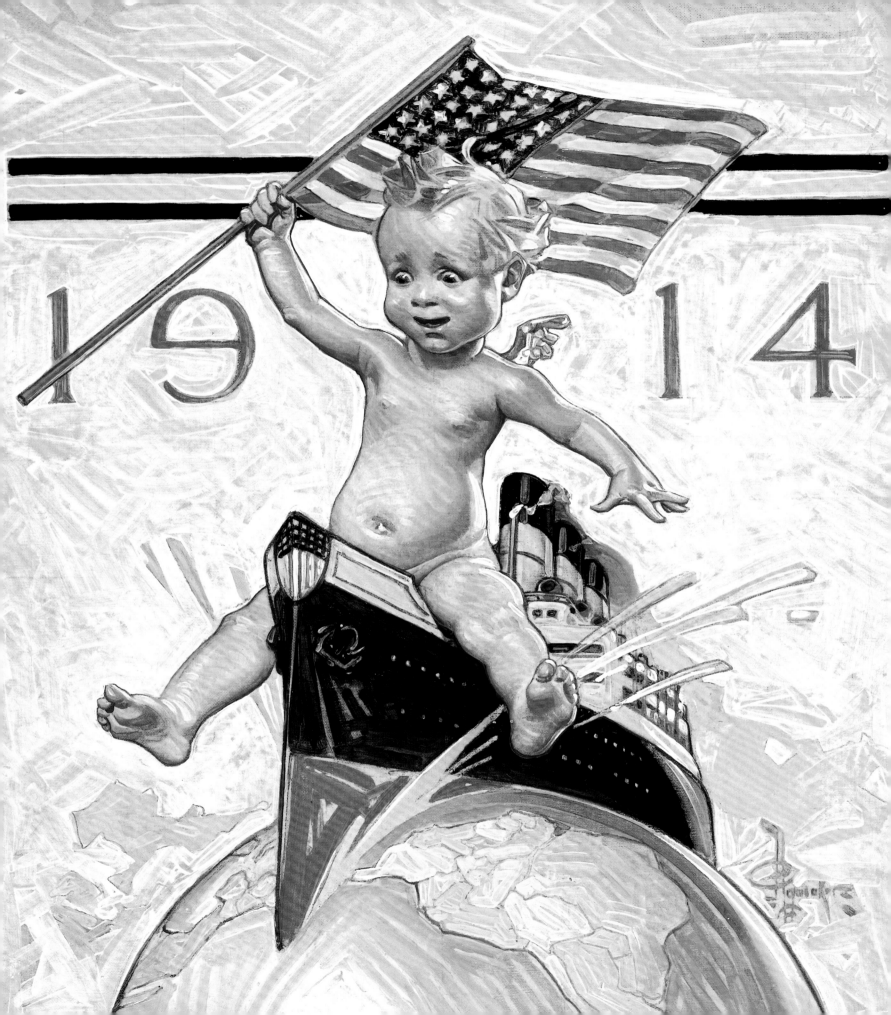

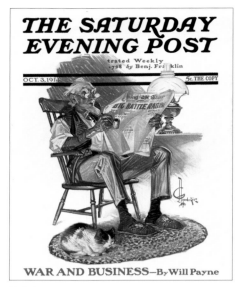

October 3, 1914

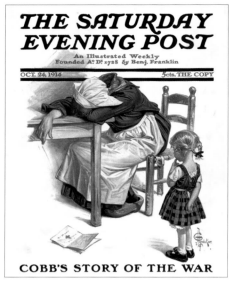

October 24, 1914

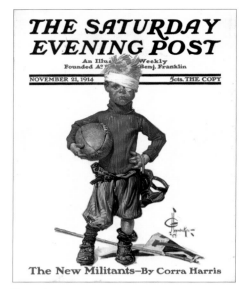

November 21, 1914

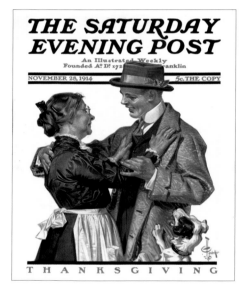

November 28, 1914

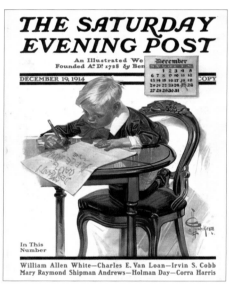

December 19, 1914

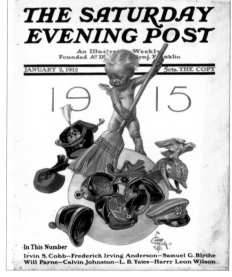

January 2, 1915

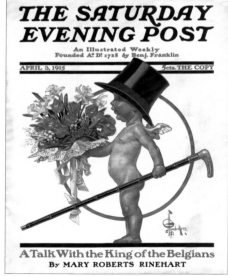

April 3, 1915

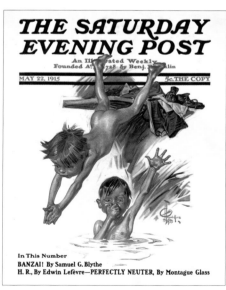

May 22, 1915

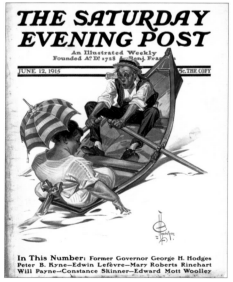

June 12, 1915

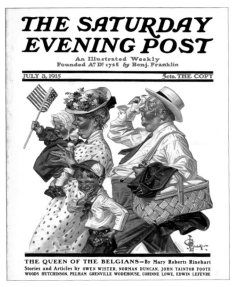

July 3, 1915

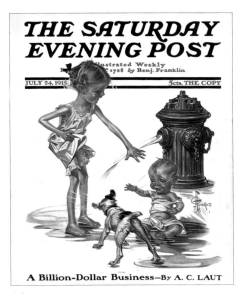

July 24, 1915

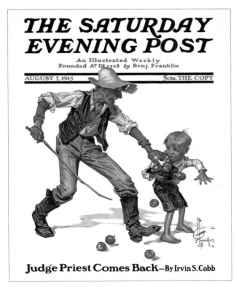

August 7, 1915

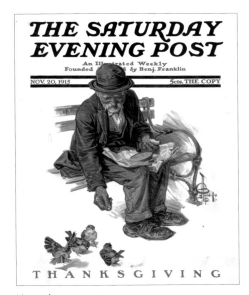

November 20, 1915

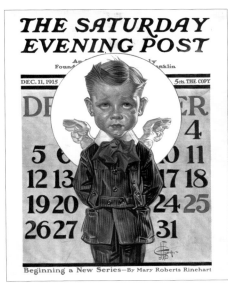

December 11, 1915

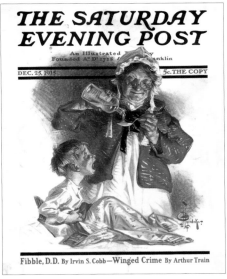

December 25, 1915

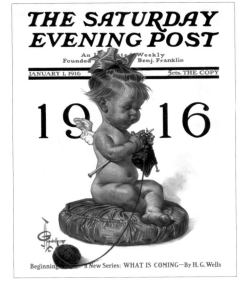

January 1, 1916

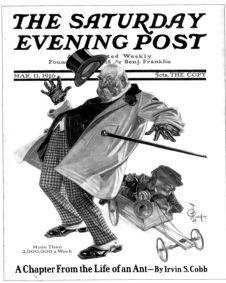

March 11, 1916

April 15, 1916

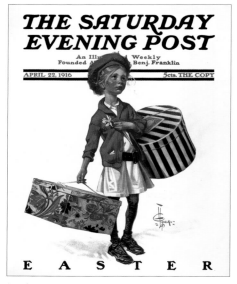

April 22, 1916

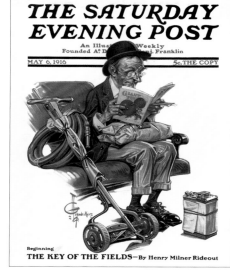

May 6, 1916

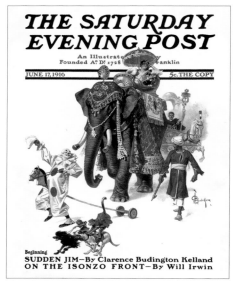

June 17, 1916

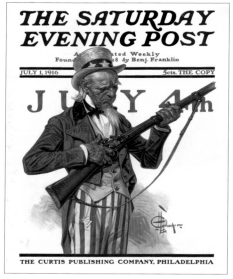

July 1, 1916

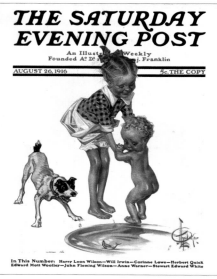

August 26, 1916

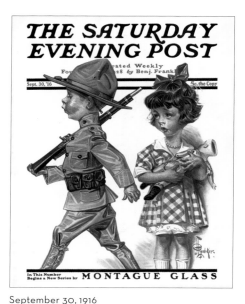

September 30, 1916

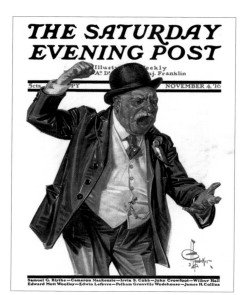

November 4, 1916

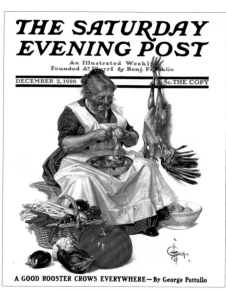

December 2, 1916

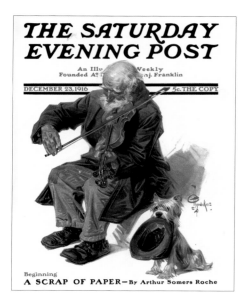

December 23, 1916

OPPOSITE: *The Politician (Campaign Orator)*. 1916. Oil on canvas, 30 x 21". Signed lower right

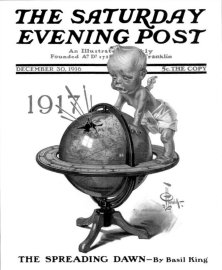

December 30, 1916

March 10, 1917

April 17, 1917

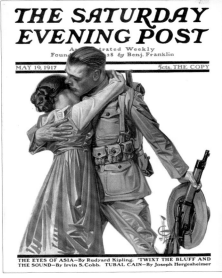

May 19, 1917

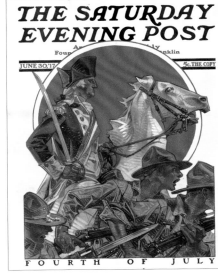

June 30, 1917

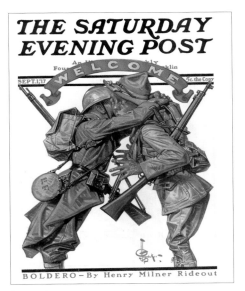

September 1, 1917

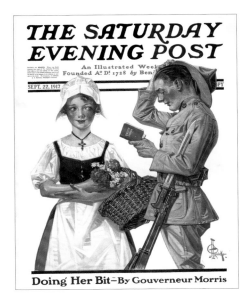

September 22, 1917

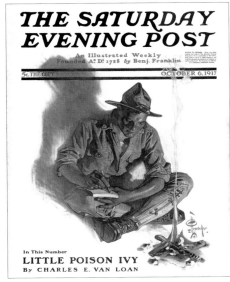

October 6, 1917

November 10, 1917

OPPOSITE: *Soldier and French Girl.* 1917. Oil on canvas, 26 x 20". Signed lower right

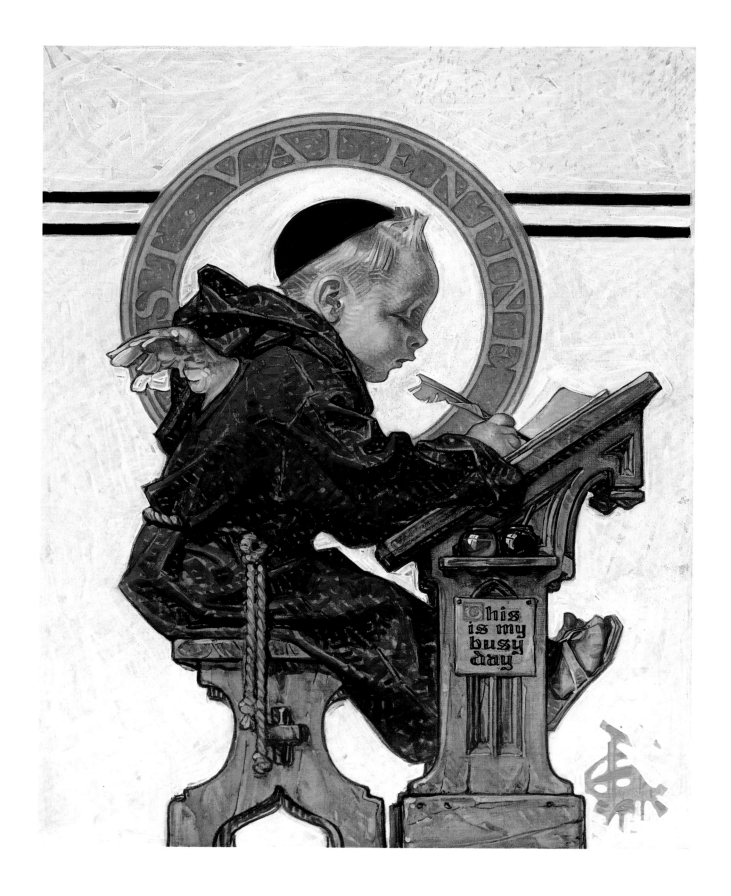

November 24, 1917

December 8, 1917

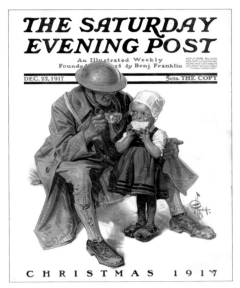

December 22, 1917

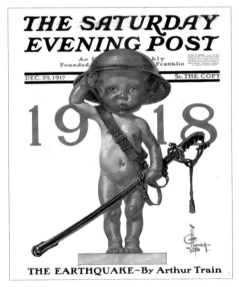

December 29, 1917

February 16, 1918

March 2, 1918

March 23, 1918

March 30, 1918

June 1, 1918

OPPOSITE: *St. Valentine—This Is My Busy Day*. 1918. Oil on canvas, 25 x 19". Signed lower right

June 29, 1918

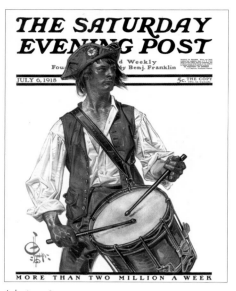

July 6, 1918

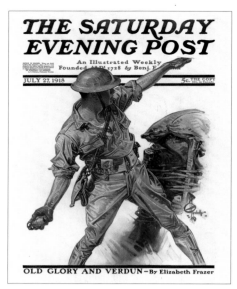

July 27, 1918

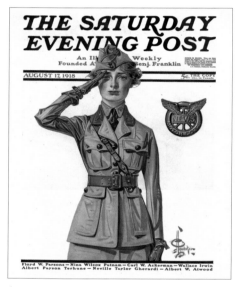

August 17, 1918

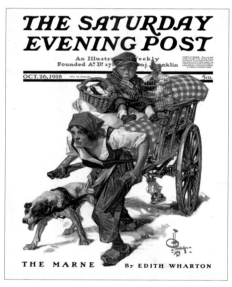

October 26, 1918

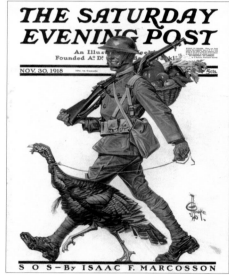

November 30, 1918

December 7, 1918

December 21, 1918

December 28, 1918

OPPOSITE: *The Minute Man.* 1918. Oil on canvas, 25 x 29". Signed lower left

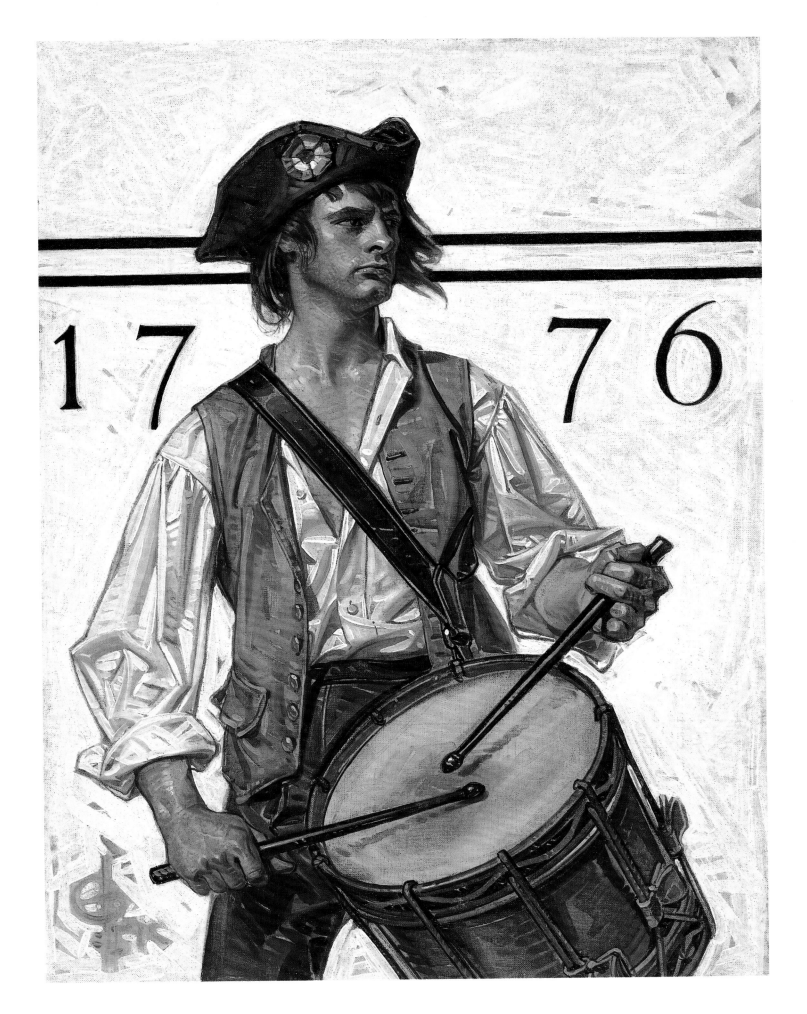

April 5, 1919

April 19, 1919

May 10, 1919

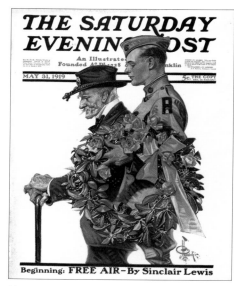

May 31, 1919

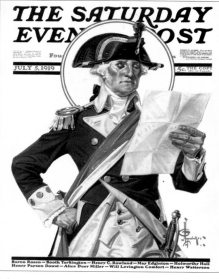

July 5, 1919

August 23, 1919

November 1, 1919

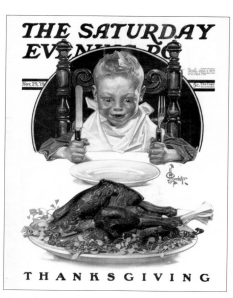

November 29, 1919

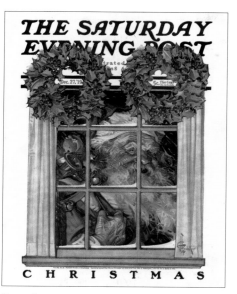

December 27, 1919

OPPOSITE: *The War Veteran*. 1919. Oil on canvas, 25¹/₅ x 18³/₄". Signed lower right

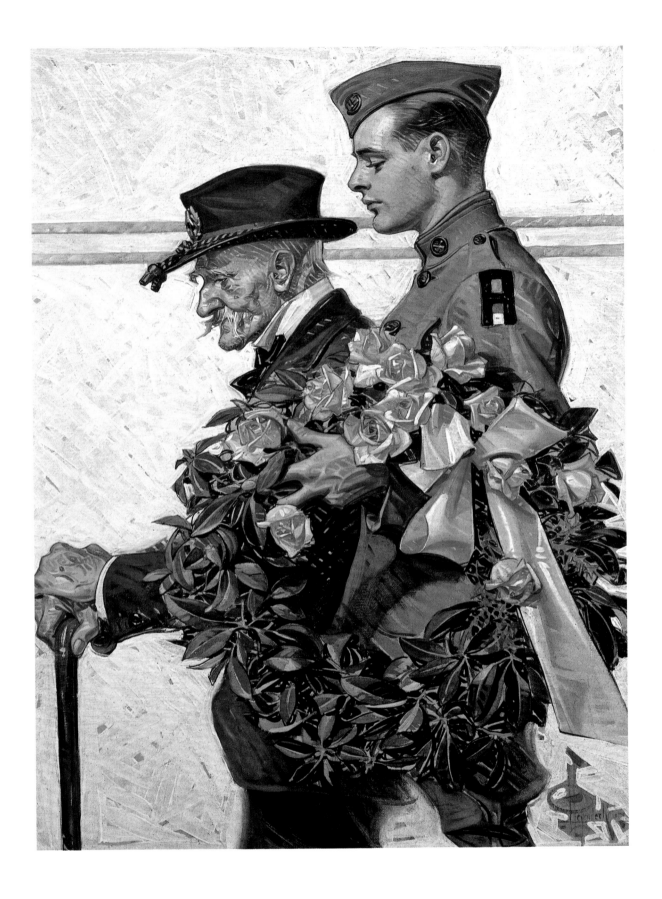

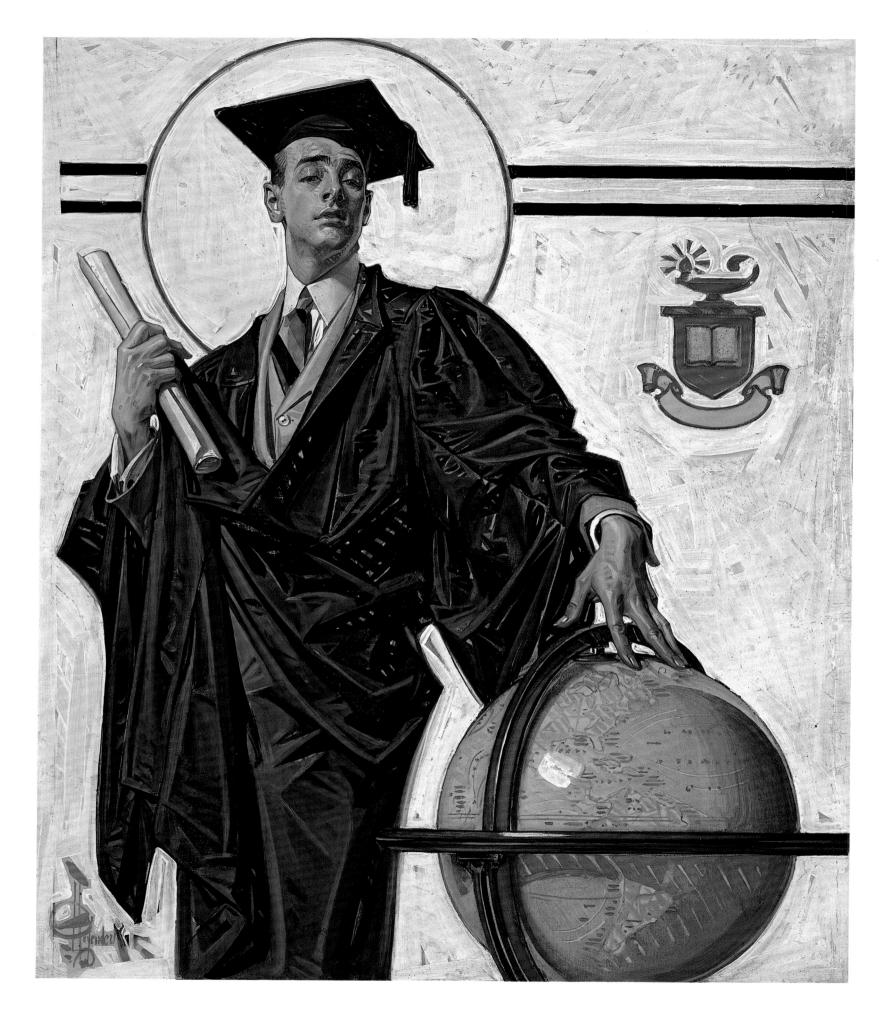

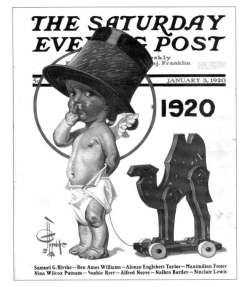

January 3, 1920

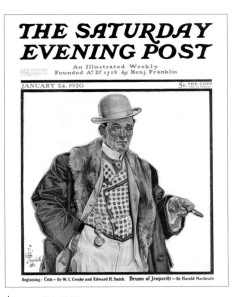

January 24, 1920

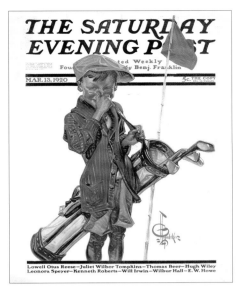

March 13, 1920

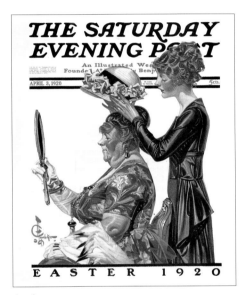

April 3, 1920

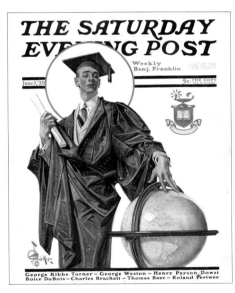

June 5, 1920

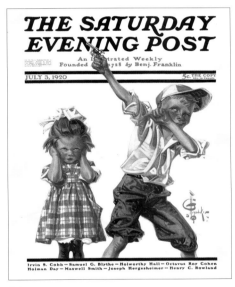

July 3, 1920

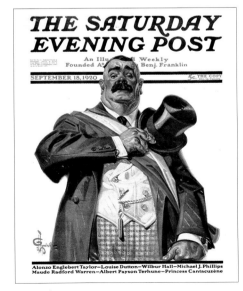

September 18, 1920

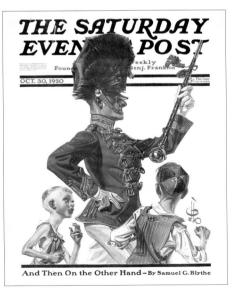

October 30, 1920

November 27, 1920

OPPOSITE: *June Graduate.* 1920. Oil on canvas, 24 x 20". Signed lower left

December 25, 1920

January 1, 1921

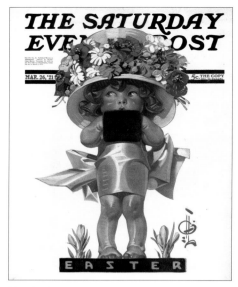

March 26, 1921

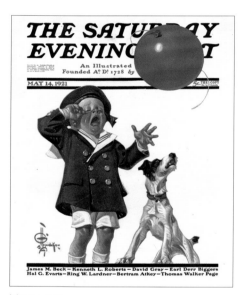

May 14, 1921

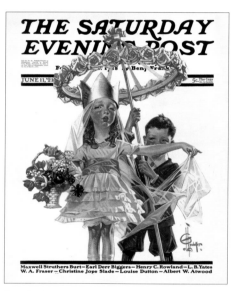

June 11, 1921

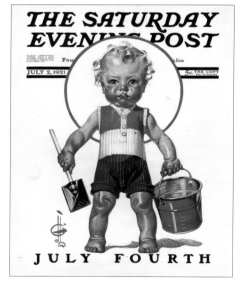

July 2, 1921

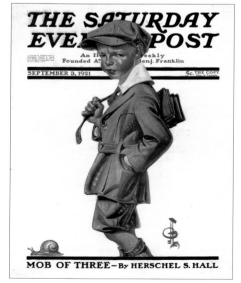

September 3, 1921

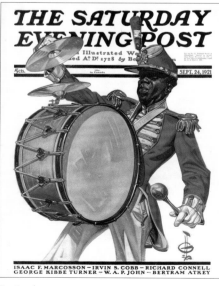

September 24, 1921

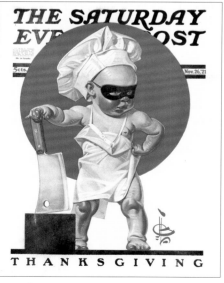

November 26, 1921

OPPOSITE: *Bass Drummer.* 1921. Oil on canvas, 27½ x 20½". Monogrammed lower right

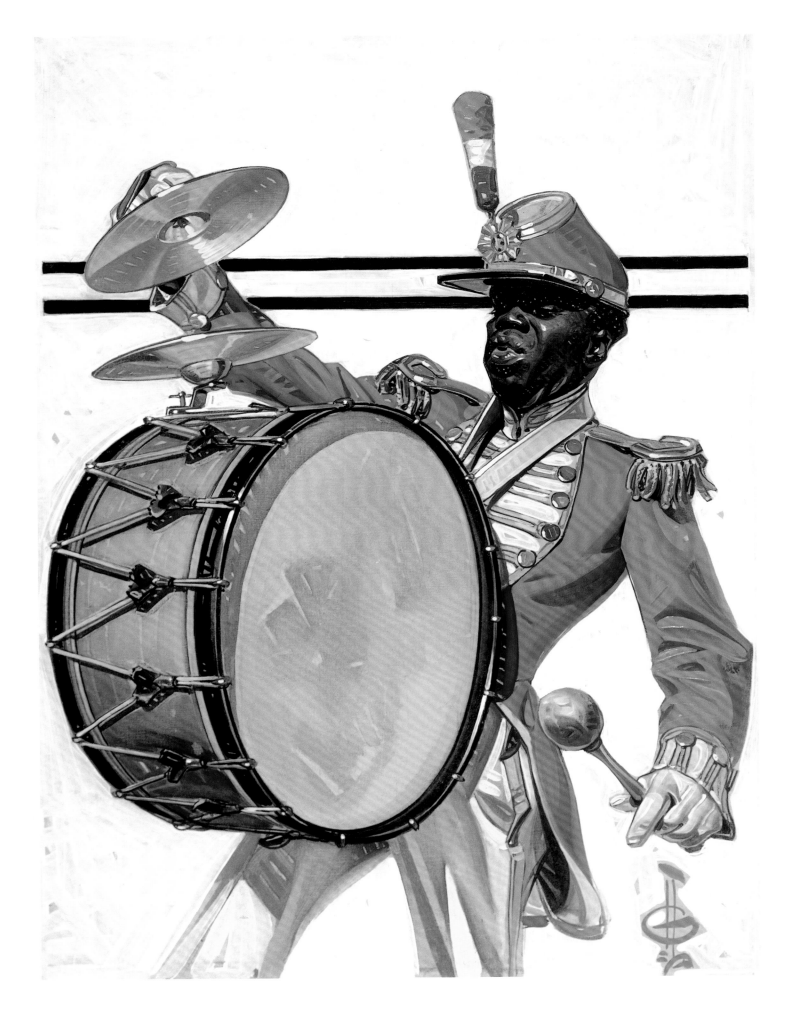

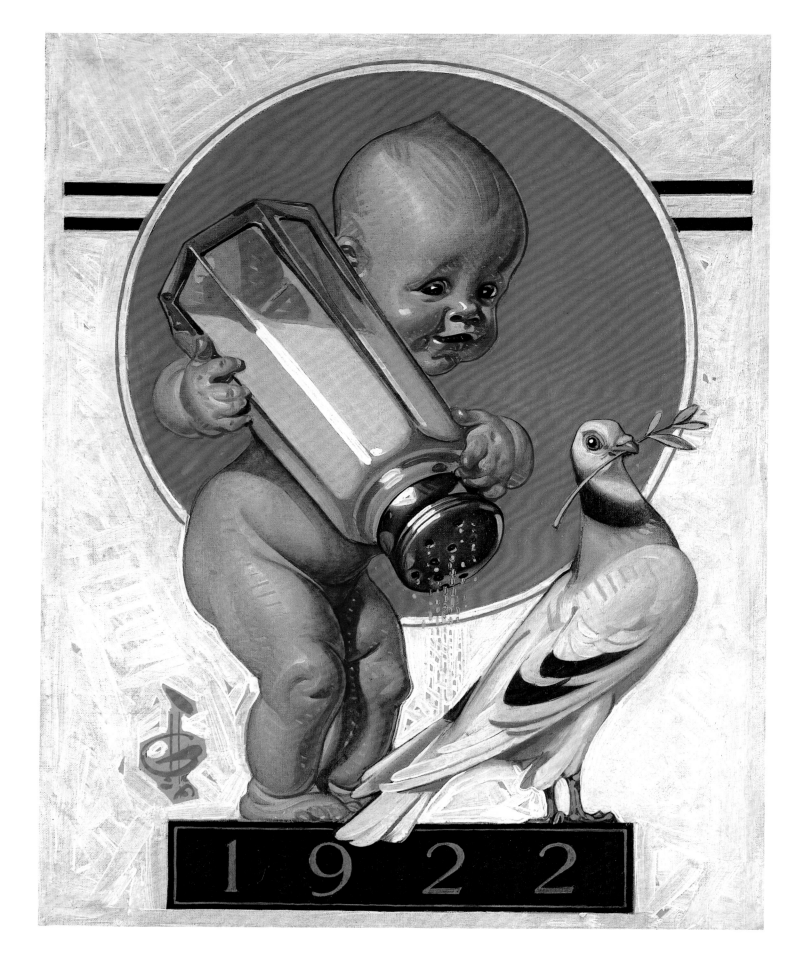

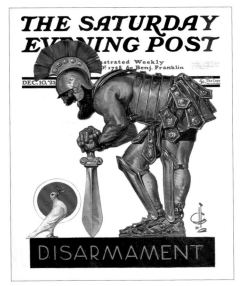

December 10, 1921

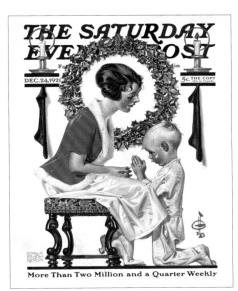

December 24, 1921

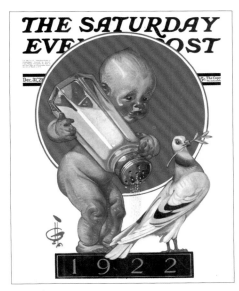

December 31, 1921

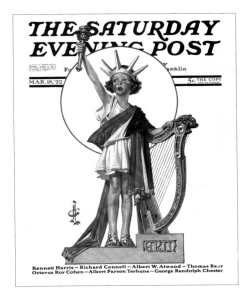

March 18, 1922

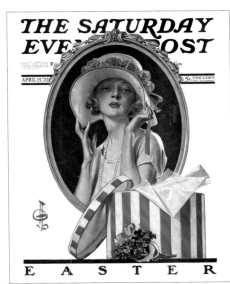

April 15, 1922

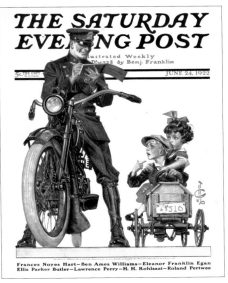

June 24, 1922

July 29, 1922

August 26, 1922

October 14, 1922

OPPOSITE: *New Year's Baby 1922 (Baby with Dove)*. 1921. Oil on canvas, 21½ x 16¾". Monogrammed lower left

November 25, 1922

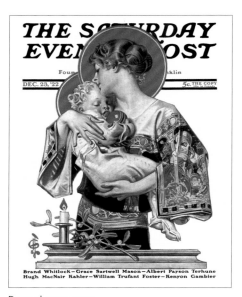

December 23, 1922

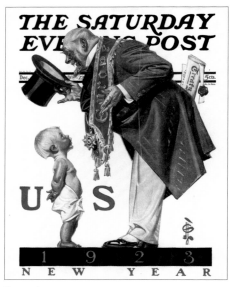

December 30, 1922

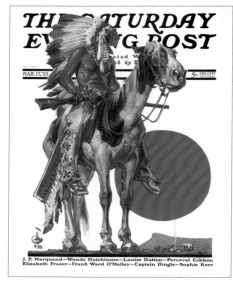

March 17, 1923

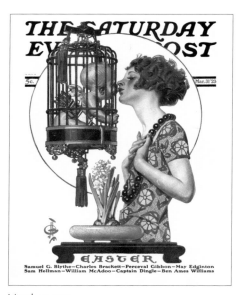

March 31, 1923

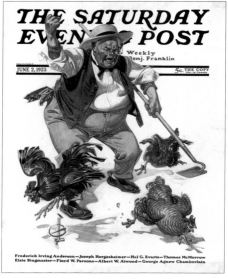

June 2, 1923

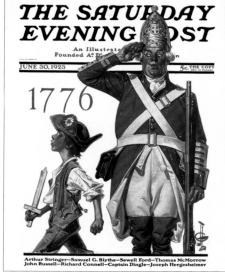

June 30, 1923

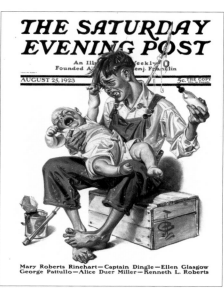

August 25, 1923

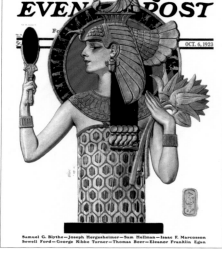

October 6, 1923

OPPOSITE: *Indian with Campfire Below.* 1923. Oil on canvas, 26 x 18½". Monogrammed lower left

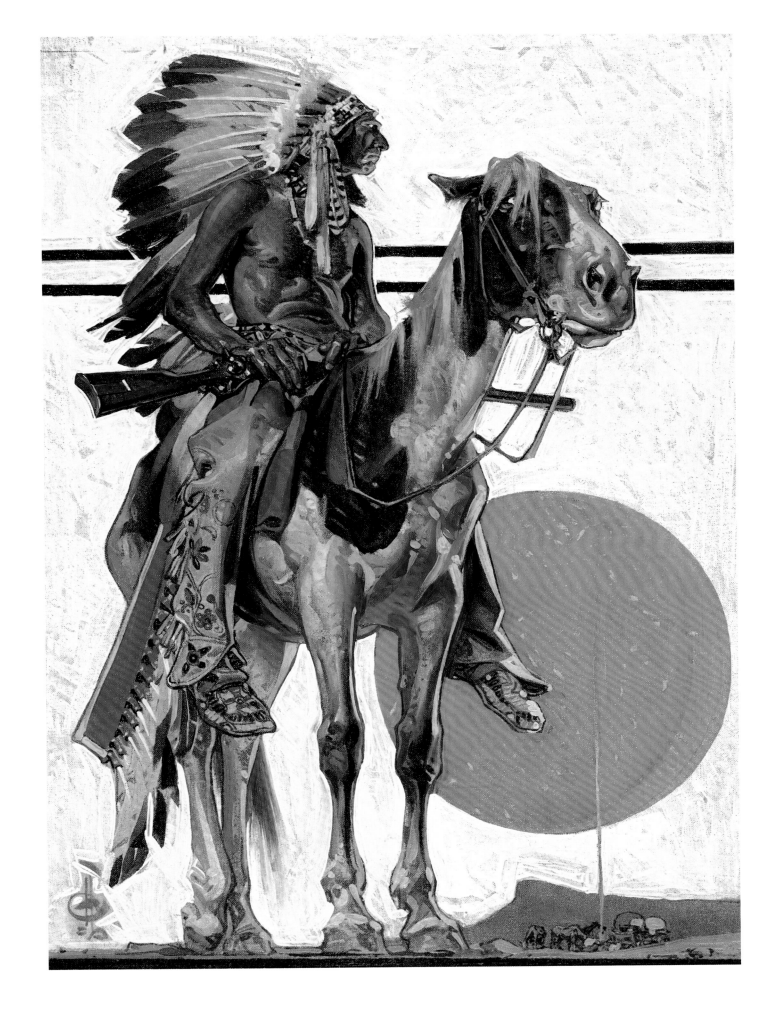

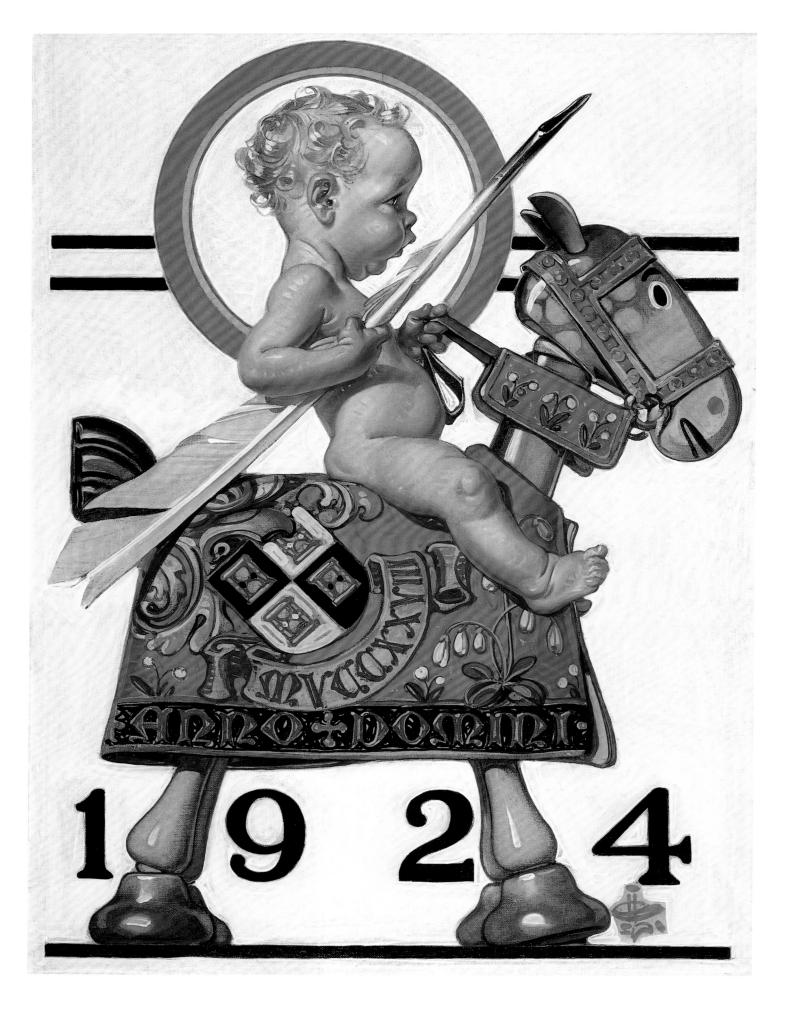

October 27, 1923

December 1, 1923

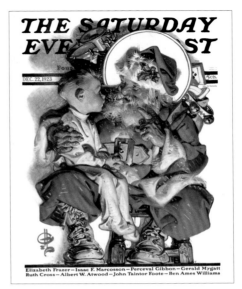

December 22, 1923

December 29, 1923

February 16, 1924

April 19, 1924

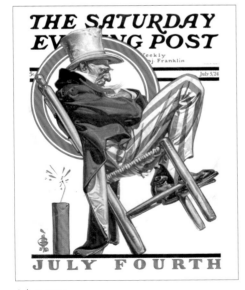

July 5, 1924

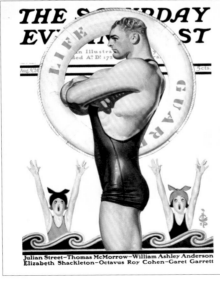

August 9, 1924

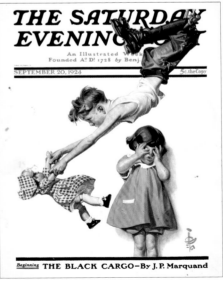

September 20, 1924

OPPOSITE: *New Year's Baby 1924 (Jousting)*. 1923. Oil on canvas, 25¼ x 18½". Monogrammed lower right

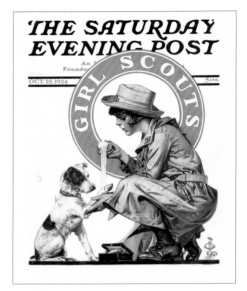

October 25, 1924

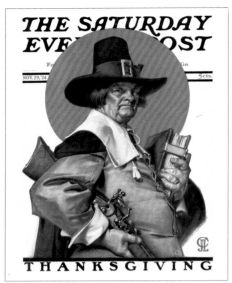

November 29, 1924

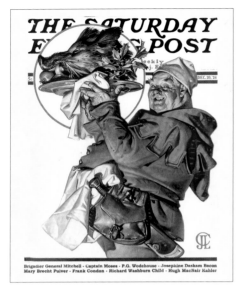

December 20, 1924

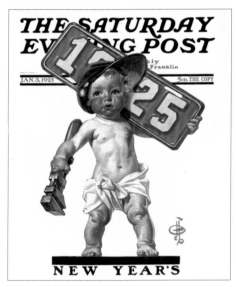

January 3, 1925

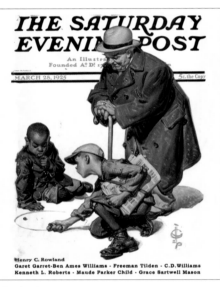

March 28, 1925

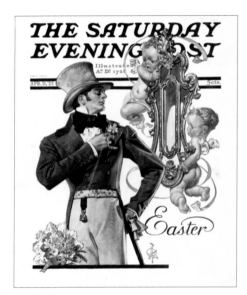

April 11, 1925

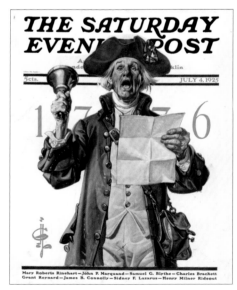

July 4, 1925

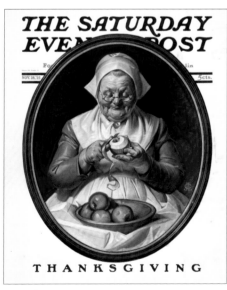

November 28, 1925

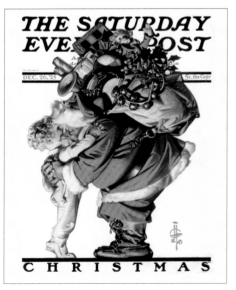

December 26, 1925

OPPOSITE: *Boys Playing Marbles.* 1925. Oil on canvas, 27½ x 19½". Monogrammed lower right

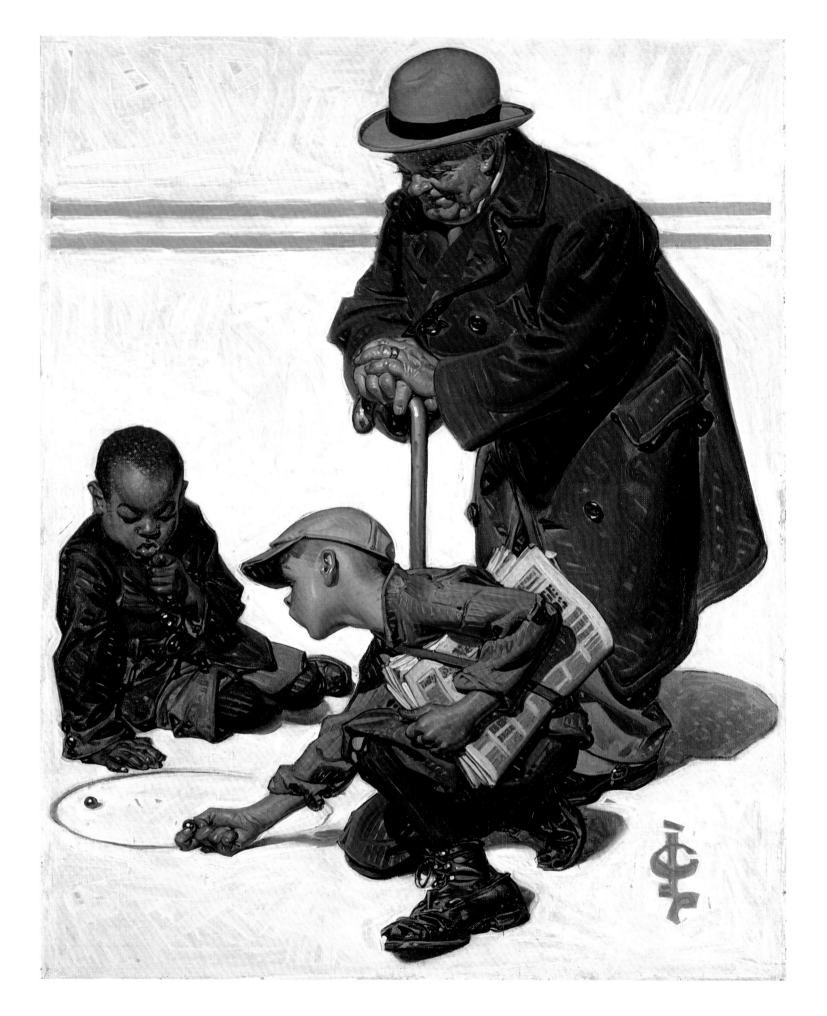

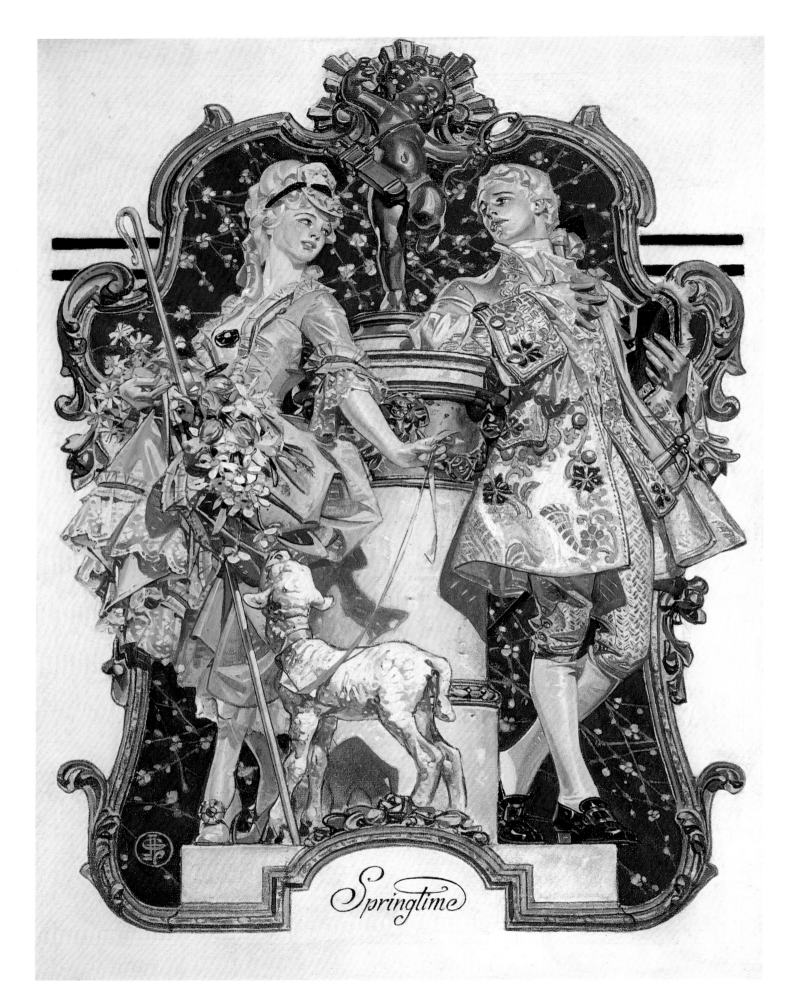

Springtime

January 2, 1926

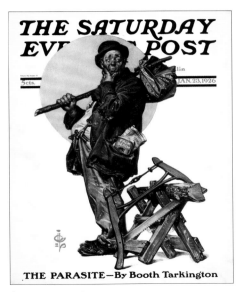

January 23, 1926

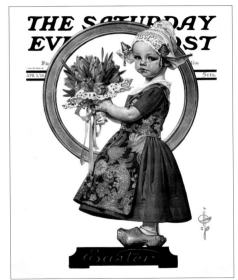

April 3, 1926

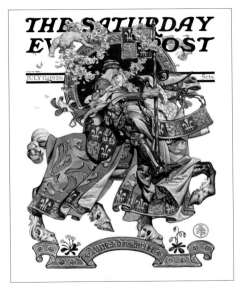

July 17, 1926

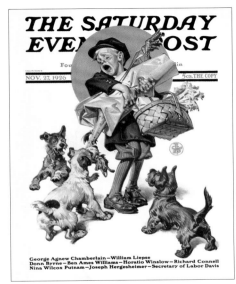

November 27, 1926

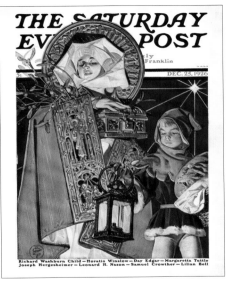

December 25, 1926

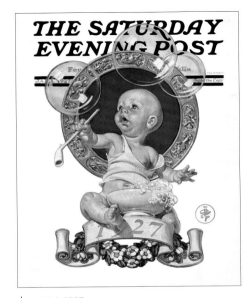

January 1, 1927

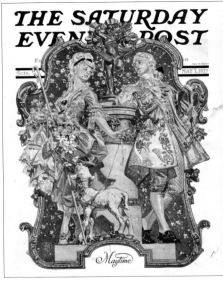

May 7, 1927

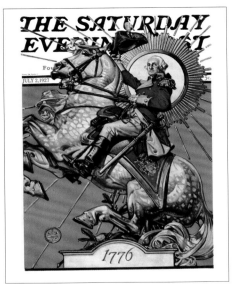

July 2, 1927

OPPOSITE: *Springtime—Little Bo Peep.* 1927. Oil on canvas, 32 x 24". Monogrammed lower left

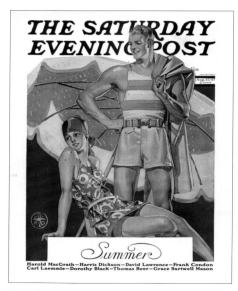

August 27, 1927

November 26. 1927

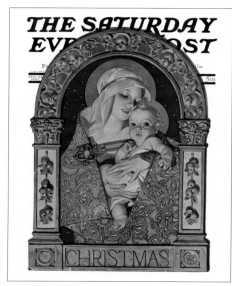

December 24, 1927

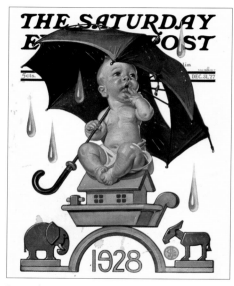

December 31, 1927

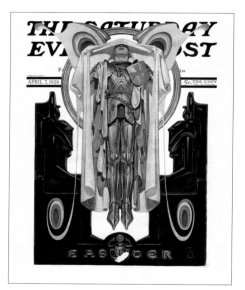

April 7, 1928

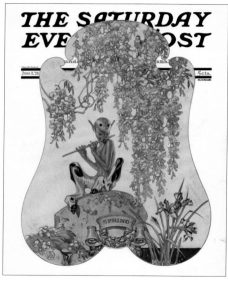

June 2, 1928

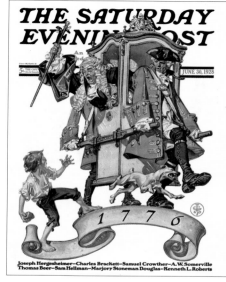

June 30, 1928

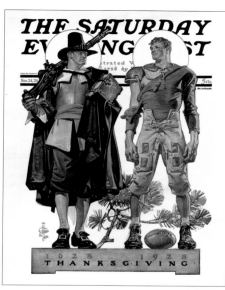

November 24, 1928

December 22, 1928

OPPOSITE: *Thanksgiving—Pilgrim and Football Player.* **1928. Oil on canvas, 28 x 22". Monogrammed lower left**

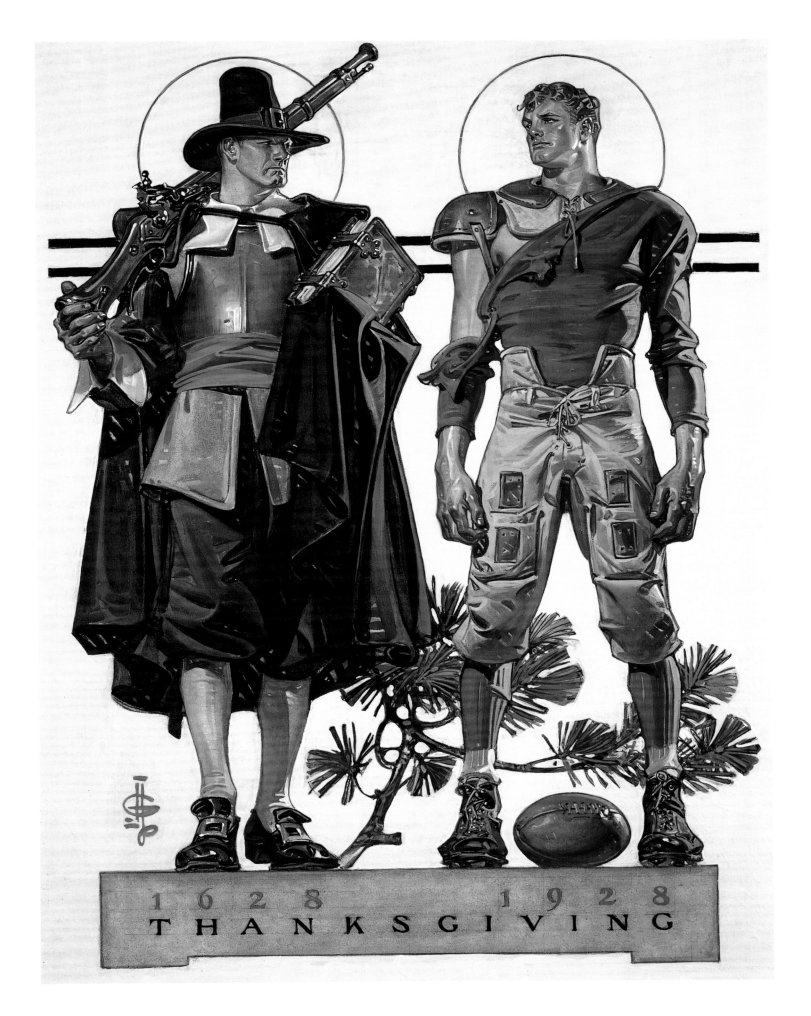

December 29, 1928

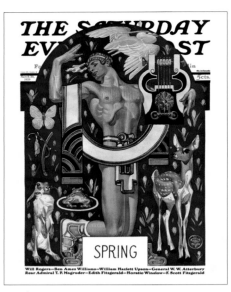

March 30, 1929

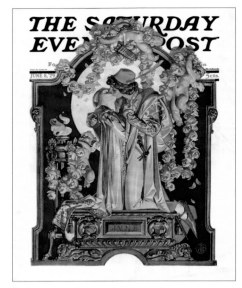

June 8, 1929

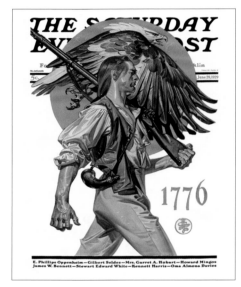

June 29, 1929

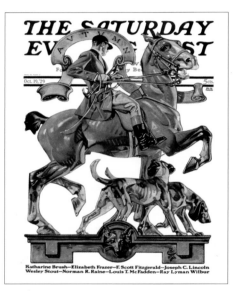

October 19, 1929

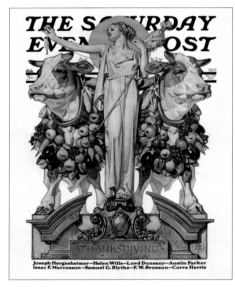

November 23, 1929

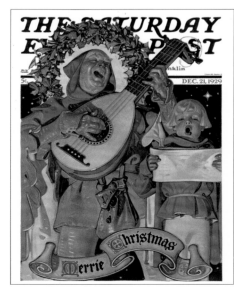

December 21, 1929

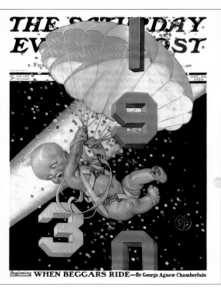

December 28, 1929

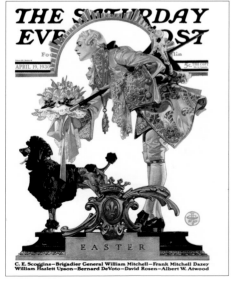

April 19, 1930

OPPOSITE: *Spring—Apollo and Animals.* 1929. Oil on canvas, 27³/₄ x 20¹/₂". Monogrammed lower right

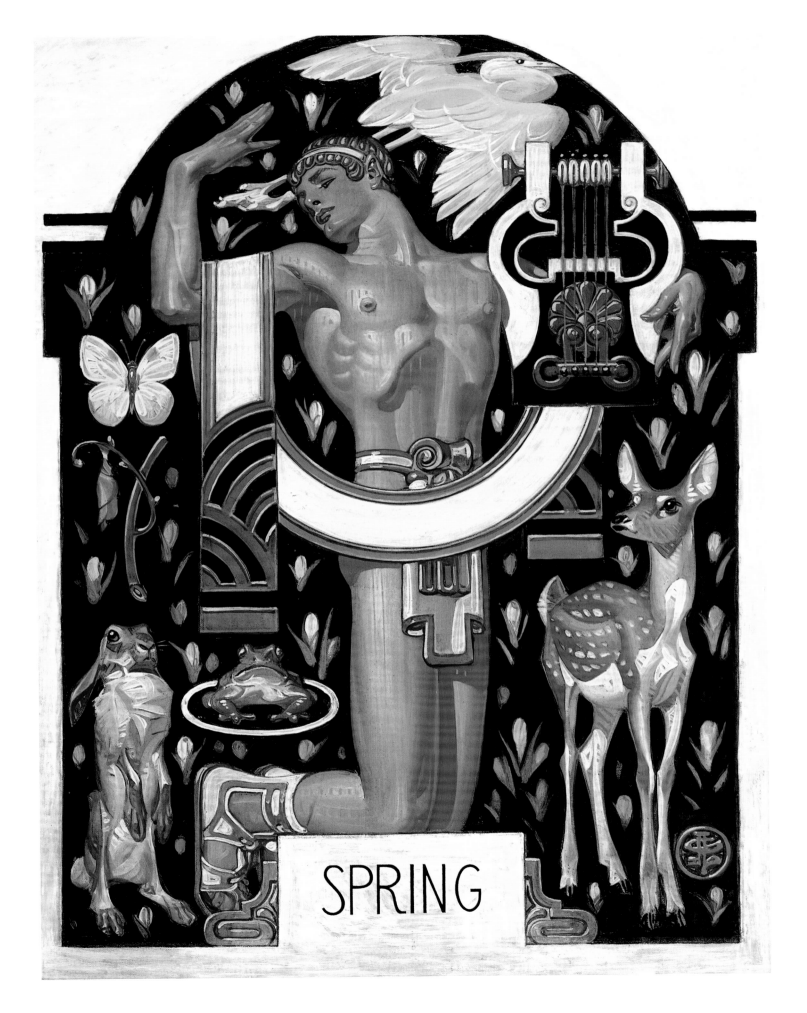

SPRING

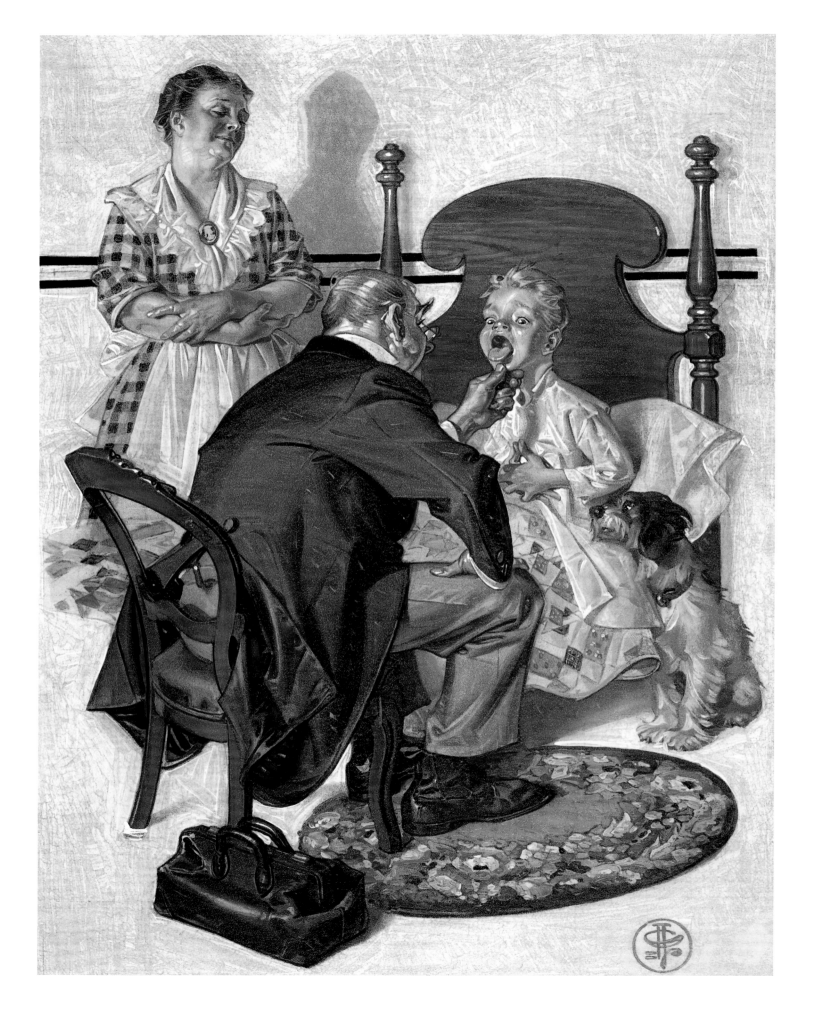

June 28, 1930

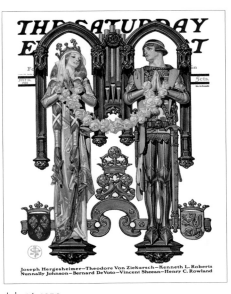

July 26, 1930

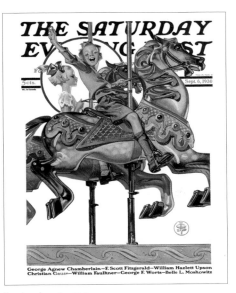

September 6, 1930

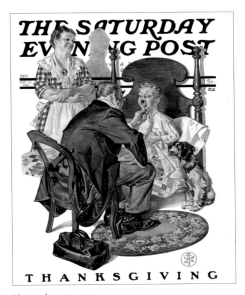

November 22, 1930

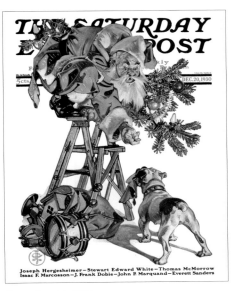

December 20, 1930

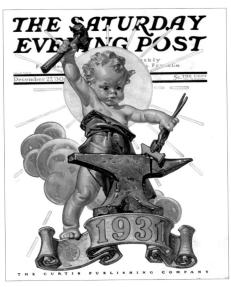

December 27, 1930

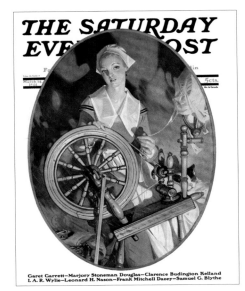

March 14, 1931

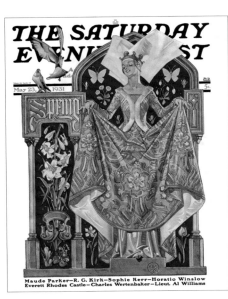

May 23, 1931

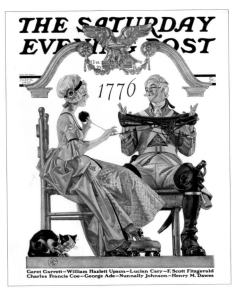

July 4, 1931

OPPOSITE: *Sick in Bed.* 1930. Oil on canvas, 32 x 24". Monogrammed lower right

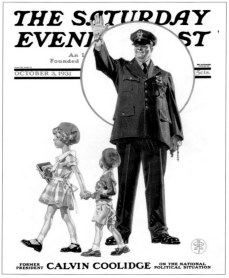

October 3, 1931

November 28, 1931

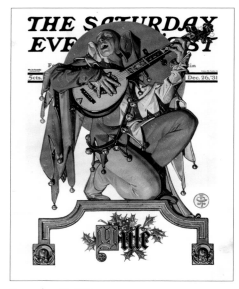

December 26, 1931

January 2, 1932

March 5, 1932

March 26, 1932

May 14, 1932

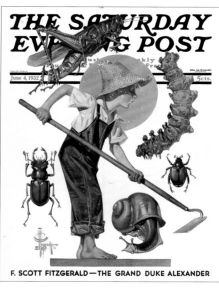

June 4, 1932

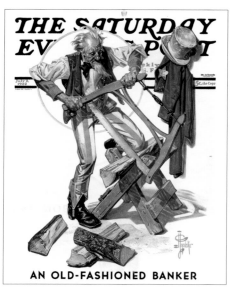

July 2, 1932

OPPOSITE: *Easter Couple*. 1932. Oil on canvas, 32¼ x 24¼". Monogrammed lower right

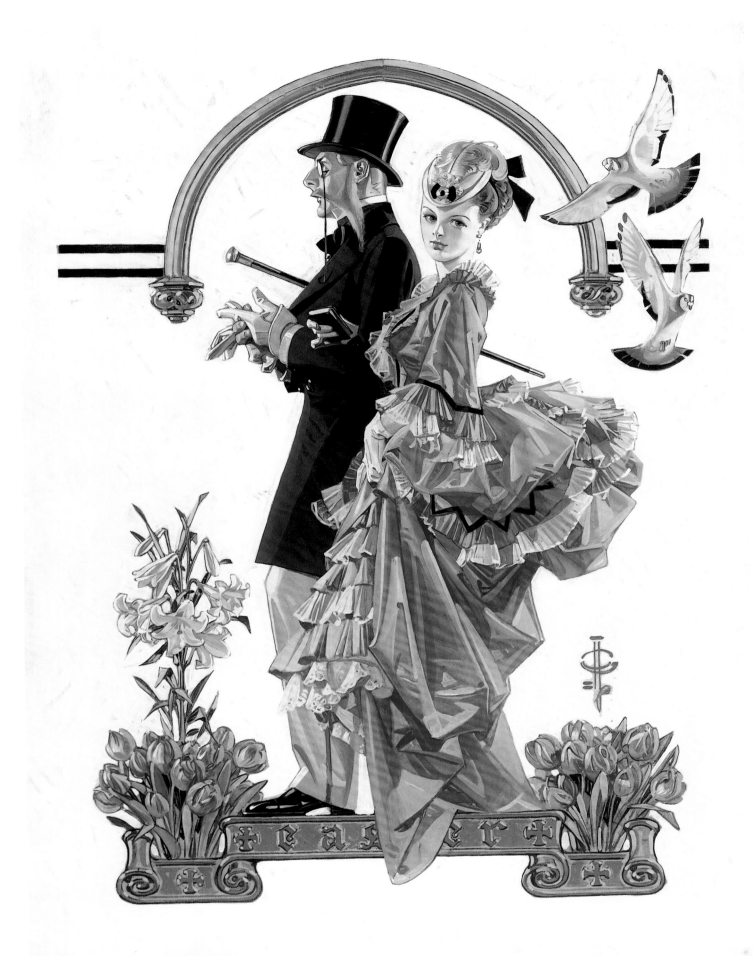

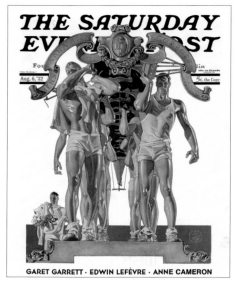

August 6, 1932

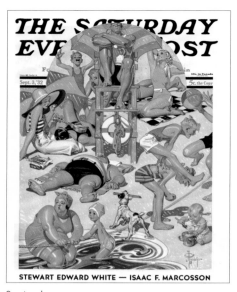

September 3, 1932

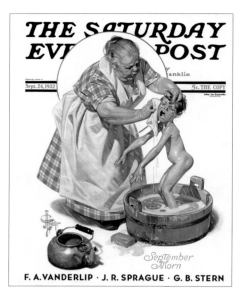

September 24, 1932

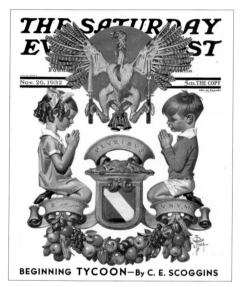

November 26, 1932

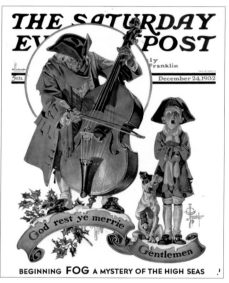

December 24, 1932

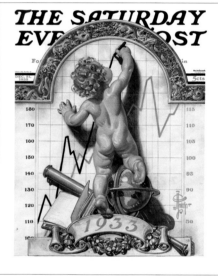

December 31, 1932

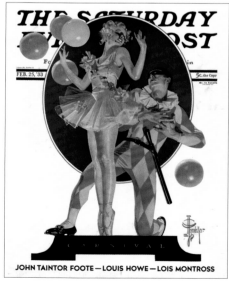

February 25, 1933

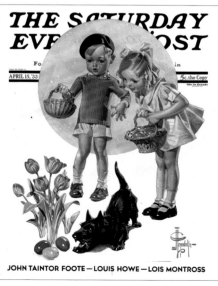

April 15, 1933

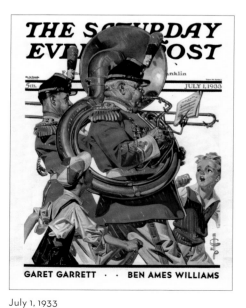

July 1, 1933

OPPOSITE: *Labor Day at the Beach.* 1932. Oil on canvas, 32 x 24". Signed lower right

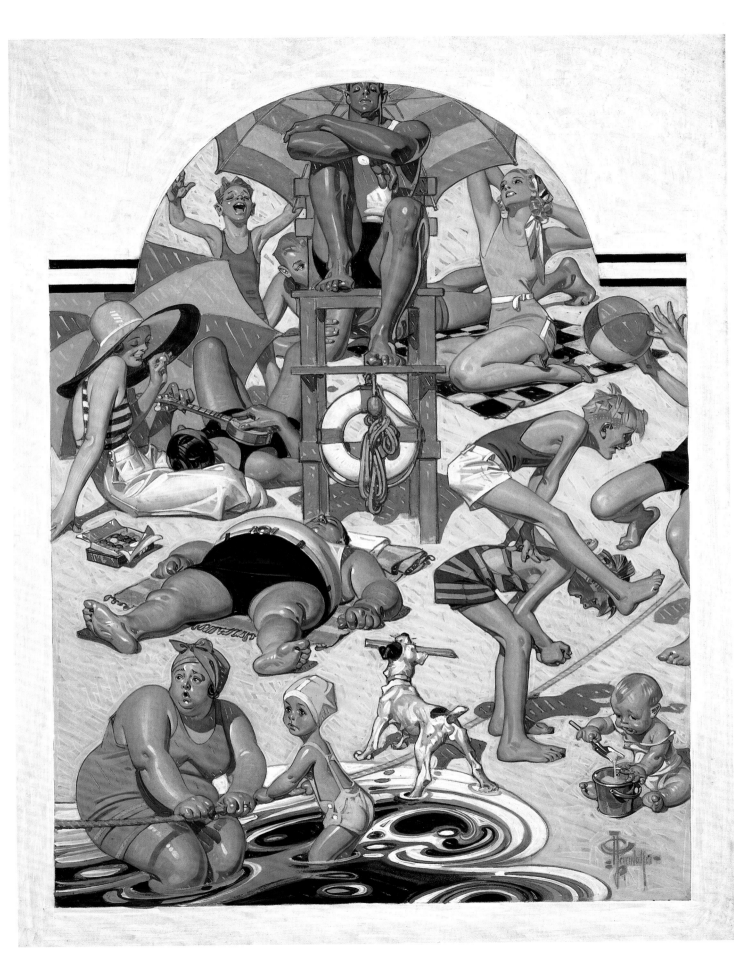

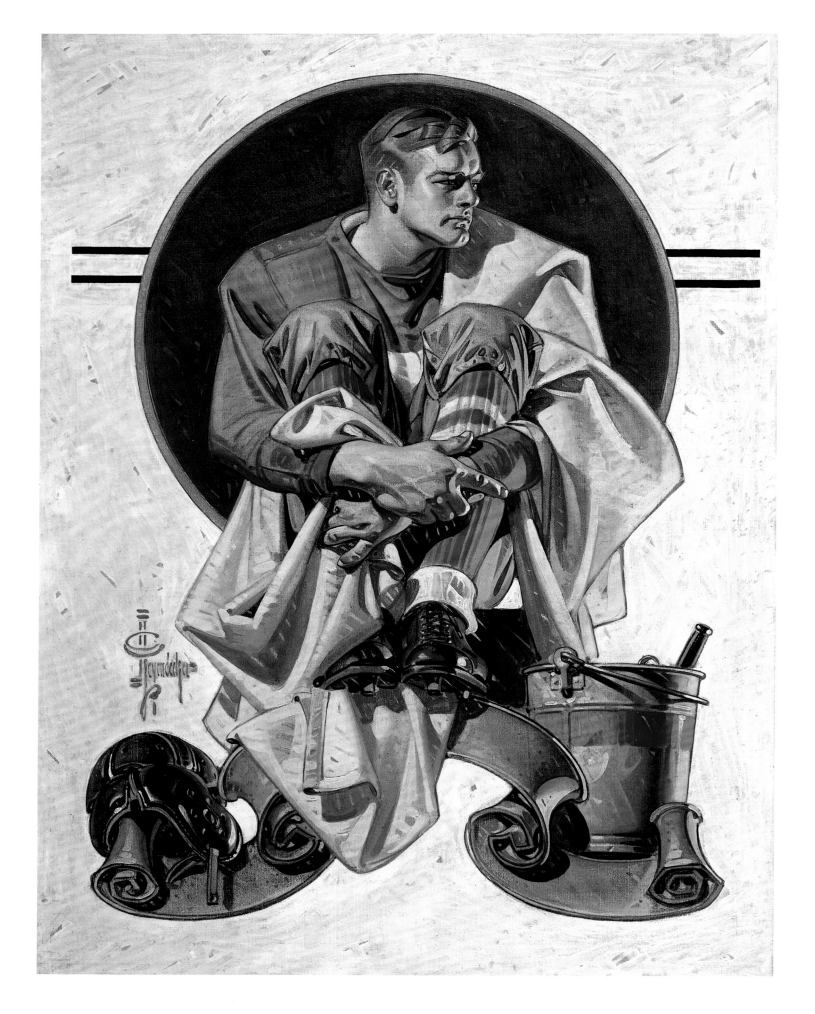

August 26, 1933

September 16, 1933

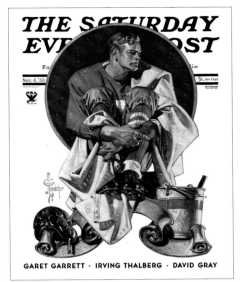

November 4, 1933

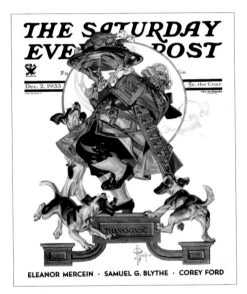

December 2, 1933

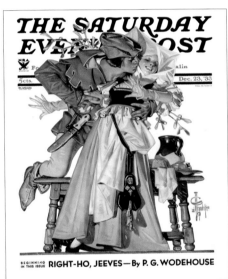

December 23, 1933

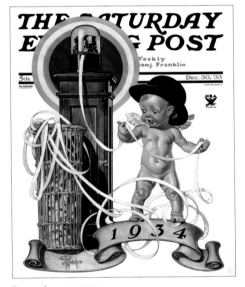

December 30, 1933

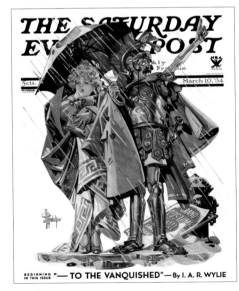

March 10, 1934

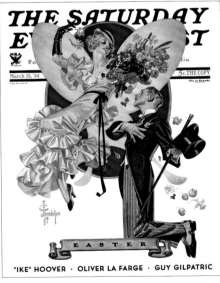

March 31, 1934

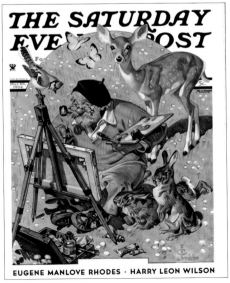

May 26, 1934

OPPOSITE: *Football Hero*. 1933. Oil on canvas, 32 x 24". Signed lower left

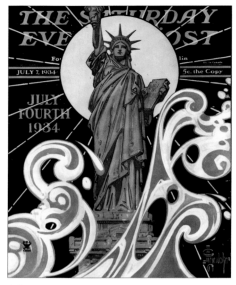

July 7, 1934

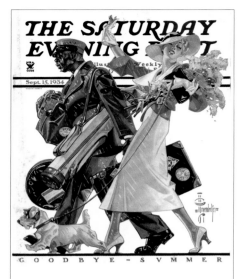

September 15, 1934

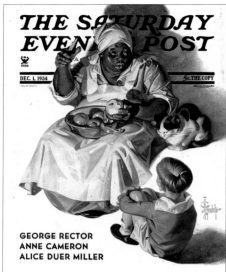

December 1, 1934

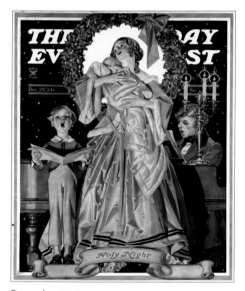

December 29, 1934

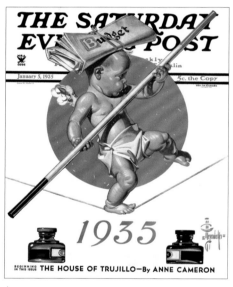

January 5, 1935

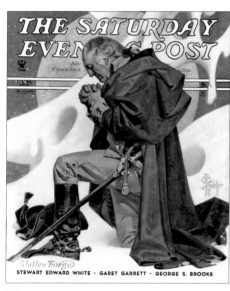

February 23, 1935

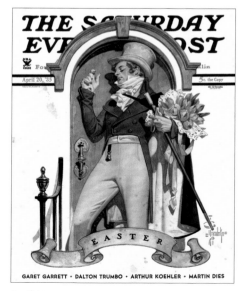

April 20, 1935

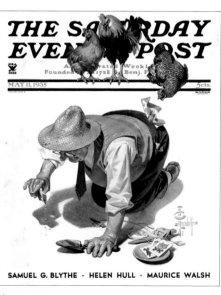

May 11, 1935

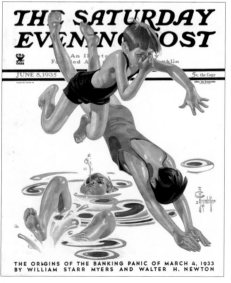

June 8, 1935

OPPOSITE: *Statue of Liberty (July 4, 1934)*. 1934. Oil on canvas, 32 x 25". Signed lower right

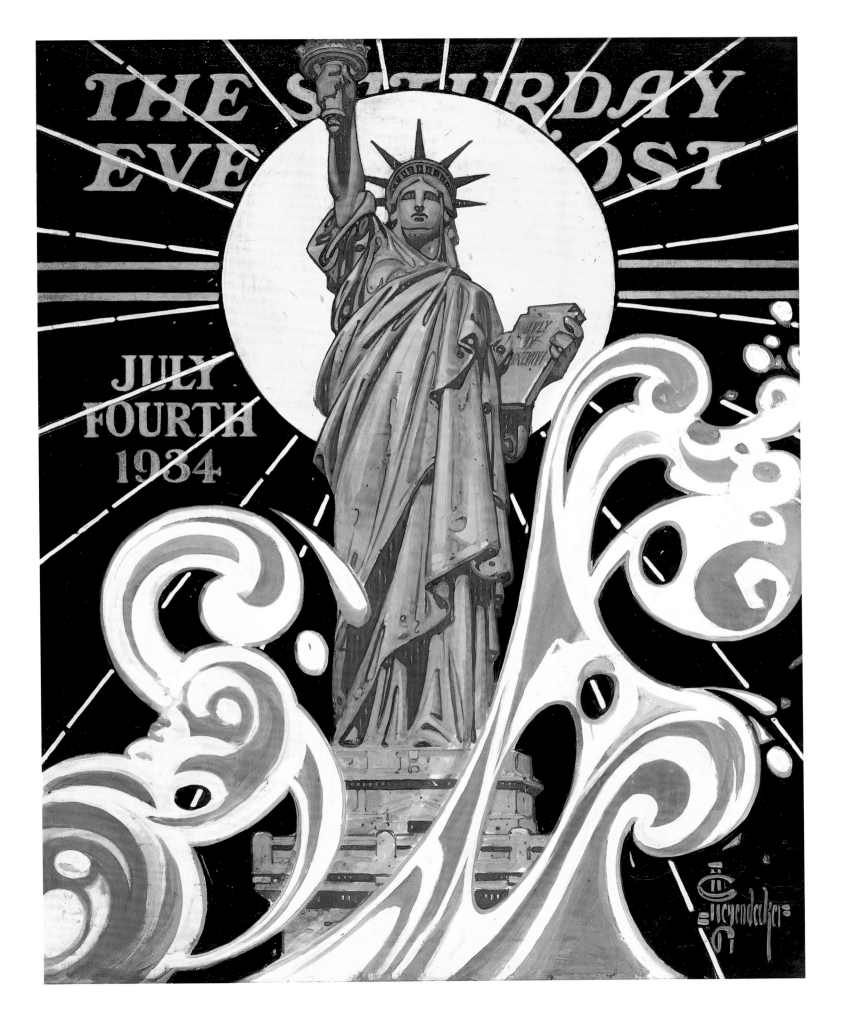

THE SATURDAY EVENING POST

JULY
FOURTH
1934

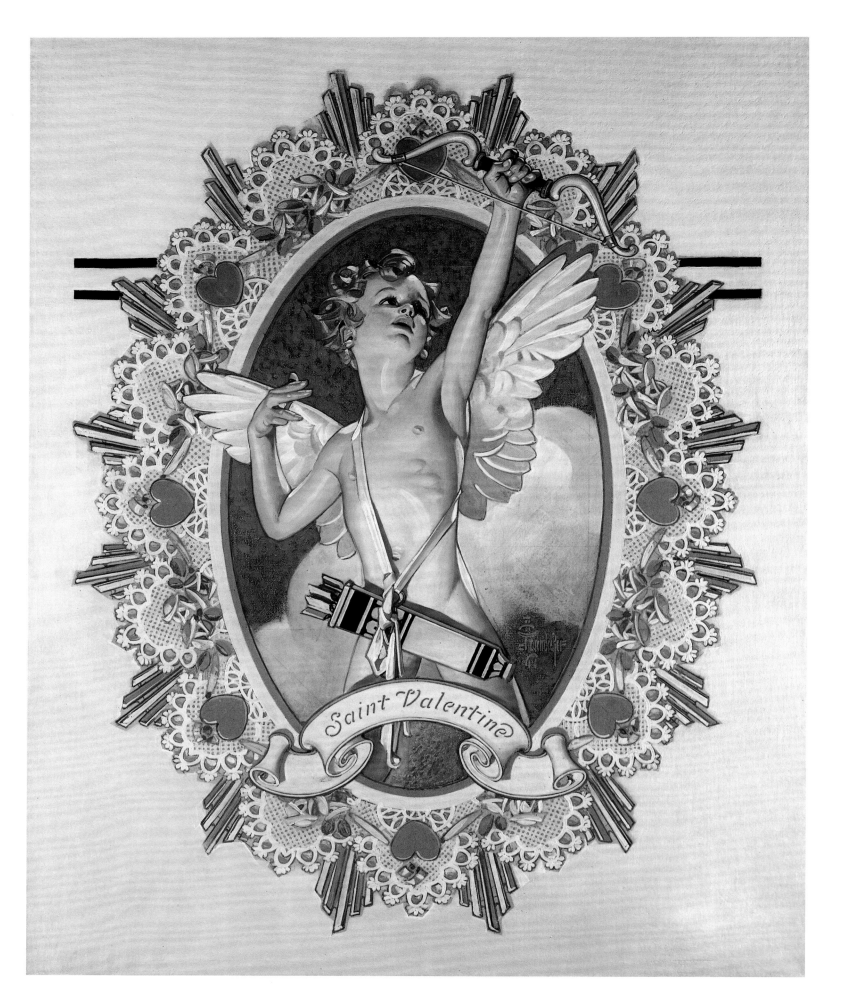

Saint Valentine

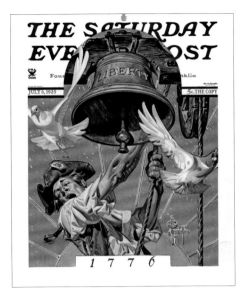

July 6, 1935

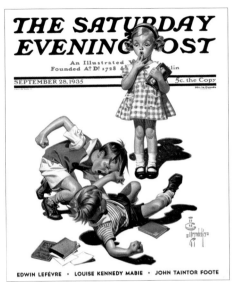

September 28, 1935

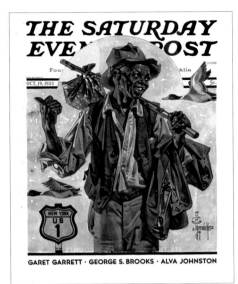

October 19, 1935

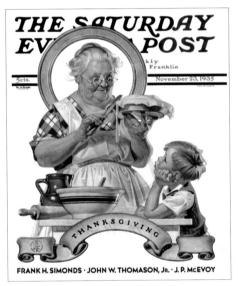

November 23, 1935

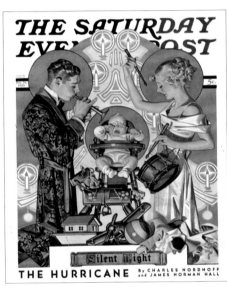

December 28, 1935

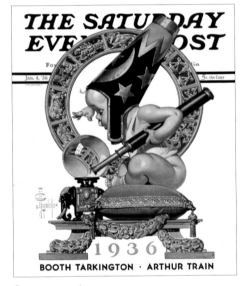

January 4, 1936

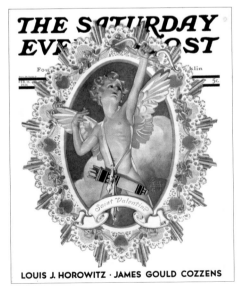

February 15, 1936

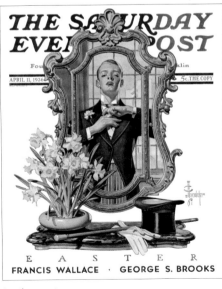

April 11, 1936

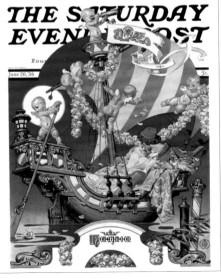

June 20, 1936

OPPOSITE: *Saint Valentine*. 1936. Oil on canvas, 30 x 24". Signed center right

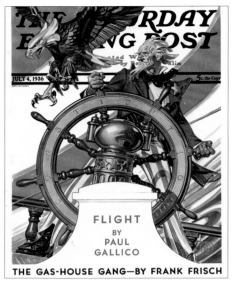

THE GAS-HOUSE GANG—BY FRANK FRISCH

July 4, 1936

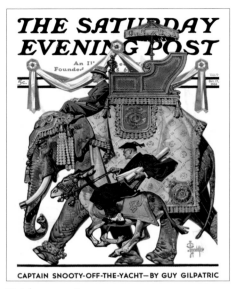

CAPTAIN SNOOTY-OFF-THE-YACHT—BY GUY GILPATRIC

October 17, 1936

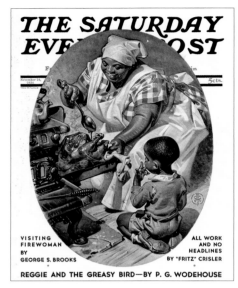

REGGIE AND THE GREASY BIRD—BY P. G. WODEHOUSE

November 28, 1936

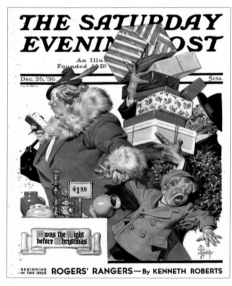

ROGERS' RANGERS—By KENNETH ROBERTS

December 26, 1936

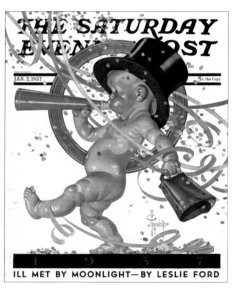

ILL MET BY MOONLIGHT—BY LESLIE FORD

January 2, 1937

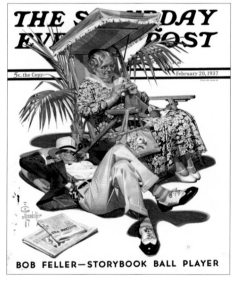

BOB FELLER—STORYBOOK BALL PLAYER

February 20, 1937

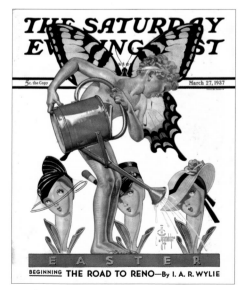

EASTER

BEGINNING THE ROAD TO RENO—By I. A. R. WYLIE

March 27, 1937

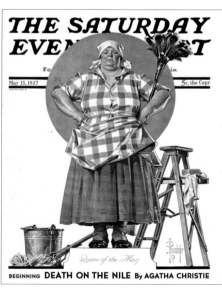

BEGINNING DEATH ON THE NILE By AGATHA CHRISTIE

May 15, 1937

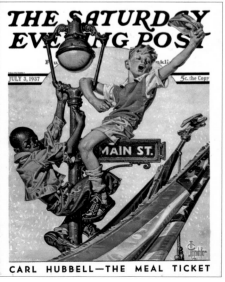

CARL HUBBELL—THE MEAL TICKET

July 3, 1937

OPPOSITE: *Fourth of July Flagpole.* 1937. Oil on canvas, 31½ x 24¼". Signed lower right

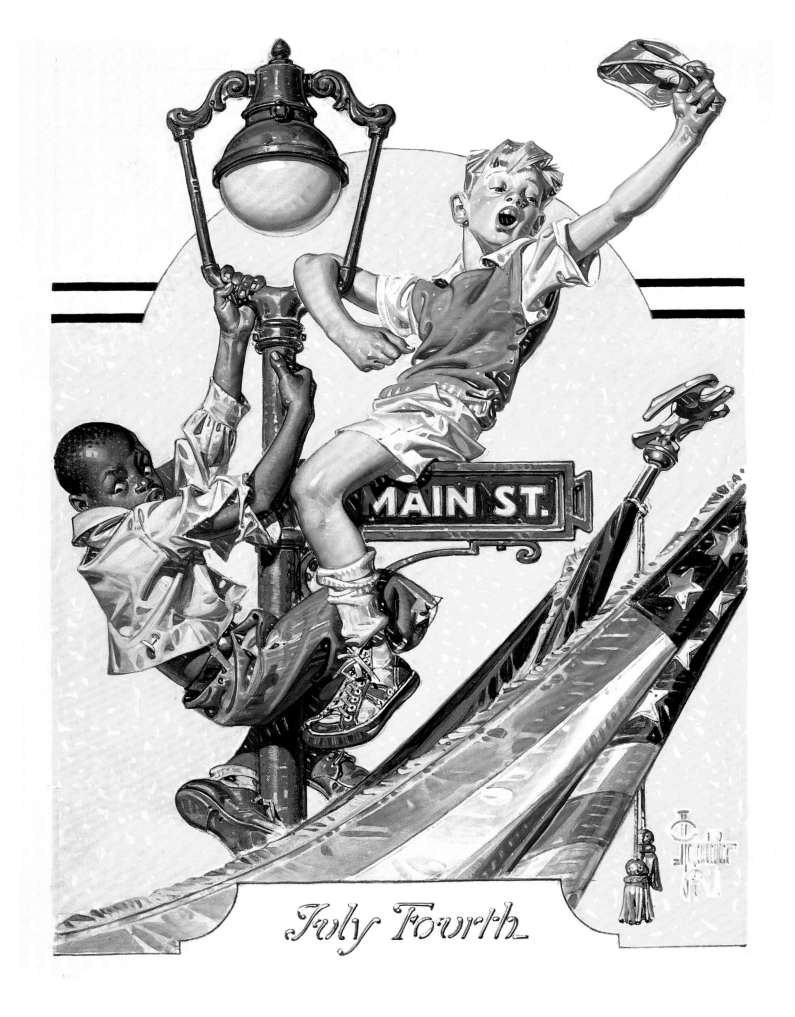

July Fourth

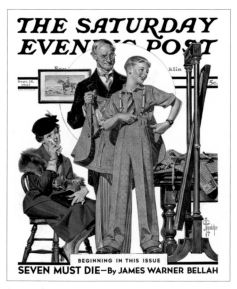

September 18, 1937

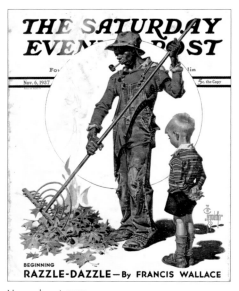

November 6, 1937

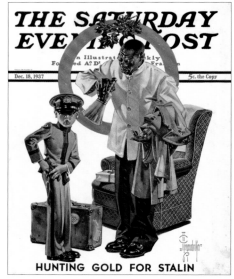

December 18, 1937

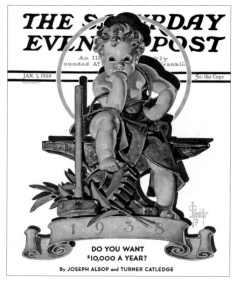

January 1, 1938

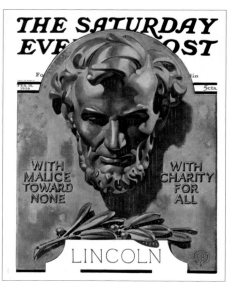

February 12, 1938

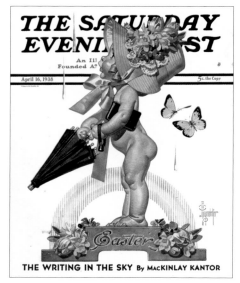

April 16, 1938

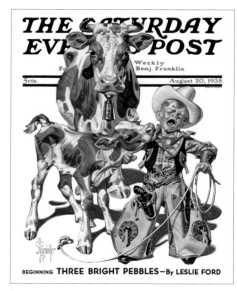

August 20, 1938

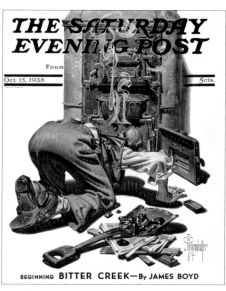

October 15, 1938

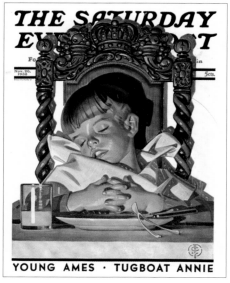

November 26, 1938

OPPOSITE: *Raking Leaves.* 1937. Oil on canvas, 31 x 24". Signed lower right

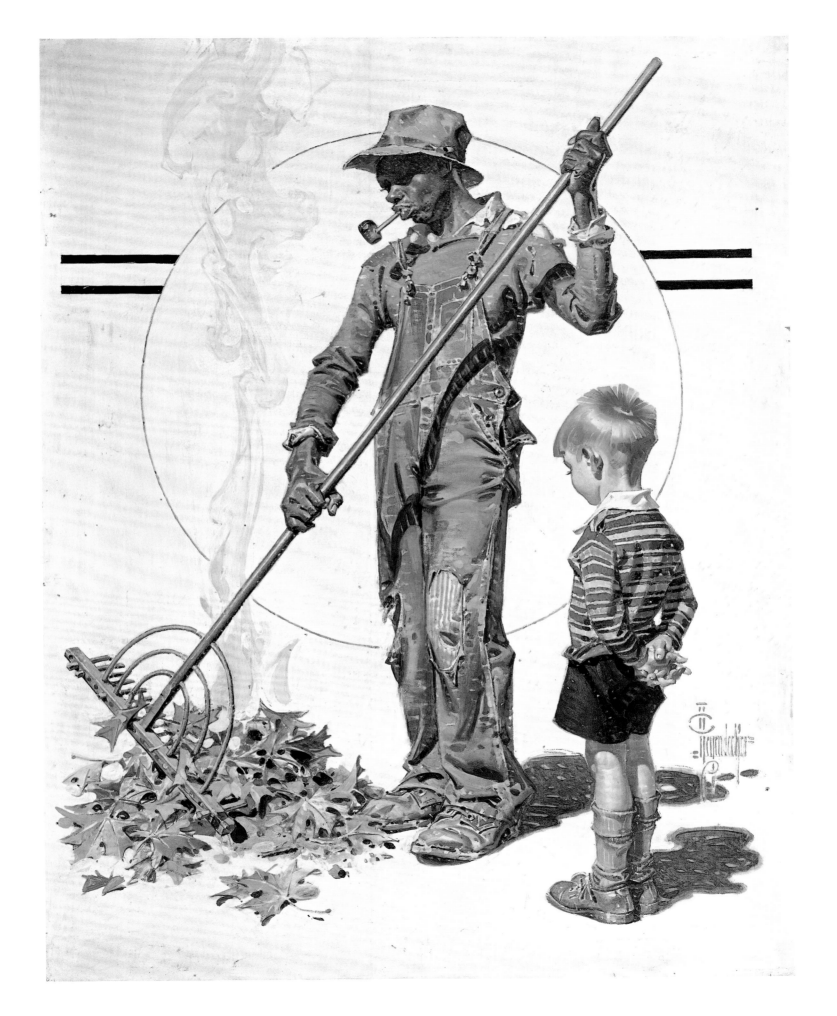

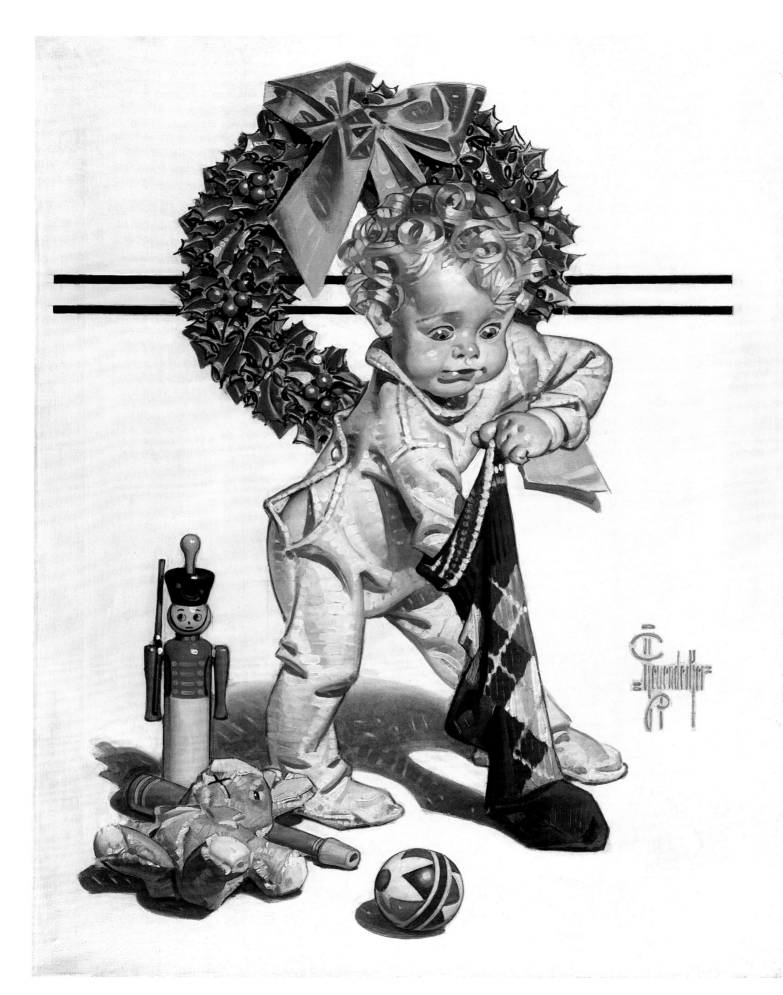

DOC MELLHORN AND THE PEARLY GATES—BENÉT

December 24, 1938

1939

A TRACTOR STORY BY WILLIAM HAZLETT UPSON

December 31, 1938

BEGINNING
ARIZONA By CLARENCE BUDINGTON KELLAND

February 25, 1939

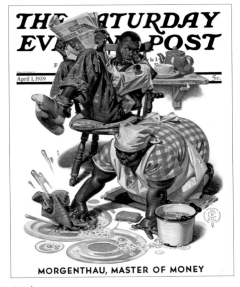

MORGENTHAU, MASTER OF MONEY

April 1, 1939

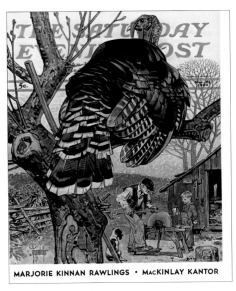

MARJORIE KINNAN RAWLINGS • MacKINLAY KANTOR

November 25, 1939

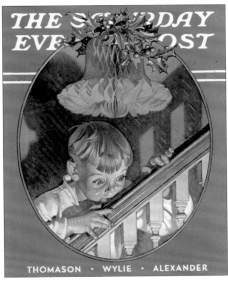

THOMASON • WYLIE • ALEXANDER

December 23, 1939

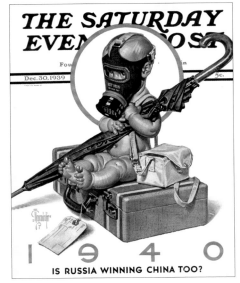

1940

IS RUSSIA WINNING CHINA TOO?

December 30, 1939

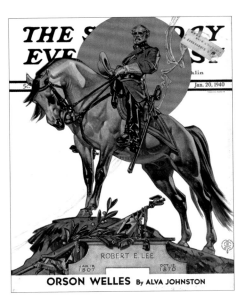

ROBERT E. LEE
JAN. 19, 1807 OCT. 12, 1870
ORSON WELLES By ALVA JOHNSTON

January 20, 1940

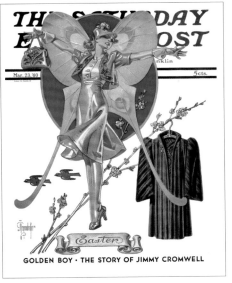

Easter
GOLDEN BOY • THE STORY OF JIMMY CROMWELL

March 23, 1940

OPPOSITE: *Baby's First Christmas*. 1938. Oil on canvas, 31 x 24". Signed lower right

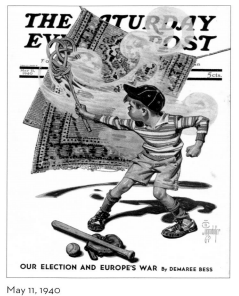

May 11, 1940

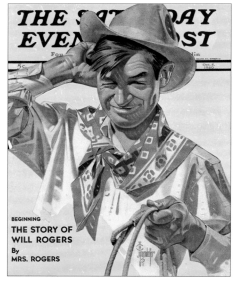

October 5, 1940

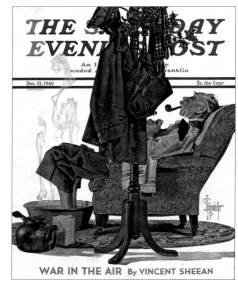

December 21, 1940

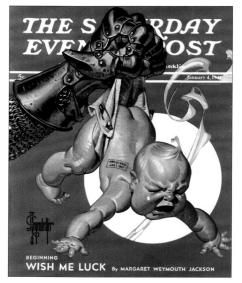

January 4, 1941

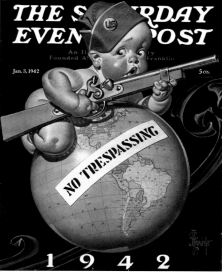

January 3, 1942

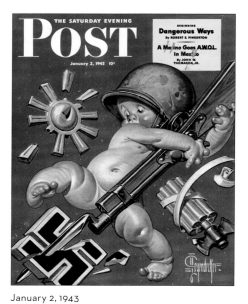

January 2, 1943

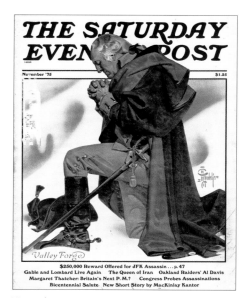

November 1975

August 1986

OPPOSITE: *Thanksgiving 1648.* 1940. Oil on canvas, 31 x 23". Signed lower right. Reproduced: *American Weekly*, November 1948, cover

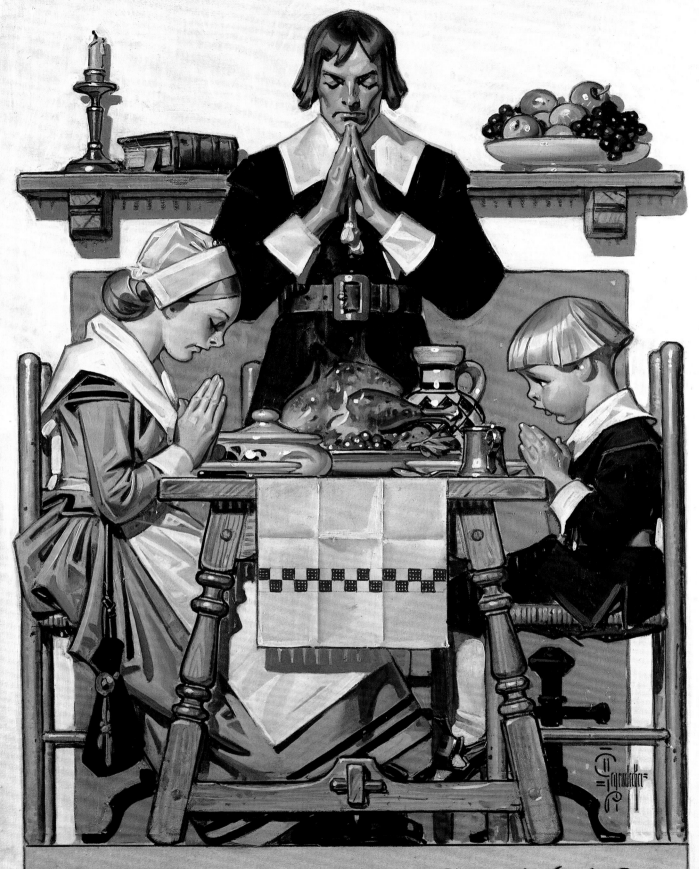

THANKSGIVING 1648

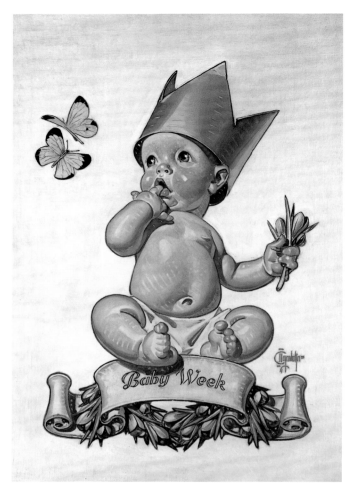

ABOVE: *The American Weekly.* April 28, 1946. Printed magazine cover

RIGHT: *Baby Week.* 1946. Oil on canvas, 33 x 23". Signed lower right

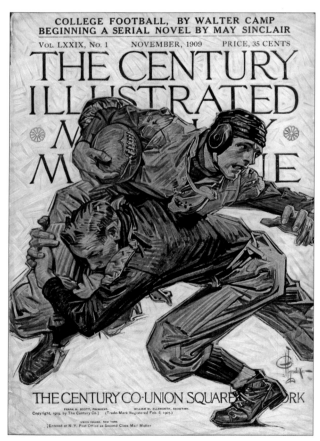

The Century. November 1909. Printed magazine cover

Football Players (College Football). 1909. Oil on canvas, 26 x 20". Signed lower right

The Club-Fellow. c. 1904. Printed magazine cover

November 1898

April 1, 1899

February 20, 1904

March 5, 1904

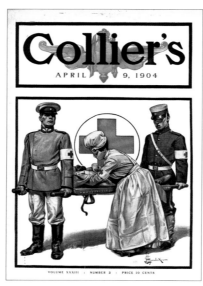

April 9, 1904

May 7, 1904

June 4, 1904

June 18, 1904

September 3, 1904

OPPOSITE: *Couple on Deck Chairs*. 1904. Tempera on board , 16 x16". Signed lower left

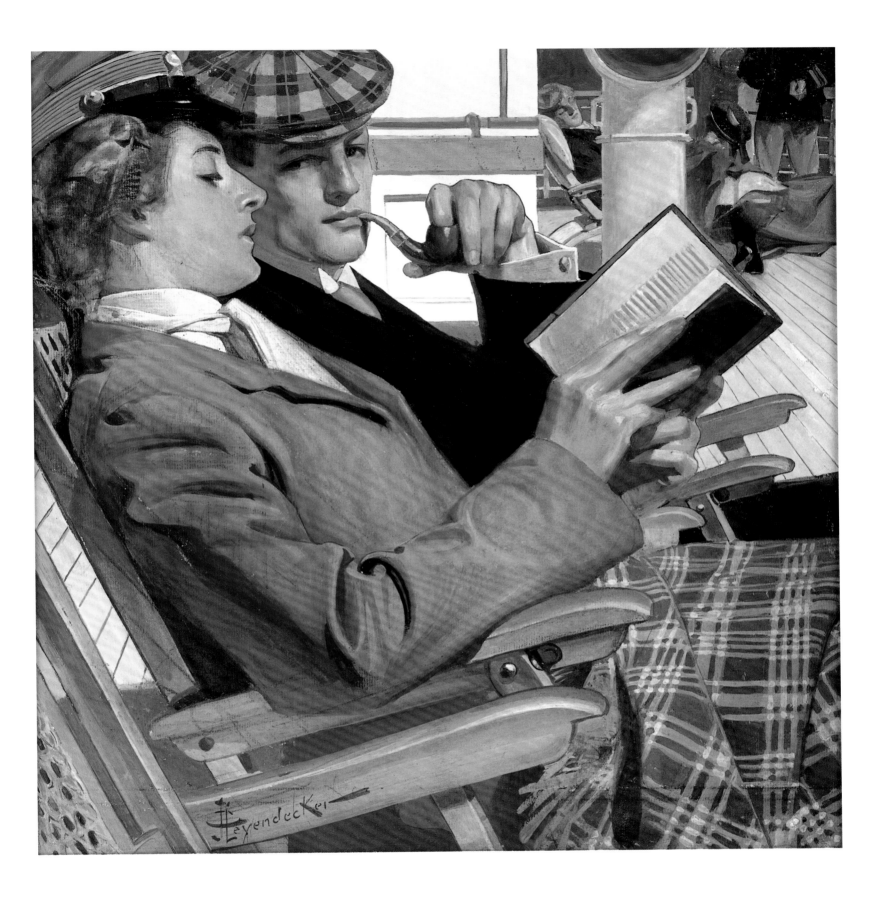

October 22, 1904

November 19, 1904

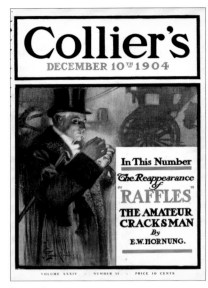

December 10, 1904

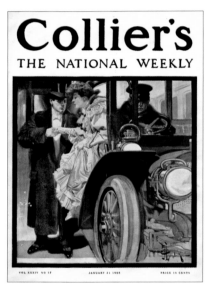

January 21, 1905

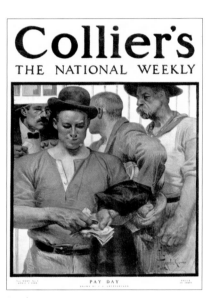

April 1, 1905

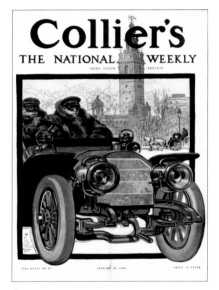

January 20, 1906

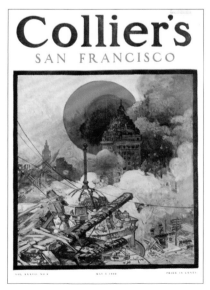

May 5, 1906

August 11, 1906

October 6, 1906

OPPOSITE: *Football Players (The Tackle)*. 1904. Oil on canvas, 21¼ x 19¼". Signed lower right

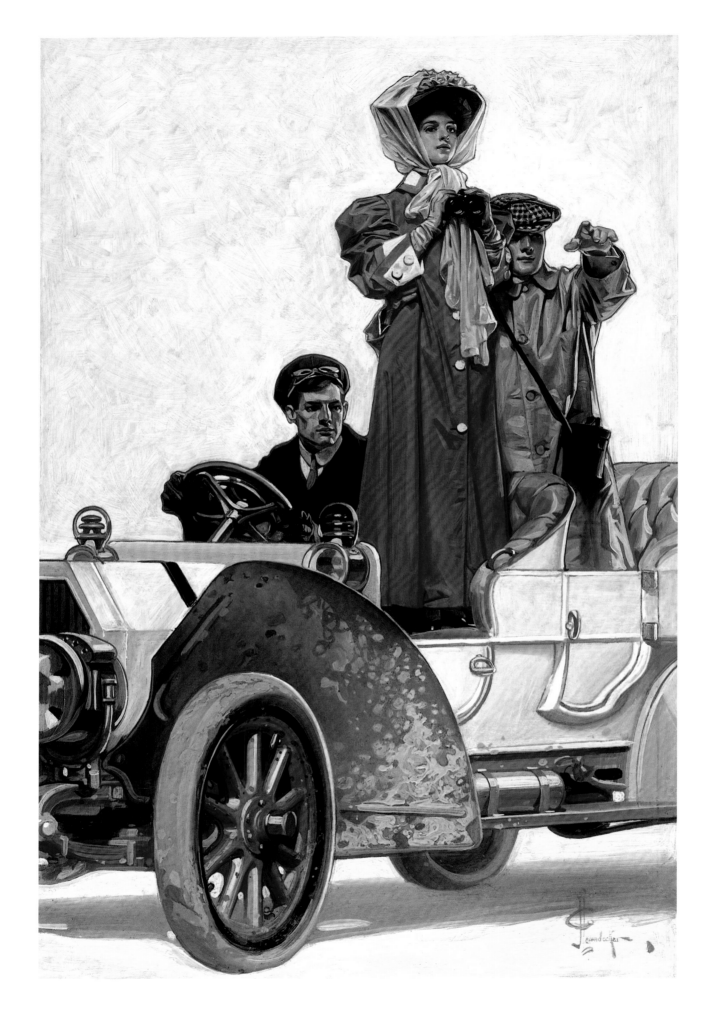

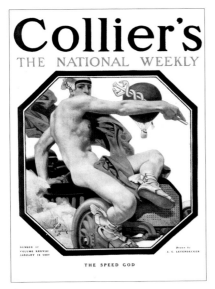

January 19, 1907

February 23, 1907

March 23, 1907

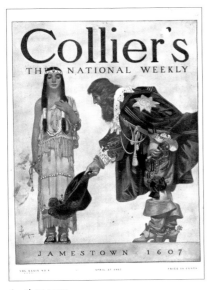

April 27, 1907

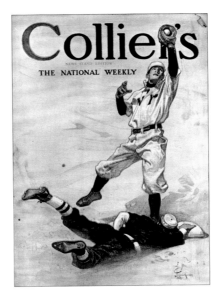

May 25, 1907

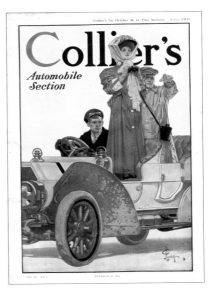

October 26, 1907

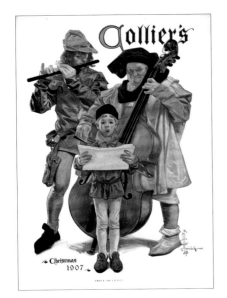

December 21, 1907

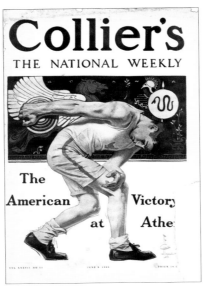

June 9, 1908

August 28, 1909

OPPOSITE: *The Lady and Her Motorcar.* 1906. Oil on canvas, 31 x 21". Signed lower right

October 16, 1909

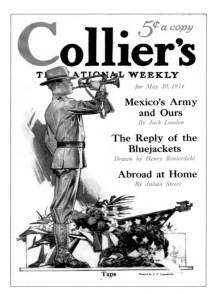

May 30, 1914

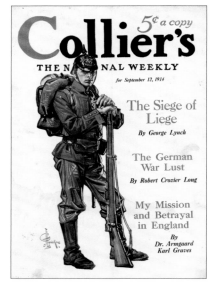

September 12, 1914

November 28, 1914

October 9, 1915

December 11, 1915

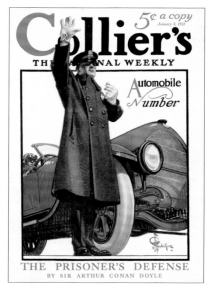

January 8, 1916

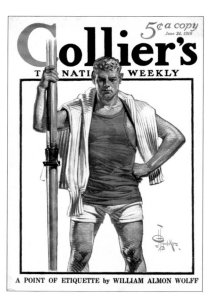

June 24, 1916

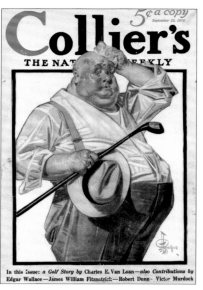

September 23, 1916

OPPOSITE: *German Soldier*. 1914. Oil on canvas, 30 x 21". Signed lower left

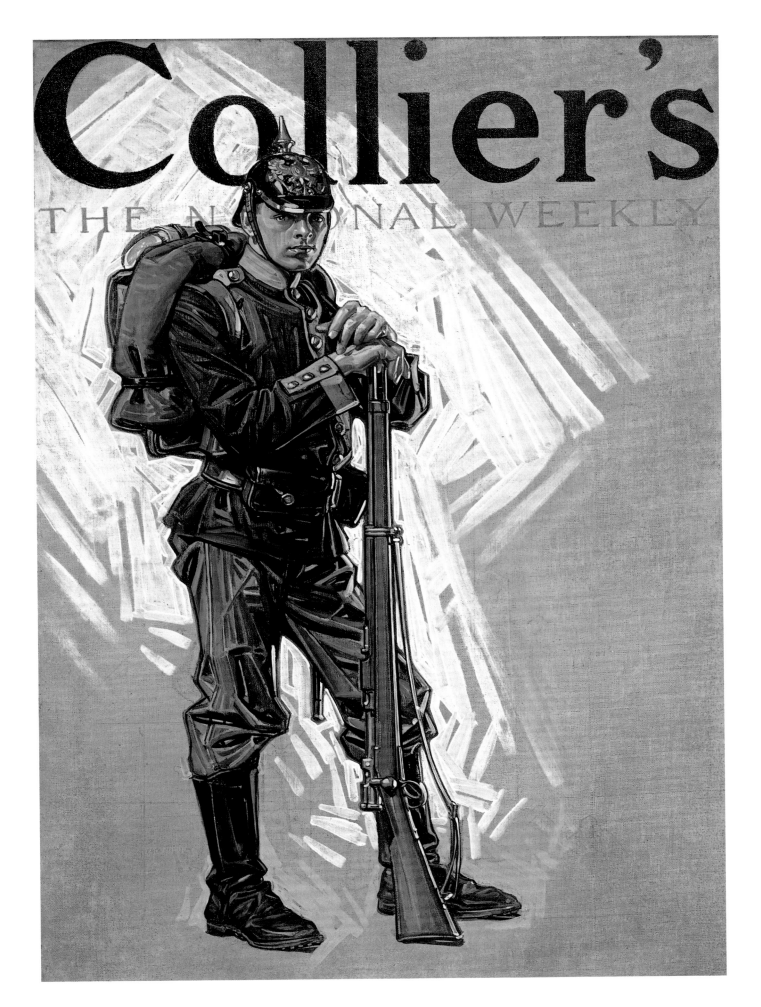

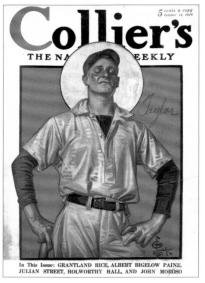

October 14, 1916

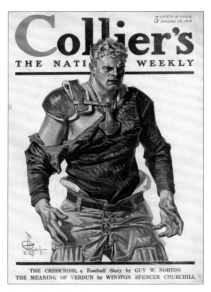

November 18, 1916

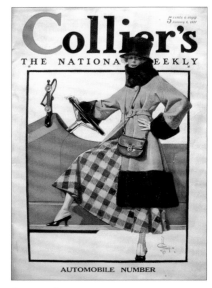

January 16, 1917

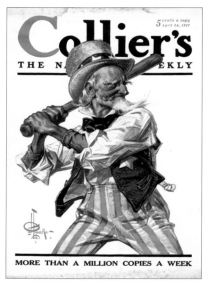

April 14, 1917

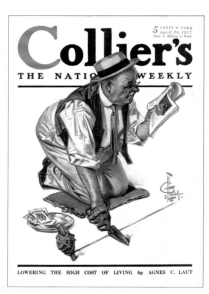

April 28, 1917

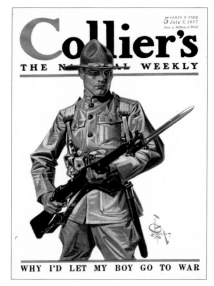

July 7, 1917

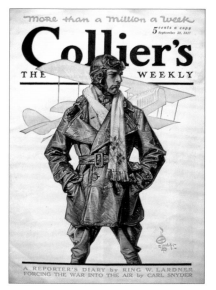

September 29, 1917

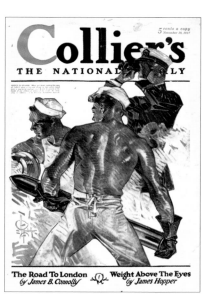

November 10, 1917

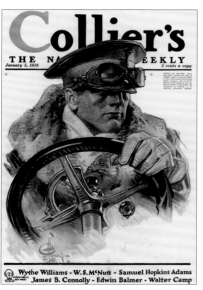

January 5, 1918

OPPOSITE: *Air Force Pilot*. 1917. Oil on canvas, 27 x 20". Signed lower right

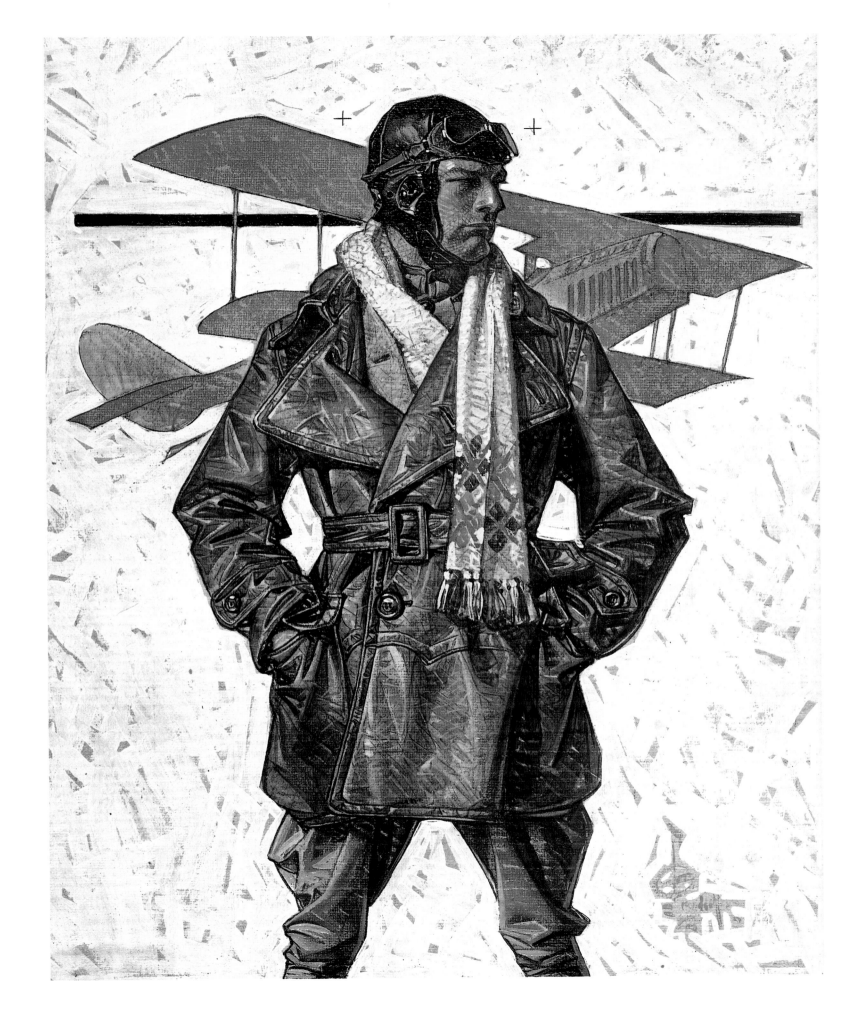

November 1896

December 1896

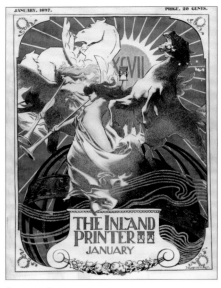

January 1897

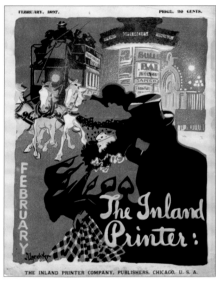

February 1897

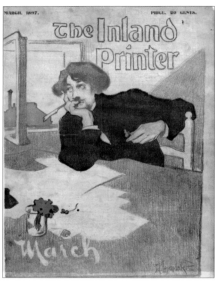

March 1897

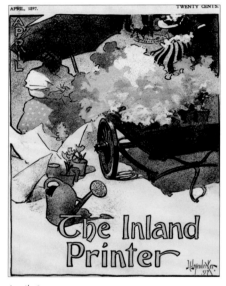

April 1897

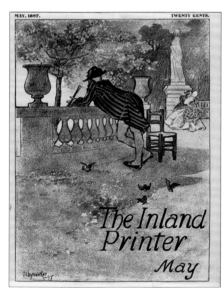

May 1897

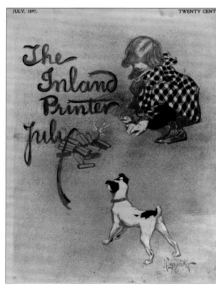

July 1897

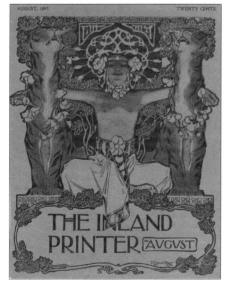

August 1897

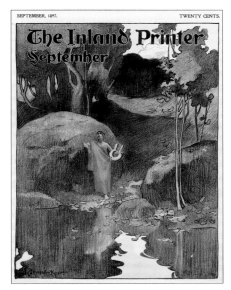

September 1897

October 1897

Poster from artwork for *The Inland Printer*,
December 1901 issue

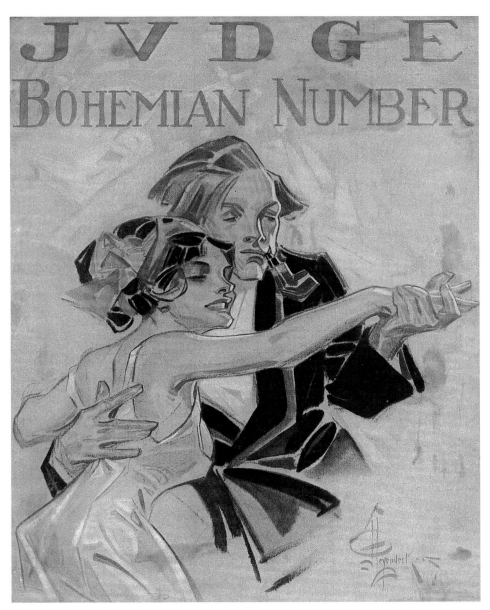

Judge. c. 1905. Printed magazine cover

CLOCKWISE FROM TOP LEFT: *Lady in Grecian Gown Draping Flowers* (study). 1903. Gouache, watercolor, conté and ink on board, 11⅝ x 15⅛". Signed, inscribed, and dated verso. *The Literary Digest*. December 25, 1915. Printed magazine cover. *Lady Diving*. 1910. Oil on canvas, 16 x 12". Signed lower right. Reproduced: *The Pittsburgh Dispatch Monthly Magazine*, June 12, 1910, cover. *The Literary Digest*. April 25, 1908. Printed magazine cover

OPPOSITE: *Couple on Raft*. 1909. Oil on canvas, 30 x 20". Signed lower left and inscribed, "To My Friend W. H. Haines/ Sincerely, J. C. Leyendecker." Reproduced: *Popular Magazine*, August 1909, cover

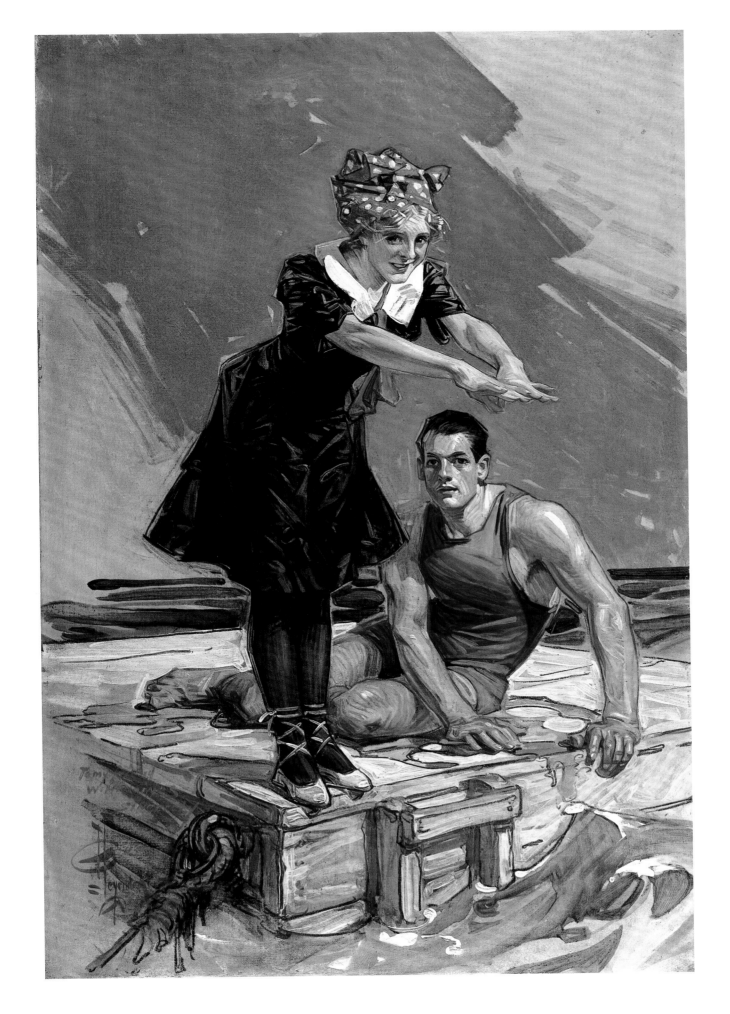

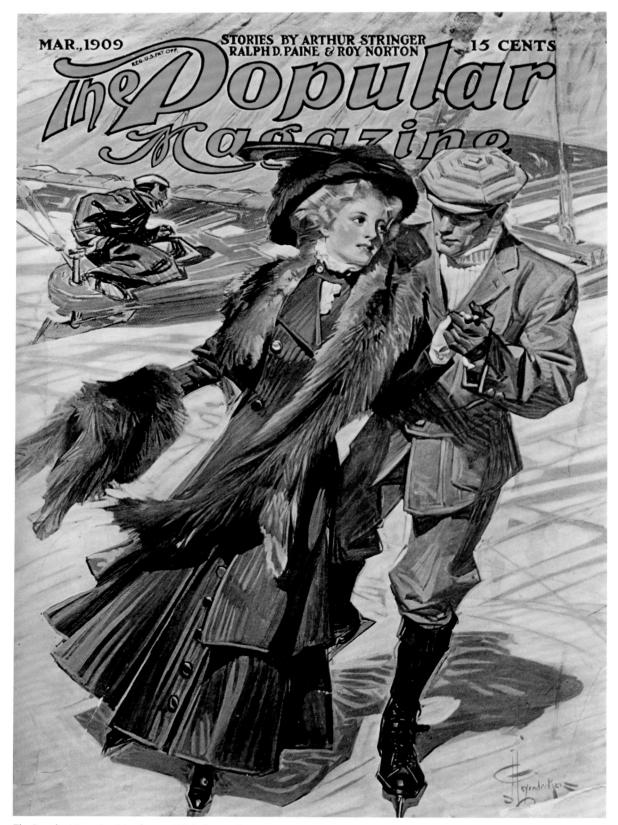

The Popular Magazine. March 1909. Printed magazine cover

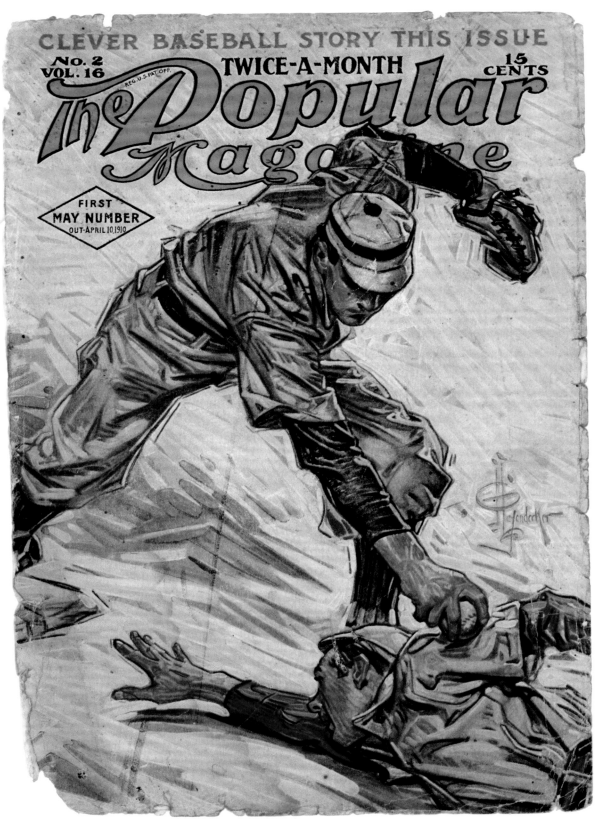

Out or Safe? April 10, 1910. Printed magazine cover

ABOVE: *The Garden Walk. Success.* June 1904. Printed magazine cover

RIGHT: *The Garden Walk.* 1904. Tempera on board, 21⁷/₈ x 15¼". Signed lower left

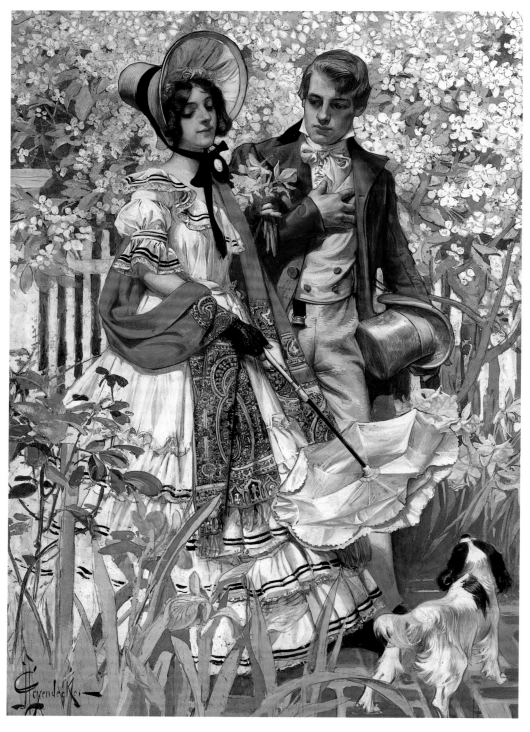

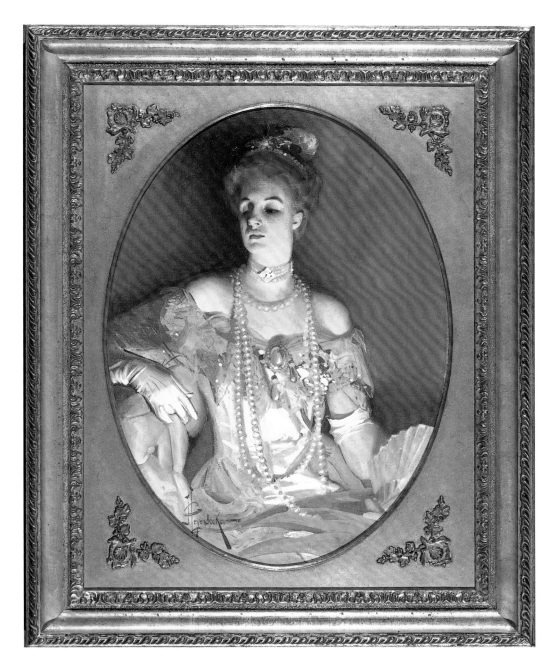

ABOVE: *Success*. February 1905. Printed magazine cover

LEFT: *Victorian Lady at the Opera*. 1905. Oil on canvas on board, 26 x 18" (oval). Signed lower left

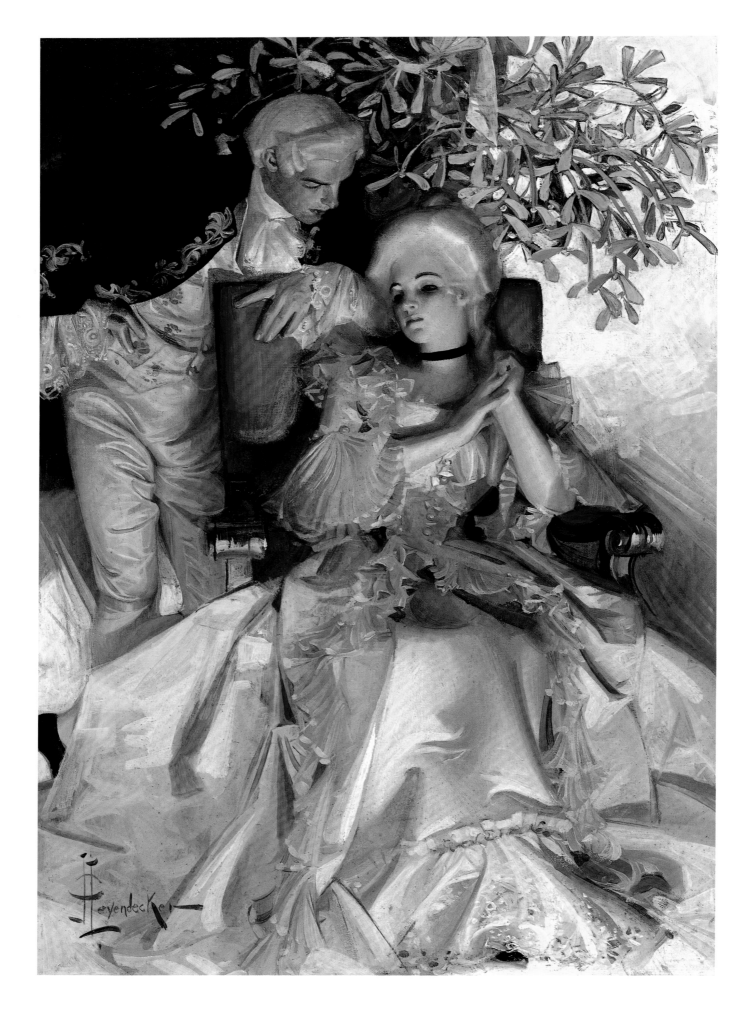

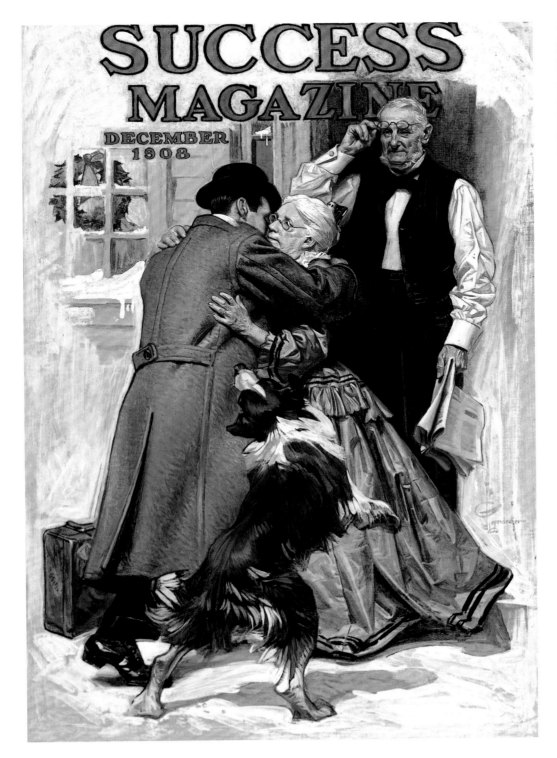

OPPOSITE: *Colonial Couple under the Mistletoe.* 1905.
Oil on canvas, 22 x 15¼". Signed lower left. Reproduced:
Success, December 1905, cover

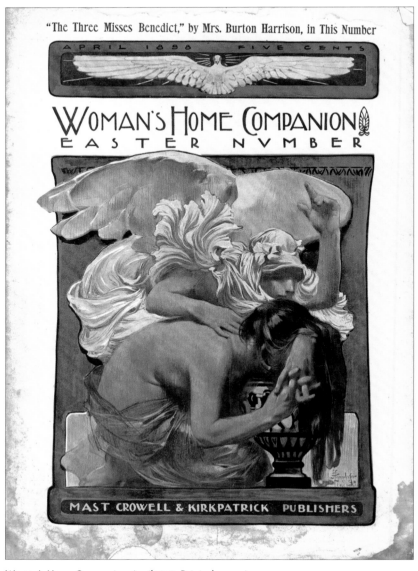

Woman's Home Companion. November 1897. Printed magazine cover

Woman's Home Companion. April 1898. Printed magazine cover

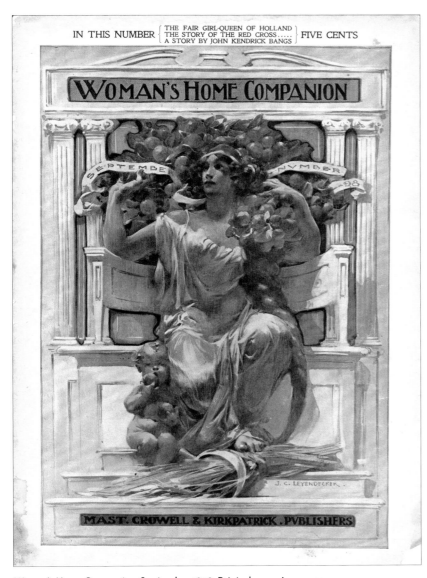

Woman's Home Companion. September 1898. Printed magazine cover

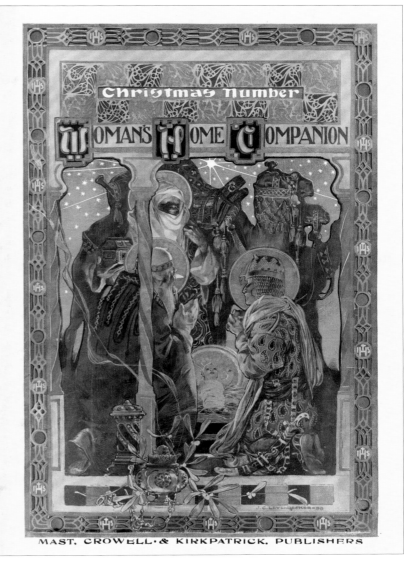

Woman's Home Companion. December 1898. Printed magazine cover

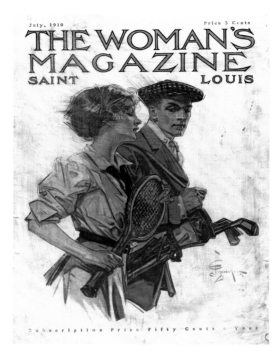

ABOVE: *The Woman's Magazine of St. Louis.* July 1910.
Printed magazine cover

RIGHT: *Golf or Tennis?* 1910. Oil on canvas, 30 x 21". Signed
lower right

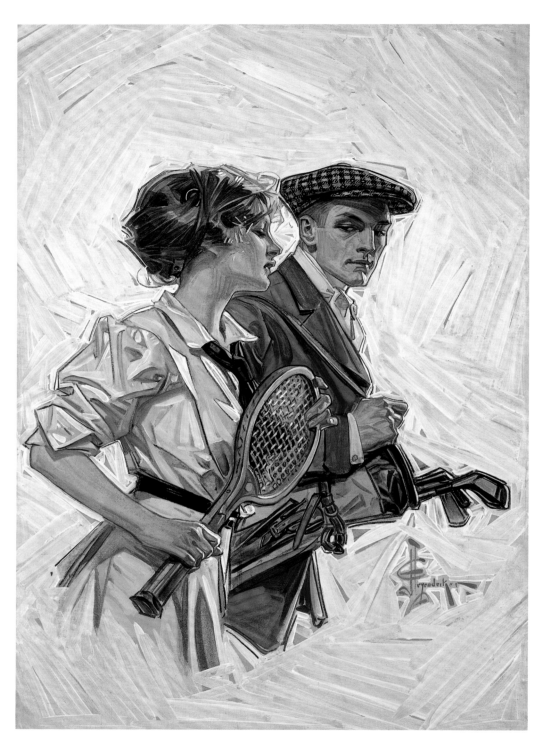

OPPOSITE: *The World's Work.* November 1901. Printed
magazine cover

THE
WORLD'S
WORK

VOLUME III; Nº 13.
NOVEMBER 1901.

PRICE 25 CENTS
3.00 A YEAR.

J.C.LEYENDECKER

DOUBLEDAY, PAGE & COMPANY, NEW YORK.

New Year's • Baby

While the Arrow Collar Man was seminal in the business world, the New Year's Baby was perhaps J.C. Leyendecker's greatest contribution to global iconography. He invented the notion of a baby ringing in the New Year for a December 1906 *Saturday Evening Post* cover. Joe's first New Year's Baby was actually a cherub with small wings, an illustration that immediately caught the public's fancy. Subsequently, for almost forty years every January issue of *The Saturday Evening Post* had a Leyendecker New Year's Baby on the cover. Throughout America, people anxiously awaited the *Post*'s new Baby cover, and the magazine itself became as much a tradition as the mirrored ball dropping in Times Square. Globally, Leyendecker's New Year's Baby became as popular as Santa Claus. It is now embraced as a worldwide symbol for a new beginning and a fresh future.

Notable examples of J.C. Leyendecker New Year's Babies include his 1931 *Post* cover, where the baby is seen forging his way out of the Great Depression, and one from 1940, in which the baby wears a gas mask, indicating the horrors of World War II.

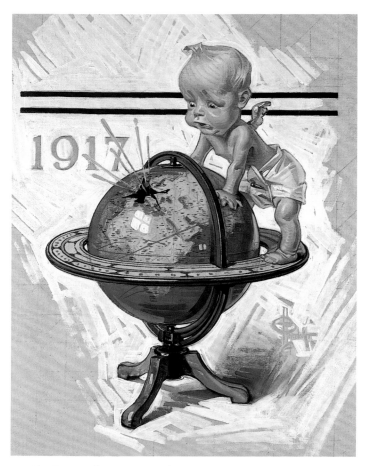

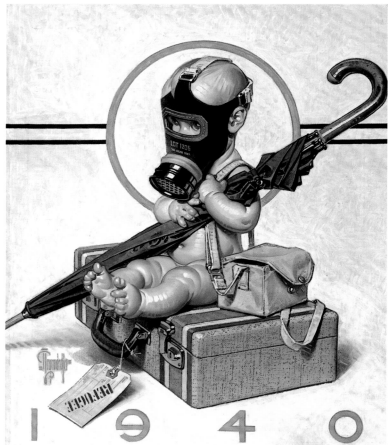

TOP: *New Year's Baby 1908.* 1907. Oil on canvas, 24 x 20". Signed lower right. Reproduced: *Saturday Evening Post,* December 28, 1907, cover

ABOVE: *New Year's Baby 1917.* 1916. Oil on canvas, 24 x 18½". Signed lower right. Reproduced: *Saturday Evening Post,* December 30, 1916, cover

ABOVE: *New Year's Baby 1940.* 1939. Oil on canvas, 31½ x24". Signed lower left. Reproduced: *Saturday Evening Post,* December 30, 1939, cover

OPPOSITE: *New Year's Baby 1931.* 1930. Oil on canvas, 32 x 24". Monogrammed lower left. Reproduced: *Saturday Evening Post,* December 27, 1930, cover

PAGE 198: *New Year's Baby 1925.* 1924. Oil on canvas, 28¼ x 20¼". Monogrammed lower right. Reproduced: *Saturday Evening Post,* January 3, 1925, cover

PAGE 199: *New Year's Baby 1938.* 1937. Oil on canvas, 31½ x 24". Signed lower right. Reproduced: *Saturday Evening Post,* January 1, 1908, cover

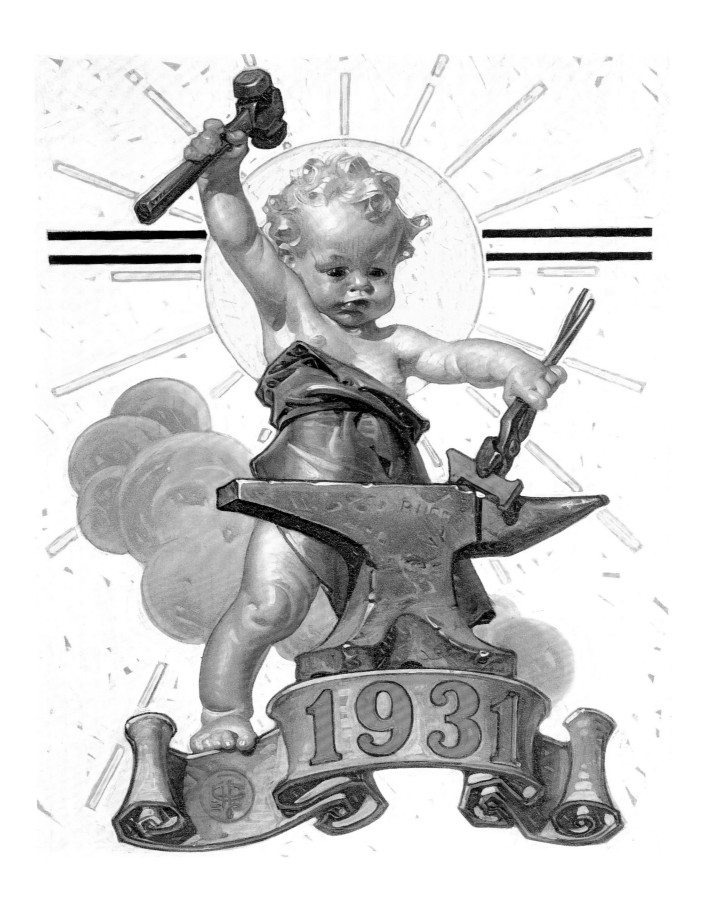

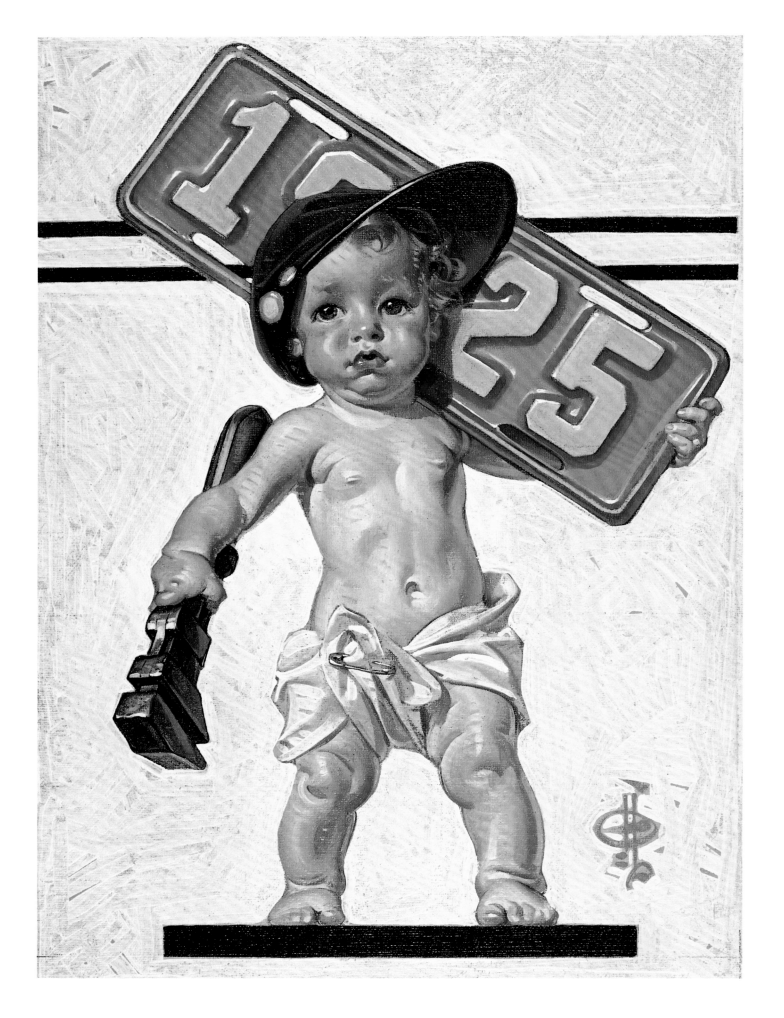

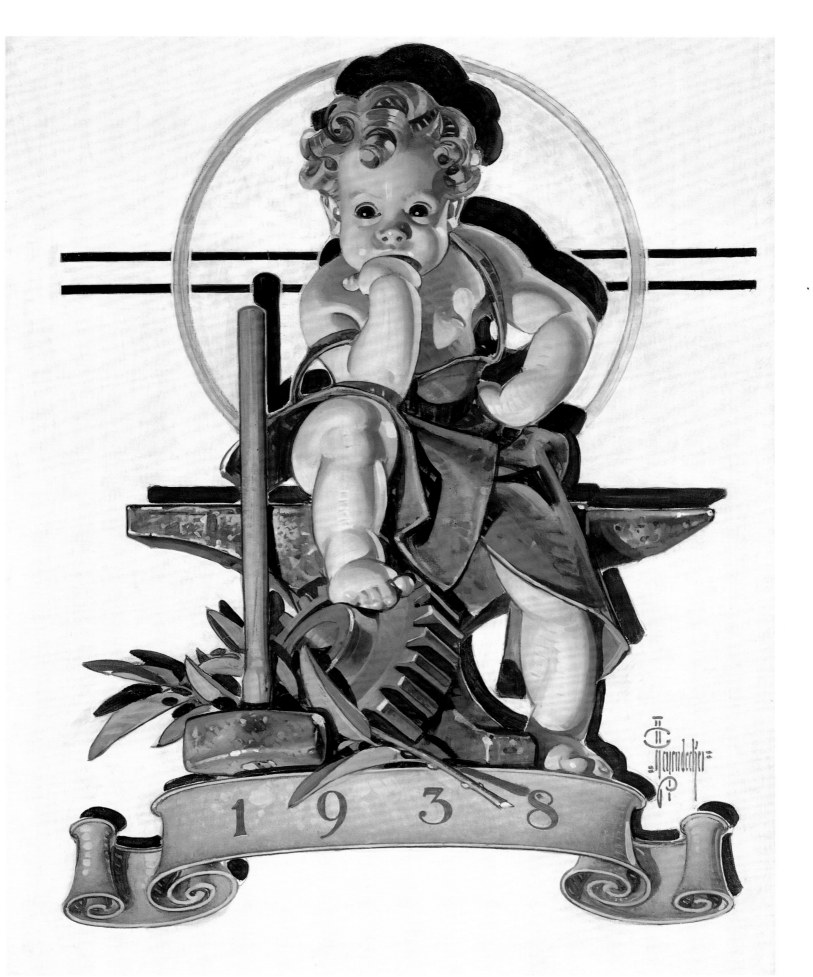

Mother's Day • Flowers

Mother's Day was never intended to be commercially celebrated. Yet today, the Mother's Day holiday virtually sustains florists and generates sales of over 425 million greeting cards annually, 125 million more than the United States population. Mother's Day was originally conceived by Julia Ward Howe (1819–1910). Distraught over the senseless carnage and splitting up of families during the Civil War, the prominent social activist, editor, and author of the *Battle Hymn of the Republic* released in 1870 a Mother's Day Proclamation calling for an international day to celebrate peace and motherhood. It was not until Anna M. Jarvis (1864–1948) campaigned for the creation of a national day of observance in honor of motherhood and peace, however, that the holiday actually came about. The first official observance was May 10, 1908; national recognition did not come until May 1914, when President Woodrow Wilson signed the holiday into law.

Leyendecker was assigned the *Post* cover for the nation's newest national holiday. He decided to use flowers as a gift, instantly creating an American tradition. Not so coincidentally, it was just after Leyendecker completed his beloved Mount Tom gardens, which in the springtime were coming into bloom. Flowers were a logical, sensitive, and beautifully appropriate gift for a mother, and besides, the gender bias of the day assumed that all women loved to putter in their gardens.

After seeing Leyendecker's *Post* cover (*Bellhop with Hyacinths*), America immediately embraced the ritual of giving flowers on the second Sunday in May, erupting into an incredible boon for florists. The fascination with the celebration has grown each year. Mother's Day, like so many American holidays, is now celebrated internationally, and flowers are offered everywhere without either giver or recipient aware that the original impetus was a J.C. Leyendecker magazine cover.

Christmas • Santa's Persona

Thomas Nast (1840–1902), a notable eighteenth-century illustrator dubbed the "Father of Political Cartooning," has often been acknowledged as the creator of our popular image of Santa Claus. Nast, like Leyendecker, was born in the Rhineland-Palatinate. His first Santa—slender with a scraggly, salt-and-pepper beard—appeared climbing into a chimney on an 1863 *Harper's Weekly* cover. Over time, Nast's Santa Claus changed from an elflike creature to a gangly old man, and he went through many variations on that age-old theme.

In truth, Santa Claus's image has been evolving since the time of the real Saint Nicholas in the fourth century A.D. It was not until J.C. Leyendecker interpreted him with finality—and with a specific uniform—that Santa became a brand unto himself. Everyone embraced J.C. Leyendecker's Santa Claus, *our* Santa Claus. Leyendecker took his elements directly from the 1823 poem " 'Twas the Night Before Christmas" by Clement Clarke Moore. A guest had read the poem at one of the annual Mount Tom Christmas parties, enthralling Joe with the intensity and charm of the reading. Suddenly Santa appeared as a rotund fellow with rosy red-tipped nose and cheeks, a belly which shook "like a

Bellhop with Hyacinths. 1914. Oil on canvas, 28 x 20". Signed lower right. Reproduced: *Saturday Evening Post*, May 30, 1914, cover

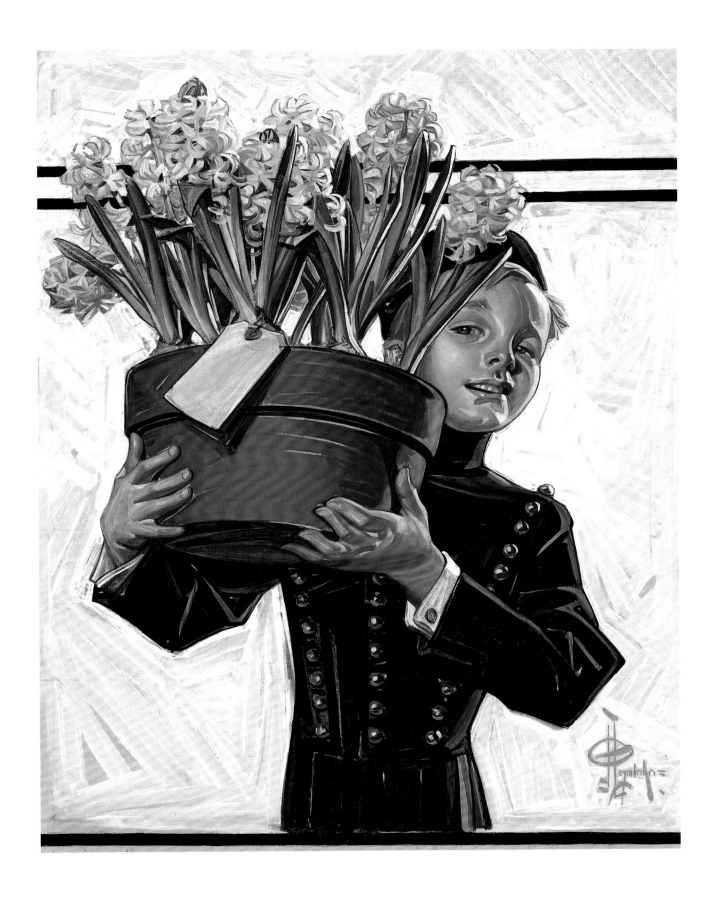

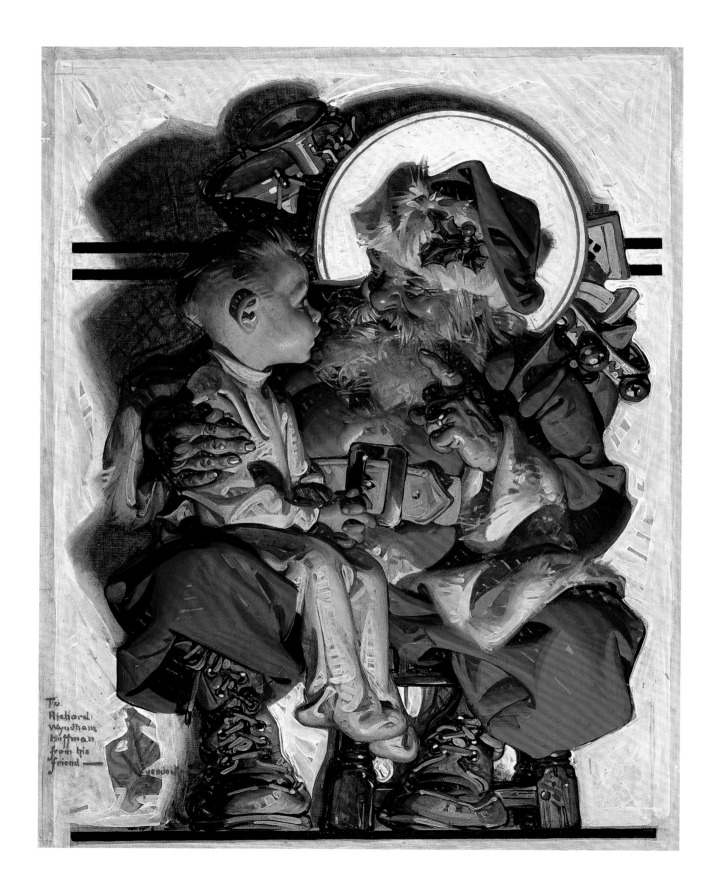

bowlful of jelly," and a red costume with white fur trim. Prior to Leyendecker, interpretations of Santa's outfits ranged from red to green, blue and purple; there was no consistency in the way he was portrayed.

While for many years, illustrator Haddon Hubert Sundblom (1899–1976) was credited with having depicted Santa Claus as we know him, it is clear that he derived his concept from J.C. Leyendecker's image, which predated Sundblom's considerably. Sundblom had simply reconfirmed Leyendecker's 1912 Santa in the 1930s for some advertising pieces he was commissioned to undertake for the Coca-Cola Corporation. Sundblom, with great business acumen, adopted Joe's use of the red and white suit primarily because they were Coca-Cola's corporate colors. To satisfy his client, Sundblom used Santa annually thereafter in Coke ads wearing Joe's red and white. Additionally, he appropriated all the other specific attributes invented by Leyendecker. Massive advertising campaigns at holiday time helped Coca-Cola rise to become the ubiquitous American drink, along with the tagline, "the Claus that refreshes."

Thanksgiving · Football & Homecoming

Since Governor William Bradford of the Plymouth Colony first proclaimed in the seventeenth century the need for a special day dedicated to "giving thanks," debates engendered over which symbol was most suited to the Thanksgiving holiday. Fall foliage, Indians helping Pilgrims, the *Mayflower* were all appealing, uncontroversial suggestions, and all had their proponents, but eventually the turkey surpassed every other. Leyendecker, a great turkey lover himself, created many variations on the turkey theme, portraying, for example, a Pilgrim carrying a squawking fowl to decapitation, a grandmother roasting the bird, and Pilgrims and Native Americans together with turkeys. His greatest Thanksgiving success came, however, when he complemented that singular symbol with another, even more popular one—football—as a secondary theme for his *Saturday Evening Post* covers, creating in the process another uniquely American tradition.

The popularity of the sport had erupted after 1900, when Leyendecker's depictions of football players from Yale, the University of Pennsylvania, and Harvard appeared on the covers of *Collier's*, *The Century*, *The Saturday Evening Post*, and other periodicals. His handsome footballers, shown wrestling, provoking one another, ripping shirts off, muscles and other body parts protruding, were hugely popular with all segments of the American public. Years later, with the game ensconced in the collective consciousness and nearing baseball's popularity, Joe conjoined it with Thanksgiving as a specific holiday theme.

Leyendecker's November 24, 1928, *Post* cover counterbalanced a weary, battle-fatigued player with torn jersey coupled with a genteel Pilgrim, carrying a Bible and a gun (see page 147). This endearing, homoerotic juxtaposition of sensitivity and roughhousing infatuated the readers. It also augmented the customary turkey dinner with physical activity, something which no other holiday offered. Football at Thanksgiving took off like a rocket. Colleges scheduled contests with their traditional archrivals for

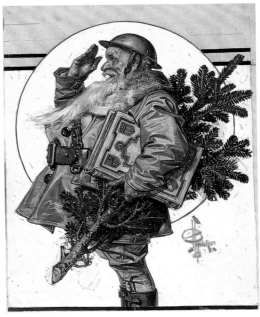

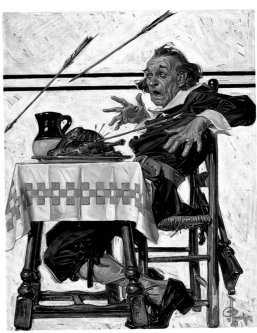

TOP: *World War I Santa*. 1918. Oil on canvas, 30 x 21". Signed lower right. Reproduced: *Saturday Evening Post*, December 7, 1918, cover

ABOVE: *Startled Pilgrim*. 1920. Oil on canvas, 26½ x 19½". Signed lower right. Reproduced: *Saturday Evening Post*, November 27, 1920, cover

OPPOSITE: *Twas the Night Before Christmas (Boy on Santa's Lap)*. 1923. Oil on canvas, 28 x 21". Signed and inscribed lower left: "To Richard Wyndham Hoffman from his Friend—J.C. Leyendecker." Reproduced: *Saturday Evening Post*, December 22, 1923, cover

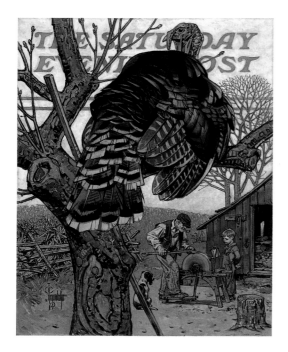

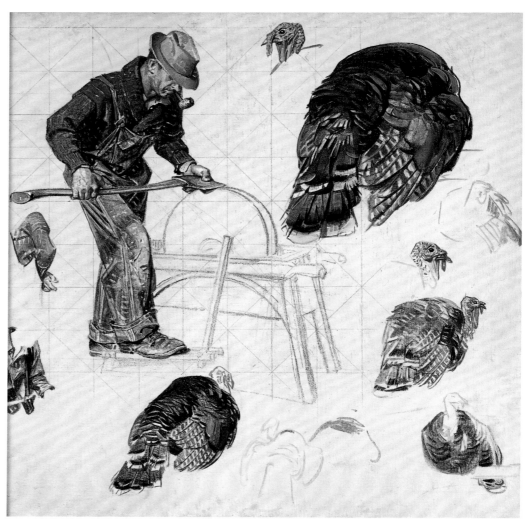

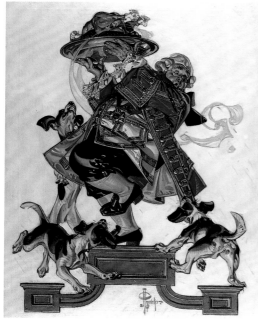

TOP: *A Turkey for Thanksgiving.* 1939. Oil on canvas, 31 x 24". Signed lower left. Reproduced: *Saturday Evening Post*, November 25, 1939, cover

ABOVE: *Bringing in the Turkey.* 1933. Oil on canvas, 32 x 24". Signed lower center. Reproduced: *Saturday Evening Post*, December 2, 1933, cover

ABOVE RIGHT: *A Turkey for Thanksgiving* (study). 1939. Oil on canvas, 23³/₄ x 23⁵/₈". Unsigned

that day in order to enhance and heighten interest in their particular games. This in turn drew school loyalists "back home" for the battle of the year. "Homecoming" became a formal event on campuses thereafter, and this too, can be directly attributed to J.C. Leyendecker.

Independence Day • Firecrackers

Independence Day, celebrated on the fourth day of July, has been taken very seriously since the Declaration of Independence was signed in 1776. It commemorates America's separation from England and recognizes fierce battles fought for freedom from colonial masters. In the early days of rejoicing, real guns and cannons were fired, causing hundreds of deaths across the country. Celebrations were usually government–based with reenactments of battles and bonfires creating battlefield atmospheres, replete with the speeches by political leaders and the firing of weapons. In 1900, the public pleaded with the government for a "safe and sane Fourth." Politicians, taking heed of their constituents, futilely joined the call to wrest away weapons as the means for celebration.

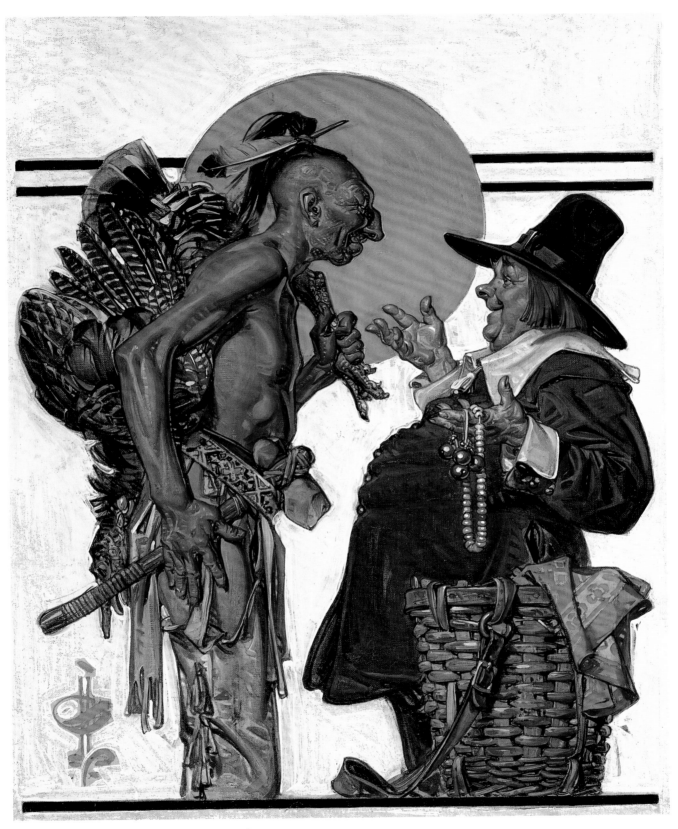

Thanksgiving—Indian Bartering with Pilgrim. 1923. Oil on canvas,
26 x 20". Monogrammed lower left. Reproduced: *Saturday Evening Post*,
December 1, 1923

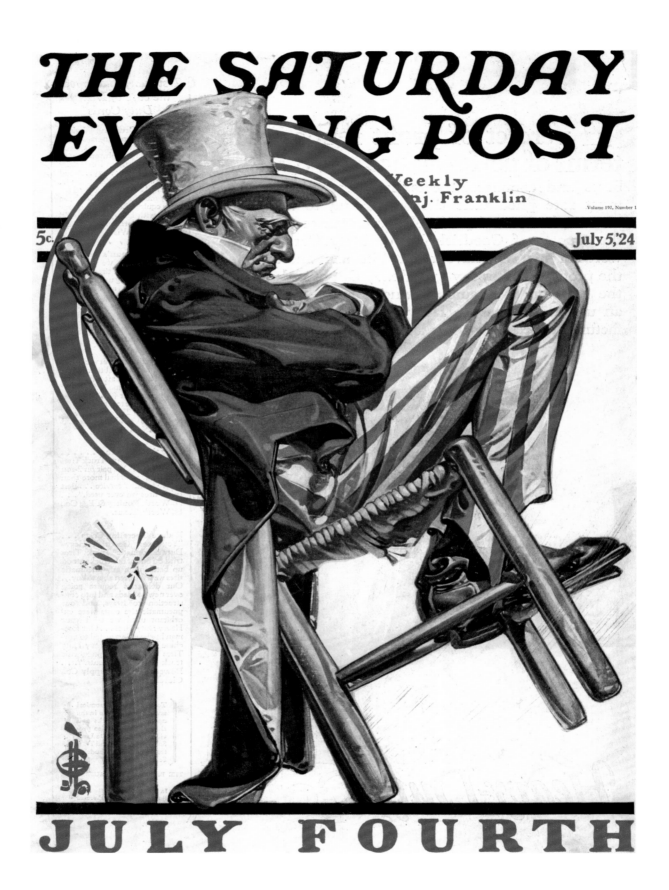

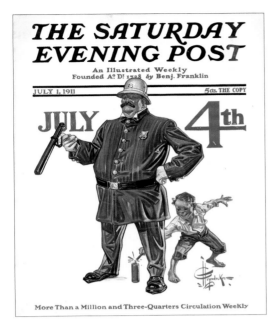

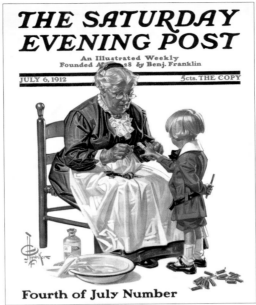

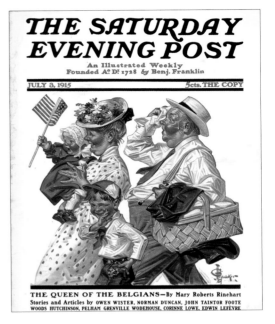

What the politicians could not do by means of years of speechifying, Leyendecker accomplished with a single image. By featuring on a *Saturday Evening Post* cover what had been hitherto a small part of the festivities, he launched the firecracker into new prominence as integral to the Fourth of July celebration. (As with all his work, Leyendecker put his unique slant on his Fourth of July covers; his image of Uncle Sam with a firecracker under his bottom was the most irreverent and the humor purely American.) After its successful appearance, a rage for firecrackers—salutes, cherry bombs, and sparklers—took hold. New industries were born, legal and illegal, professional firecracker igniters were hired for large celebrations, and amateurs were blowing off their fingers and blinding themselves instead of killing each other.

With a Leyendecker cover promoting it, the use of firecrackers was given the *Saturday Evening Post* stamp of approval, meaning that all America approved. Pyrotechnics on the Fourth of July caught on, and the firecracker has served as a symbol of national independence ever since.

Seasons and Mid-Season · Themes

With the public anxiously awaiting each holiday number of the *Post*, the editors selfishly but cleverly recognized that they could increase circulation even further if there were more of them to celebrate. They pushed the government via editorials to declare more holidays, but with employers rebelling, both politicians and the public realized that there had to be a limit. Obviously, while the *Post* tried, it could not invent holidays, so when J.C. Leyendecker suggested painting the four seasons, the editors seized onto the idea. And so Leyendecker provided the magazine with another four record-breaking issues during the course of every year.

While classical allegorical treatments of the seasons had been undertaken by painters, sculptors, poets, and composers for centuries, the only art most of mainstream America

TOP LEFT: *Saturday Evening Post.* July 1, 1911. Printed magazine cover

TOP CENTER: *Saturday Evening Post.* July 6, 1912. Printed magazine cover

TOP RIGHT: *Saturday Evening Post.* July 3, 1915. Printed magazine cover

ABOVE: *Saturday Evening Post.* July 2, 1910. Printed magazine cover

OPPOSITE: *Saturday Evening Post.* July 5, 1924. Printed magazine cover

RIGHT: *Interrupted Picnic*. 1933. Oil on canvas, 31 x 24". Monogrammed lower right. Reproduced: *Saturday Evening Post*, August 26, 1933, cover

OPPOSITE: *Farewell to Summer*. 1934. Oil on canvas, 31 x 24". Signed lower right. Reproduced: *Saturday Evening Post*, September 15, 1934, cover

GOODBYE - SUMMER

RIGHT: *Saturday Evening Post.* May 11, 1940. Printed magazine cover

FAR RIGHT: *Saturday Evening Post.* September 3, 1921. Printed magazine cover

was exposed to on the subject were Leyendecker's images. Soon after those seasonal successes, Leyendecker suggested ways to increase the number from four to eight seasonal issues with his indelible art, humor, and milestone-setting themes. Thus he conceived "Summer" (see *Interrupted Picnic*, August 26, 1933) and then its converse, *Farewell to Summer* (September 15, 1934). He stretched "Spring" out with *Spring Cleaning* (May 11, 1940) and in the process elevated that abhorred chore to near-holiday status. Just before "Fall," Joe devised a *Back to School* theme (September 3, 1921), and this notion too worked its way into the communal acceptance. The public literally bought it, bought it all: *Post* subscriptions rose beyond the publishers' wildest dreams. Four more holidays became eight, and then eleven more guaranteed successful covers during the course of a year.

Labor Day • The Working Man

Honoring the workingman and all working people, this legal holiday is observed on the first Monday in September, as a day of rest and recreation. It is also considered the day that demarcates summer's end.

In 1882, the founder of the United Brotherhood of Carpenters proposed it as a national holiday and organized a parade to make the point. Leyendecker, although not political at all, took advantage of the strong image of a powerful worker, sometimes sitting astride the globe, to project the message of American strength to the world, particularly during World War II (and afterward, to reiterate the point). His depictions of the American working man were as powerful as any Soviet Realist images promoted by the Communist Party in Russia or Eastern Europe. At the same time, they were astonishingly parallel to Fascist images of blonde Teutonic warriors as marshaled by Albert Speer and the other Nazi propagandists and photographed by Leni Riefenstahl. His Labor Day covers were the closest Joe ever came to making a political statement, visually or otherwise.

OPPOSITE: *The American Weekly.* September 1, 1946. Printed magazine cover

THE AMERICAN WEEKLY

Greatest Circulation in the World

"The Nation's Reading Habit"
Magazine Section—Boston Advertiser
Copyright, 1946, by American Weekly, Inc.
All Rights Reserved.

Week of Sept. 1, 1946

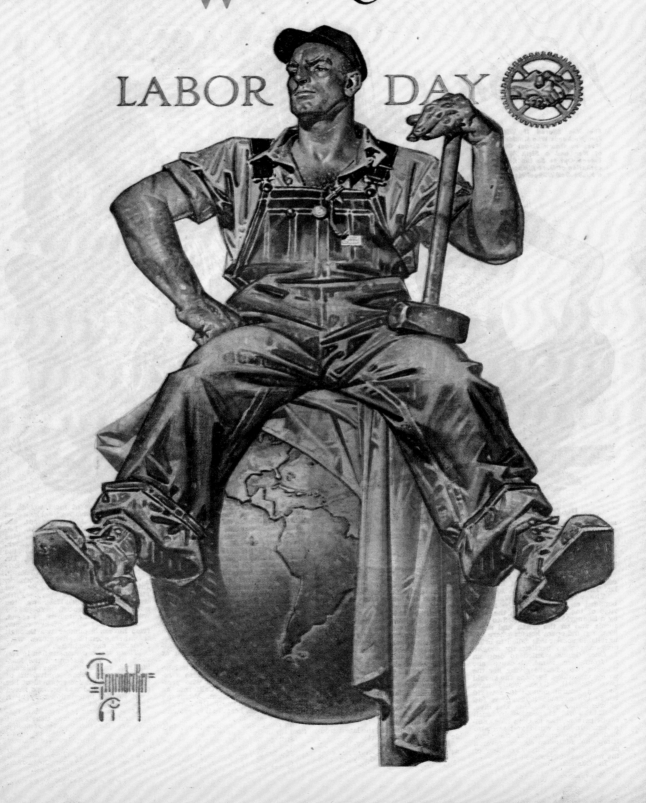

LABOR DAY

BOOK ILLUSTRATION

Despite the axiom of old, there is no question that a book is judged by its cover. And editors still invoke the cover to try to give potential readers a sense of what they will find within. Marketing managers, on the other hand, care only to sell books, and to them the cover is their primary tool. To this end a plethora of studies have been commissioned to guide marketing decisions and cover design.

Leyendecker did not have the benefit of such studies, but he quickly realized another popular age-old axiom, "A picture is worth a thousand words." His clients benefited from additional factors—Joe's uncanny, instinctive creativity, and the popularity of the Leyendecker Look. When describing his success in creating images that worked for his clients, in a brief, unusual comment to a New York newspaper, he stated succinctly that a cover or an advertisement "is like a poster and therefore like a poster it should tell its story on a single flat plane, as if pasted to a wall board. They exist as single flat planes in any case. A cover or a poster or an advertisement should be devoid of perspective and distance should only appear in the abstract and the artist should never have to explain its content."[11] Unlike inside art, the cover must tell a whole story in a single image and sell the magazine or book on which it is placed.

Never really interested in books *per se* as a vehicle for his artworks, Leyendecker was nevertheless thrust into book illustrations from an early age when, prior to receiving any formal training, he painted erudite Bible illustrations for Powers Brothers, a J. Manz Company client. As his career developed, primarily creating advertisements, magazine covers, and inside illustrations for periodicals, he also worked between these assignments on a small group of very diverse books. While his pictures were well received by authors and publishers, books clearly did not have the impact he sought. Unlike the instant gratification he received from periodicals and commercial commissions, which were seen everywhere and spread his reputation overnight, books took more time to appear in the public domain. With their small fees and omniscient and overbearing publishers who attempted to stifle his creative spirit, or so he believed, they were also more frustrating to produce.

Titles of books illustrated by J.C. Leyendecker include *Vendetta or the Story of One Forgotten* (1886), *One Fair Daughter* (1895), *Dolly Dialogues* (1895), *Ships That Pass in the Night* (1898), *The Kiss of Glory* (1902), *Love Songs from the Wagner Operas* (1902), *Pit: The Epic of the Wheat* (1903), *Ridolfo* (1906), *Iole and Mortmain* (1907), *The Crimson Conquest* (1907), *Get Rich Quick Wallingford* (1908), *The Voice in the Rice* (1910), and *The Lonely Guard* (c. 1912).

"Quick!" Cristoval whispered, "They are upon us!"

[Page 196]

ABOVE: *Crimson Conquest* (by Charles Bradford Hudson). 1907. Printed book illustration

LEFT: *The Crimson Conquest*. 1907. Printed book cover

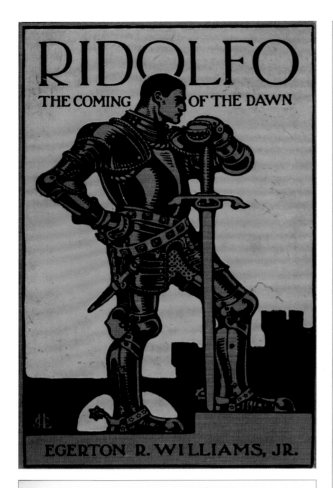

THE RESCUE OF GISMONDA
Her intended destroyer had gone before her to the world unknown. Page 198

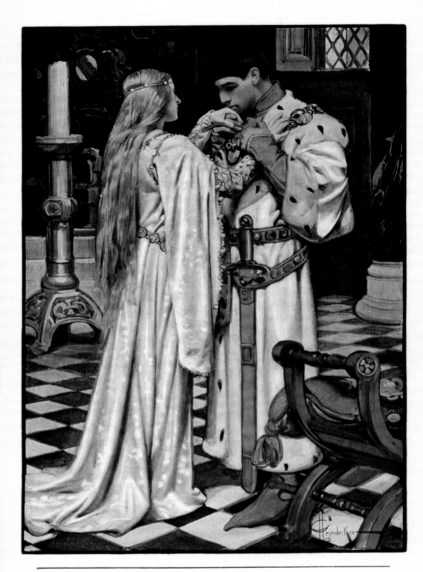

IN THE BANQUET HALL
The sunlight caught in its golden shaft the pair of lovers, offsetting her glistening gown against his regal robe. Page 240

ABOVE LEFT: *Ridolfo, The Coming of the Dawn: A Tale of the Renaissance* (by Egerton R. Williams, Jr.). 1906. Printed book cover

LEFT: *In the Banquet Hall* (from *Ridolfo*). 1906. Printed book illustration

ABOVE: *The Rescue of Gismonda* (from *Ridolfo*). 1906. Printed book illustration

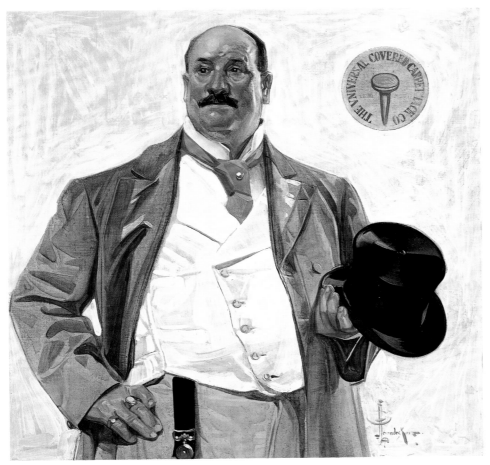

ABOVE : *Get Rich Quick Wallingford.* 1907. Oil on canvas, 18 x 18". Signed lower right

ABOVE RIGHT: *Get Rich Quick Wallingford* (by George Randolph Chester). 1908. Printed book cover

RIGHT: *Japan: Her Strength & Her Beauty.* 1904. Printed book cover

ABOVE: *The Kiss of Glory* (by Grace Duffie Boylan). 1902. Printed book cover

RIGHT: *Antony and Cleopatra* (from *The Kiss of Glory*). 1902. Gouache on board, 24 x 15". Signed lower left

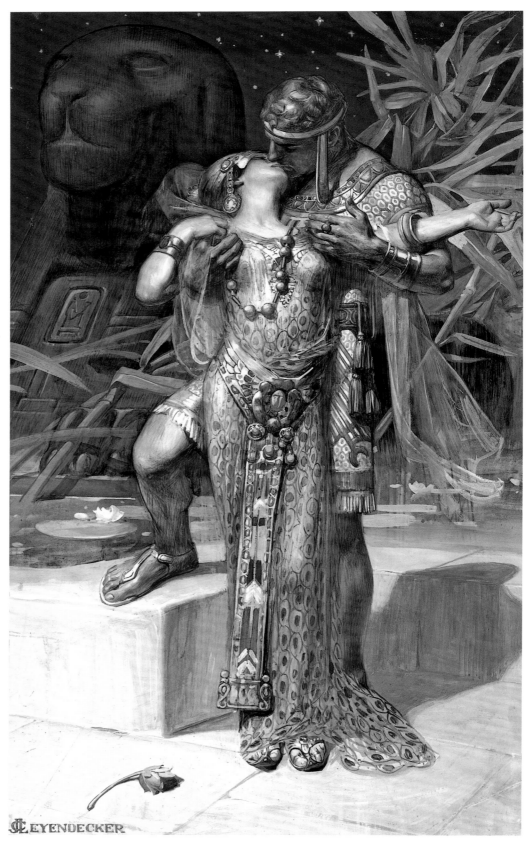

THE VOICE IN THE RICE

GOUVERNEUR MORRIS

ABOVE: *The Voice in the Rice* (by Gouverneur Morris). 1909. Printed book cover

LEFT: *Man and Woman in Canoe* (from *The Voice in the Rice*). 1909. Oil on canvas, 29 x 21". Monogrammed lower left. Reproduced: *Saturday Evening Post*, June 1909

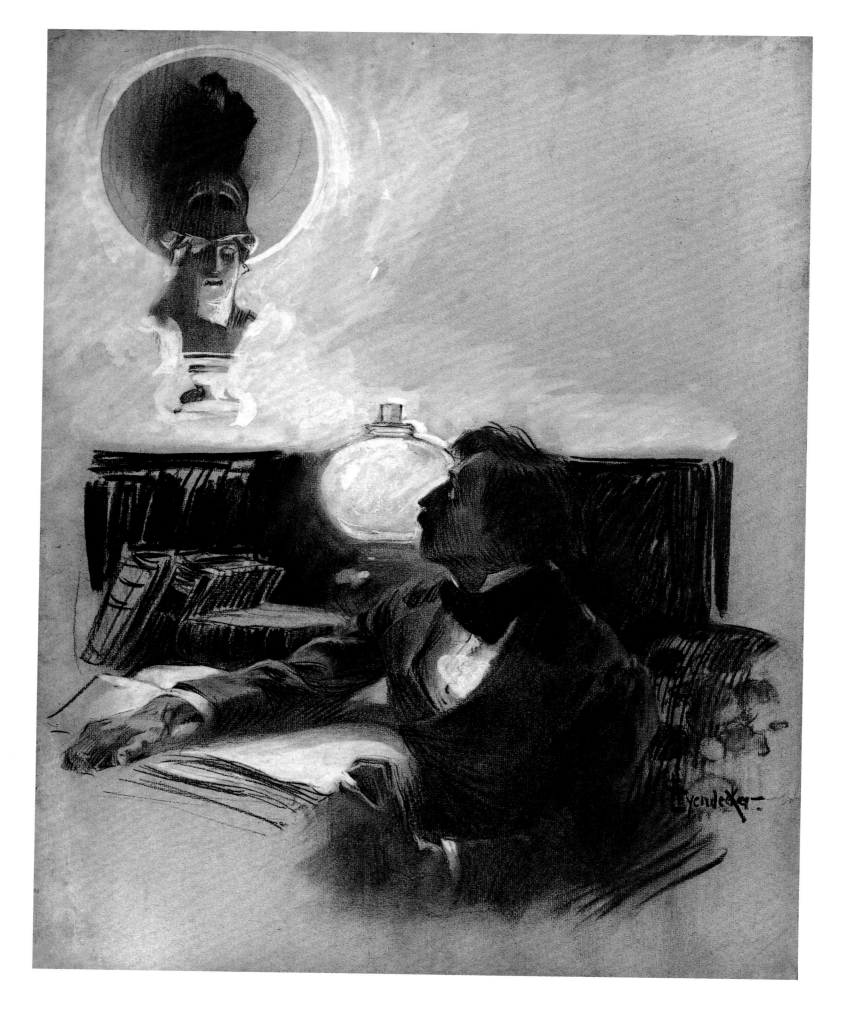

LEFT: *Caught in the Act of the Plan* (from *The Voice in the Rice*). 1909. Oil on board, 19 x 28". Signed lower right. Reproduced: *Saturday Evening Post*, June 1909

BELOW: *The Wedding* (from *The Voice in the Rice*). 1909. Oil on canvas, 15 x 28". Monogrammed lower right. Reproduced: *Saturday Evening Post*, June 1909

OPPOSITE: "The Raven" (by Edgar Allan Poe). Date unknown. Charcoal pencil and gouache on paper, 23¹/₂ x 18". Signed lower right

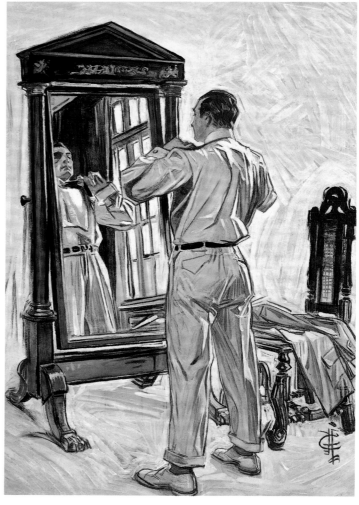

ABOVE: *Man in Pajamas* (from *The Voice in the Rice*). 1909. Oil on canvas, 26½ x 20½". Signed lower right

ABOVE RIGHT: *Man in Mirror* (from *The Voice in the Rice*). 1909. Oil on canvas, 31x 21" Monogrammed lower right

RIGHT: *Lady with Parasol* (from *The Voice in the Rice*). 1909. Oil on canvas, 18½ x 24". Monogrammed lower right. Reproduced: *Saturday Evening Post*, June 1909

OPPOSITE: *Two Men Fighting* (from *The Voice in the Rice*). 1909. Oil on canvas, 31 x 21". Monogrammed lower right. Reproduced: *Saturday Evening Post*, June 1909

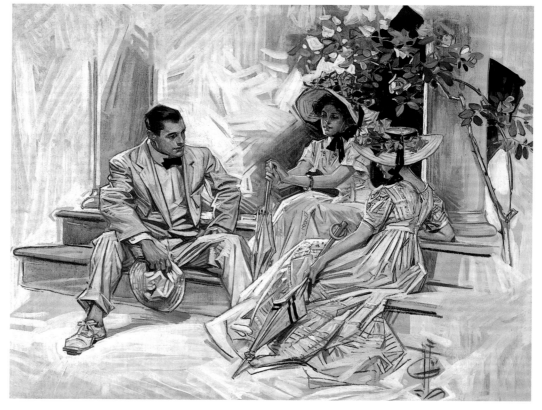

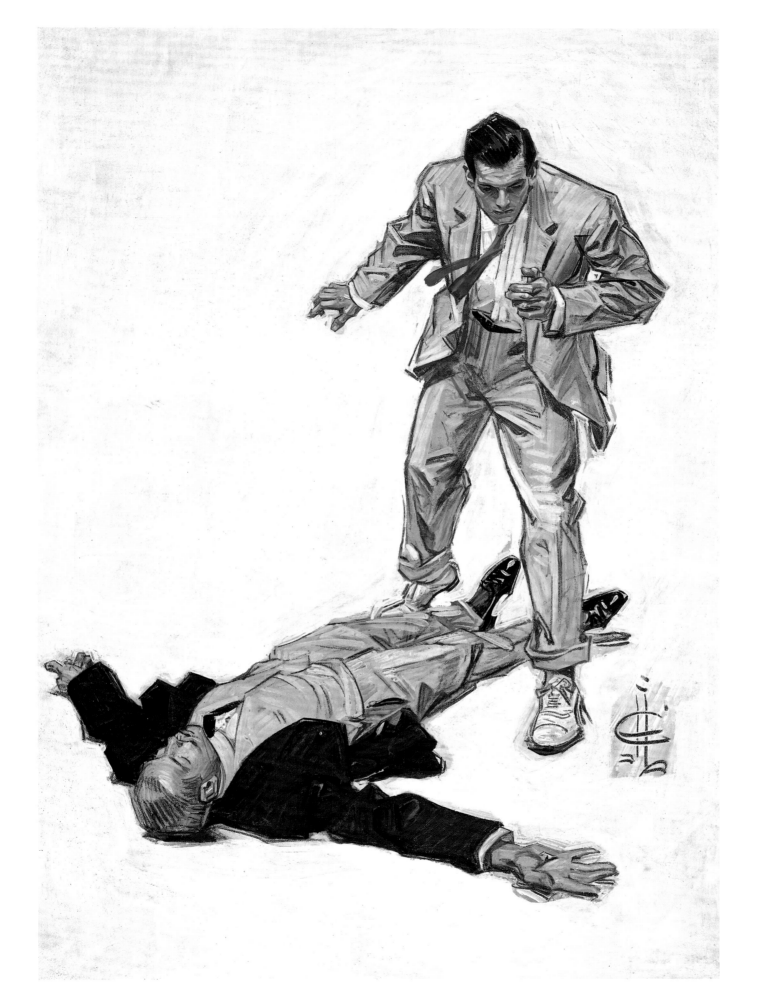

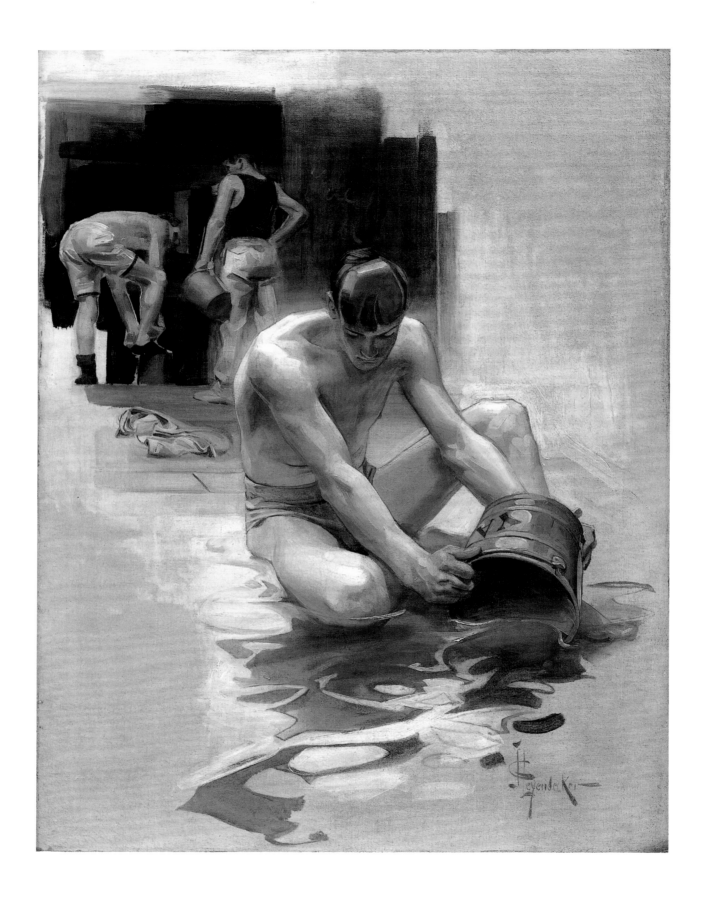

ABOVE: *Consolation* (from *A Victory Unforeseen*). 1905. Oil on canvas laid down on board, 25 x 17". Signed lower right. Reproduced: *Scribner's,* July 1905

LEFT: *The Crew Were Borne on Tossing* (from *A Victory Unforeseen*). 1905. Oil on canvas, 30½ x 22". Signed lower right. Reproduced: *Scribner's,* July 1905

OPPOSITE: *Squatted on the Boathouse Floor* (from *A Victory Unforeseen* by Ralph D. Paine). 1905. Oil on canvas, 28 x 21". Signed lower right. Reproduced: *Scribner's,* July 1905

POSTERS: THE PEOPLE'S ART

Posters as an art form were truly the genius of Jules Chéret. While posters historically existed from just after the French Revolution in 1789, Chéret used pictorial posters as a marketing scheme for his lithographic skills to earn a living and inundated the city of Paris, plastering walls wherever he could. In 1889, the *Exposition Jules Chéret* was held at the Galeries du Théâtre d'Application, the first one-person poster exhibition. The event took place just a few years prior to the Leyendecker brothers arriving in France. It heralded Chéret's new business in a bold light, elevating posters to something more than graffiti-like incursions and a nuisance. It gave credence to that which originally was considered an attractive marketing gimmick. Chéret revealed his thoughts, "To wrest the street from the gray and bleak monotony of buildings strung in long rows; to cast upon them the fireworks of color, the glow of joy; to convert their walls into decorable surfaces and let this open air museum reveal the character of a people and at the same time become the subconscious . . . public taste."

Leyendecker seized this valuable lesson, realizing that poster art had the same goal as cover art. Both were advertising with art. The major difference from a technical standpoint was that the end product was often printed in different sizes on different paper.

He was immediately attracted to "show posters" announcing circuses, expositions and exhibitions, concerts, and sporting events. Then other uses became popular, and he began producing posters for military recruiting, on political themes, for victim aid, and for selling business services, periodicals, and all sorts of products, including Arrow Collars.

Like his *Saturday Evening Post* covers and his other iconic images, the Leyendecker poster is a record of its times. It is content and artistic merit clashing and merging into a single message.

ABOVE: *Vinegar Joe Stillwell.* 1944. Oil on canvas, 23 x 16¼". Monogrammed lower right. War Bonds poster

LEFT: *Weapons for Liberty.* 1917. Ink on paper, 29¼ x 19 ½". U.S.A. War Bonds advertisement

OPPOSITE: *Join the U.S. Marines.* 1918. Recruiting advertisement

ENLIST TODAY

JOIN FOR TWO, THREE or FOUR YEARS
FOR FULL INFORMATION APPLY AT
24 East 23rd Street, New York City

TOP: *U.S. Navy—America Calls*. 1917. Printed advertisement. Reproduced: *Saturday Evening Post*, July 7, 1917

ABOVE: *Order Coal Now*. Printed U.S. Fuel Administration poster

ABOVE RIGHT: Navy Recruitment advertisement. 1918. Printed advertisement

OPPOSITE: *The Pageant and Masque of Saint Louis*. May 1914. Printed advertisement

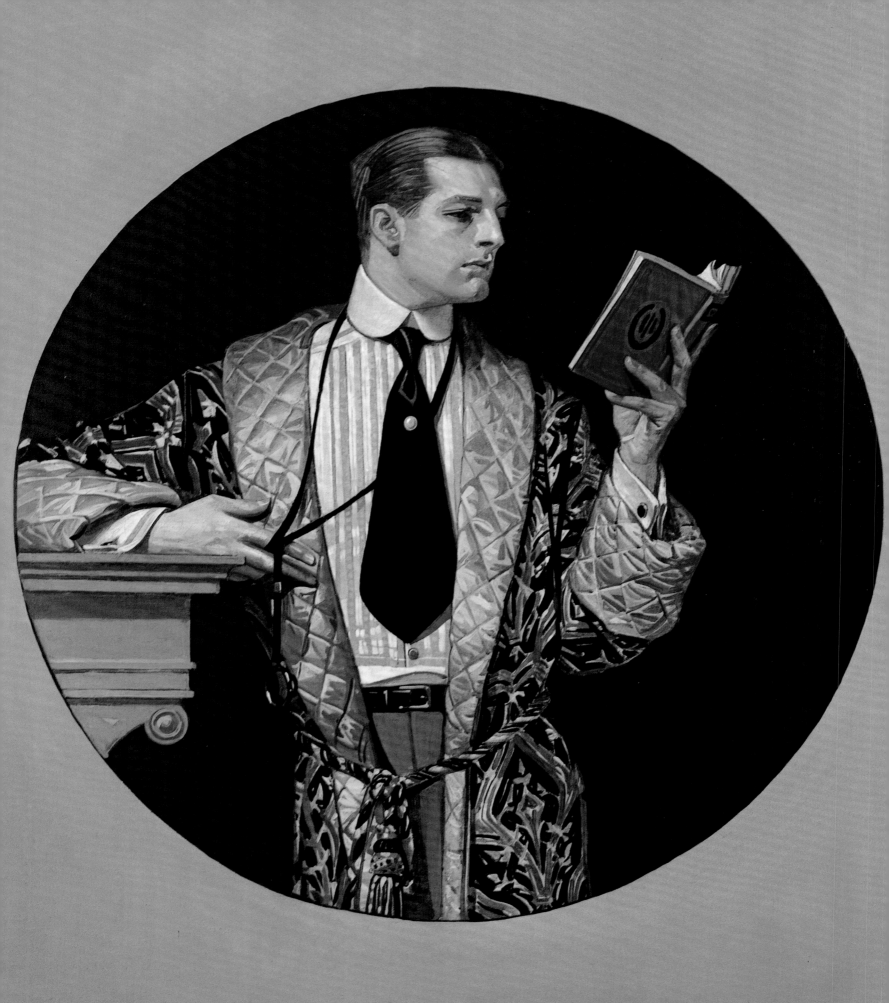

LEYENDECKER AND THE AMERICAN IMAGISTS: A HISTORICAL PERSPECTIVE

Illustration is now accepted and credited for truly being the most American of American art. Yet despite its obvious influence, it has long received short shrift by the fine arts establishment. In considering this situation, Paul Josefowitz, Legion of Honor winner (2005) and former publisher of the British fine arts magazine *Apollo*, has proposed that this oversight may be due to the simple fact that illustrators were not joined under a unifying name, indicating their common purpose. Contrarily, European artists, for example, always in a rage to market their wares, named art movement after art movement, primarily for marketing purposes, and only secondarily for inspirational consideration. Grouping artists under a name and allowing them to create within a defined framework satisfied the establishment and enabled the buying public to get a handle on the artistic intent. Romanticism, Symbolism, Modernism, Expressionism, Cubism, Dadaism, Futurism, and Surrealism are but a few such titles that permitted galleries to better market their wares.

Imagine if you will that those artists who created the greatest iconic images during the Golden Age of American Illustration had united under the name of "American Imagists." The most noted artist–illustrators of this period knew each other as colleagues or classmates; they lived and worked nearby each other in the Brandywine, New England, New York City, or New Rochelle. They sustained one another, sharing clients, models, and sometimes lovers. Many of them subscribed to similar design systems. They recognized each other's styles and emulated the strongest and most successful among themselves. Although rarely did American artist–illustrators exhibit together, they were united by a common aim.

As in painting, there was a group of Anglo–American writers and poets in the early twentieth century known as *les Imagistes* or "The Imagists" who shared a camaraderie and common purpose. Ezra Pound, editor of the 1914 book *Des Imagistes*, was a prime proponent of Imagism, and the de facto movement leader. Other notable members of the group included Hilda Doolittle, Ford Maddox Ford, James Joyce, D.H. Lawrence, Amy Lowell, W. B. Yeats, and William Carlos Williams. The Imagists existed as a group from 1905 until 1930, rejecting leftover remnants of the syrupy sentimentality of nineteenth-century poetry and literature of Victorian and Romantic writings, the most prevalent

Man Reading in Circle. 1916. Oil on canvas, 29 x 20". Unsigned. Arrow Collar advertisement

in their time. They believed passionately in an artistic notion of modern life, that one should hold a view and seldom let it blur. They were steadfast and successful, similar in philosophy to the greatest American illustrators in underlying thoughts regarding their work.

If there were such a group as the American Imagists, J.C. Leyendecker, though foreign born, would be the de facto leader. He was a powerful influence on his colleagues, many of whom, Norman Rockwell in particular, molded their careers after him. As with other definitive art and literary movements, American Imagist individuals were unique, achieving stylistic and technical feats all their own while continuing to share common origins and goals.

The literary Imagists were influenced by European literature classics and Asian poetry. The American Imagists were likewise influenced by classical painting techniques taught by Royal Academicians such as Bougereau and Constant, teachers to J.C. Leyendecker. He, too, was influenced by the Asian art to which he was exposed while studying in Europe, especially the Japanese prints that were so popular at the time.

The Imagists felt that they should transmit their works in ways that clearly expressed their feelings in order to ensure that readers would understand the meaning without having to guess at an author's intentions. Interestingly, Ezra Pound defined an "image" as "that which presents an intellectual and emotional complex, in an instant of time." The American Imagists did just that: definition was their inherent goal. Their very purpose in creating illustrations was to elucidate a subject or persuade a viewer. A cover image was intended to sell a book or a magazine: in order to do so, the picture had to be grasped instantly, the whole story told in a flash of an eye. "The amateur draws an illustration, and offers it as a cover," Leyendecker once said, "whereas a cover at its best is truly a poster, more related to murals or sculpture than to illustration. It should tell its story on one plane, without realistic perspective and distance. And that story should be told in pantomime, without explanatory legend."[12]

Like the Imagists in literature, the American Imagists naturally believed in certain professional tenets as initially taught by Howard Pyle: experience the environment which one intends to illustrate, use authentic costumes and props, and properly research historical antecedents to bring near reality to the audience. Such canons were universally accepted so that illustrators would produce images with quality, truth, and beauty as their underlying motives.

Illustrators believed in using common settings to express evolving social moods and to create new visual goals for an emerging nation. They believed in defining a subject so the viewers could without question concentrate on the essence of visual messages. Such notions are the quintessence of all great art, but often disguised or discarded by effete painters.

Unlike easel artists, American Imagists were not merely inspired to paint by a white canvas, a luscious nude model, and a dusty bottle of absinthe. The American Imagists comprised a discrete school with comprehensive technical abilities. They created paintings with strict parameters: specific assignments with deadlines, assigned subject matter,

OPPOSITE: *Merry Christmas from Kuppenheimer* 1924. Oil on canvas mounted on panel, 30½ x 25½". Signed lower left. House of Kuppenheimer advertisement

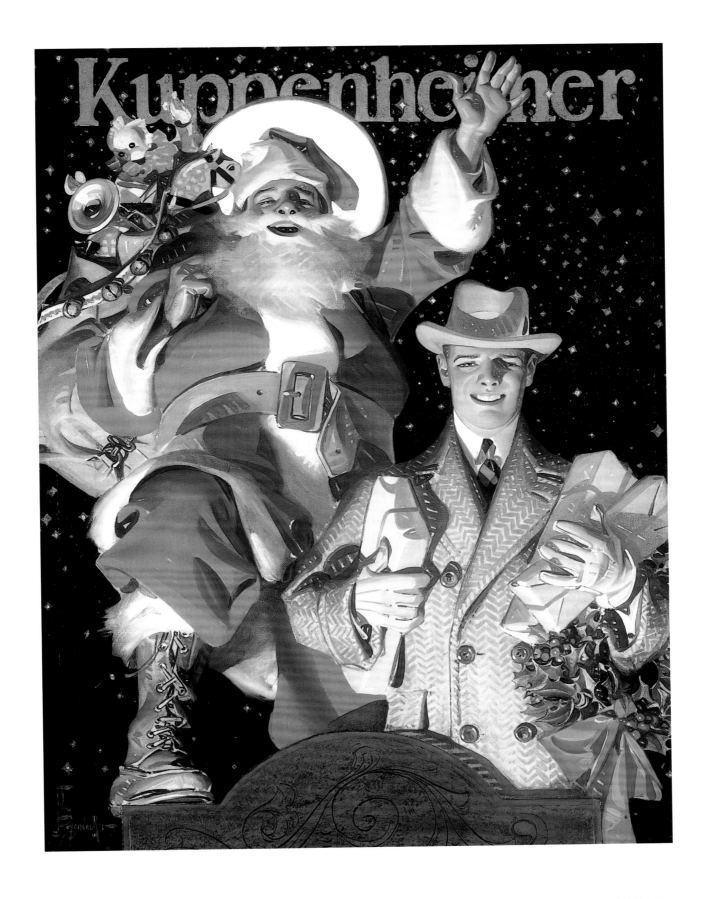

A Dainty Breakfast. 1909. Oil on canvas, 30 x 22". Unsigned. Cream of Wheat advertisement

mediums, and materials, even size and shape of canvas and other guidelines dictated by clients. Yet while working within such tight constraints, they documented our history, illustrated our idiosyncrasies, weaknesses, and strengths—and created iconic images in the process.

Still, easel painters and Golden Age illustrators had more in common than they had differences. They studied the same subjects, taught by the same instructors, in the same art schools. The main distinction between them was that illustrators created paintings with the express intention of having them reproduced. As a result, J.C. Leyendecker and his colleagues were extraordinarily successful, in terms of both fame and fortune, while most easel artists were not. This very achievement may have worked against them in the public view. Perhaps it is because the American Imagists did not fulfill the romantic notion of starving artists in a loft, that their work is sometimes slighted as "commercial" rather than "high" art. The American Imagist artworks were created to be appreciated by large audiences rather than a few critics or gallery-goers or a single collector wanting a painting just to impress others.

Maxfield Parrish called himself "a businessman with a brush." He wisely said, "I paint a picture and sell a one-time use only, sometimes for use on a toy, deck of cards, calendars and greeting cards, then I sell the painting. I sell it six times, while other artists paint a picture and sell it once."

Industrial design and illustration emerged simultaneously as complementary professions. Charles Eames and his wife, Ray, noted for their work in modern architecture and furniture design, realized early on that they could either design a single great chair coveted by a collector, or a chair which everyone could enjoy. The same design energy and creativity would go into a chair accommodating a single bottom, or one mass-produced and designed to accommodate bottoms of all sizes. Obviously, in this manner, a larger audience could appreciate their creative efforts. The Eameses chose the latter direction rather than becoming sculptors of unique objects, and the Eames Lounge Chair became a timeless classic, still in production today.

Today, technology is forcing us beyond illustration as we have known it. The computer and its manipulation of photography are eliminating manual artistic illustration from the vocabulary. Like it or not, we receive on a daily basis a plethora of images illuminating little and confusing much. This is not to deny that today's professional illustrators continue in the creative traditions of their profession. They may be as talented as their predecessors,

but fewer are enabled because enlightened clients are rare. The best example is in movie poster illustration, where Hollywood producers once sought creative artists to tout their films. Just like the popular magazines of the day, movie studios had favorite illustrators: Paramount had Harrison Fisher in the 1920s, Constantin Alajalov in the 1930s, and John LaGatta in the 1950s; MGM, John Held Jr. in the 1940s; United Artists, Saul Bass in the 1960s; Warner Brothers', Bob Peak in the 1970s; Twentieth-Century Fox, Richard Amsel in the 1980s; and Dreamworks and LucasFilms, Drew Struzan in the 1990s. However, since the turn of the century, most movie posters are created by nameless souls with a Macintosh computer but without formal art education and/or natural creative talent.

But in all aspects of current cultural endeavor the public seeks the artifacts of bygone eras. Thus we are seeing a resurgence of "golden oldies" in music, post-post-Modernism in architecture, and Biedermeier revivals in the decorative arts.

Likewise, there is a newfound appreciation of art from America's Golden Age of Illustration—and of the brilliance of J.C. Leyendecker in particular. Leyendecker captured lifestyles with superior technical skills, with an imaginative use of subject, and with an originality that many have sought to imitate. In the idiom of Paul Klee, J.C. Leyendecker's illustrations were created not only by the artist's heart and brain, but also by a *thinking eye*. Unquestionably the greatest of the icon makers, his *oeuvre* stands out to this day as among the most recognizable and luminous American artists.

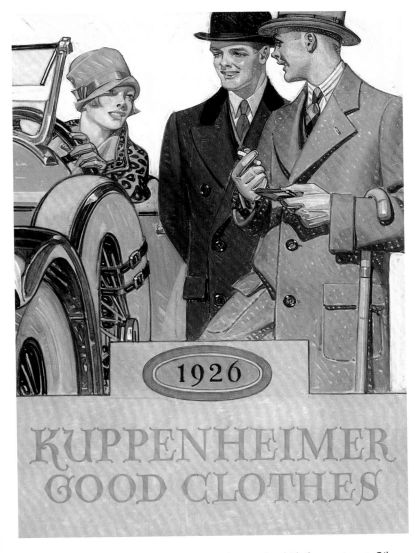

Kuppenheimer Good Clothes: 1926. 1926. Oil on canvas, 27 x 19³/₄". Unsigned. House of Kuppenheimer advertisement

AFTERWORD

J.C. Leyendecker was laid to rest in a family gravesite at Woodlawn Cemetery, following a requiem mass at New Rochelle's Blessed Sacrament Church. Charles Beach, film actor-model Neil Hamilton, and colleagues Norman Rockwell and Orson Lowell, were among the pallbearers.

At the cemetery, Orson Lowell noted that the day before Joe died, he was painting his last magazine cover commission for *The American Weekly*. Lowell eulogized, "unlike many artists, Joe was able to transpose the delicate details of his original small sketches to a larger canvas without loss of his original expression. He often cancelled social engagements if they interfered with his work and craftsmanship . . . he was a designer rather than an illustrator since he conceived of each assignment with a cover layout in mind with lettering and artwork all composed together." Finally, he called him "a master painter"; that was really all one had to say.

Charles Beach then spoke, muttering that his lifelong companion was "top notch, few could touch him, his skills were beyond any competition." Beach went on to say, "He was wedded to his art, and had no time for running around. His only other pleasure was his home and its landscaping. He received great joy from the house and loved supervising the gardening, spending many happy times there."

A few days later, in a newspaper article entitled "Leyendecker as Perfectionist; Cover Designer Preferred Art for the Masses," Beach mused that "Joe focused on magazine art, posters and advertising while other artists focused on portraits, vignettes, and religious or otherwise inspired works for small audiences." He noted that Joe did not take an active role in the Society of Illustrators, or in local art circles in a very vibrant arts community. He just did his artwork to his own satisfaction without a need for acceptance or recognition from others.

In the same newspaper, Jim Connell, who had modeled for Joe, remembered, "Mr.

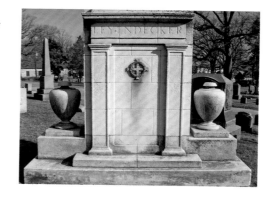

LEFT AND OPPOSITE: *Quality by Kuppenheimer (Mermaid and Handsome Men)*, details. c. 1930. Oil on canvas, 2 panels, 25 x 19" each

RIGHT: Leyendecker family gravesite at the Woodlawn Cemetery, Bronx, New York

Leyendecker was a very quiet man, very easygoing, but when he was working and his mind was set on something you couldn't go near him."

Over the years, stories have sprung up surrounding Joe's death—that he had left no money at all, that an illustrator paid for his funeral and a small grave marker, that he was buried in an unknown pauper's graveyard without a marker. Yet, the facts are quite the opposite.

The Leyendecker family gravesite in which he was buried was purchased by Joe after his mother's death in 1905; today, both parents, Peter and Elizabeth, and three of their children—Mary, Frank, and Joe—are there (brother Adolph is at rest with his wife and children in Kansas City, where he spent most of his life). For each family member there are separate footstones.

J.C. Leyendecker left an estate of $60,000 (equivalent to nearly half a million today), personal effects including his Pierce-Arrow roadster, and the valuable real estate. Mary Leyendecker and Charles Beach shared equally in whatever remained from a whirling-dervish life. *The New York Times* ran a short article on the inheritance, "Model Inherits $30,000" and referred to Beach as "a friend who posed for the original Arrow Collar portraits and other paintings . . . he had been associated with Mr. Leyendecker for forty-eight years as his secretary and aide. . . . The bequeath included original paintings, personal effects and automobiles." Joe's last will was signed on May 11, 1944.

"Magazine Cover Artist and Illustrator Stricken on Terrace of His Home—Joseph Christian Leyendecker of 48 Mount Tom Road, noted commercial artist and magazine cover illustrator, died of a heart attack. He was seventy-seven . . . and recently completed a 1952 calendar for the American Oil Company." So read the notice in the *New Rochelle Standard Star*: a short and inconsequential announcement for such a giant of our popular culture, already largely forgotten at death. The commission that Joe had been working on for *The American Weekly* was a Christmas cover, which had just been approved by the infamous William Randolph Hearst, his last client; Joe smugly bragged to Beach that it would be his greatest painting, but sadly it was never completed. The unfinished work disappeared into oblivion. Beach must have destroyed it.

After the funeral and mourning period, a deeply shaken and despondent Charles Beach stood alone for the first time in half a century. Anguished by the loss of his lover, there were no friends to lean on, no servants, and his impending fate was obvious. On August 28, 1952, Charles Beach died alone at age seventy, without objects to remind him of his past, only foggy memories of the glory days hidden deep in his then alcohol-diminished mind. The location of his gravesite is a mystery, for he had no people in the United States and few friends left; he had only Joe nearly his whole life.

ATTIC TREASURES

Molly Guion (1910–1982), a local portrait artist with an international reputation, rented Joe's studio for a short stint from the new owners in the fall of 1952. A generous heart and joyous woman, she let neighborhood children play in the studio while she worked. Having conjured up a game of pirates, the rambunctious youths climbed a

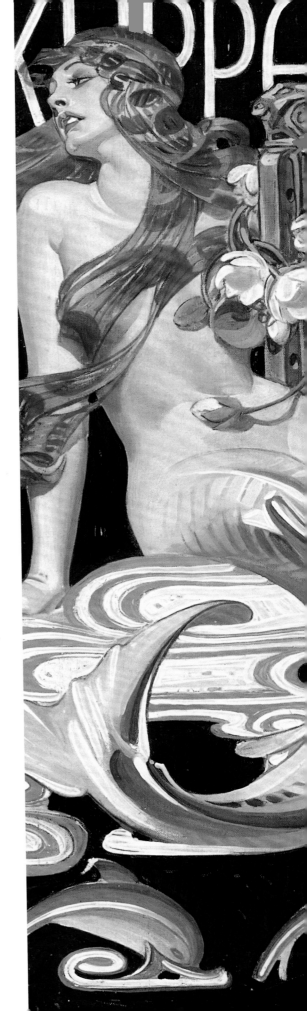

Kuppenheimer Good Clothes (Man in Fur Collar Coat). 1917. Oil on canvas, 25½ x 18½". Unsigned. House of Kuppenheimer advertisement

ladder and entered a small access hatch in the ceiling of Frank's studio, looking for places to hide and explore. They discovered a veritable real-life treasure, a cache of original paintings in an ancient Louis Vuitton steamer. There were several other trunks covered with sheets littered with mouse and squirrel droppings, water stains from roof leaks, stacks of yellowed periodicals and waterlogged news clippings, various artist props, suits of armor, whips, hats, and assorted clothes. Inside these now heralded 'pirate chests' were sketches, studies, and an unknown number of finished oil paintings, the detritus of a long and successful career. A newspaper account described the find, "A cow's skull lay buried midst yards of brocade curtains. Other old trunks containing velvets, satins, and laces once used by the Leyendecker brothers." A grotty sight indeed, under a dark eave with squirrel nests, it had apparently gone unnoticed by a distraught and lonely Beach.

Ms. Guion sorted the pirate's booty to her taste, putting aside valuable originals, studies, and sketches in portfolios, then kindly gave 1920s-style costume jewelry and some masks to the boys as their rewards. Knowing the significance of the find, she enlisted the help of illustrator Frank Reilly (1906–1967), instructor at the Art Students League. Taking his advice, she magnanimously donated several paintings to the New York Public Library, and a few others to admiring friends. The new owners apparently were more interested in subdividing the estate into small house lots than to investigate the dusty remains of a dead artist's career in the attic.

Molly Guion later painted portraits of Winston Churchill, Queen Elizabeth (the Queen Mother), and New York Governor Thomas Dewey, but her most notable contribution to art was saving this last stash of Joe's originals.

After Charles Beach's death in 1952, other artworks from the Mount Tom estate cache were gifted to the Society of Illustrators. Between April 17 and May 13, 1953, the Society held a special Leyendecker exhibition of the last of his personal collection followed by a post-exhibit sale of many of the exhibited works. Mary had managed to keep several dozen items she admired; she particularly liked Joe's paintings for Kellogg's Corn Flakes boxes: children's faces fascinated her. They must have replayed faces from her youth in Chicago immigrant neighborhoods and she loaned them to the exhibition. Like so many illustrators, Frank Reilly admired Joe and was pleased to organize the exhibition and its subsequent sale. At the time of the sale, Reilly griped about Joe's last days, "Mr. Leyendecker could not even answer the telephone any more . . . all his contacts were made through an associate, C. A. Beach, original model for the Arrow Collar illustrations, who assisted the painter with his work and upkeep of the house for nearly half a century. Beach kept us all from the artist all the time!"

The artworks went primarily to Society members' appreciative hands, as evident from this account by member Robert Geissmann: "Proverbial hotcakes never sold faster than the original works by the late JC Leyendecker displayed in our vest-pocket gallery . . . every single item—from the fascinating hodgepodge of unmated preliminary cover ideas, figure studies, life sketches and working roughs that covered the huge table, to the large unframed *Saturday Evening Post* cover originals filling every inch of wall space—became a

proud possession of the enthusiastic admirers of this popular latter-day idol . . . it was no surprise to see many of today's big leaguers giving attention to this wizard's delineation of idealized American youth of a generation or so ago . . . the popeyed curiosity and earnest study Leyendecker's unique craftsmanship received was simply an extension of the respect and admiration he earned and enjoyed from the turn of the century until his passing a couple of years ago." Such compliments from within the profession would have warmed the heart of Leyendecker, who in his last years felt that he had been totally forgotten by his audience and colleagues alike.

MOUNT TOM ROAD ESTATE

Garden at Mount Tom, 1919

In July 1952, new owners of the Leyendecker estate at 48 Mount Tom Road subdivided the land into separate house lots; it is now surrounded by Korean War–era bungalows. The so-called "mansion" was sold in September; with less than half its original acreage. A newspaper account on October 10, 1952, described the property just after the building portion was sold: "The entire plot is landscaped . . . with shrubbery worth about $25,000 and the house would cost $125,000 to build today. . . . Off to one side there is a rose garden with a fountain and fish pool in the middle and hemlocks in the back . . . the house is barely visible from the road . . . it looks out on the Long Island Sound. . . . [T]wo studios are attached . . . and were used by Mr. Leyendecker and his brother Frank, also a commercial artist. . . . [T]he three story structure is Normandy in architecture and has five bathrooms, four fireplaces, two large center reception halls and seven bedrooms."

Purchased by Raymond and Mary Force, the Mount Tom Road "mansion" was converted into The Storybook House, a nursery school. That preschool became a landmark in the rapidly growing community and it remains so today, albeit as the Mount Tom Country Day School. When we visited recently, Director Jill Newhouse proudly searched for original architectural details, including the letter 'L' in black wrought iron she pointed out on each side of twin chimneys.

There is no Department of Interior, National Register of Historic Places bronze plaque to denote the property as an historic site, nor any meaningful Leyendecker remembrances in the house itself, but for ghosts, real and imagined. The grounds so dutifully and lovingly cared for by the Leyendecker couple were torn apart several times over the years to make way for swing sets, sandboxes, and play areas. One can only reflect sadly and listen for echoes of what was once there. Suffice it to say the mansion on Mount Tom Road is no longer what it had been.

On May 1st, 1953, New Rochelle art professor Ernest Thorne Thompson donated a restored Joe Leyendecker painting entitled *The Huguenot* to the Huguenot and Historical Society of New Rochelle. This work was presented at the Thomas Paine Building with Joe's sister, Mary Leyendecker, and artist Molly Guion in attendance as guests of honor. About three dozen people attended the unheralded event. A visit to New Rochelle's City Hall in 2007 to

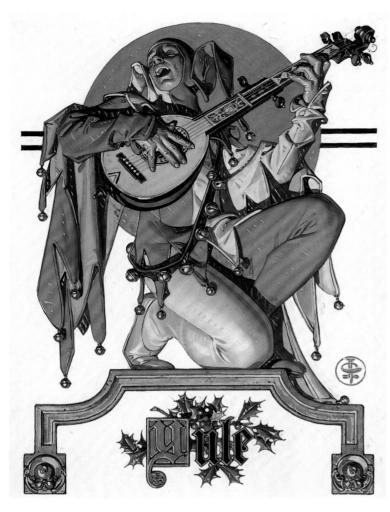

Yule. 1931. Oil on canvas, 30¼ x 22¼".
Monogrammed lower right

find *The Huguenot* painting showed the lack of recognition of the artist in his own community. No one even knew of his painting or where it might be.

Just after this occasion, Mary was inspired to gift three of Joe's works on paper (graphite, watercolor, and a gouache) to The Metropolitan Museum of Art, the nation's most important art museum. Joe would have been astounded and exceedingly flattered, for in the 1950s few museums accepted what they considered to be "commercial art." However, Mary valued Joe's remaining oils in her care too much to give them away; even though she was in her eightieth decade and with no heirs apparent, she gave some atypical works on paper, no oils on canvas, no known images, not even a cereal box painting. Near the end of her life, she was persuaded by Earl Rowland, director of the San Joaquin Pioneer and Historical Society and the Haggin Museum, to loan all her remaining works, including all those Kellogg cereal box cover images, to the San Joaquin Pioneer and Historical Society for exhibition. She still had some cousins to whom she planned on bequeathing the oils: all other more direct heirs, including her niece (Genevieve) and nephew (Joseph A. Leyendecker), were dead.

BELATED RECOGNITION IN A CHANGING CLIMATE

Slowly but surely in the years since Joe's death, his work has acquired the admiration and prestige he so craved in his lifetime.

In 1977, the Society of Illustrators Hall of Fame posthumously inducted J.C. Leyendecker, where his memory lingers. That same year, the Royal Cornwall Corporation, a collectibles company, released an "Official First Edition by the Leyendecker Foundation," *Santa Loves You*, a limited edition of 19,500 plates by the Calhoun Collectors Society. Apparently, a quarter century after J.C. Leyendecker's death, he still had a substantial audience. In 1980, Royal Cornwall issued a "Classic Collection" of four more ceramic plates emblazoned with his art images. Each plate was $65, its value projected to climb. The series was entitled the "Four Faces of Love: Innocence, Romance, Motherly Love, and Sacred Love for the Creator."

On January 2, 1984, Ken Stuart, art editor for the *Saturday Evening Post* from 1943 to 1963, wrote to Judy Cutler (née Goffman) in response to a Leyendecker image (*Yule*, *Post* cover, December 26, 1931) that Judy had reproduced as a Christmas card:

What a splendid card! Thank you, and an un-Orwellian 1984 to you and yours. I always regretted that the Post Editors had sacked Joe Leyendecker before I came on as their Art Director. I strenuously objected to the firing and argued for months to reverse it, but it was one I lost. Great shame and a great mistake. His New Year's baby covers

were classics. The editors wanted me to do them whilst I was still a freelance artist; but I couldn't bring myself to do it much as I needed the exposure that a cover could give to an artist. Good luck. You people are doing a much-needed work.

In 1989, the American Illustrators Gallery NYC held a milestone exhibition, "J.C. Leyendecker: An Age of Elegance," with visitors coming from across the nation, reviving and reigniting great interest in J.C. Leyendecker.

On April 21, 1993, "The Great American Illustrators" exhibition opened at the Odakyu Museum in Tokyo, Japan. Curated by Judy Cutler and produced by Laurence Cutler, it toured several Japanese museums through November 1993. Patronized by the U.S. Embassy, and organized by the *Yomiuri Shimbun*, the world's largest newspaper, the show took Japan by storm, with Leyendecker a special hit. Michael Schau wrote for the catalogue, "All we need to know about this artist is in the paintings . . . every painting points to a vision and a character that is elegant, he was vital and devoted to his craft."

On October 6, 1997, the American Illustrators Gallery NYC opened the exhibition "J.C. Leyendecker: The Retrospective." It was scheduled to end in January 1998, but it was held over for six months due to popular demand. Simultaneously, the Norman Rockwell Museum at Stockbridge, Massachusetts held "J.C. Leyendecker: A Retrospective," a major exhibition featuring more than one hundred Leyendecker paintings and drawings. These exhibitions were clear testimony to the rebirth of wide-ranging interest in J.C. Leyendecker's art at the end of the twentieth century.

Such a reawakening was far from all-encompassing, however. In March 1998, a New Rochelle senior citizens group toured the retrospective exhibition at American Illustrators Gallery NYC. During a gallery talk, the lecturer asked, "How many of you have ever heard of J.C. Leyendecker before today?" Of the sixty persons present, only one gentleman raised his hand, interestingly the cousin of the Surrealist artist/photographer Man Ray. The next question asked was whether anyone knew that Leyendecker had lived in his or her community. No one knew! Yet, eleven people had grandchildren or children at the Mount Tom nursery school.

In 1999, the U.S. Postal Service issued a Millennium 2000 Celebration stamp series showing illustration art. A Leyendecker stamp of a New Year's Baby (1937) was included, with the statement, "Largely through the work of artist J.C. Leyendecker, the New Year's Baby became a fixture of American popular culture. During 40

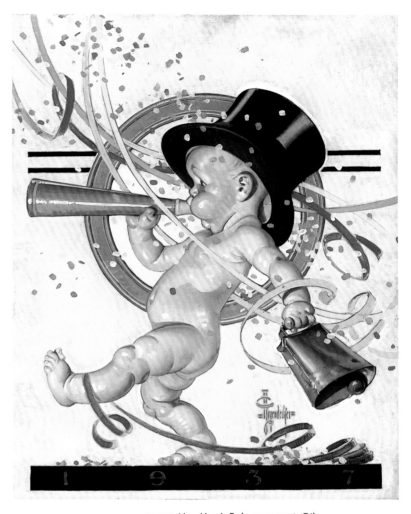

ABOVE: *New Year's Baby 1937.* 1936. Oil on canvas, 30 x 22¾". Signed lower right. Reproduced: *Saturday Evening Post,* January 2, 1937, cover; U.S. postage stamp, 1999

BELOW: Millennium stamp, 1999

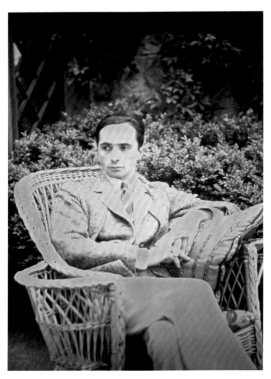

J. C. Leyendecker, age 35. 1905. Autochrome

years as an illustrator for the *The Saturday Evening Post*, he created many memorable New Year's covers each picturing a baby."

On July 4, 2000, J.C. Leyendecker's paintings graced the walls at the opening of the National Museum of American Illustration (NMAI) in Newport, Rhode Island. The NMAI's American Imagist Collection includes the largest collection of Leyendecker's original and vintage works from all phases of his career. Many are on permanent exhibition in Vernon Court, a Beaux Arts rendition of an early-eighteenth-century chateau—a site worthy of J.C. Leyendecker.

THE LEGEND SURVIVED AND IS REVIVED

Over half a century after his death, the Leyendecker legend is intact. It tells of a man who created iconic images and through his art and life influenced America immeasurably in the process. Joe gained immortality as America's greatest icon-maker, promulgator of mass advertising, de facto leader of the American Imagists, master of magazine covers. His cover art attracted sports buffs: Yale and Princeton football players, Penn and Harvard crews sculling on the Schuylkill, auto racers and motor car enthusiasts, are all images as compelling today as when they were painted more than half a century ago. Charles Beach and Joe Leyendecker are held up as examples of monogamy among the gay community, so often criticized for promiscuity. They live on in Joe's matchless illustrations, Charles's Dorian Gray image never aging in Joe's eyes nor in ours either.

Artist-illustrators, for his unique painting style; art historians, for artistic milestones; art and advertising industry creative directors, for setting the parameters for eternal styles and for being the supreme image-maker in an industry increasingly mediocre; and members of the gay community, for icons of masculinity and sensitivity: all remember Leyendecker for his contributions to American art and civilization. Joseph Christian Leyendecker was the prototypical American Imagist, a global standard-bearer for illustrators.

OPPOSITE: *Interwoven Socks—Famous for Their Colors*. 1927. Oil on canvas, 39 x 28³/₄". Interwoven Socks advertisement featuring model Charles Beach. Reproduced: *Saturday Evening Post*, 1927

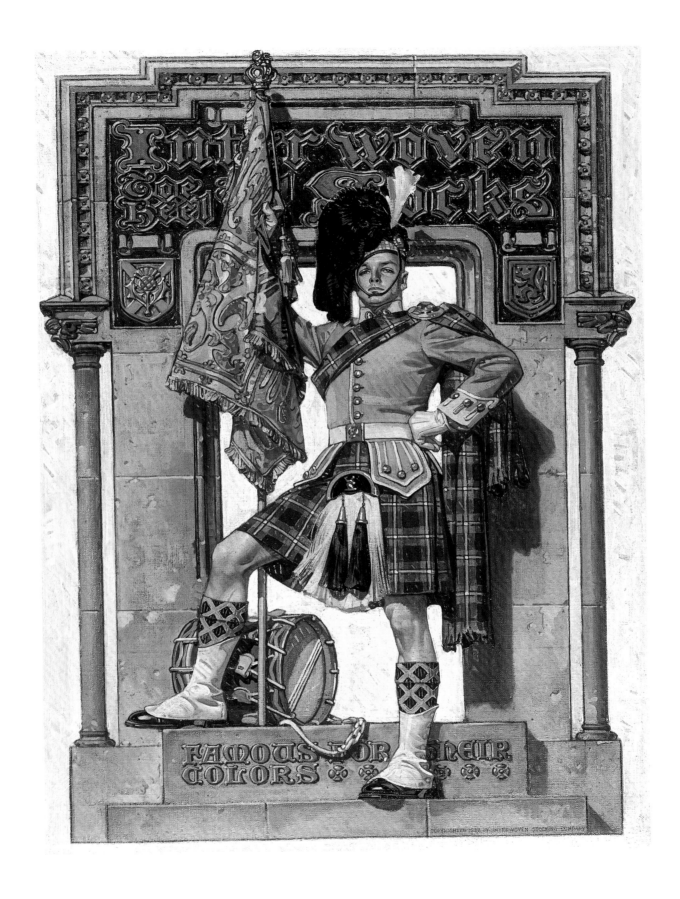

CHRONOLOGY

J.C. LEYENDECKER

(1874–1951)

1895 The Golden Age of American Illustration begins

1863 Impressionist movement begins as reaction to Académie des Beaux-Arts. Degas, Manet, Monet, Pisarro, Renoir, and Sisley exhibit in the Salon des Refuses

1870 Frederick Maxfield Parrish born in Philadelphia

1869 Adolph A. ("Aaych" or "Adam") Leyendecker, J.C. Leyendecker's older brother, born in Germany

1872 Augusta Mary Leyendecker ("Mary"), J.C. Leyendecker's sister, born in Germany

1874 Joseph Christian ("J.C." also known as "Joe") Leyendecker born on March 23 in Montabaur, Germany

First Impressionist exhibition held in Paris

1876 Franz Xavier ("F.X." or "Frank") Leyendecker, J.C. Leyendecker's younger brother, born in Germany

1880 Art Nouveau movement, international sensation of highly decorative elements in architecture, fine art, decorative arts, and illustration, begins

1882 Leyendecker family immigrates to Chicago

1886 Charles A. Beach, Leyendecker's life partner, born in Ontario, Canada

1889 Leyendecker begins engraving apprenticeship at J. Manz & Company

Adolph and Joe Leyendecker study art and design with Carl Ludwig Brandt (1831–1905)

1890s Nabis art movement—in which avant-garde Parisians, including Denis, Maillol, Gauguin, Bonnard, Vuillard, and Roussel—try to revive the art world like the Prophets (Les Nabis) revitalized Israel

1894 Leyendecker completes series of sixty illustrations for a special engraved edition of the Bible

Leyendecker studies at the Art Institute of Chicago under noted artist-educator John H. Vanderpoel (1857-1911)

Norman Perceval Rockwell born in New York State

1895 Illustration commissions completed for two books: *Dolly Dialogues* by Anthony Hope Hawkins, and *One Fair Daughter* by Frank F. Moore

1896	First place prize–winner, *Century Magazine's* Midsummer Holiday Number Contest, August issue
	Leyendecker brothers matriculate in Paris at Académie Julian and study at Académie Colarossi. Joe meets Mucha at the Julian, becoming fast friends with reciprocal artistic influences
1897	First independent freelance illustration commission at the recommendation of Will Bradley, to create twelve covers for *The Inland Printer*
	First one–man exhibition on April 24, at the Salon du Champs de Mars, with a charcoal drawing of Frank in the catalogue
	Mucha's first exhibition staged by the *Journal des Artistes* at Galerie La Bodiniere. Leyendecker meets Gauguin and his coterie
	Leyendecker brothers return to Chicago and open studio at the Stock Exchange Building
1898	Leyendecker exhibition showing of the *Inland Printer* originals held at Chicago's New York Life Building
	First of forty–eight covers for *Collier's* magazine, November issue, completed
	Construction of Vernon Court mansion, now the National Museum of American Illustration, completed
1899	First cover painted for *Saturday Evening Post*, May issue, starting a forty–four year association
1900	Joe and Frank leave for New York City and open a studio at 7 East 32nd Street
	Joe begins his distinctive painting style, to be labeled, "The Leyendecker Look"
	Advent of the rotary press permits full color printing and transforms illustration
1901	Leyendecker illustrates *The Rubaiyat of Omar Khayyam* for *Delineator Magazine*
1902	Illustrates book *The Kiss of Glory* by Grace Duffie Boylan
1903	Leyendecker meets Charles A. Beach
1904	Cubism movement formed
1905	The Leyendecker Look evolves into a clearly recognizable style with strong iconic images, wide brushstrokes with Impressionistic influences, academic Beaux Arts techniques, and a Japanese chop mark–like signature and begets mass marketing using sex symbols for first time
	Leyendecker creates the Arrow Collar Man for Cluett, Peabody & Company making Charles Beach the symbol of masculinity
	Elizabeth Leyendecker (mother) dies; Joe moves entire family and an Irish maid to Pelham Road, New Rochelle
1906	Leyendecker invents the New Year's Baby for *The Saturday Evening Post*, December issue, which immediately becomes an icon embraced worldwide
	Illustrates book *Ridolfo, The Coming of the Dawn* by Edgerton R. Williams
	Fauvism and Expressionism art movements begin
1907	Moves studio to 40th Street and Bryant Park, the Beaux Arts Building
	First Thanksgiving cover for *Saturday Evening Post*, November issue, signaling holiday issue successes

OPPOSITE AND RIGHT: *Kuppenheimer Good Clothes: Wolfhound*, details. 1925. Oil on board, 26³⁄₄ x 20³⁄₄"

1908	Begins long-term business relationships with B. Kuppenheimer & Company and Interwoven Socks
	Last visit to Curtis Publishing Company offices for twenty-six years
	Advertisements commissioned by Kellogg's Corn Flakes, hitherto an unknown cereal
	Joseph Adolph Leyendecker, nephew, born in Kansas
1913	Dubbed "The Master of the Magazine Cover" by Norman Rockwell
1914	Builds house on Mount Tom Road in New Rochelle with studio for Frank; Joe commutes to New York City studio where Charles Beach lives
	Beginning of a series of legendary parties believed to have inspired the central character in the F. Scott Fitzgerald novel *The Great Gatsby*
1915	Norman Rockwell moves his studio to 24 Lord Kitchener Road in New Rochelle
	Rockwell receives first *Saturday Evening Post* cover commission (for the May 20 issue)
	Peter Leyendecker (father) dies on November 11
	Beach moves to house on Mount Tom Road
	Receives commissions for war posters, along with fellow American Imagists Christy, Flagg, Gibson, Phillips, N.C. Wyeth, and others
	Last work for *Colliers* magazine
1919	Moves studio to West 54th Street; Texas Guinan's speakeasy in building
1920–30	Art Deco movement develops distinctively from Art Nouveau with cleaner lines, simplified elements, and materials to be used for mass production
1920	Wins award for Arrow Collar advertisement of Charles Beach in the first *Annual of Advertising Art in the United States* under category "Paintings in Color"
	Phyllis Frederic models for Joe; her father, Pops Frederic, also models for Rockwell
1921	Created Interwoven sock advertisement of dapper young man on fence rail, still used today as a logo by Paul Stuart Clothing
	Frank paints *The Flapper* for *Life* magazine cover, coining a Roaring Twenties sobriquet in the process
	Leyendecker gives up NYC studio and works exclusively at Mount Tom Road estate. Frank and Mary move out: Frank sets up studio near Rockwell, Mary moves to a woman's residential hotel on 29th Street
	Frank paints his last *Life* cover
	Phyllis Frederic models as Cleopatra for October *Saturday Evening Post* cover
	Rockwell leaves to study at the Académie Colarossi in Paris
1924	Frank Leyendecker dies at forty-five years of age on Good Friday, after losing his battles with depression and addictions
	Surrealism Art movement founded by Breton emphasizes psychological meaning of images and objects, juxtaposed with the unconscious
1926	*Saturday Evening Post* publishes first four-color cover on April 3
1927	Coles Phillips (artist and friend) dies on June 13

1929	New York Stock Market crashes
	Genevieve Charlotte Leyendecker, niece, commits suicide with poison
1930	Termination of Arrow Collar commissions
1936	George Horace Lorimer, editor of the *Saturday Evening Post*, retires. New editor rarely uses Joe
1938	250th Anniversary Commemorative booklet for New Rochelle, entitled *The Huguenot* with cover by Leyendecker and interior illustrations by Rockwell, Penfield, Lowell, and Phillips
	Adolph Leyendecker dies, buried in Cavalry Cemetery in Kansas City
1939	Norman Rockwell moves to Arlington, Vermont
1940	Leyendecker's photograph appears on January cover of *American Artists*, featured as one of America's greatest artists
1941	Ben Hibbs appointed editor of *Saturday Evening Post*
1943	Leyendecker's last *Saturday Evening Post* cover, baby ringing in the New Year, ending a thirty-six-year run
1944	War bond poster series commissioned by the Timken Company with most images of generals Douglas MacArthur and Dwight David Eisenhower
1945	Cover for *The American Weekly* magazine, December issue
	Europe's' most avant-garde creatives flee Hitler, settling mostly around New York City
	Abstract Art movement begins and, after World War II, thrives
1951	J.C. Leyendecker dies at age seventy-seven years on July 25 at his Mount Tom Road refuge. Estate divided equally between Mary Leyendecker and Charles Beach. Joe laid to rest at the Woodlawn Cemetery
1952	Charles Beach holds a yard sale, selling remaining paintings; studies sell for fifty cents
	Molly Guion, a neighboring portrait artist, rents Joe's studio, discovers more paintings, drawings, and sketches in loft
	Mount Tom Road house sold
	The Metropolitan Museum of Art accepts gift from Mary Leyendecker of three Leyendecker works on paper, marking the first museum acceptance of his artworks
	Charles Beach dies
1953	Exhibition at the Society of Illustrators, followed by a final sale of Joe's remaining works
1957	Mary Leyendecker dies in New York City; leaving a perpetual care fund for the Leyendecker family gravesite and the other half of her estate to fund a book (never written) on Joe's life and works
1960	Pop Art movement founded to bring more popular art to the masses through emerging reproduction techniques—serigraphy, silk-screening—and obliterating artificial lines drawn by art critics between illustration and fine art
1966	Maxfield Parrish dies in Cornish Colony, New Hampshire

1969	The original *Saturday Evening Post* closes
	End of the Golden Age of American Illustration
1974	Publication of *J.C. Leyendecker* by Michael Schau, the first book on Leyendecker and his work
1975	Publication of *J.C. Leyendecker Poster Book* with introduction by Rockwell
1976	Release of the Official First Edition of the Leyendecker Foundation, *Santa Loves You*, a limited edition collectible plate in an edition of 19,500 by Calhoun's Collectors Society
1977	Joe posthumously elected to the Society of Illustrators Hall of Fame
	U.S. Government, in recognition of J.C. Leyendecker as "America's mirror in art of the first half of the twentieth century," publishes a Leyendecker painting as the official Christmas stamp for 1977
	Joseph Adolph Leyendecker, nephew, dies by self-inflicted shotgun wound
1978	Norman Rockwell dies at age eighty-four
1980	Royal Cornwell Corporation issues four ceramic plates, as collectibles
1982	Leyendecker included in the exhibition entitled: "Great American Illustrators" at the C.W. Post Gallery
1988	"American Imagists" first used as a unifying name for artists from the Golden Age of American Illustration who created icons and symbols of American civilization
1989	"J.C." Leyendecker: An Age of Elegance" milestone exhibition at the American Illustrators Gallery in New York
	Phyllis Frederic visits American Illustrators Gallery NYC
1993	"The Great American Illustrators" exhibition in Japan organized by American Illustrators Gallery NYC includes Leyendecker, in his second exhibition abroad
1997	"J.C. Leyendecker" exhibition at the Norman Rockwell Museum, Stockbridge, Massachusetts
1998	"J.C Leyendecker: The Retrospective" exhibition at the American Illustrators Gallery NYC
	Founding of the National Museum of American Illustration at Vernon Court in Newport featuring the largest permanent collection of J.C. Leyendecker originals
1999	December 27, U.S. Postal Service issues a Millennium 2000 Celebration, thirty-three-cent stamp featuring a Leyendecker New Year's Baby
2000	National Museum of American Illustration opens to the public on July 4, with Leyendecker's works displayed in the American Imagist Collection
2002	"J.C. Leyendecker—The Great American Illustrator" CD documentary produced by Kultur Video
2006	"J.C. Leyendecker" exhibition at the American Illustrators Gallery NYC
	"J.C. Leyendecker: America's 'Other' Illustrator" opens at the Haggin Museum and begins three-year tour of ten other museums.
2008	J.C. Leyendecker featured in "American Imagist" exhibition at National Museum of American Illustration

NOTES

1. Regina Armstrong, a friend of Mary Leyendecker's, opined on the influence the Leyendecker brothers' ethnic origins had on their talents in her article about a posthumous exhibition honoring Frank Leyendecker at the New Rochelle Public Library: "Social Circle—An Appreciation," *The Standard Star* (New Rochelle), December 9, 1924.

2. David Rowland, "Leyendecker: Sunlight and Stone," *Saturday Evening Post*, May–June 1973, pp 56–62, 118–21. In 1938, when Joe was sixty-two years old and had not visited the offices of the *Post* since 1912, this mysterious and notorious man for the first and only time ruminated about his personal history with a *Post* editor. The result was not particularly revealing but was considered by the *Post* to be a "journalistic triumph," for he was, after all, a silent living legend.

3. "Keeping Posted," *Saturday Evening Post*, October 15, 1938.

4. Ibid.

5. Neil Hamilton letter to Michael Schau dated March 7, 1972.

6. Norman Rockwell, *My Adventures as an Illustrator* (Garden City, NY: Doubleday and Co., 1960), p. 202.

7. *The Roaring Twenties* (1939); its main character had a life story identical to Guinan's. Betty Hutton played Texas Guinan in *Incendiary Blond* (1945), Phyllis Diller played her in *Splendor in the Grass* (1961), and Whoopi Goldberg played a character names "Guinan" in twenty-eight episodes of television's *Star Trek: The Next Generation* (1988–93).

8. Norman Rockwell as interviewed by Dick Barclay and Bob Deubel for the documentary film *Norman Rockwell: An American Portrait* (1972); edited recollection by the authors from a recorded tape of Rockwell reflecting on J.C. Leyendecker.

9. Michael Schau, *J.C. Leyendecker* (New York: Watson-Guptill, 1974), p. 35. Excerpt of J.C. Leyendecker letter to Ial Radon, December 25, 1950.

10. Ibid.

11. *The Standard Star* (New Rochelle). July 28, 1951.

12. As quoted in Gatchel & Manning brochure, 1940, January 1940 *American Artist* feature.

Man with Cane and Gloves, detail. 1914. Oil on canvas, 29½ x 20¾". Unsigned. Arrow Collar advertisement

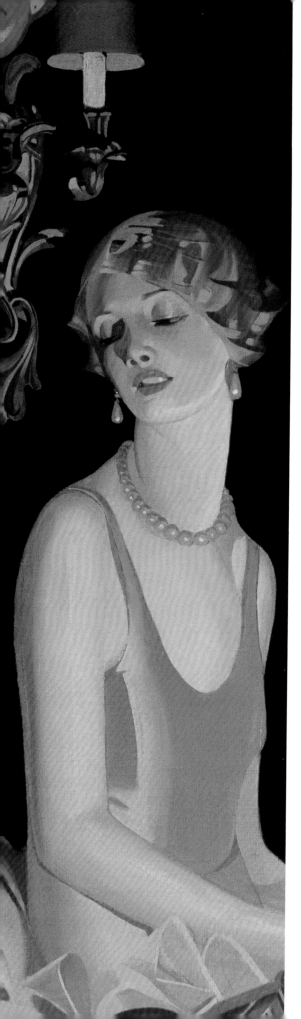

SELECTED BIBLIOGRAPHY

This bibliography is provided as an assist to those undertaking further research on J.C. Leyendecker and the American Imagists. It is not meant to be comprehensive but rather a starting point, for there is a general dearth of information available on illustration. Until rather recently, illustration art was not accepted as a scholarly pursuit. Times have begun to change, and hopefully this book and its bibliography will inspire others to undertake more research into this rich segment of the fine arts spectrum.

Allen, Michael. "Norman Rockwell's Idol." *The Saturday Evening Post*, October 1981.

The Art of J. C. Leyendecker. Royal Oak, MI: 21st Century Archives, 1995.

American Art by American Artists. New York: P.F. Collier & Sons, 1914.

Annuals of American Illustration. New York: Watson–Guptill, 1959–2001.

Bird, William L., and Harry R. Rubenstein. *Design for Victory: World War II Posters on the American Home Front*. Princeton, NJ: Princeton Architectural Press, 1998.

Bland, David. *A History of Book Illustration*. Cleveland: The World Publishing Company, 1958.

Bogart, Michele H. *Advertising, Artists, and the Borders of Art*. Chicago: The University of Chicago Press, 1995.

Bolton, Theodore. *American Book Illustrators: Bibliographic Check Lists of 123 Artists*. New York: R.R. Bowker Co., 1938.

Bowers, Q. David, et al. *Harrison Fisher*. Cincinnati: Bowers, Budd and Budd, 1984.

Boylan, Grace Duffie. *The Kiss of Glory*. New York: G. W. Dillingham Co., 1902.

Bradley, Will. "The Art of Illustration." *The Nation*, July 1913.

Broder, Patricia Janis. *Dean Cornwell: Dean of Illustrators*. New York: Balance House, 1978.

Brokaw, Howard Pyle. *The Howard Pyle Studio: A History*. Wilmington, DE: The Studio Group, 1983.

Brownell, W. C. *French Art*, Charles Scribner's Sons, New York: 1901.

Buechner, Thomas S. *Norman Rockwell, Artist and Illustrator* New York: Abrams, 1970.

Butterfield, Roger. *The Saturday Evening Post Treasury*, Simon and Schuster, New York: 1954.

Carter, Alice A. *The Red Rose Girls*. New York: Abrams, 2000.

A Century of American Illustration. New York: The Brooklyn Museum Press, 1972.

Chester, George Randolph. *Get Rich Quick Wallingford*. New York: A. L. Burt Company, 1908.

Christy, Howard Chandler, ed. *Liberty Belles: Eight Epochs in the Making of the American Girl*, Indianapolis: Bobbs–Merrill, 1912.

Cohn, Jan. *Covers of The Saturday Evening Post*. New York: Viking Studio Books, 1995.

Cooper, Emmanuel. *The Sexual Perspective: Homosexuality and Art in the Last 100 Years in the West*. London: Routledge, 1994.

Corelli, Marie. *Vendetta or the Story of One Forgotten*. London: Bentley, 1886.

Crane, Walter. *The Decorative Illustration of Books*. London: G. Bell & Sons, 1896.

Cutler, Laurence S., and Judy Goffman. *Maxfield Parrish*. London: Bison Books, and Greenwich: Brompton Books, 1993.

——. *The Great American Illustrators* (exhibition catalogue). Tokyo: The Great American Illustrators Catalogue Committee, 1993.

Cutler, Laurence S., and Judy A. G. Cutler. *Parrish & Poetry*. San Francisco: Pomegranate, 1995.

——. *Maxfield Parrish: A Retrospective*. San Francisco: Pomegranate, 1995.

——. *Maxfield Parrish*, San Diego: Thunder Bay Press, 2001.

Cutler, Laurence S., and Judy A. G. Cutler with The National Museum of American Illustration. *Maxfield Parrish: Treasures of Art*. London: Gramercy Books and New York: Random House Value Publishing, 1999.

——. *Maxfield Parrish and the American Imagists*. London: Regency House Publishing International and Edison, NJ: Wellfleet Press, 2004

Davis, Whitney, ed. *Gay and Lesbian Studies in Art History*. New York: Harrington Park Press, 1994.

Dodd, Loring Holmes. *A Generation of Illustrators and Etchers*. Boston: Chapman & Grimes, 1960.

Dohanos, Stevan. *American Realist*. New York: Van Nostrand Rheinhold, 1980.

Ellis, Richard. *Book Illustration*. Kingsport, TN: Kingsport Press, 1952.

Elzea, Rowland, and Iris Snyder, gen. eds. *The American Illustration Collections of the Delaware Art Museum*, Wilmington: Delaware Art Museum, 1991.

Elzea, Rowland. *The Golden Age of Illustration, 1880–1914* (exhibition catalogue). Wilmington: Delaware Art Museum, 1972.

Fitzgerald, F. Scott. *The Great Gatsby*. New York: Charles Scribner & Sons, 1925.

Gillon, Jr., Edmund Vincent. *The Gibson Girl and Her America*. New York: Dover, 1969.

Grunwald Center for the Graphic Arts. *The American Personality: The Artist–Illustrator of Life in the United States, 1860–1930*. Introduction by E. Maurice Bloch. Los Angeles: University of California, 1976.

Halsey, Jr., Ashley. *Illustrating for the Saturday Evening Post*. New York: American Book–Knickerbocker Press, 1951.

Harraden, Beatrice. *Ships That Pass in the Night*. New York: Frank A. Munsey Company, 1898.

Haskell, Barbara. *The American Century: Art & Culture 1900–1950*. New York: Norton, 1999.

Holme, Bryan. *The Journal of the Century*. New York: Viking, 1976.

Hornung, Clarence P., and Fridolf Johnson. *200 Years of American Graphic Art*. New York: Braziller, 1976.

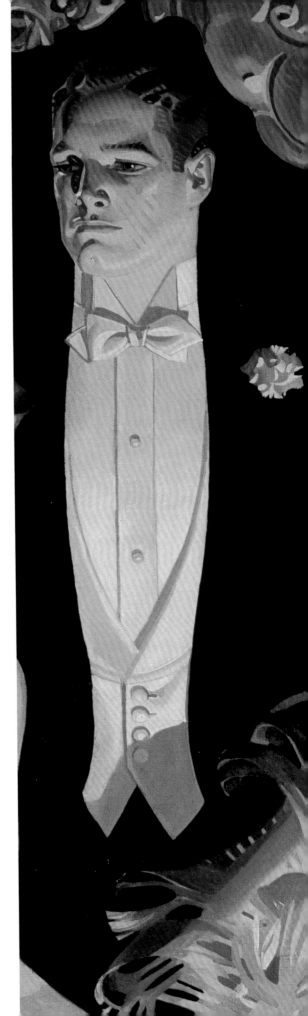

RIGHT AND OPPOSITE: *Man with Seated Lady*, details. 1929. Oil on canvas, 51 x 33". Unsigned. Arrow Collar advertisement

Hornung, Clarence P. *The Advertising Designs of Walter Dorwin Teague*. New York: Art Direction Book Company, 1991.

Horwitt, Nathan G. *A Book of Notable American Illustrators —1926*. New York: Walker Engraving Company, 1926.

Hudson, Charles Bradford. *The Crimson Conquest*. Chicago: McClurg, 1907.

Innes, Norman. *The Lonely Guard*. New York: Jacobs, circa 1912.

Jackson, Denis. *"The Man Who Inspired Rockwell: J.C. Leyendecker." The Antique Trader*, December 31, 1980.

———. "The Price & Identification Guide to: J.C. Leyendecker & F.X. Leyendecker" (pamphlet). Sequim, WA: Illustrator Collector's News, 1992.

Jacobson, Egbert G. *Annual of Advertising Art in the United States*. New York: Publishers Printing Company, 1921.

Larson, Judy L. *American Illustration 1890–1925*. Calgary: Glenbow Museum, 1986.

Lehmann-Haupt, Hellmut. *The Book in America: A History of the Making and Selling of Books in the United States*. New York: Bowker, 1951.

Margolin, Victor. *American Poster Renaissance*. New York: Watson-Guptill, 1975.

Martin, Richard. *What Is Man! The Imagery of Male Style of J.C. Leyendecker and Giorgio Armani, Textile & Text*, 13:1, 1990.

———. "American Chronicle: J.C. Leyendecker's Icons of Time." *Journal of American Culture*, 19:1, Spring 1996.

———. "J.C. Leyendecker and the Homoerotic Invention of Men's Fashion Icons, 1910–1930." *Prospects*, Fall–Winter 1996.

Meyer, Susan E. *James Montgomery Flagg*. New York: Watson-Guptill, 1974.

———. *America's Great Illustrators*. New York: Abrams, 1978.

Morris, Gouverneur. *The Voice in the Rice*. New York: Dodd, Mead, 1910.

Muller-Brockmann, Josef, and Shizuko Muller-Brockmann. *History of the Poster*. London: Phaidon Press, 2004.

New Britain Museum of American Art, *The Sanford Low Memorial Collection of American Illustration*, New Britain, CT: 1972.

Norris, Frank. *The Pit: The Epic of the Wheat*. New York: Doubleday, Page & Co., 1903

O'Neill, John P., ed. *American Art Posters of the 1890's*. New York: Metropolitan Museum of Art and Abrams, 1987.

Pitz, Henry Clarence. *The Practice of Illustration*. New York: Watson-Guptill, 1947.

———. *The Brandywine Tradition*. Boston: Houghton-Mifflin, 1968.

———. *200 Years of American Illustration*. New York: Society of Illustrators, 1977.

Rawls, Walton. *Wake Up, America!* New York: Abbeville, 1988.

Reed, Walt. *Great American Illustrators*. New York: Abbeville, 1979.

Rockwell, Norman. *My Adventures as an Illustrator*, New York: Abrams, 1988; reprint of Garden City: Doubleday, 1960.

———. *The J.C. Leyendecker Poster Book*, New York: Watson-Guptill, 1975 (adapted from Rockwell, *My Adventures as an Illustrator*).

Rowland, David. "Leyendecker: Sunlight and Stone," *Saturday Evening Post*, May–June issue, 1973, pages 56–63, 118–121.

Saslow, James M. *Pictures and Passions: A History of Homosexuality in the Visual Arts*. New York: Penguin Putnam, 1999.

Schau, Michael, *The All-American Girl: The Art of Coles Phillips*. New York: Watson-Guptill, 1975.

———. *The Original Gatsby Style: Art by J.C. Leyendecker*. New York: TWA Ambassador, July 1974.

———. *J.C. Leyendecker*. New York: Watson-Guptill, 1974.

Smith, Patricia Juliana. *An Encyclopedia of Gay, Lesbian, Bisexual, Transgender, and Queer Culture*. Chicago: Glbtq, 2002.

The Smithsonian Institution. *Directory to the Bicentennial Inventory of American Paintings Executed Before 1914*. Washington, DC.: Arno Press, 1976.

Steine, Kent, and Frederick B. Taraba. *The J.C. Leyendecker Collection: American Illustrators Poster Book*. Washington, DC: Collectors Press, 1995.

Three Centuries of American Art—Bicentennial Exhibition. Philadelphia Museum of Art, Philadelphia, 1976.

Williams, Egerton R. *Ridolfo—The Coming of the Dawn*. Chicago: McClurg & Co., 1906.

Zolomij, John. *The Motor Car in Art*. Kutztown, PA: Kutztown Publishing Co., Inc., 1990.

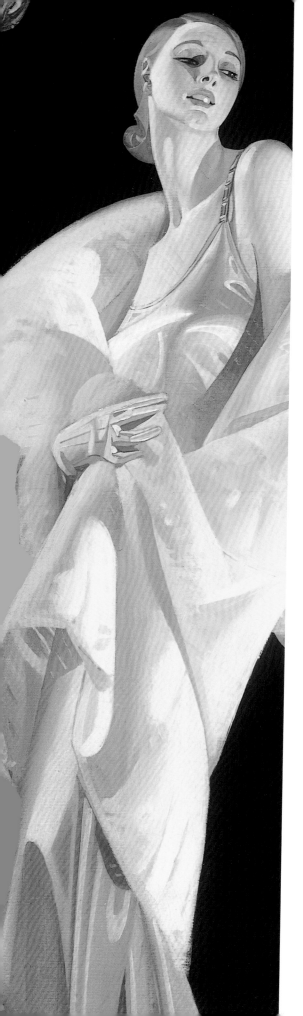

ACKNOWLEDGMENTS

We gratefully acknowledge all those who assisted us in synthesizing that which we found in the course of creating this book. Each person, institution, and corporation mentioned helped to bring J.C. Leyendecker's art and personal story to a longing audience, and we thank you all. We also thank those whom we may have inadvertently overlooked, while specifically crediting:

Andrew Douglas Goffman of the American Illustrators Gallery, for his tireless enthusiasm and perseverance in locating primary Leyendecker paintings.

Jessica Labbé, Dan Haar, Christine Shannon, and Andrew Weingert of the American Illustrators Gallery and Eric Brocklehurst, Jill Perkins, Benjamin Langley III, and Catherine Smith of the National Museum of American Illustration, for their team support of our efforts.

ARTShows and Products Worldwide (ASaP), the torch-bearers of Leyendecker's eternal flame, for the JC Leyendecker® trademark.

Dick Barclay and Bob Deubel, makers of the 1972 Academy Award–winning documentary "Norman Rockwell," for dreaming of yet another Academy Award–winner, this time about Joe Leyendecker.

Shep Brozman and his late wife, Melba, for searching for new plateaus from Japanese Inro to Leyendecker, and for encouraging us to again put pens to paper.

Michael Dolas, Renaissance man; illustrator-artist, engineer, collector, inventor, and sculptor, whose life revolves around Lura's operas, fine arts, and the Lotos Club.

The Dorros Family Photo Collection, for the autochrome portrait of Leyendecker.

Phyllis Frederic, charming Leyendecker model from the Roaring Twenties, whose devotion to his art and persona withstood the test of time. Her joyous sharing of stories provided rare insights into his lifestyle and the man and turned the mystery of the Leyendecker legend into a virtual being for us and you.

Bill Hargreaves, whose expertise and willingness to share vintage Leyendecker is most appreciated, and whose devotion to illustration is extraordinary.

Beatrix Kunzer of the Montabaur State Archives in Germany for Leyendecker and Ortseifen family archival searches.

Darwin Lin, for promoting J.C. Leyendecker's artworks in Asia, creating an awareness in new realms.

Susan E. Meyer, author of *America's Great Illustrators* (1978), for her early contribution to the lore.

Gary Meyers and Brian Leonard, documentary filmmakers, for their ambitious efforts to create a high definition television film on this artist and the other American Imagist masters.

Jill Newhouse, who graciously welcomed us to the Mount Tom Day School, the former Leyendecker estate.

Susan Olsen, whose research clarified rumors regarding a hitherto unknown brother, Adolph A. Leyendecker.

Arnold Quinn, for his efforts to publish the best replications of Leyendecker artworks ever created.

Baron Alan H. Rothschild, Esq., who with an astute eye proofed an early manuscript. They say it is comforting to have critics as friends—or did they say, friends who are critics?

Tod Ruhstaller, curator of the 2006 exhibition "J.C. Leyendecker: America's 'Other' Illustrator," for sharing the story of Earl Rowland.

Michael Schau, whose 1974 *J.C. Leyendecker* book was all one had to go on for many years. Michael's recent visits proved his passion has not waned and we thank him for the loan of photographs, letters, and memorabilia—a gracious and welcome assist.

Joan SerVass, President of Curtis Publishing Company, publisher of *The Saturday Evening Post*, for granting reproduction rights. Also *The Saturday Evening Post* magazine, for rights to reproduce those covers over which they assert copyrights.

G. J. Sullivan, for sharing photographs and personal knowledge of the Leyendecker and Ortseifen families.

Creston Tanner, collector of both Joe Leyendecker and Maxfield Parrish's vintage works, for generously offering help whenever needed.

J.C. Leyendecker's corporate clients, including Kellogg's Corn Flakes; Kuppenheimer; Cluett, Peabody & Co. (Arrow); Interwoven Socks Inc.; Hart Schaffner & Marx; Proctor & Gamble; The Timken Company; and others, for the historic advertising campaigns they waged using his images as weapons against competitors and lures for customers.

We also extend thanks to the following institutions, Art Institute of Chicago, Chicago Historical Society, Columbia University Library, Museum of the City of New York, New Rochelle Public Library and City Hall, New York City Public Library, National Arts Club, New-York Historical Society, Salmagundi Club, and Society of Illustrators.

Finally, we are sincerely grateful to Eric Himmel, editor-in-chief of Harry N. Abrams, for more than a decade of patience and continuing interest in publishing this book; to the late Paul Gottlieb, president, publisher, and editor-in-chief of Abrams, for his faith that we would ultimately produce this book; to Laura Lindgren, for her superb book design, which complements Joe Leyendecker's artworks so well; and lastly, to Beverly Fazio Herter, for her surgical wisdom and talent at selecting what to leave in and what to take out.

J.G.C. and L.S.C.

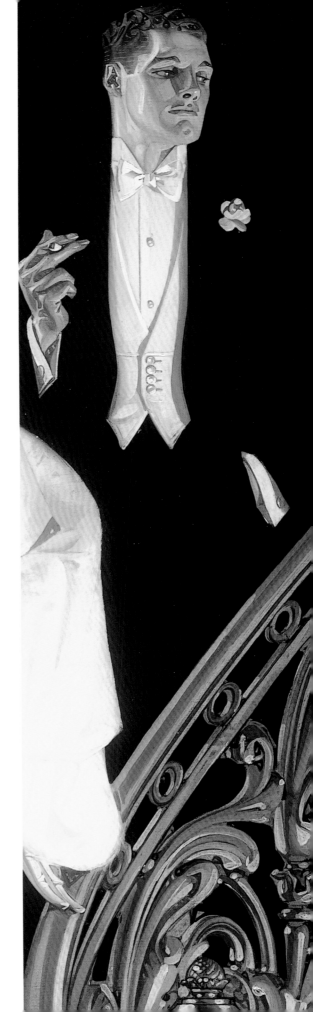

RIGHT AND OPPOSITE: *Couple Descending Staircase*, details. 1932. Oil on canvas, 49¼ x 32". Unsigned

PHOTOGRAPH CREDITS

The authors and publishers would like to thank the individuals and institutions who so kindly loaned photographs and/or gave consent to their publication. References are to page numbers.

All transparencies of original artwork © 2008 with all rights reserved and courtesy of the Archives of the American Illustrators Gallery, NYC, www.americanillustrators.com, except as noted. All reproductions of printed material © 2008 with all rights reserved and courtesy of the Archives of the National Museum of American Illustration, Newport R.I.,

www.americanillustration.org, except as noted. All *Saturday Evening Post* cover images © 2008 SEPS: www.curtispublishing.com.

Country Life magazine, June 1919: 39 below, left and right. Photo by Judy and Laurence Cutler: 39 above left. Courtesy Dorros Family Photo Collection: 240 above left. Courtesy Bill Hargreaves: 30 above left; 31 middle right; 35 above right; 42 above left; 53; 64 below left; 66 above left; 170 above left; 171; 177 bottom right; 178 middle, left and right; 179 bottom right; 180 top center; 180 bottom right; 182; 183 above row;

184 below left and above right; 186; 187; 191 above right; 193 right; 195; 215 below right; 211; 227. *New Rochelle Standard Star*, May 1, 1953: 32. Courtesy Mrs. James F. Parr and Michael Shau: 39 above right. Private Collection: 51. Courtesy Michael Schau: 29 above; 31 bottom; 38 below; 40 below; 71; 177 middle center; 183 below; 226 below left. Courtesy Society of Illustrators: 173. Courtesy G. J. Sullivan: 20; 21; 22. "The Syndicates of Chicago," www.americanbreweriana.org: 23. Courtesy Creston Tanner: 172 top left; 180 bottom left; 180 top right. Courtesy The Woodlawn Cemetery, Bronx, NY: 234 right.

INDEX